The Neo-Impressionist Portrait
1886–1904

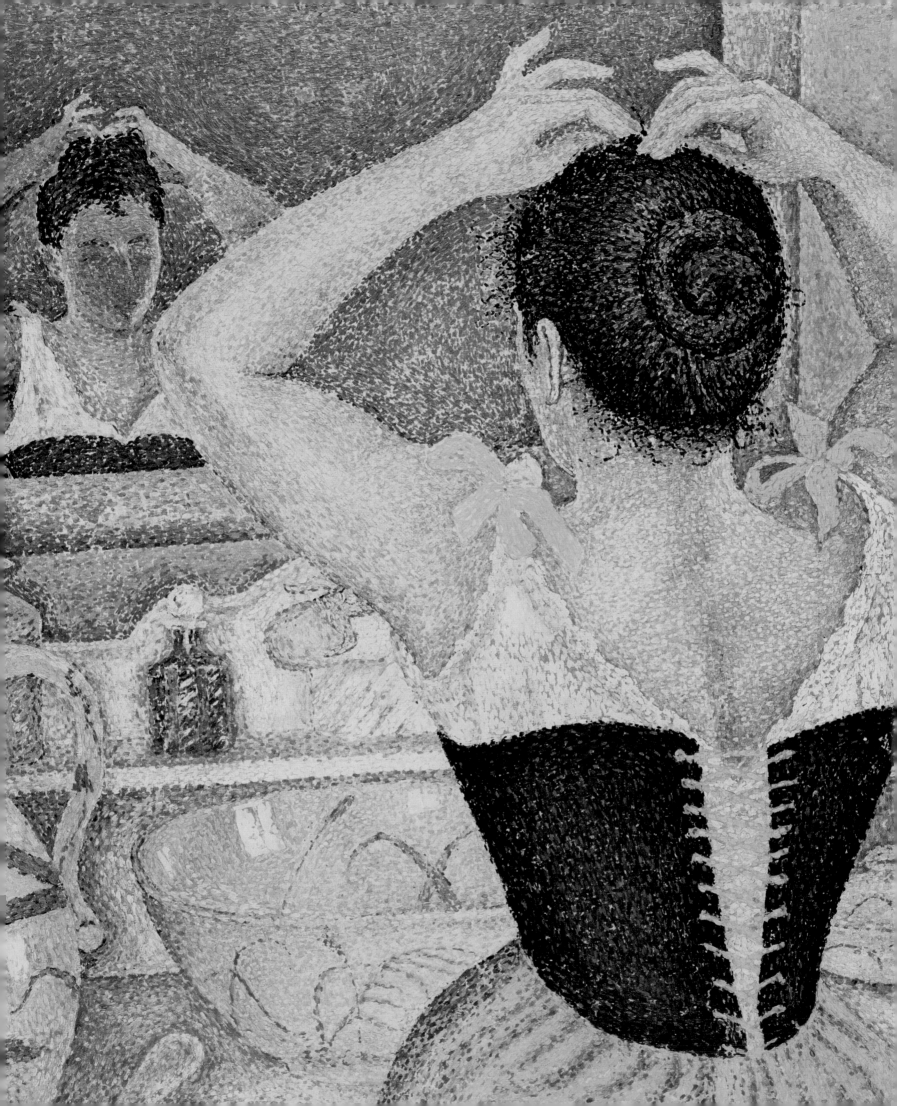

The Neo-Impressionist Portrait 1886–1904

Jane Block and Ellen Wardwell Lee

With contributions by Marina Ferretti Bocquillon and Nicole Tamburini

INDIANAPOLIS MUSEUM OF ART
Indianapolis

YALE UNIVERSITY PRESS
New Haven and London

Published on the occasion of the exhibitions:

To the Point: Le portrait néo-impressionniste, 1886–1904
ING Cultural Centre, Brussels
February 19–May 18, 2014

Face to Face: The Neo-Impressionist Portrait, 1886–1904
Indianapolis Museum of Art
June 15–September 7, 2014

The exhibition is made possible through the generosity of the Allen Whitehill Clowes Charitable Foundation. Additional support for the exhibition and catalogue provided by the National Endowment for the Arts.

yalebooks.com/art

Translations from French for the contributions of Marina Ferretti Bocquillon and Nicole Tamburini are by Elizabeth G. Heard.

Designed by Miko McGinty and Rita Jules
Set in Atma Serif and Gotham Narrow by Tina Henderson
Printed in China by Regent Publishing Services Limited

Library of Congress Cataloging-in-Publication Data
Block, Jane.
 The neo-impressionist portrait, 1886-1904 / Jane Block and Ellen Wardwell Lee ; with contributions by Marina Ferretti Bocquillon and Nicole Tamburini.
 pages cm
 "Published on the occasion of exhibitions at ING Cultural Centre, Brussels, February 19–May 18, 2014, and Indianapolis Museum of Art, June 15–September 7, 2014."
 Includes bibliographical references and index.
 ISBN 978-0-300-19084-7 (cloth : alk. paper) 1. Portrait painting, French—19th century—Exhibitions. 2. Portrait painting, Belgian—19th century—Exhibitions. 3. Neo-impressionism (Art)—Exhibitions. I. Lee, Ellen Wardwell. II. ING Cultuurcentrum. III. Indianapolis Museum of Art. IV. Title.
 ND1316.5B59 2013
 757.0944'07477252—dc23 2013029219

A catalogue record for this book is available from the British Library.

This paper meets the requirements of ANSI/NISO Z39.48–1992 (Permanence of Paper).

10 9 8 7 6 5 4 3 2 1

Jacket illustrations: (*front*) Théo van Rysselberghe, *Three Children in Blue (The Three Guinotte Girls)* (detail of plate 58); (*back*) Jan Toorop, *The Print Lover (Dr. Aegidius Timmerman)* (detail of plate 40)
Page ii: Paul Signac, *Woman Arranging Her Hair, Opus 227 (Arabesques for a Dressing Room)* (detail of plate 37)
Page vi: Henry van de Velde, *Père Biart Reading in the Garden* (detail of plate 43)
Page xiv: Théo van Rysselberghe, *In July, Before Noon* (detail of plate 48)
Page xviii: Georges Seurat, *Young Woman Powdering Herself* (detail of plate 33)
Page 28: Georges Lemmen, *Mademoiselle Maréchal* (detail of plate 17)

Contents

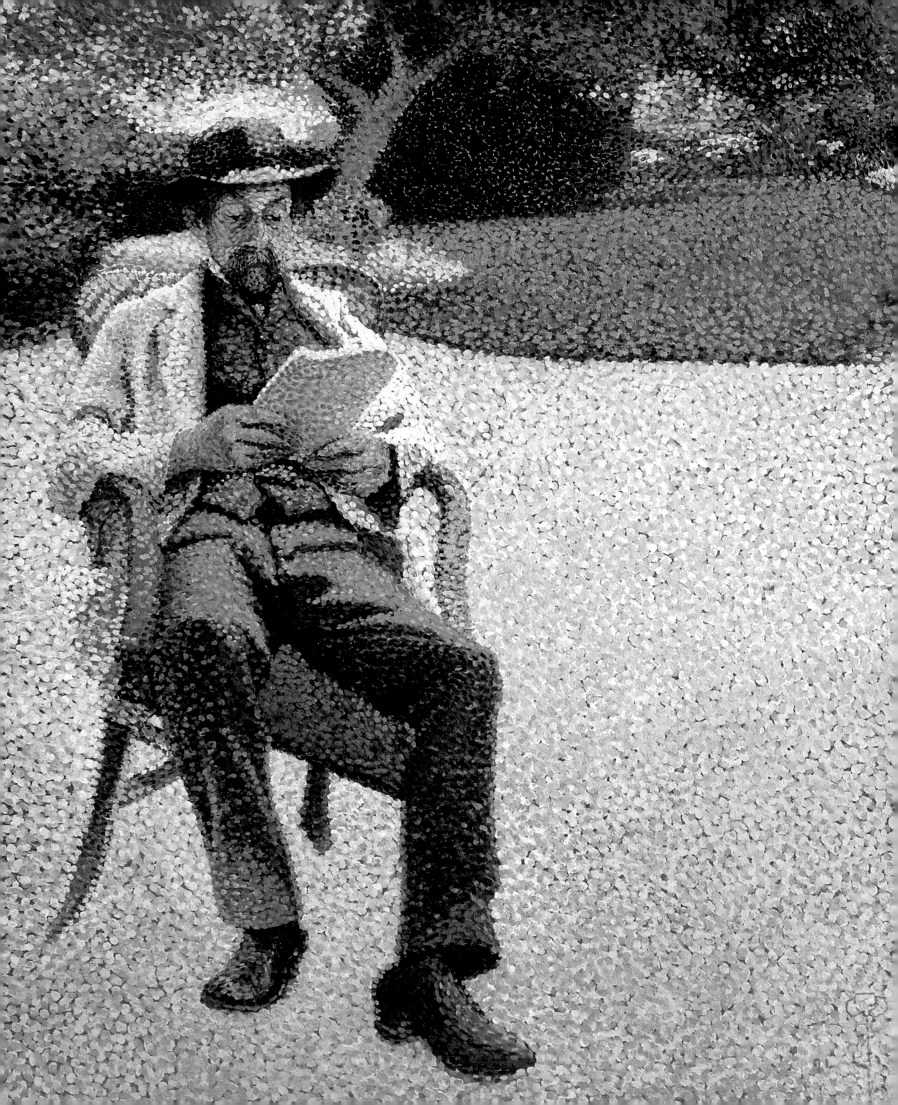

Foreword

The Neo-Impressionist movement is appropriately associated with exquisite landscapes and intriguing scenes of urban leisure and modern life. Yet its dotted brushwork and color theory also produced arresting portraits of unusual beauty and perception. *Face to Face: The Neo-Impressionist Portrait, 1886–1904* is the first exhibition to focus on the likenesses created by this challenging method.

The Indianapolis Museum of Art is the natural host for this initiative. The museum has the most important collection of Neo-Impressionist paintings in America, including several notable portraits that suggest the range and appeal of this genre. The exhibition is the latest effort in the leading role the IMA has played in the study and conservation of Neo-Impressionist works of art.

Exhibition co-curator Dr. Jane Block is a widely published author and distinguished scholar of nineteenth-century Franco-Belgian art and culture. She recognized the lack of attention to this subject and conceived the idea of a thorough study of the Neo-Impressionist portrait. She has a fitting collaborator in Ellen W. Lee, the IMA's Wood-Pulliam Senior Curator. During her long tenure at the museum, Lee has been critical in developing the IMA's Neo-Impressionist collection, as well as responsible for significant exhibitions and research devoted to our holdings. Their partnership has brought this exhibition and catalogue to fruition, and we are proud to present the extraordinary results of their efforts.

A number of individuals and institutions have extended critical assistance along the way. The IMA gratefully recognizes our exhibition partner, the ING Cultural Centre in Brussels, and its senior curator, Patricia De Peuter. It is particularly satisfying to have this exhibition appear in Brussels, a city so important to the development of Neo-Impressionism.

We are also honored to work with Yale University Press to bring this scholarship and beautiful body of work to light. In addition, I acknowledge with appreciation the Allen Whitehill Clowes Charitable Foundation and the National Endowment for the Arts, which provided generous support for the exhibition and catalogue.

This project would have been impossible without our lenders. We are indebted to the museums, libraries, private collectors, and galleries who have allowed their works to be encountered face to face in the exhibition and on the pages that follow.

Dr. Charles L. Venable
The Melvin & Bren Simon Director and CEO
Indianapolis Museum of Art

Preface

As Georges Seurat developed his approach to painting in the 1880s, he turned to recent studies in optics and perception, and his use of color theory and pointillist brushwork became known as Neo-Impressionism. His style attracted an enthusiastic band of practitioners in France, Belgium, and the Netherlands. Scholars have examined the paintings they produced from several perspectives: as the application of science to art, as social commentary, as a reflection of political philosophies, and as a precursor to many concepts of twentieth-century aesthetics. Perhaps because Seurat's great initiative was so rooted in the creation and capture of brilliant color and natural light, the primary vehicles for analyzing Neo-Impressionist technique have been landscapes, seascapes, and urban scenes. As a result, Neo-Impressionist portraits and their place in the modern era have received insufficient attention. This publication and the exhibition it accompanies explore these works as a key element of the movement and an important chapter in the dynamic interaction between artist and subject that defines the art of the portrait.

The Neo-Impressionist portrait came into existence decades after the invention of photography had made realistic images widely available. While physical resemblance remained a natural component of portraiture, artists of the era were also free to emphasize their individual techniques, their pursuit of psychological or spiritual identity, and their own emotional connection with their subjects. Paintings by Paul Gauguin, Paul Cézanne, and Vincent van Gogh are evidence that portraiture had earned an expressive as well as a descriptive raison d'être. The most insightful "modern portrait" was often the one in which artistic choice trumped realistic facial features.

One might well ask if the demands of the Neo-Impressionist method, with its small dots and rules of color division, compromise the visual accuracy or emotive quotient of the portrait. The answers lie in the faces of the Neo-Impressionist subjects—from the intimate

likenesses of family and friends to the commissioned portrait, from sympathetic pictures of colleagues to genre scenes casting specific individuals as unnamed characters in intricate tableaux. These images reflect the Neo-Impressionists' capacity to invest their portraits with psychological intensity as well as realistic detail.

Neo-Impressionist portraiture is not entirely a story of painting. Seurat created only one oil portrait—an ironic look at contemporary vanities—yet his mastery of the conté crayon demonstrated irrefutably the expressive potential of the black-and-white drawing. The intimate portrait drawings created by some of his followers are a special component of this study. While not all can lay claim to purely Neo-Impressionist methods, many use crosshatching or the dotted result of dragging the crayon across textured paper to achieve the effect of divided brushwork. Frequently their use of black-and-white contrast is the tonal counterpart of the complementary color harmonies at the heart of Seurat's aesthetic.

In the first essay of this assessment of the Neo-Impressionist portrait, Jane Block describes the state of portraiture in the nineteenth century and traces the birth of Neo-Impressionism in Paris and its enthusiastic reception by progressive artists in Belgium. Her second essay situates the portrait within the practice of French Neo-Impressionism before examining its treatment in Belgium, where the portrait enjoyed a special prominence. The catalogue section presents the key examples of Neo-Impressionist portraiture individually and devotes special attention to the sitters and their settings, drawing upon aspects of history, music, and literature to describe many of the era's more fascinating personalities. While some of the featured works were not available for exhibition in Brussels or Indianapolis, they are included here in order to provide a comprehensive survey of the subject. A newly compiled roster of all known Neo-Impressionist oil portraits appears in the appendix.

The human face must be one of the most natural of artists' subjects. Exploring the Neo-Impressionists' treatment of this enduring theme takes us from the theoretical to the specific, from the aesthetic to the pragmatic, as we examine the character and context of their efforts.

EWL

Acknowledgments

One of the most satisfying aspects of completing a cherished and complicated project is the opportunity to identify and thank those who helped make it a reality. *Face to Face: The Neo-Impressionist Portrait, 1886–1904* could not have happened without the support of the Indianapolis Museum of Art, and we thank its directors, Maxwell L. Anderson and his successor, Charles L. Venable, for their belief in the exhibition concept and their commitment to its realization. We also extend warm thanks to our exhibition partner, Patricia De Peuter, senior curator at the ING Cultural Centre, who responded so positively to the beauty of these works and their resonance for Belgium. Many institutions and individuals have generously shared their paintings and works on paper in order to make this study possible. We hope this publication will be a worthy reminder of our appreciation.

We are proud to count as contributors to this publication Marina Ferretti Bocquillon, directeur scientifique of the Musée des Impressionnismes, Giverny, and independent scholar Nicole Tamburini. For their expertise and invaluable assistance in locating works for the exhibition, we are very grateful.

It has been an honor to collaborate with Yale University Press on this catalogue. We extend our thanks to Patricia Fidler, publisher; Katherine Boller, associate editor; Heidi Downey, manuscript editor; and Sarah Henry, production manager, for their professionalism and faith in the project. It is especially satisfying to see this beautiful body of work treated with such sensitivity and skill through the graphic design of Miko McGinty Inc.

This publication and the exhibition it accompanies have benefited at every stage from the talent and dedication of the Indianapolis Museum of Art staff. Heartfelt thanks go to assistant curator Rebecca Long, who coordinated myriad details of the project and never failed to provide an empathetic ear and sound judgment. When authors surrender their manuscripts, they hope to encounter an editor with rigorous standards and sensitivity. That

was our experience with IMA editor and publications manager Emily Zoss, who deserves enormous credit for leading the museum's production of the catalogue. Other critical players were Anne Young, manager of rights and reproductions, and manager of photography Tascha Horowitz. Exhibition registrars Angie Day and Brittany Minton handled the organization of loan agreements, transportation, and insurance with impeccable accuracy. We were fortunate to work with chief designer Phillip Lynam, lighting designer Carol Cody, graphic designer Matthew Taylor, and the entire installation crew as they brought their sensitivity and vision to the presentation of these beautiful objects. We also thank Kathryn Haigh, the deputy director for collections, research, and exhibitions, and curatorial associate Petra Slinkard for their many contributions. To Preston Bautista, Silvia Filippini-Fantoni, Rachel Huizinga, and Daniel Beyer in the museum's department of audience engagement, as well as the loyal IMA docents, we extend thanks for all the insights they offer our audiences.

This project has developed over many years, and in that time we have been treated to the wise counsel and generous assistance of so many colleagues, acknowledged here with our warmest thanks: Anne Adriaens, Lucile Audouy, Marie-Laurence Bernard, Olivier Bertrand, Guy Biart, André and Nicky Bollen, Laurence Boudart, Jack Perry Brown, Françoise Cachin (+), Tony Calabrese, Brigitte Cardon, Véronique Cardon, Guy Cogeval, Michael Conforti, Stephane Connery, Lieven Daenens, Jean Danhaive, Kathy Danner, Ninette and Guy De Bry, Dr. Étienne Demanet, Patrick Derom, Pascal de Sadeleer, Michel Draguet, Eric Drossart, Douglas Druick, Danielle Dubois, Raphaël Dupouy, Christophe Duvivier, Ronald Feltkamp, Tomas Firle, Adrienne Fontainas (+), Donald Friedman, Claude Ghez, Catherine Gide (+), Stephen Glickman, Ingrid Godderis, Gilles Grannec, Nadine Grelsamer, Gloria Groom, Pierre Hallet, Katelyn Harper, Elizabeth G. Heard, Charlotte Liebert Hellman, Rik Hemmerijckx, Andy and Carol Herzig, Connie Homburg, Robert Hoozee (+), Paul Huvenne, Véronique Jago-Antoine, Jean-David Jumeau-Lafond, Paula Kaufman, Marjorie Klein, Benoît Labarre, Sarah Lees, Patrick Lefèvre, François Lespinasse, Claire Maignon, Dominique Marechal, Gilles Marquenie, Caroline Mathieu, Bertrand Maus de Rolley, Dan Mayer, Marie-Noëlle Maynard, Suzanne McCullagh, Jean Morjean, Moniek Nagels, Juan San Nicolás, Martijn and Ada Oleff, Soledad de Pablo Roberto, Lisette Pelsers, Roberto Polo, Marc Quaghebeur, Chris Quinn, Jenny Reynaerts, Johanna and Hedwig Ruyts, Peter Schnyder, Yves Serruys, Thomas Seydoux, Colette Simonet, Claude Sorgeloos, Liz Spiro, Peter Spiro, Claire Stoullig, Thérèse Symons, Caroline Szylowicz, Sabine Taevernier, Monique Tahon, Élisabeth and Henri Thévenin (+), Françoise Thomas, Marina G. Thouin, Herwig Todts, Maurice Tzwern, Fabrice van de Kerckhove, Toos Van Kooten, Jean-Pierre Van den Branden, Mme Paul Van der Perre (+), Catherine Verleysen, and Berthe (+) and Louis (+) Wittamer.

JB and EWL

Curating an exhibition and publication examining the Neo-Impressionist portrait has been my fondest desire these many years. I can think of no better partner for such an undertaking than the Indianapolis Museum of Art, which has a stellar collection of Neo-Impressionist works. I thank Ellen Lee, who has been a dear friend and valued colleague for many decades and a constant companion in investigating this compelling subject. I also want to acknowledge the assistance of Roger Cardon for his expertise on Belgian art and for his unfailing friendship. Finally, to my husband, Paul Kruty, a giant thanks for his keen editorial assistance and for the joy of sharing the discovery of many of these artists who have enriched our lives.

 JB

Following the saga of the Neo-Impressionist portrait has been a long and intriguing road. For her exceptionally generous help along the way, I would like to thank Susan Alyson Stein for her advice and steady support. My thanks go also to the late Paul Josefowitz for his ongoing interest and his never-failing optimism that this project could be realized. And, finally, a word of advice to anyone contemplating working "face to face": try to find a colleague with impeccable scholarship, integrity, patience, common sense, and uncommon generosity—try to find another Jane Block. It won't be easy.

 EWL

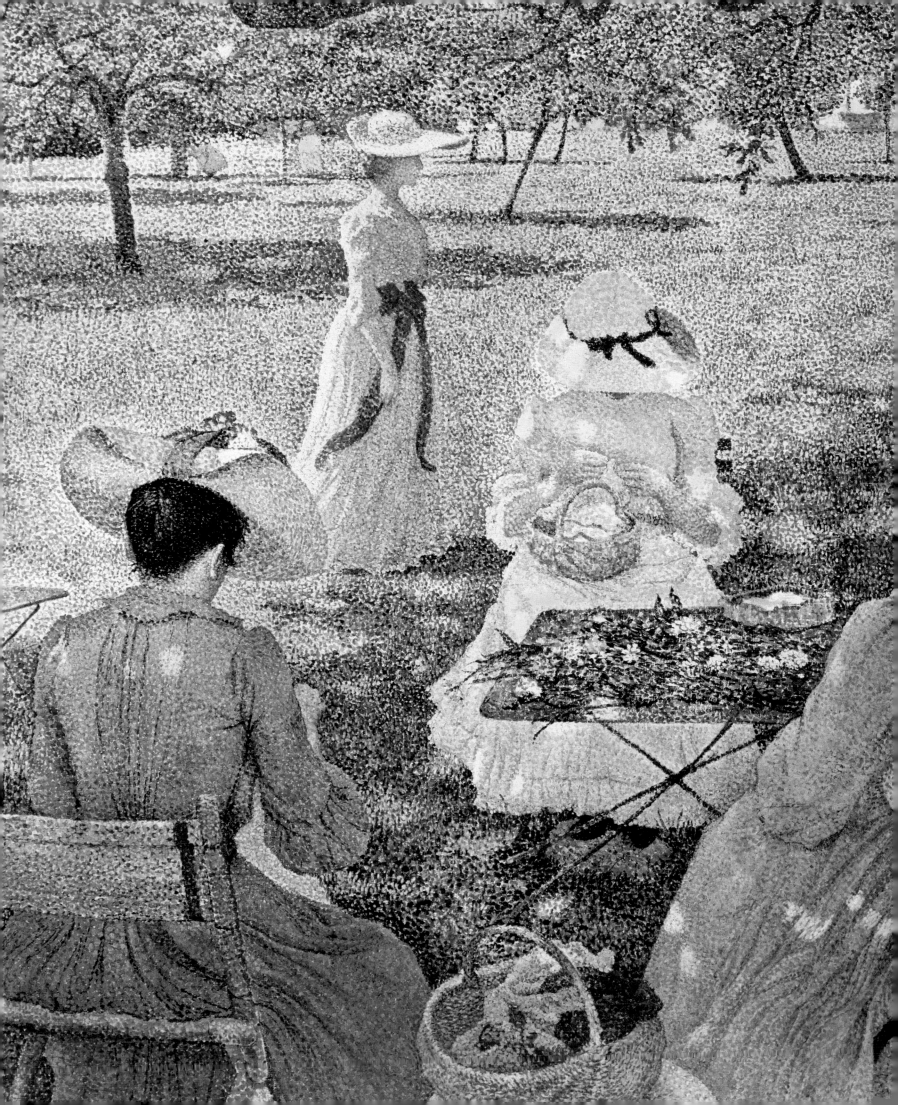

Lenders to the Exhibition

The Art Institute of Chicago

Robert Bachmann

Bibliothèque royale de Belgique, Brussels

The Dyke Collection

Galerie Michael Haas, Berlin

Galerie Moulins, Toulouse

Groeningemuseum, Bruges

Indianapolis Museum of Art

Koninklijk Museum voor Schone Kunsten, Antwerp

Kröller-Müller Museum, Otterlo

The Metropolitan Museum of Art, New York

Michele and Donald D'Amour Museum of Fine Arts, Springfield, MA

Musée d'art moderne de Saint-Étienne Métropole

Musée départemental Maurice Denis, Saint-Germain-en-Laye

Musée des Beaux-Arts de Carcassonne

Musée d'Orsay, Paris

Musées royaux des Beaux-Arts de Belgique, Brussels

Museum Plantin-Moretus, Antwerp

National Gallery of Art, Washington, DC

Petit Palais, Musée d'art moderne, Geneva

Roberto Polo Gallery, Brussels

Sterling and Francine Clark Art Institute, Williamstown, MA

Stichting Hannema-de Stuers Fundatie, Heino

Greta van Broeckhoven

Private collections

Note to the Reader

The works featured in the Plates section of this publication are presented alphabetically by artist, and each artist's works appear in chronological order. Dates that appear in brackets indicate that the date of execution was not inscribed by the artist on the work but has been determined through primary sources. For dimensions, height precedes width. When a work is cited in the exhibition history, the title of the accompanying publication is not repeated in the bibliography. The individual exhibition histories and bibliographies for each work are comprehensive but do not necessarily include every citation. For quotations in the text that have been translated into English, the original French is provided in the notes when it is critical to understanding the author's text or when it can be found in only unpublished sources.

Plate entries and artist biographies are by Jane Block (JB), Marina Ferretti Bocquillon (MFB), Ellen Wardwell Lee (EWL), and Nicole Tamburini (NT).

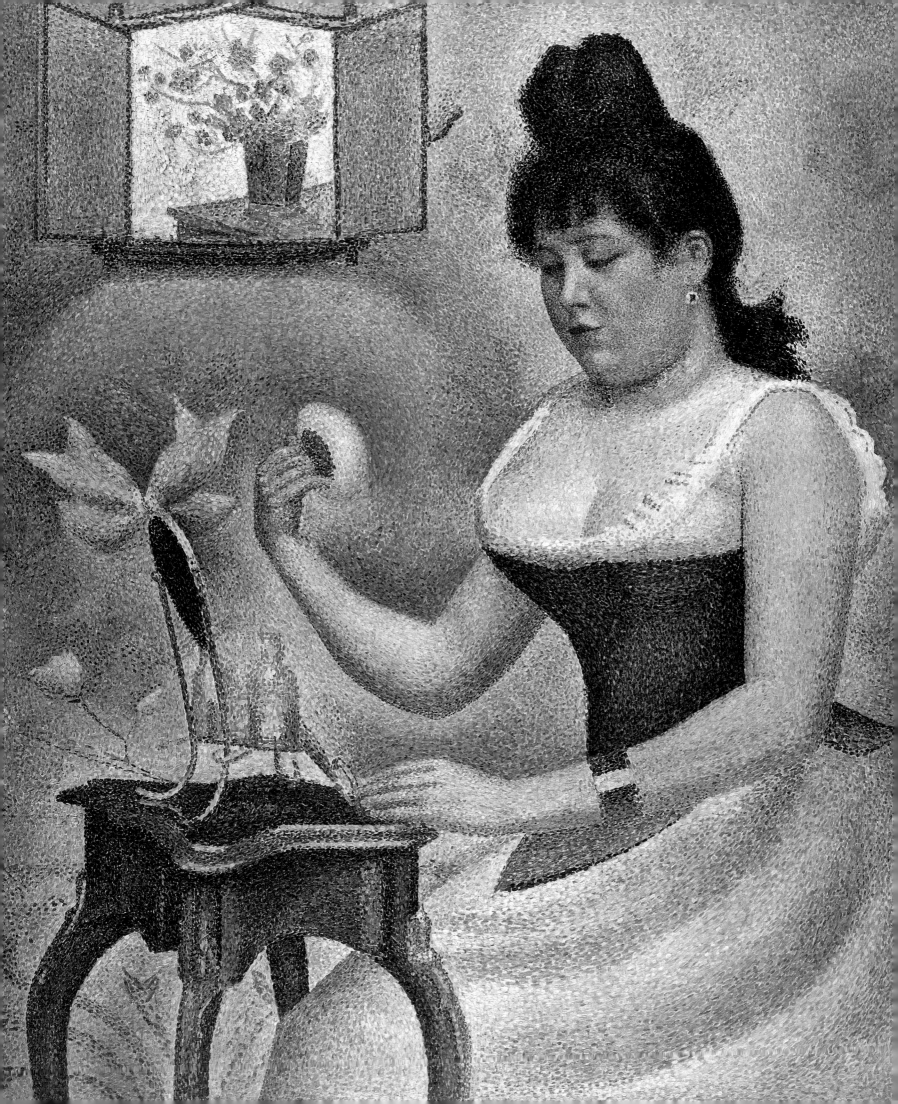

The Flowering of Neo-Impressionism amid a Demand for Portraiture

Jane Block

Capturing the human likeness has been a recurring preoccupation in the history of art. In modern France, from the founding of the Paris Salon in 1699, portraiture was considered an important genre, surpassed only by history and mythology in the hierarchy of subjects set forth by the Academy of Fine Arts. Portrait painting remained wildly popular in nineteenth-century Paris, even as avant-garde artists forged new vocabularies of color and line that often presented their sitters in unconventional ways. In the mid-1880s, when Georges Seurat invented the manner of painting eventually called "Neo-Impressionism," the result was a tendency toward a reductivist, abstracted presentation of form seemingly antithetical to the purpose of individual portraiture. Yet between 1886 and 1904, French and Belgian artists created a significant body of such works in the Neo-Impressionist style that can teach us much about both Neo-Impressionism and portraiture.

The Portrait in the Nineteenth Century

Artists have explored many ways to create what John Gere called a work "in which the artist is engaged with the personality of his sitter and is pre-occupied with his or her characterization as an individual."[1] As the nineteenth century opened, painters continued to use portraiture to immortalize an elite figure, surrounding the subject with important furnishings and objects to confirm the sitter's status. In Jacques-Louis David's *Bonaparte Crossing the Great Saint Bernard Pass* (*Le Premier Consul franchissant les Alpes au col du Grand Saint-Bernard*) (1801, fig. 1), portraiture is used as state propaganda. Napoleon, the supreme commander, prepares to lead a military exploit across the Alps, as the stone inscription records.

As the century progressed, the taste for the commissioned image as conveyor of status and power continued, though the client base changed from royalty and rulers to the rising

bourgeoisie. And while painters were still expected to capture an idealized likeness, trappings remained crucial.[2] The academician Carolus-Duran recorded the wives of wealthy politicians, and Léon Bonnat rendered government officials and American industrialists, who paid as much as 15,000 francs for a full-length portrait. (By comparison, in 1868, Claude Monet received only 130 francs for a similar work.)[3] Carolus-Duran intended his portrait *Woman with a Glove* (*La Dame au gant*) (fig. 2), exhibited at the Salon of 1869, to show the kind of fashionable society portraits he could produce; it became his calling card.[4] The model was his wife, Pauline Croizette, posed against a neutral background to heighten the focus on her jewelry and attire.[5] The Impressionists and Neo-Impressionists objected to what they believed were vapid portraits, with their polished surfaces and academic poses. Camille Pissarro could hardly contain his glee when critic Octave Mirbeau skewered Carolus-Duran for his "pretty" works at the 1892 Salon.[6]

Among the progressive artists, a new relationship between painter and subject began to emerge. In 1846, while reviewing the Paris Salon, Charles Baudelaire made the distinction between portraiture that is primarily accurate—"history"—and portraiture that reveals

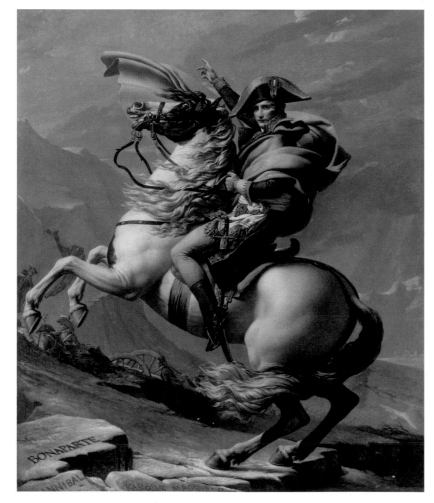

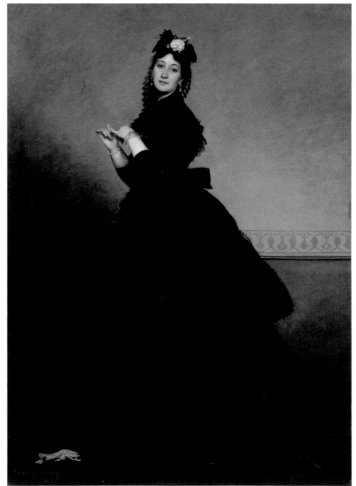

Fig. 1. Jacques-Louis David (French, 1748–1825), *Bonaparte Crossing the Great Saint Bernard Pass* (*Le Premier Consul franchissant les Alpes au col du Grand Saint-Bernard*), 1801. Oil on canvas, 102 × 87 in. (259 × 221 cm). Châteaux de Malmaison et Bois-Préau, Rueil-Malmaison, France.

Fig. 2. Charles Émile Carolus-Duran (French, 1837–1917), *Woman with a Glove* (*La Dame au gant*) (Mme Carolus-Duran, née Pauline Croizette), 1869. Oil on canvas, 89¾ × 64⅝ in. (228 × 164 cm). Musée d'Orsay, Paris.

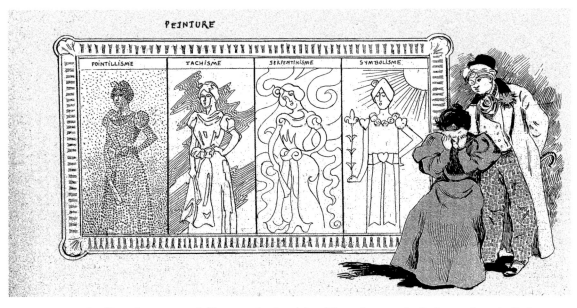

Fig. 3. Henri Avelot (French, 1873–1935), "A travers les Quat'z'arts" from the revue *La Caricature,* June 6, 1896. Drawing. Bibliothèque nationale de France (BnF), Paris.

more—"fiction."[7] Rejecting the traditional emphasis on the exteriorization of the subject, avant-garde painters, including the Neo-Impressionists, combined Baudelaire's alternatives for portraits: history in the relative fidelity of capturing the sitter's physiognomic uniqueness; fiction in the use of colors and line charged with expressive meanings that could lead to a new understanding of the individual. The popularity of the portrait photograph further freed the painter to explore inner personalities.

With the rise of the anti-academic avant-garde, the individual's identity was subject to a new relationship between artist and sitter. Through the artist's use of liberated color and line, the portrait would be imbued with a personal interpretation—a balancing act that might reveal more about artist than sitter. Once this equilibrium was altered, it often took some adjustment on the part of the client to appreciate the results. In an 1896 caricature (fig. 3), a young woman breaks down in tears after seeing her portrait rendered in four modern styles, including Neo-Impressionism, none of them photographic. A new kind of portrait was coming into being that would eventually lead to Picasso's Cubist portrait of Ambroise Vollard (1909) and Picabia's Dada portrait of Alfred Stieglitz (1915).

Impressionism was the first modern movement to wrestle with this new dialectic. Portraiture played an important role in the career of nearly all the Impressionists, who typically depicted their friends and relatives in relaxed poses in undefined settings.[8] In Pierre-Auguste Renoir's *Alfred Sisley* (1876, fig. 4), the artist's colleague sits astride a bamboo chair in a shallow interior space rendered in a loose, visible brushstroke. Sisley appears lost in contemplation, head resting on hand. Neo-Impressionists used the informality of the Impressionists' poses but rejected their impetuous brushwork, seeking instead to fashion reality in a more controlled manner according to the latest "scientific" theories.

As the number of portraits at the Salon rose proportionately from 11 to 21 percent between 1864 and 1887, a series of French exhibitions documented this seemingly insatiable

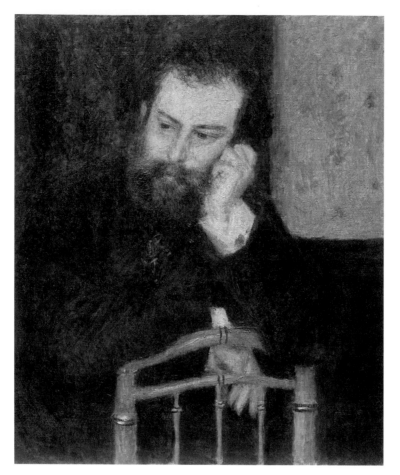

Fig. 4. Pierre-Auguste Renoir (French, 1841–1919), *Alfred Sisley,* 1876. Oil on canvas, mounted on composition board, 26⅛ × 21⁹⁄₁₆ in. (66.4 × 54.8 cm). The Art Institute of Chicago. Mr. and Mrs. Lewis Larned Coburn Memorial Collection.

demand.[9] The Universal Exposition in Paris of 1878 included an important component entitled "National Portraits."[10] In 1883 the exhibition *Portraits of the Century (1783–1883)* included works by such successful portraitists as Bonnat and Carolus-Duran, who served on the organizing committee.[11] In 1888, Henry Jouin argued in his book *The Museum of Artists' Portraits* that establishing a national portrait gallery was a moral imperative.[12] Although such a museum was not created, nor was a gallery in the Louvre set aside for portraits despite official promises in 1887, there was official interest in portraiture.[13]

The French taste for exhibiting portraits eventually extended to avant-garde examples. In 1893, the exhibition *Portraits of the Next Century* was organized at the gallery of Le Barc de Boutteville, who in 1891 had favored including Neo-Impressionist works among Impressionist and Symbolist ones. Among the progressive painters represented were Charles Angrand, Paul Cézanne, Paul Gauguin, Maximilien Luce, and Vincent van Gogh, while works included Raffaëlli's portrait of novelist Georges Rodenbach and Édouard Vuillard's depiction of the avant-garde director Aurélien Lugné-Poe.[14]

In Belgium, the revival of portraiture occurred early in the century with the presence of the French artist Jacques-Louis David, then in exile, whose students attempted to reawaken the grand Flemish tradition established in the seventeenth century by Frans Hals,

Peter Paul Rubens, and Anthony van Dyck. Lineage can be traced from David's followers, including François-Joseph Navez and Jean Portaels, to Théo van Rysselberghe. In Belgium the strong native tradition became allied to the new way of looking at portraiture invented by the Neo-Impressionists.

The demand for portraiture at the Triennial Salons, which rotated among the Belgian cities of Brussels, Ghent, and Antwerp, remained constant from 1881 to 1904.[15] In 1889, Brussels held its own retrospective survey, *Portraits of the Century, 1789–1889,* an ensemble that included works by Belgian, French, English, Spanish, Hungarian, and Austrian artists. Showing alongside the Frenchmen Henri Fantin-Latour, Jules Bastien Lepage, and Carolus-Duran were such leading Belgian academic portrait painters as Portaels, Navez, and Alfred Stevens. Only a few nonacademic Belgian artists were represented, including Xavier Mellery and Fernand Khnopff, and none who were Neo-Impressionists.[16] In reviewing the exhibition, Émile Verhaeren praised the greatest portraitists as those "who represented their friends and relatives in effigy."[17]

Khnopff lent the portrait of his sister Marguerite (1887, fig. 5), in which the painter focuses on the interiorization of the model, whose gaze is turned away from the viewer. This

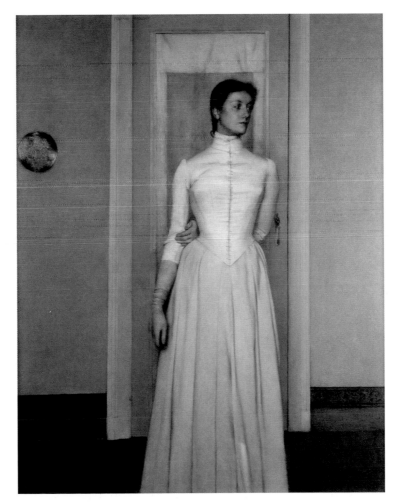

Fig. 5. Fernand Khnopff (Belgian, 1858–1921), *Portrait of the Artist's Sister, Marguerite Khnopff,* 1887. Oil on canvas, mounted on panel, 37¾ × 29⅜ in. (96 × 74.5 cm). King Baudouin Foundation, on permanent loan to the Musées royaux des Beaux-Arts de Belgique, Brussels.

quality of suggestiveness as opposed to explicit meaning links Khnopff to the Symbolist movement. The likeness of Marguerite accurately portrays her features yet transcends the individual subject to make a larger statement about the human condition—to add fiction to history.

Concurrently with the Symbolist attempt to capture the inexpressible, an opposing notion was being explored by other avant-garde artists. These artists, in seeking to abstract form from nature, were attracted to the materiality of the painted surface taking precedence over representation, as if following Maurice Denis's famous dictum, "A picture—before being a battle horse, a nude woman, or some anecdote—is essentially a plane surface covered with colors assembled in a certain order."[18] Similarly, the idea of linear decoration—best captured in Henry van de Velde's pronouncement that "a line is a force"—was sweeping the art world in 1890.

The Neo-Impressionists in their portraits were drawn to all of these elements: abstraction and decoration, the effervescence of Symbolist suggestion, and the vast historical dimension of portraiture itself. Georges Lemmen's double portrait of the Serruys sisters (see plate 24) is a stunning primer in the science of color theory and the abstraction inherent in Neo-Impressionism, and alludes to the Flemish still-life tradition and the inexpressibly haunting aura of Symbolism.

The Advent of a Movement

An investigation of the problems posed by Neo-Impressionist portraiture must begin with a review of the theory and practice of Neo-Impressionism itself. Georges Seurat (1859–1891) invented this method of painting and became the de facto founder of the movement that followed, a movement that can be divided into two phases.[19] The first phase began in 1886 when Seurat, an obsessive and private individual, exhibited his famous painting *Sunday on the Grande Jatte* (*Un Dimanche à la Grande Jatte,* hereafter *La Grande Jatte,* fig. 6), precipitating a creative outpouring by a group of "converts" that continued until his death in 1891. The second phase saw Seurat's most ardent follower, the charismatic and extroverted Paul Signac (1863–1935), assume the role of torchbearer to what was now a broad movement. Following a lessening of general interest by the mid-1890s, the Neo-Impressionists were reduced to a handful of committed artists. As theorist and historian, Signac penned the first major account of the movement, *From Eugène Delacroix to Neo-Impressionism* (*D'Eugène Delacroix au Néo-Impressionnisme,* 1899), which rekindled the flames of color theory for a younger generation, including Henri Matisse and the painters known as Les Fauves.

The story of how a core group of French artists dedicated to this new method of painting nurtured one another is tied to the creation in 1884 of the Society of Independent Artists (Société des Artistes Indépendants, hereafter the Independents), which was "jury-free" in the sense that everyone's work was admitted without first being subjected to a committee's judgment.[20] The Independents was one of the most important venues for

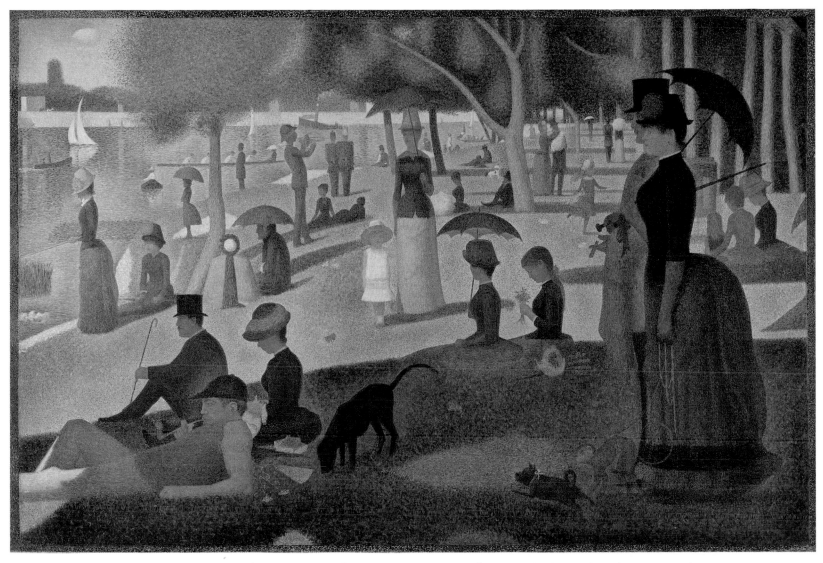

Fig. 6. Georges Seurat (French, 1859–1891), *Sunday on the Grande Jatte* (*Un Dimanche à la Grande Jatte*), 1884–86. Oil on canvas, 81¾ × 121¼ in. (207.5 × 308.1 cm). The Art Institute of Chicago. Helen Birch Bartlett Memorial Collection.

anti-academic art in nineteenth-century Paris.[21] Here Seurat met several of his future followers, including Signac, Albert Dubois-Pillet, Charles Angrand, and Henri-Edmond Cross. At the inaugural exhibition, held from May 15 to July 1, 1884, Seurat exhibited his first large painting, *Bathing Place* (*Une Baignade,* 1883–84), measuring some seven by ten feet. To create this large work, Seurat made numerous preparatory drawings and small oil panels and began to develop a pictorial response to his ongoing research into color theory. Signac, who before his exposure to *Bathing Place* had emulated the work of Claude Monet and Armand Guillaumin, immediately began to adopt Seurat's emerging "scientific" method in preference to the Impressionists' empiricism. In turn, Seurat, whose work was still in flux, sought to banish earth tones in favor of pure colors, which he applied as separate units. Like Seurat, the Impressionists were interested in increasing the luminosity of their paintings, but they proceeded instinctively. In contrast, Seurat sought to system-atize his search for color and light in a rational manner. While the Impressionists aimed

at capturing fugitive aspects of nature, Seurat and his followers strove to render what they believed to be the eternal elements underlying the world around them. The dichotomy between the empirical technique of the Impressionists and the objective vision of the Neo-Impressionists led Camille Pissarro to label these camps romantic and scientific Impressionism.

Seurat sought to codify a manner of reproducing on a canvas how color and line affected the viewer in nature.[22] He studied optics to learn how one processes visual information and attempted to replicate the luminosity of light through paint. Seurat's pursuit was supported by his readings of new studies, including the American physicist Ogden Rood's *Modern Chromatics,* which he read in translation.[23] Seurat accepted Rood's belief that "optical mixture" (the light from discrete colors mixing in the eye) was preferable to the "palette mixture" (gradations of color produced by mixing pigments) employed by Eugène Delacroix and the Impressionists. This "optical mixture" would result in causing the surface of the canvas to appear to quiver with light.

According to this argument, the goal of optical mixture—greater luminosity—was achieved by placing the separate touches of color, or *points,* side by side, hence the term Pointillism. The scheme of dividing color into these discrete units led to an alternate term, Chromo-luminarism, which Seurat preferred. In addition, these points enabled the artists to achieve a consistency of brushstroke and a unity of surface. The separation of color into discrete dots was applicable even to black-and-white drawings. Form could be defined by individual dots instead of lines, nuanced through the application of light and shade to paper, and through control of the pressure applied to the raised grooves in the support. Seurat's pointillist method of drawing imbued his works with what has been termed an "aesthetic of silence," creating a hushed and meditative mood.[24]

The relationship among the colors themselves was crucial. Michel-Eugène Chevreul's treatise *Laws of Contrast of Color and Their Applications* (*De la loi du contraste simultané des couleurs et ses applications,* 1839), laid out two principal visual results of using complementary colors—those opposite each other on a color wheel. When two complementaries are juxtaposed, a greater intensity and vibrancy results in simultaneous contrast—for example, orange intensifies blue; successive contrast produces greater vibrancy between adjoining colored passages and the characteristic optical illusion of a halo around figures. The small dots necessary for "optical mixture" also allowed for these complementary color effects. The interest in color contrasts extended to the borders around the canvases. At first Seurat favored the neutral white frames used by the Impressionists, believing that the standard gold competed with the orange hues in his paintings. After a brief period of experimentation during which he added a dotted inner border of complementary colors, Seurat seemed to settle on a cool dotted dark-blue border surrounding the work, and a pointillist frame.[25]

Wishing to leave nothing to chance, Seurat sought rational control over the entire composition. He was influenced by the mathematician and aesthetician Charles Henry, who wrote *Introduction to a Scientific Aesthetic* (*Introduction à une esthétique scientifique,* 1885), an exploration of physiological responses to line and color.[26] According to Henry, upward

lines and warm colors produced a "dynamogenous" or uplifting effect, downward lines an "inhibitory" one, and horizontal lines calmness. Henry studied how color and line could elicit physiological and psychological responses from his subjects; Seurat was attracted to the possibility of exploring these ideas in pictorial form. He wished to make painting a rational construct, from the actual color of the object (which would seem to change under different lighting conditions and under the influence of nearby colors) to the application of paint, and from the object itself to the selection of colors and lines to interpret it. This set of possibilities inherent in color and line became for Seurat the "rules" for a Neo-Impressionist "method."

In December 1884 Seurat exhibited again at the Independents (in what was the first of their numbered exhibitions), showing a fully pointillist landscape study devoid of people, *The Isle of La Grande Jatte* (*Île de la Grande Jatte*), and the stunning crayon-and-pencil portrait of his friend Edmond-François Aman-Jean, an artist (see fig. 14). In the latter he applied the principle of irradiation to his use of contrasting light and shadow to create the halo around his friend's head.[27] Following the summer of 1885, spent along the English Channel, twenty-six-year-old Seurat returned to Paris to rework the entire composition of *La Grande Jatte,* the landscape now populated with pleasure seekers.

In October 1885, Seurat met the elder Impressionist Camille Pissarro through an introduction by Signac and Guillaumin at the famous Durand-Ruel gallery. Watching Seurat work on *La Grande Jatte* in his studio in early 1886, Signac, Pissarro, and his son Lucien were struck by its audacity and intrigued by the rational theory behind it. The three were soon trying the "method" themselves. For Seurat the new friendships increasingly pulled him away from his more conservative colleagues, including Aman-Jean, and toward the avant-garde. Signac introduced Seurat to the writer Robert Caze, at whose gatherings Seurat met other literati, including J. K. Huysmans (1848–1907) and Gustave Kahn (1859–1933). Some of these writers would become major critical defenders of the movement that Seurat was unwittingly creating.

Seurat first exhibited *La Grande Jatte* at the eighth and last Impressionist exhibition, held from May 15 to June 15, 1886. Alongside five more of his oil landscapes and three drawings were contributions in the new manner by Signac and Camille and Lucien Pissarro. Grouped together in the last room, they could not be missed: *La Grande Jatte* drew visitors like moths to a candle. Many scorned the painting, while others were intrigued. Nearly every critic was perplexed. Henry Fèvre, while admitting to being "dazzled," compared Seurat's figures to well-known toys from Nuremberg.[28] The figures' apparent stiffness and "primitiveness" were the subjects of many reviews. Octave Mirbeau referred to an "Egyptian fantasy," while Octave Maus saw "figures made of wood, naively sculpted . . . as little soldiers that come to us from Germany."[29]

Only Félix Fénéon provided an explanation that seemed to match Seurat's "scientific" earnestness. Fénéon described *La Grande Jatte* in a typically dispassionate manner, without condescending comparisons: "The subject: beneath a sultry sky, at four o'clock, the island, boats slipping past its flank, stirring with a casual Sunday crowd enjoying the fresh air

among the trees; and these forty or so figures are endowed with a succinct, hieratic line, rigorously drawn in full-face or in profile or from the back, some seated at right angles, others stretched out horizontally, others standing rigidly; as though by a modernized Puvis. The atmosphere is transparent and uncommonly vibrant; the surface seems to flicker or glimmer."[30]

On August 21, 1886, only two months after the closing of the Impressionist exhibition, the Independents opened its second numbered show, to which Seurat lent ten works, among them *La Grande Jatte*. Along with Seurat's works, divisionist paintings by Signac, Lucien Pissarro, and Albert Dubois-Pillet were shown together in the same room. While works by soon-to-be followers Cross and Angrand were not yet Neo-Impressionist in style, Dubois-Pillet's use of divided color showed his understanding of Seurat's principles. At this second Independents exhibition, Fénéon, musing for a second time on the growing movement, first used the term "Neo-Impressionist" in a review penned for the Belgian periodical *L'Art moderne* (for which he served as Paris correspondent).[31] Fénéon stressed the reform elements of Seurat and his coterie and discussed their differences from the Impressionists. With Fénéon providing critical support, theory and practice in the new manner were becoming significant topics among avant-garde artists and their defenders.

The Neo-Impressionist movement seemed to blossom in 1887 at the Independents exhibition. Seurat showed a study for the *Model* (*Poseuse*), along with works from Honfleur, including *The Lighthouse* (*La grève du Bas Butin*). He was joined by Signac exhibiting *The Dining Room* (*La Salle à manger*) and a newcomer to the Independents, Maximilien Luce, showing his first divisionist works, a group highly admired by Fénéon.[32] Dubois-Pillet returned with a clutch of ten works, half of which were now portraits, including Captain Pool (see plate 4). This new subject matter, the individual portrait, immediately caught Fénéon's attention as a vehicle for combining the abstract with the particular. Vincent van Gogh similarly saw the possibilities of uniting the universal and the personal in Neo-Impressionist portraiture. In spring 1887, working with Signac at Asnières, he attempted to understand the divisionist technique. His *Self-Portrait* (see plate 44) reveals in a flash the potential for meaningful portraiture inherent in the seemingly unlikely method of color divided into pure points.[33]

Thus in three public exhibitions—the eighth Impressionist and the Independents' shows of 1886 and 1887—Neo-Impressionism became established as a modern art movement centered in Paris.

Belgian Flowering

A challenge to the Parisian hegemony of modern art in general and Neo-Impressionism had arisen to the north, in Belgium. Through the influential exhibitions of the avant-garde society Les XX (Les Vingt, or "The Twenty"), originally a group of twenty artists, Brussels played a crucial role in the development and propagation of Neo-Impressionism. Beginning in 1884, Les XX held ten annual exhibitions before disbanding in 1893. Although consisting

primarily of Belgian artists who invited Europeans and Americans to exhibit with them, according to its secretary and leader, Octave Maus (1856–1919), Les XX welcomed "the bearers of the new (les apporteurs de neuf)" from anywhere. A principal ingredient of the group's success was the support provided by the weekly Brussels review *L'Art moderne,* which challenged the conservative press. Filled with articles by Maus, lawyer and provocateur Edmond Picard, Émile Verhaeren, and Félix Fénéon, the review educated its readers about the aims of the new art, while stimulating curiosity and intentionally fomenting controversy. As nowhere else in Europe, Les XX supported the revolutionary ideas emanating from Seurat's studio.[34]

The uproar caused by *La Grande Jatte* in May 1886 at the last Impressionist exhibition was not lost on Maus. Urged by Verhaeren to travel to Paris, Maus was stunned by the controversial painting and relished the opportunity to bring it to Brussels. He promptly issued a challenge to his Belgian colleagues by declaring in *L'Art moderne* that if the enormous canvas were shown in Brussels, it would cause a great scandal—indeed, "there would be unexpected cases of mental derangement and fatal seizures."[35]

Following the Impressionist exhibition, Maus invited Seurat and Camille Pissarro to bring their new paintings to the Les XX exhibition the following February 1887. He then asked Fénéon to review in *L'Art moderne* the works of Seurat and his followers shown at the Independents during August and September 1886. Fénéon obliged by discussing the "Neo-Impressionist method" for the first time, as we have seen, contrasting the works of the Impressionists with those of the new *intransigents,* the Neo-Impressionists.[36] One month after Fénéon's review, Verhaeren reported to Maus his meeting with Seurat and Dubois-Pillet in Paris on October 23, 1886: "What interesting darers are they and as they are going forward, turning their backs on formulas and their noses toward the New. I have seen once more (Seurat's) *Grande Jatte* and an entire series of superb black and whites and studies upon studies. What a synthesizer he is and how much a painting by him is work, research, and exploration!"[37]

Seurat gladly accepted Les XX's invitation and lent *La Grande Jatte* and six canvases of the Normandy coast to the fourth exhibition of Les XX, held February 5 to March 6, 1887. One of the six, *Corner of Dock Basin, Honfleur (Coin d'un bassin. Honfleur),* appeared in the catalogue as belonging to Verhaeren, a gift from Seurat.[38] Verhaeren supported his new friend with a review in the Parisian journal *La Vie moderne,* in which he defended the use of a "scientific" approach to art: "A recipe? Science killing Art? Are they to fear, because they see the tones in order to combine them, and to see them with the eye of a painter, no savant, no theorist, no scientist could ever succeed unless he was himself an artist?"[39] Seurat attended the Brussels opening with Signac, who offered his impressions to Camille Pissarro, who also had lent three works to the exhibition: "I left the Les XX exhibition exhausted: an enormous crowd, a dreadful mob, very vulgarly anti-artist. In short, a great success for us: Seurat's canvas was invisible, impossible to approach—that's how enormous the crowd was. . . . Pointillism intrigues people and forces them to think that there is something underneath it all."[40]

The exhibition of *La Grande Jatte* as well as the rhetoric from *L'Art moderne* engendered a lively discussion in the press. The critic for *L'Étoile belge,* likening the clamoring crowd to an "immense sizzling, similar to a large frying pan," further recounted the scene. "A crowd in delirium piled up before the canvas of the Parisian Seurat. Here is at least a work that is not pessimistic. Que sera sera (Seurat). And everyone drinks to the Grande Jatte. But it is the Grande Jatte that has the inside track."[41] Some critics ridiculed Seurat's use of a scientific method as an impediment to creativity, while others feared that Belgian painters would succumb to this French invasion and renounce their superior Flemish heritage.[42]

Among the Vingtistes there was an immediate reorientation. Willy Finch confessed to Signac, "I was profoundly moved by the canvasses of Messrs. Seurat and Pissaro [*sic*], who were at Les XX."[43] Henry van de Velde recalled, "Coming into contact with *Sunday Afternoon on the Grande Jatte,* I was thrown into disorder and fell prey to an inexpressible agitation. From that moment on it was impossible for me to resist the need to assimilate, as quickly and as conscientiously as possible, the theories, rules, and fundamental principles of the new technique to test its validity."[44]

As Neo-Impressionism grew in strength among artists in Brussels, Belgian patrons joined the ranks of its earliest collectors, making Brussels the "second home of Neo-Impressionism."[45] The first works Seurat ever sold—*The Lighthouse at Honfleur* (*Le phare d'Honfleur*) and *The Shore at Bas-Butin, Honfleur* (*La grève du Bas-Butin [Honfleur]*)—went to Belgians. These were listed the next time Seurat showed them, at the 1887 Independents, as owned, respectively, by Verhaeren (his second Seurat painting) and Henri van Cutsem, a wealthy businessman and collector.[46]

Buoyed by the success of Seurat and Pissarro at Les XX, Signac seized upon the possibility of collaboration between the art capitals of Paris and Brussels. Although Seurat bristled at the idea of propagating his method, Signac persisted. He wrote to Pissarro in February 1887 of his intention to exhibit in Paris with the "most advanced of the Brussels Vingtistes" in the offices of *La Vie moderne,* the periodical which had carried the favorable review of the Neo-Impressionists that had caught Pissarro's attention.[47] Signac also wrote to Maus, explaining: "The Belgian artists who come closest to our propensities would be [Théo] Van Rysselberghe, [Willy] Finch, [Willy] Schlobach, Darío de Regoyos, and [Frantz] Charlet."[48] Despite Signac's optimism, none of these painters was yet working in a rigorous divisionist method, and the scheme was aborted.

By April 1887, Finch had decided to dedicate himself to studying pointillist principles. He turned to Signac for guidance concerning "the separation of colors (la décomposition des couleurs)" and searched for a manual on color theory: "I've been told about a theory of colors by Road [*sic*] of New York. Where can I obtain it [Rood's manual] and what does it cost?"[49] Finch revealed that he was already hard at work on a "painting using divided color."[50] In the summer of 1887, Finch produced the first Belgian Neo-Impressionist canvases.

At Les XX's next exhibition, held from February 4 to March 4, 1888, Finch showed his new work alongside the French contingent, represented by Signac and Dubois-Pillet, without Seurat and Pissarro.

Fig. 7. Alfred William (Willy) Finch (Belgian, 1854–1930),
Le Port. Illustration used in the 1888 Les XX catalogue designating
Finch's entries. Photomechanical reproduction. Archives de l'art
contemporain, Musées royaux des Beaux-Arts de Belgique, Brussels.

Both Finch and Dubois-Pillet submitted pointillist drawings for their self-designed entries to the catalogue, resulting in original works of art and advertisements for the new style (fig. 7). Finch earned Verhaeren's praise as "decidedly the first among the Belgians to enroll among the Neo-Impressionists: adopting the divided tone, rejecting the mixing of colors on the palette, admitting only the colors of the spectrum and employing only them."[51] Many critics were less sure, finding that Finch had erred by adopting the "morbid genre of mosaic tiles" and labeling him a "victim . . . of French Neo-Impressionism."[52]

Signac arrived in Brussels for the opening, and both he and Finch accepted Verhaeren's invitation to lodge in the quarters shared by Verhaeren and Van Rysselberghe.[53] Verhaeren described the amusing scene to Van Rysselberghe, who was away: "Finch sleeps in the studio; Signac aloft in your four-poster canopy bed. . . . As for Finch, he is in full pointillist mode and studies hard and is instructed by Signac, and one hears talk only of 'complementaries' and 'contrasts.'"[54] Signac was pleased that his twelve entries, coupled with Dubois-Pillet's and Finch's, gave the public more than twenty-five Neo-Impressionist works to study. Excited with the addition of the Belgian Finch, Signac remarked to Maus, "Our technique is much more understandable for the public when it has before it numerous examples of its application with differing results." He concluded, "Before a complete showing, the public is forced, if not to understand, at least to reflect."[55] After the close of the 1888 exhibition, the importance of Les XX as a vehicle for promoting Neo-Impressionism and as a recruiting ground was indisputable.

In Paris, Seurat regularly showed at the Independents, submitting groups painted during his summers along the Channel coast. In each set his command of pointillist technique grew until he was able to produce such serene yet provocative works as *The Channel of Gravelines, Petit Fort Philippe* (*Le Chenal de Gravelines, Petit Fort Philippe,* 1890, fig. 8), where

the natural world is sublimely harmonized and synthesized into an abstracted, universal composition. During what turned out to be his final years, Seurat explored the symbolic meaning of line under the influence of Charles Henry, in large, complex compositions showing popular entertainment filled with human figures: *Circus Sideshow* (*Parade de Cirque*, 1887–88), *Chahut* (1889–90), and *Circus* (*Cirque*, 1890–91).

Seurat was eager to return to Les XX in 1889. From among his nine paintings and three drawings, a Brussels banker named Georges de la Hault purchased *Port-en-Bessin: The Outer Harbor* (*Low Tide*) (*Port-en-Bessin, l'avant-port [marée basse]*), and Gustave Gevaert, a doctor, bought his drawing *At the Concert Européen* (*Au Concert Européen*).[56] Seurat's French comrades Henri-Edmond Cross, Camille Pissarro, and Maximilien Luce also exhibited, with Luce selling two genre portraits, *The Ragpickers* (*Les Chiffonniers*) and *Le Chauffeur*.[57] Maus's defense of Seurat in the French press greatly pleased the artist: "I thank you infinitely for what you have written about me in *La Cravache* of the 16th. All my gratitude."[58]

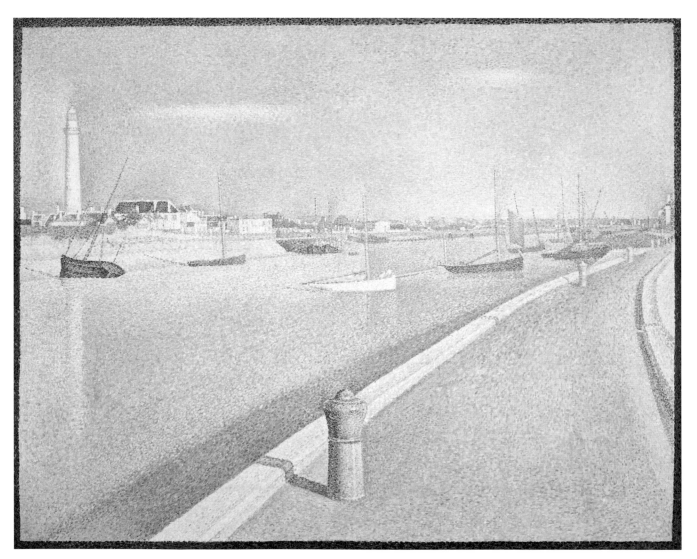

Fig. 8. Georges Seurat (French, 1859–1891), *The Channel of Gravelines, Petit Fort Philippe* (*Le Chenal de Gravelines, Petit Fort Philippe*), 1890. Oil on canvas, 28⅞ × 36½ in. (73.3 × 92.7 cm). Indianapolis Museum of Art. Gift of Mrs. James W. Fesler in memory of Daniel W. and Elizabeth C. Marmon.

In the Belgian camp, Henry van de Velde and Théo van Rysselberghe joined Finch. As a provocative symbol of his conversion to Neo-Impressionism, Van Rysselberghe created a pointillist exhibition poster (fig. 9) in which the anonymous critic for *La Chronique* saw a subversive message: "The small dot is in fashion, the wafers triumph along the wall. The poster itself has not escaped: small-pox has spotted it abominably."[59] He likened Neo-Impressionism to an epidemic from France threatening to destroy those who succumbed to its charms, terming those who employed the new method utterly reprehensible. He labeled them "les bubonistes," producing canvases spotted with pustules of Bubonic plague.[60]

Van de Velde, who first experimented with divisionist color theory the previous year, showed six Neo-Impressionist works. Only one of Van Rysselberghe's sixteen submissions was Neo-Impressionist, the portrait

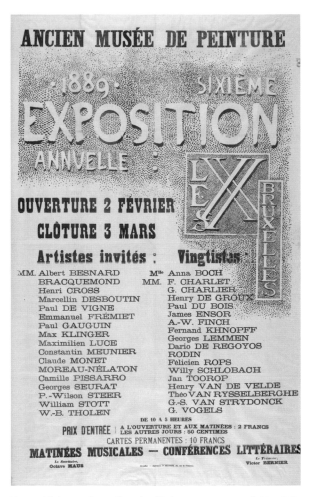

Fig. 9. Théo van Rysselberghe (Belgian, 1862–1926), Les XX poster for the 1889 exhibition. Lithograph in blue ink, 55⅝ × 34⅜ in. (141.2 × 87.2 cm). Archives de l'art contemporain, Musées royaux des Beaux-Arts de Belgique, Brussels.

of *Mademoiselle Alice Sèthe* (see plate 46), but it was universally admired. The writer for *L'Escaut* pronounced it "the most accomplished work of the show."[61] Among the Belgian trio, Finch bore the brunt of the criticism. Max Waller, the Belgian author writing for the French review *L'Artiste,* referred to Finch as "one of the first Belgian neophytes—or should I say victims—of French Neo-Impressionism."[62] Believing that the Belgians were already establishing their own approach to the style, a clearly worried Finch expressed to Maus the fear that "eyes that are not sufficiently trained will not see the differences of technique between us and our Parisian friends."[63]

Before the close of Les XX, Signac again tried to mount a Franco-Belgian exhibition. Van Rysselberghe provided Signac with a fresh assessment of the Belgian Neo-Impressionists as of March 1889: "At Les XX there are only the two of us [Finch and Van Rysselberghe] who use divisionism totally (and we do it more and more). There remain those who are on the road and will be the followers of tomorrow: Miss [Anna] Boch and H. Van de Velde. Already the tendency is marked in their entries to Les XX this year. There is also [Willy] Schlobach, who tried it in several canvases (not exhibited); [Jan] Toorop, who 'makes dots'

but does not *divide* at all; and [Georges] Lemmen—who paints very little, but instead makes sketches, in which he is searching for character-types."[64] Although Signac's plan, yet again, did not materialize, Van de Velde, Toorop, and Lemmen soon became committed Neo-Impressionists, confirming Van Rysselberghe's prediction, while his hopes for Boch and Schlobach faded quickly, as they only briefly experimented with the style.

Neo-Impressionism reached its climax at the Les XX exhibitions in 1890. Nearly one-fourth of the works displayed were pointillist, constituting the largest showing to date. The reviewer for the French periodical *La Revue Blanche* found nearly everything praise-worthy: "Les XX's salon is like a powerful declaration against the ineptitude of official salons."[65] French contributors included Dubois-Pillet, Louis Hayet, Lucien Pissarro, and Signac, who returned with twelve paintings, including five painted on the seacoast east of Marseilles. The Belgians consisted of Finch and Van Rysselberghe, now joined by Toorop and Van de Velde. Finch sent six Neo-Impressionist compositions, including *The Nieuport Channel, Grey Weather (Summer)* (*Le Chenal de Nieuport: temps gris [été]*), whose simplified composition and light effects of delicate greens, yellows, lavenders, and reds recall Seurat's *Evening, Honfleur* (*Embouchure de la Seine, soir, Honfleur*), shown at Les XX in 1887. Van Rysselberghe exhibited seven paintings and a drawing, *Interior, Evening* (*Intérieur le soir*, see plate 47), which, in the manner of Seurat, emphasized the contrast of artificial light and shade in a domestic setting. Toorop sent four Neo-Impressionist works, while Van de Velde sent three paintings from his series *Faits du village*. At the close of Les XX, Finch, Van Rysselberghe, and Van de Velde were able to send many of their submissions to the 1890 Paris Independents because of their ties to Signac and the other French Neo-Impressionists.[66] Signac, for his part, was excited to have been elected a member of Les XX in the fall of 1890 and pledged his continued support of the group.

The introverted Seurat had become increasingly protective of his ideas and technique. When Fénéon, in a series devoted to modern painters published in the review *The Men of Today* (*Les Hommes d'aujourd'hui*), wrote about Signac and his new style without mentioning Seurat, the latter was deeply hurt and offended. In one of his rare letters, sent to Fénéon on June 20, 1890, Seurat staunchly defended his paternity of the Neo-Impressionist technique.[67]

Although the 1891 exhibition included fewer Neo-Impressionist works than did the 1890 show, the French remained strong contributors. Signac's eight submissions joined paintings by Angrand, Camille Pissarro, and Seurat, whose seven works included *Chahut*. Among the Belgians, Finch sent several landscapes, while Van Rysselberghe submitted seven entries, including *In July, Before Noon* (*En juillet, avant-midi,* see plate 48), a large canvas inspired by *La Grande Jatte.* Georges Lemmen, a new adherent and the last major Belgian convert to Neo-Impressionism, exhibited his first such works.[68] Lemmen, whose famous art nouveau sunrise graced the catalogue's cover, sent a painting of his sister Julie crocheting (see fig. 19), two studies for an oil entitled *Bourgeois Interior* (*Intérieur bourgeois*) (see plate 14), and a drawing of his colleague Jan Toorop (see plate 12). Like

Seurat's conté crayon drawings, Lemmen's depiction of Toorop relies on the weave of the paper and the medium to explore the mood of reverie and silence.

Belgian patronage remained strong in 1890 and 1891. One of two works by Signac sold during the 1890 show was acquired by Madame Sylvie Monnom, the publisher of *L'Art moderne* and Van Rysselberghe's mother-in-law.[69] After the show's close, Belgian critic and writer Camille Lemonnier bought two more Signac paintings. In 1891, Signac sold a painting to Victor Boch, a wealthy Belgian industrialist and the father of Vingtiste Anna Boch.[70]

Three weeks after Les XX closed, during the run of the next Independents show, an alarmed Lemmen reported to Signac that he had found Seurat ill at home: "He was waiting for me, but in bed, overwhelmed by a high fever; a chill, he told me, caught at the exhibition."[71] Two days later, on March 29, 1891, the leader of the Neo-Impressionist movement died at age thirty-one. A grief-stricken Signac wrote to Van Rysselberghe, "Horrible news: our poor Seurat died yesterday morning after two days of illness—an infectious diphtheria, I'm told."[72] Verhaeren wrote immediately in *La Nation* of the crushing news, proclaiming that Seurat "appeared to be the inspirer, the founder, the master." Verhaeren assessed Seurat's legacy: "His name will remain for certain in the history of art, not as one who was an artist of genius, which perhaps he was, but as someone who brought to the profession, through the procedure, the technique, the greatest amount of innovation since the invention of oil painting."[73]

At the request of Seurat's family, Signac, Fénéon, and Luce prepared an inventory of the atelier. Seurat's mother provided for works to go to the artist's Belgian friends, including Finch, Lemmen, Van Rysselberghe, Van de Velde, Anna Boch, Darío de Regoyos, Paul Dubois, and Robert Picard, son of Edmond. In addition, Verhaeren, Picard, Maus, Pierre-Marie Olin, and Madame Gustave Kahn, wife of the French poet, were all beneficiaries of Madame Seurat's generosity.

It was less clear what would happen to the movement now that it had lost its leader. To assess Seurat's accomplishment, Maus organized a major retrospective shown at Les XX in 1892. Signac coordinated the effort with a larger retrospective to be held at the Paris Independents after the exhibition closed in Brussels.[74] Among forty paintings and drawings on view, many lent by Belgians, were *Models* (*Les Poseuses*), *Circus Sideshow* (*Parade de cirque*), *Young Woman Powdering Herself* (*Jeune femme se poudrant*) and *Circus* (*Cirque*).

At Les XX in 1892 the movement seemed to be flourishing. In addition to the works by Seurat were those by three French Neo-Impressionists (Signac, Léo Gausson, and Luce) and three Belgian Vingtistes (Lemmen, Finch, and Van Rysselberghe). In a personal homage to Seurat's urban scenes, Lemmen showed his monumental work *Carnival, decorative motif* (*Fête foraine [motif de décor]*, visible in fig. 22).[75]

As usual, pointillist seascapes were prominent. The decorative tendencies that the Neo-Impressionist technique engendered in so many artists seemed to find expression by reducing nature to a basic geometry in such compositions. Lemmen's *Sunset on the Beach* (*Coucher de soleil sur la plage*, fig. 10), exhibited in 1892, shows the ebb of a glowing sunset of

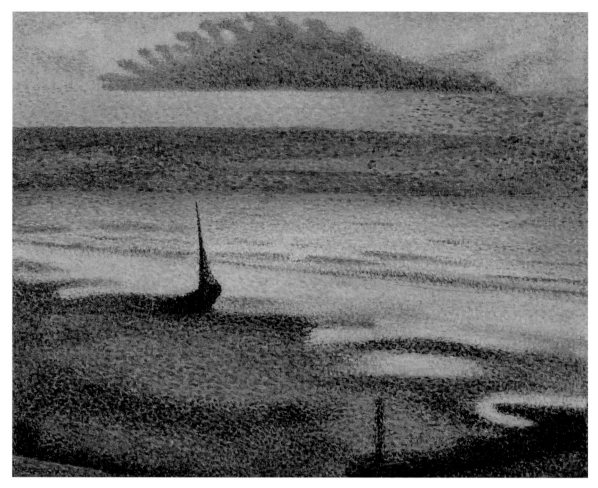

Fig. 10. Georges Lemmen (Belgian, 1865–1916), *Sunset on the Beach* (*Coucher de soleil sur la plage*), 1891–92. Oil on panel, 14¾ × 18⅛ in. (37.5 × 46 cm). Musée d'Orsay, Paris.

fiery oranges, yellows, and reds, between a biomorphic cloud and ominous boats moored on the beach. Similarly, in Van Rysselberghe's *Big Clouds* (*Gros nuages,* fig. 11), exhibited the following year, the decorative use of line traces the sinuous clouds while glowing colors reflect an orchestration of complementary colors.[76] Both artists used the Neo–Impressionist technique to create abstracted marinescapes of striking simplicity.

The most noteworthy development, however, was the number of portraits displayed at Les XX in 1892. Seurat's *Young Woman Powdering Herself* was joined by Signac's iconic *Portrait of Félix Fénéon* (see plates 33, 36). Among Van Rysselberghe's portraits were his wife, *Maria Van Rysselberghe,* cleverly placed beneath a study of her for *In July, Before Noon,* and *Maria Sèthe at the Harmonium* (see plate 51), showing Van de Velde's fiancée surrounded by her cultural interests. Lemmen showed the portrait of *Mademoiselle Maréchal* (see plate 17), his future wife, intimately posed with a simple and abstracted décor. If the reductivist qualities of Neo–Impressionist landscapes seem predictable, this application to portraiture by so many was unexpected. It established portraiture as an integral part of Neo–Impressionism alongside landscapes, marines, and scenes of urban life.

In 1893, Les XX's final year, Signac and Cross represented the French contingent. Signac's marines and portraits of his mother (see plate 38) and his future wife (*Woman*

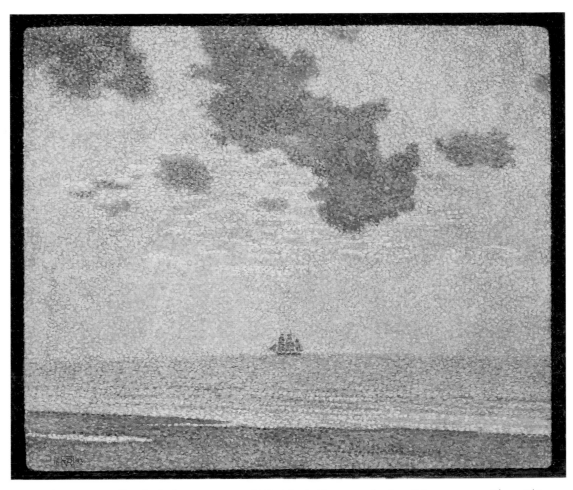

Fig. 11. Théo van Rysselberghe (Belgian, 1862–1926), *Big Clouds (Gros nuages)*, 1893. Oil on canvas, 19½ × 23½ in. (49.5 × 59.7 cm). Indianapolis Museum of Art. The Holliday Collection.

Arranging Her Hair, Opus 227 [*Femme se coiffant. Opus 227*; see plate 37]) joined five works by Cross that affirmed their allegiance to the style while revealing their interest in its decorative possibilities. Among the Belgians, Finch displayed only one Neo-Impressionist work, a landscape, while Van de Velde exhibited several pointillist canvases, including *Childhood Landscape (Paysage puéril)*, but his soft pastel dots of pinks and purples and indefinite setting suggest a Symbolist dreamscape. While Lemmen sent only drawings and book designs, Van Rysselberghe showed a group of Neo-Impressionist portraits and landscapes.

Despite Signac and Van Rysselberghe's commitment, the movement seemed to lose its hold on many of its former followers. By 1895 only Van Rysselberghe among the Belgians continued to employ the Neo-Impressionist method. His portrait of Signac (see fig. 28), painted in 1896, depicted his friend as an accomplished sailor but also as heroic captain of the diminishing Neo-Impressionist movement. Yet by then, the style that had shocked the art world in the late 1880s and early 1890s had waned as an avant-garde phenomenon. Van Rysselberghe, who successfully applied the method to large-scale decorative projects, such as *A Reading in the Garden (Une lecture au jardin,* fig. 12) of 1902, created for Victor Horta's art nouveau masterpiece, the Hôtel Solvay, did not finally abandon the system until 1904. That year, La Libre Esthétique (1894–1914), successor to Les XX, paid homage to the

Fig. 12. Théo van Rysselberghe (Belgian, 1862–1926), *A Reading in the Garden* (*Une lecture au jardin*), 1902. Oil on canvas, 126 × 176⅜ in. (320 × 448 cm). Hôtel Solvay, Wittamer-Descamps, Brussels.

Neo-Impressionists by exhibiting works by Signac, Cross, Luce, C. Pissarro, and Van Rysselberghe, the sole Belgian, alongside a selection of Seurat's paintings.[77] It appeared that the movement had run its course.

The Movement and Its Influence

The Neo-Impressionists never functioned as a cohesive exhibition society. For a variety of reasons, keeping a unified front eluded them. While Seurat was not temperamentally disposed to lead a movement, nor did he live long enough to reveal where his formal search might ultimately have led him, his friend and associate Signac stood in his place. Signac's determination and strong personality fostered a communal feeling among a variety of artists broadly related to Divisionism that continued into the early twentieth century. Signac attempted to keep practitioners from defecting; he rallied adherents to exhibit at group shows, he wrote a manifesto for the movement, and he served as host in the south of France to a new generation of artists attracted to Neo-Impressionist theory and practice.

Yet even before Seurat's death there were signs that Neo-Impressionism was fracturing. As early as fall 1888, Camille Pissarro renounced division of color, complaining that his creativity suffered because the technique was too exacting. Although he continued to employ parts of Seurat's theory, Pissarro was never again dogmatic or "scientific" about it. Signac became increasingly upset with Pissarro's withdrawal from the movement and tried to get his friend to recommit.[78]

Other defections followed. Lucien Pissarro left for London in November 1890, where he became increasingly involved in the book arts, ultimately founding the Eragny Press, a major Arts-and-Crafts production. Hayet, who met Lucien in 1883 and was interested in Neo-Impressionism from 1887, was forced for monetary reasons to work as a painter of stage sets and moved away from the group. Among the Belgians after 1892 both Van de Velde and Finch abandoned painting for the decorative arts. After 1895, Luce's and Gausson's enthusiasm for the method and for the movement declined. In 1896, Angrand

returned to his birthplace, Rouen, and, although he did not renounce Neo-Impressionism, he painted less and less, producing instead many black-and-white drawings of mothers and children.

Death thinned the ranks of early practitioners. On August 18, 1890, Dubois-Pillet died, shortly after Van Gogh's demise on July 29. The following year caused the greatest trial when Seurat himself succumbed on March 29, while his *Circus* was on display at the Independents. For a time new recruits appeared, beginning with Cross, who embraced the style with his portrait *Madame Hector France* (see plate 1), shown at the 1891 Independents just before Seurat's death. In addition, Hippolyte Petitjean adopted the dot in 1891 and exhibited regularly with the group before abandoning divided color in 1894. Lemmen painted his first pointillist works in 1891, remaining true to the method until late in 1894. Achille Laugé, after living in Paris for seven years, returned to his birthplace, Aude, in 1892 and only then began painting Neo-Impressionist works, continuing in the style until 1900.

Ironically, in December 1892, the year after Seurat's death, when the original adherents had begun to splinter, the first exhibition devoted almost entirely to divisionist works opened in Paris. It was titled "Exhibition of Neo-Impressionist Painters."[79] Among the nine artists submitting works was only one Belgian, Van Rysselberghe, who lent the portraits of his wife, Maria, and Maria Sèthe (see plate 51). Signac again showed the portrait of his mother and *Woman Arranging Her Hair.*[80] Also on display were works by Cross, Gausson, Luce, Petitjean, and Lucien Pissarro, as well as by Seurat. Seurat's drawing of Paul Alexis was lent by the critic and playwright himself, and *The Channel of Gravelines, Evening* was lent by Sylvie Monnom, whose firm printed the catalogue.

In December 1893, eleven artists participated in an exhibition simply titled "Group of Neo-Impressionist Painters," financed by Antoine de la Rochefoucauld, who sent one of his own paintings, and managed by Lucien Moline, secretary of the gallery.[81] Camille Pissarro refused to exhibit, calling it the "boutique néo" and confessing to Lucien, "My nest is made, I am remaining with the old. Signac wanted me to decide in favor (of exhibiting), but I am declining."[82] Signac showed the portrait of his wife Berthe, *Woman with a Parasol (Femme à l'ombrelle)* (see fig. 16). Van Rysselberghe exhibited *Young Girl in Green (Jeune fille en vert)* and designed the invitation, contributing one of his characteristic ornaments. La Rochefoucauld supported the enterprise for the entire year, after which the gallery fell to the direction of Moline. In all, four Neo-Impressionist group exhibitions were held. By 1895 these were replaced by retrospective exhibitions and smaller one-man shows, including one devoted to Van Rysselberghe.[83]

Signac continued in his role as leader of the movement, writing the theoretical treatise *From Eugène Delacroix to Neo-Impressionism,* published first in 1898 as articles in the periodical *La Revue Blanche.* Issued as a book in 1899, it was translated into German and reprinted several times. Following his move in 1895 to Saint-Tropez, Signac's own work evolved: his colors became more vibrant and his brushstrokes almost mosaic-like. The decorative qualities of color and line became paramount. His presence served as a mecca for established Neo-Impressionists, including Van Rysselberghe, and for a younger generation

of artists who explored elements of Seurat's method for themselves. Henri Matisse spent the summer of 1904 in Saint-Tropez painting with Signac and Cross, while young painters attracted to this liberation of color—including André Derain, Georges Braque, Jean Metzinger, and Robert Delaunay—dabbled in Neo-Impressionism.[84]

The Dutch artist Piet Mondrian responded to the brick-like brushstrokes and fierce colors of later Neo-Impressionism, as did the Italian Gino Severini and the Russian Wassily Kandinsky. Through the influence of the Vingtiste Jan Toorop, the Dutch artists H. P. Bremmer, Jan Vijlbrief, and Johan Aarts experimented with Neo-Impressionist color theory.[85] Seurat's approach found sympathetic artists even in America. In fact, Georgia O'Keeffe created a pointillist work in 1914. As late as 1917, Raymond Jonson, who began as an expres-

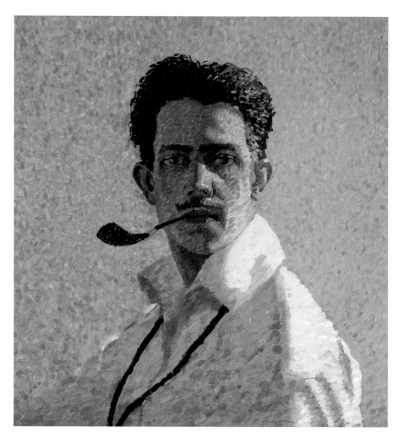

Fig. 13. Raymond Jonson (American, 1891–1982), *Self Portrait,* 1917. Oil on canvas, 26 × 24 in. (66 × 61 cm). Collection of The Albuquerque Museum. Museum Purchase, 1983 General Obligation Bonds.

sionist in Chicago and later created abstract paintings in New Mexico, experimented with Neo-Impressionism, painting a haunting self-portrait (fig. 13).[86]

By century's end, galleries and collectors outside of France began to show an interest in Neo-Impressionism. Henry van de Velde's growing ties with Germany led to Count Harry Kessler's organizing the first Neo-Impressionist exhibition in Germany, held in 1898 at the Berlin gallery Keller & Reiner. Van de Velde's move to Germany in 1900 resulted in continued patronage for the Neo-Impressionists, living and dead, through Kessler and such notable collectors as Julius Meier-Graefe, Curt Herrmann, and Karl Ernst Osthaus.[87]

Seurat invented Neo-Impressionism as an advance over the Impressionists' spontaneous use of color and line. Through an understanding of how color and line, light and shadow, affected humans, Seurat sought to replicate these effects on canvas and paper, thereby bending nature to his aesthetic vision. Around him coalesced a loyal following in France and Belgium that responded to this new path as embodying the quintessentially modern. The Neo-Impressionists in Seurat's circle found hospitable arenas for exhibiting and selling their works in Paris and Brussels, and, through selective retrospective exhibitions, they continued to influence younger artists. Although the movement waxed and waned after Seurat's death, it was harnessed in the twentieth century by artists seeking liberation through color.

The introduction of Neo-Impressionism to Belgium in 1887 had been a watershed moment for the movement, promoting the French artists while transforming and nurturing the artistic vision of many Belgians. Through the exhibitions of Les XX, Seurat, Signac, and their French colleagues found a welcome venue for sharing ideas, finding patronage, and spreading the gospel of Neo-Impressionism. Finch, Van Rysselberghe, Toorop, Van de Velde, and Lemmen became ardent disciples of Seurat and Signac. As we are about to discover, a lasting contribution of the Belgian Neo-Impressionists was the expansion of the range of portraiture in oil and conté crayon, perhaps most remarkably by Lemmen and Van Rysselberghe, but with additions by many of Seurat's followers. Together they produced an extraordinary body of landscapes, urban scenes, and portraits that remains powerful, witty, entrancing, and deeply satisfying to this day.

Notes

1. John Gere, *Portrait Drawings, XV–XX Centuries* (London: British Museum, 1974), [1].

2. The literature on portraiture is vast. Among the texts that have informed this discussion are Paul Lambotte, *Les Peintres de Portraits* (Brussels: G. Van Oest, 1913); Luc Haesaerts, *Histoire du Portrait de Navez à Ensor* (Brussels: Éditions du Cercle d'art, 1942); Jozef Muls, *Een eeuw portret in België: Van het Classicisme tot het Expressionisme* (Diest: Pro Arte, 1944); John Pope-Hennessey, *The Portrait in the Renaissance* (London: Phaidon, 1966); André A. Moerman, *Regards et attitudes d'un siècle: Portraits et figures de Navez à Evenepoel* (Brussels: Musées royaux des Beaux-Arts de Belgique, 1967); James D. Breckenridge, *Likeness: A Conceptual History of Ancient Portraiture* (Evanston, IL: Northwestern University Press, 1968); Melissa McQuillan, *Impressionist Portraits* (London: Thames and Hudson, 1986); George Shackelford, *A Magic Mirror: The Portrait in France, 1700–1900* (Houston: Museum of Fine Arts, 1986); Lorne Campbell, *Renaissance Portraits: European Portrait-Painting in the 14th, 15th and 16th Centuries* (New Haven: Yale University Press, 1990); Richard Brilliant, *Portraiture* (Cambridge, MA: Harvard University Press, 1991); Marcia Pointon, *Hanging the Head: Portraiture and Social Formation in Eighteenth-Century England* (New Haven: Yale University Press, 1993); William Rubin, ed., *Picasso and Portraiture: Representation and Transformation* (New York: Museum of Modern Art, 1996); Colin B. Bailey, ed., *Renoir's Portraits: Impressions of an Age* (New Haven: Yale University Press, 1997); Joanna Woodall, ed., *Portraiture: Facing the Subject* (Manchester, Eng.: Manchester University, 1997); John Klein, *Matisse Portraits* (New Haven: Yale University Press, 2001); Heather McPherson, *The Modern Portrait in Nineteenth-Century France* (Cambridge: Cambridge University Press, 2001); Andreas Beyer, *Portraits: A History* (New York: Abrams, 2003); Stephan Kemperdick, *The Early Portrait from the Collections of the Prince of Liechtenstein and the Kunstmuseum Basel* (Munich: Prestel, 2006); *Portraits publics, portraits privés, 1770–1830* (Paris: Réunion des musées nationaux, 2006); Tamar Garb, *The Painted Face: Portraits of Women in France, 1814–1914* (New Haven: Yale University Press, 2007); Lorne Campbell, ed., *Renaissance Faces: Van Eyck to Titian* (London: National Gallery Company, 2008); and *Étrange visage: Portraits et figures de la collection Magnin* (Paris: Réunion des musées nationaux, 2012).

3. Charles Émile-Auguste Carolus-Duran was known simply as Carolus-Duran. See Bailey, *Renoir's Portraits*, for a discussion of market prices, esp. 16–19. On the figure for Monet's portrait of Madame Gaudibert, see 48n150.

4. At the Salon the work was entitled *Portrait de Mme****. See *Carolus-Duran, 1837–1917* (Paris: Réunion des musées nationaux, 2003), 86–88.

5. Ibid., 97. His success was immediate: the following year he painted the *Portrait of Madame Ernest Feydeau*, who was married to the successful writer, while in 1875 the Musée du Luxembourg acquired his wife's portrait for the handsome sum of 10,000 francs.

6. Camille Pissarro to Lucien Pissarro, May 15, 1892, Bailly-Herzberg, *Correspondance de Camille Pissarro*, 3: 229. Camille Pissarro explained to his son, "Mirbeau openly in the *Figaro* shredded Carolus."

7. Baudelaire discusses the dialectic in the following terms: "There are two ways of understanding portraiture—either as history or as fiction. The first is to set forth the contours and the modeling of the subject faithfully, severely and minutely; this does not, however, exclude idealization, which will consist of choosing the sitter's most characteristic attitude—the attitude which best expresses his habits of mind. . . . The second method, which is the special province of the colorists, is to trans-

n'admettant que les couleurs du spectre et seules les employant." Émile Verhaeren, "Le Salon des XX," *L'Art moderne,* February 5, 1888, 42.

52. For the former, see "Aux XX: Les Impressionnistes," *La Réforme,* February 11, 1888, and for the latter, Max Waller, "Le Salon des XX: Lettre de Bruxelles," *L'Artiste* 40 (March 1888): 176.

53. The apartment was at 12 chaussée de Vleurgat, Brussels. Van Rysselberghe was in Morocco on a diplomatic mission with Picard.

54. Verhaeren to Van Rysselberghe, February 1888, cited by Fabrice van de Kerckhove, "Au coeur de correspondence," in *Émile Verhaeren, un musée imaginaire* (Paris: Réunion des musées nationaux, 1997), 64.

55. Signac to Maus, January 11, 1888, Chartrain-Hebbelinck, "Les lettres de Paul Signac à Octave Maus," 63.

56. Georges Frédéric Louis de la Hault (1862–1901) was an art collector. Thanks to Roger Cardon and Françoise Thomas for assistance with research on the de la Hault family. *Port en Bessin* is mentioned as being sold but not attributed to any particular collector in "Petite chronique," *L'Art moderne,* March 17, 1889, 87. However, when the work was shown at the 1890 Paris Independents it was lent by G. de la Hault and again to the Seurat retrospectives held in Brussels and Paris in 1892 by the same collector. De la Hault is listed as a subscriber to Les XX of concerts and events in 1889; Musées royaux des Beaux-Arts de Belgique, Archives de l'art contemporain, Fonds Vander Linden no. 5207, hereafter, MRBAB, AAC, Vander Linden. Gevaert (1861–1903) was on the faculty of medicine at the University of Brussels. For the drawing, see Herbert, *Georges Seurat,* 298.

57. "Petite chronique," *L'Art moderne,* March 10, 1889, 79. For another confirmation of the sale, see Bailly-Herzberg, *Correspondance de Camille Pissarro,* 2: 267n1.

58. Seurat to Maus, February 17, 1889, MRBAB, AAC, Vander Linden no. 5237. For Maus's reviews, see "Le Salon des XX à Bruxelles," *La Cravache,* February 16, 1889, and March 2, 1889.

59. "Le petit point est à la mode, le pain à cacheter triomphe sur toute la rampe. L'affiche elle-même n'y a pas échappé: la variole l'a abominablement piquetée." "Chronique artistique," *La Chronique,* February 2, 1889.

60. "Les Bubonistes," *La Chronique* 9, no. 10 (February 11, 1889).

61. S. T. R. Chèque, "Les XX de Bruxelles," *L'Escaut,* February 5, 1889.

62. Max Waller, "Le Salon des XX," *L'Artiste* 40 (March 1888): 176.

63. "Les yeux peu exercés ne verront pas de différences techniques entre nous et nos amis de Paris." Finch to Maus, January 6, 1888, MRBAB, AAC, Vander Linden no. 5044.

64. "Aux XX, il n'y a pour l'instant que nous deux qui fassions la division totalement; (et nous la faisons de plus en plus)—Il reste alors ceux qui s'y acheminent, qui seront les adeptes de demain: Mlle. Boch, H. Van de Velde. Déjà en leurs envois de cette année aux XX, la tendance se dessine. Puis qu'il y a Schlobach qui a essayé en quelques toiles (non exposées) et Toorop, qui 'pointille' mais ne *divise* nullement et Lemmen—qui peint fort peu et fait plutôt des croquis où il recherche les caractères." Van Rysselberghe to Signac, March 1, 1889, Signac Archive, Paris.

65. J. Krexpel, "Le Salon des XX," *La Revue Blanche* (Belgian edition; February 1890): 11.

66. According to the catalogue, Lemmen was the first Belgian Vingtiste to exhibit at the Independents in 1889, although he did not show Neo-Impressionist works until 1891. In 1890 Boch, Finch, Lemmen, Van Rysselberghe, and Van de Velde also exhibited in Paris, and in 1891 and 1892, Boch, Lemmen, and Van Rysselberghe showed Neo-Impressionist works. From 1893 on, only Lemmen and Van Rysselberghe among the Belgians showed frequently at the Independents.

67. "Appendix F" in Herbert, *Georges Seurat,* 383.

68. The authoritative source on Lemmen is Cardon, *Georges Lemmen, 1865–1916* (1990); see also his *Georges Lemmen, 1865–1916* (1997).

69. Monnom purchased *Cassis, Cap Canaille. Opus 200.* The second work, Signac's *Cassis, La jetée. Opus 198,* was sold to Antoine de la Rochefoucauld through the auspices of composer Vincent d'Indy; Cachin, *Signac: Catalogue raisonné de l'oeuvre peint,* 192, 193, and "Acquisitions d'objets d'art," *L'Art moderne,* February 23, 1890, 59.

70. Victor Boch (1817–1920) is the owner of *Opus 209,* listed in the Paris Independents catalogue as no. 1112. This is confirmed by Cachin, *Signac: Catalogue raisonné de l'oeuvre peint,* 199, no. 205. See also "Aux XX," *L'Art moderne,* April 19, 1891, 128.

71. "Il m'attendait, mais au lit, accablé par une forte fièvre un froid, me disait-il, pris à l'exposition." Lemmen to Signac, March 31, 1891, Signac Archive, Paris.

72. "Une horrible nouvelle. Notre pauvre Seurat et mort hier matin après deux jours de maladie—une angine infectieuse, dit-on." Signac to Van Rysselberghe, March 31, 1891, MS416.60, Bibliothèque Centrale du Louvre, Paris.

73. É.(mile) V.(erhaeren), "Mort de Georges Seurat," *La Nation,* April 1, 1891.

74. Signac to Maus, three undated letters April, May 1892, Chartrain-Hebbelinck, "Les lettres de Paul Signac à Octave Maus," 70–73.

75. Jane Block, "Le carrousel et le monde de la fête foraine," in Cardon, *Georges Lemmen* (1997), 68–79. Although the canvas exists, Lemmen reworked it so that it is no longer a Neo-Impressionist painting.

76. This was one of two marinescapes (either 459 or 460) shown at La Libre Esthétique in 1894.

77. Jane Block, "Les XX and La Libre Esthétique: Belgium's Laboratories for New Ideas," in Stevens and Hoozee, *Impressionism to Symbolism,* 40–58. See also Madeleine Octave Maus, *Trente années de lutte pour l'art* (Brussels: L'Oiseau bleu, 1926); *Les XX & La Libre Esthétique: Cent Ans Après* (Brussels: Musées royaux des Beaux-Arts de Belgique, 1993); and Canning, "'Soyons Nous'" (1992).

78. Six years after Pissarro's disenchantment with the style, Signac chided Pissarro that "I can still remember vividly your enthusiasm for this technique and your statements of satisfaction with my work. . . . Something that one liked so much, can it suddenly appear so detestable? It is not me who has changed, dear Master, since this time; far from floundering, I am progressing in this path." Signac was adamant that Neo-Impressionism continued to be a vital force: "I am persuaded that we are on the right track, and I am even more certain that we have not yet reached the end and there is much to do. All the more reason not to be discouraged. On the contrary we must persevere and stand firm." Signac to Camille Pissarro, January 25, 1894, Ashmolean Museum, Oxford, cited in Bailly-Herzberg, *Correspondance de Camille Pissarro,* 3: 424–25n1. Pissarro remained unconvinced, confiding two days later to his son Lucien, "I find that even the method is bad. Instead of helping the artist, it ossifies and freezes him." Ibid., 423–24, Camille Pissarro to Lucien Pissarro, January 27, 1894.

79. "Exposition des peintres Néo-Impressionnistes" was held between December 2, 1892, and January 8, 1893, at the Hôtel Brébant, 32 Boulevard Poissonnière. A year earlier, in December 1891, the Neo-Impressionists had been grouped with Nabis artists at Le Barc de Boutteville's gallery, 47 rue Le Peletier.

80. One notable exception among the paintings was the pewter and terra cotta on display by the sculptor Alexandre L. M. Charpentier.

81. "Groupe des Peintres Néo-Impressionnistes" was held at 20 rue Laffitte from December 1893 to January 1894.

82. Camille Pissarro to Lucien, December 10, 1893, Bailly-Herzberg, *Correspondance de Camille Pissarro,* 3: 407. Nonetheless, three of Camille's sons sent works: Félix, Georges, and Lucien.

83. Van Rysselberghe's first one-man exhibition was held January 7–24, 1895, at the Galerie Laffitte in Paris.

84. For the impact on Matisse and his followers, see Eric de Chassey, "Signac et les fauves," in Franz, *Signac et la libération de la couleur,* 143–77; and Françoise Cachin, "Néo-impressionnisme et fauvisme," in Ferretti Bocquillon, *Le Néo-impressionnisme: De Seurat à Paul Klee,* 82–93.

85. Essays in Ferretti Bocquillon's *Le Néo-impressionnisme: De Seurat à Paul Klee,* such as Jane Block's "Au-delà de Paris: Le néo-impressionnisme de Belgique et en Hollande," 26–35, and Daniela Mondini and Felix Studinka's "La libération de la couleur en Italie: Divisionnisme et futurisme," 46–53, treat the spread of Neo-Impressionism, respectively, in Belgium, the Netherlands, and Italy. For Italy, see also Silvestra Bietoletti, "'La ricerca della luce nel colore': Il divisionismo, una via all'arte italiana del Novecento," 80–87, in Ferretti Bocquillon, *Georges Seurat, Paul Signac e i neoimpressionisti.*

86. For O'Keeffe's *Untitled* (*Horse*), see Barbara Buhler Lynes, *Georgia O'Keeffe: Catalogue raisonné* (New Haven: Yale University Press, 1999), 1: 50, no. 42.

87. For more on the important patronage of Kessler and his circle, see Alexandre Kostka, "Physiologie de l'harmonie: Kessler et son groupe, principaux médiateurs du néo-impressionnisme en Allemagne," in Franz, *Signac et la libération de la couleur,* 197–210; and for the propagation of Neo-Impressionism in Germany, see Erich Franz, "Le Néo-impressionnisme en Allemagne et en Suisse," in Ferretti Bocquillon, *Le Néo-impressionnisme: De Seurat à Paul Klee,* 37–45.

The Neo-Impressionist Portrait
A French and Belgian Dialogue

Jane Block

The idea of submitting the human portrait to the rigors of the Neo-Impressionist method involved a number of complexities that are not immediately apparent. Perhaps because of his interest in abstraction, pattern, and generalized social action, Seurat was not drawn to representing individuals. Indeed, his attention to reveal universal form and contemporary social milieu ran counter to a desire to depict the particular, an obvious necessity for the portraitist. Yet Seurat's approach to the human form proved highly influential. His ambitious compositions of grouped figures—from *La Grande Jatte* and *Models* (*Poseuses*) to *Circus Sideshow* (*Parade de Cirque*) and *Circus* (*Cirque*)—provided models for such grand canvases as Paul Signac's *In the Time of Harmony* (*Au temps d'harmonie*), Théo van Rysselberghe's *In July, Before Noon* (*En juillet, avant-midi*), and Georges Lemmen's *Carnival* (*Fête foraine*). His one portrait, *Young Woman Powdering Herself* (*Jeune femme se poudrant*), despite its inherently antiportrait stance, greatly affected the work of his followers. Seurat was not the first artist to attempt a pointillist likeness; in fact, the history of the Neo-Impressionist portrait in France and in Belgium provides a very separate narrative to that of Seurat and Neo-Impressionism, and one that hitherto has been barely examined in the scholarly literature.

Likeness in Effigy: The Neo-Impressionist Portrait in France

The Neo-Impressionists sought a new look for their works, one based in part on a rejection of the polished canvases of academic artists that conceal their method of creation. The artists' very emphasis on theories of pure color and decorative line called attention to how their paintings, and indeed their drawings, were made, as did the separate dots of color.[1]

They were less concerned with rendering the illusion of reality than with revealing an underlying "truth," while allowing the materiality of the painted surface to remain visible.

As an aid in setting aside entrenched academic methods, many of these artists sought inspiration from cultures outside canonical Western traditions. Already in 1883, Camille Pissarro advised his son Lucien to turn to Japanese drawings, Persian miniatures, Egyptian art and the Primitives.[2] Here we should understand "les Primitifs" as Early Netherlandish artists, including Jan Van Eyck and Hans Holbein, and such Early Renaissance artists as Fra Angelico.[3] Pissarro, who referred to his own work as having a "modern primitive cachet," explained, "The Primitives are our masters because they are naive and wise."[4] The stiffly drawn figures, supposed awkwardness, and apparent discrepancies of scale and proportion were actually hallmarks of true creativity and imagination.[5] Thus, the naive aspect of Neo-Impressionist art was a purposeful rejection of superficial academic "perfection" with the intent of finding a more universal meaning.

GEORGES SEURAT AND THE FIGURAL COMPOSITION

Understanding the Neo-Impressionist portrait involves revisiting a longstanding prejudice against the subject. In 1968, Robert Herbert wrote in the catalogue of the groundbreaking exhibition *Neo-Impressionism,* "Seurat and Signac each did several monumental interiors in the 1880s, but otherwise Neo-Impressionism is a style of landscape painting."[6] The exhibition included only nine portraits out of one hundred and seventy-five works, and these were not examined as a group.

As early as 1904, Paul Signac was disgusted to find that Seurat's contribution to a retrospective of Impressionism (to which Neo-Impressionism was held to be a part) had been reduced to seven seascapes. He complained to Van Rysselberghe, "The stupid ones will say, 'the dots worked only for landscapes and not for figures.'"[7] Signac explained that he even offered to lend Seurat's *Circus,* which he owned, while Fénéon and Edmond Cousturier could have lent *Baignade* (*Bathing Place*) and *La Grande Jatte,* each populated with figures. Signac lamented that an important opportunity had been lost: "It was stupid and a weakness to have only shown Seurat as a landscapist and to have skipped over Seurat the 'décorateur' and painter of figures. He was one of the rare modern painters whose figures had attained a style—and only the great works of Seurat could demonstrate his contribution to contemporary art. He considered his marines and landscapes only as exercises while his originality lay in his compositions."[8] Thus, according to Signac, Seurat himself valued his figural compositions above all else; certainly Signac felt they were crucial to understanding Seurat's art.

While *La Grande Jatte* is in no sense a group portrait, it is peopled with pleasure seekers on a Sunday afternoon. It transcends the Impressionists' search for the fleeting moment, and its expression and form link it both to the subjective elements of contemporary Symbolism and to time-honored principles of classicism. The decorative aspect of the picture, with its repeating umbrellas, paired figures, and rhythmic shadows and tree trunks, reinforces the figures' flatness and their psychological separation. Yet these figures

Fig. 14. Georges Seurat (French, 1859–1891), *Aman-Jean,* 1882–83. Conté crayon on paper, 24½ × 18¹¹⁄₁₆ in. (62.2 × 47.5 cm). The Metropolitan Museum of Art, New York. Bequest of Stephen C. Clark, 1960.

are not individuals but types. While Seurat sought to examine themes of popular entertainment in general rather than particular individuals in such major works as *Bathing Place, Circus Sideshow, Chahut,* and *Circus,* many of his contemporaries saw only the stiffness of his figures, likening them to toy soldiers and dolls.[9] Art historian Anthea Callen posits Seurat's purpose: "Not only do Seurat's figures suggest anonymous types, but his marks, while highly personal, have at the same time a universality as a language freed from the bounds of realism and received convention."[10]

Given Seurat's penchant for abstracting form and his ironic commentary on Parisian society by representing types, he was less interested in portraiture. That this was a conscious decision is revealed by several extraordinary conté crayon portraits showing his friends Edmond-François Aman-Jean, Paul Signac, and Paul Alexis (now lost). Prepared for the Salon of 1883, the drawing of Aman-Jean was his first work exhibited in public (fig. 14). With its large size (24½ × 18¹¹⁄₁₆ in.), the ambitious piece fairly begs to be considered a masterwork. Seurat depicts the intensity and concentration of his colleague, who leans

forward as he paints an unseen work. Aman-Jean's hairs stand up at the back of his head, as though making tangible the mental sparks of creativity. Enforcing this idea of a current passing through the subject, the radiant halo surrounding Aman-Jean's head ennobles both the sitter and the act of creation. Seurat's *Paul Signac,* created some seven years later, reveals the high esteem in which he held Signac (see plate 34). Shown nearly in profile, Signac is given a certain gravitas by his monumental blocky form.[11] The curtain provides the most minimal interior setting as a backdrop for the elegantly attired Signac. The portraits of Aman-Jean and Signac reveal Seurat's innate ability to portray an individual when the desire or need to do so arose.

Seurat offered a different interpretation of portraiture in *Embroidery: The Artist's Mother,* which is half the size of the Aman-Jean portrait and was also submitted to the Salon of 1883.[12] Little of the domestic interior in which Madame Seurat embroiders is shown, her son wishing to keep our attention on her sewing. This approach—a known person who is not examined as an individual—will return among the works of several Neo-Impressionists.

Following the introduction of his mature color theory into his work in about 1885, Seurat completed only one oil that may be considered a portrait, *Young Woman Powdering Herself* (*Jeune femme se poudrant*), painted in 1889–90 (see plate 33). A rather rotund woman with downcast eyes lifts a powder puff. She sits before a little table that holds a mirror and perfume bottles and whose ornate moldings echo her curvaceous body. In Seurat's abstraction of form, its stiffness and primitivism, the solemn and hieratic figure becomes a *vanitas,* a symbol of the futility of artifice and the transience of existence, rather than primarily the portrait of the individual sitter, who in fact was Madeleine Knoblock, Seurat's partner.[13] It would be left to Seurat's followers to discover whether Neo-Impressionism was suitable for portraiture.

ALBERT DUBOIS-PILLET

In fact, one such follower had already faced the subject of human likeness: Albert Dubois-Pillet, to whom Fénéon granted the distinction of being "the first to apply to the portrait systematic division of tone."[14] Dubois-Pillet exhibited these first portraits, five in all, at the third exhibition of the Independents in March 1887, more than two years before Seurat painted *Young Woman Powdering Herself.* The group, apparently all in the new style, included *Portrait of Monsieur Pool* (see plate 4), which Fénéon characterized as "stiff with his professional decorations."[15] Dubois-Pillet united his interest in the two-dimensional surface, seen on the braiding on Pool's chest as well as the Caucasian prayer rug behind him, with an exploration of his comrade's stoic nature.

Fénéon praised the entire group: "His effigies—especially the feminine ones—live. A subtle polychromatic joy flows in arabesques on the backgrounds."[16] The term *effigy* appropriately connotes the figures' primitive quality; it also is significant in understanding one component of the French Neo-Impressionist portrait, as we shall see. Dubois-Pillet

exhibited portraits at each of the next three Independent exhibitions, including another of Fénéon's effigies, *The Lady in the White Dress* (*La Dame à la robe blanche;* see plate 3). She is rendered almost as a wooden doll, with large eyes and a frozen expression, while behind her a large abstract swirling pattern flattens the composition. Unfortunately, most of Dubois-Pillet's portraits, which were dispersed after the artist's death of smallpox on August 17, 1890, have not come to light. We must await a time when the full set allows us to experience for ourselves the life Fénéon found in their "subtle polychromatic joy."[17]

PAUL SIGNAC AND THE "EFFIGY"

As the principal follower of Seurat during his lifetime and the leader of the movement after Seurat's death, Signac took as the primary subjects of his own paintings the landscapes and marines that so captivated Seurat. For Signac's larger canvases, including *Milliners* (*Les Modistes,* 1885–86), *The Dining Room* (1886–87), *A Sunday* (*Un Dimanche,* 1888–90), and the enormous *In the Time of Harmony* (1895), he developed Seurat's technique of figural compositions. Although we can identify some of the individuals depicted, including Signac's wife, Berthe, and his grandfather, these large canvases investigate bourgeois conventions and attitudes in the manner of domestic versions of Seurat's more public figural compositions, rather than explore the personas of individuals.[18]

We might expect that Signac, who raged against Maus for neglecting Seurat as "the painter of figures," would himself explore the possibility of pointillist portraiture. In fact, among his hundreds of works in the style there are only four paintings that can be considered portraits, that is, where he has depicted and explored an identifiable sitter.[19] Painted in the short span of three years, these include his good friend Fénéon (1890–91); his future wife, Berthe, in *Woman Arranging Her Hair* (*Femme se coiffant*) (1892); his mother, Héloïse Signac (1892); and Berthe again in *Woman with a Parasol* (*Femme à l'ombrelle*) (1893). Portraiture in general did not attract Signac; among the few attempts before his portrait of Fénéon are the Impressionist portraits of his childhood friend Charles Torquet (1883) and of his grandfather (1884).[20] All four Neo-Impressionist portraits by Signac privilege two-dimensional design over three-dimensional illusion. Consonant with Dubois-Pillet's portraits and Seurat's *Young Woman Powdering Herself,* they are hieratic and abstract representations of the sitters, set amid swirling decorative lines.

The portrait of Fénéon (see plate 36) is a demonstration of Signac's and Fénéon's shared interest in the theories of Charles Henry, Japanese woodblock prints, and the decorative line, and is an homage to their friendship.[21] The portrait was preceded and, indeed, inspired by Fénéon's literary interpretation of Signac's art, an essay published in 1890 in the review *Les Hommes d'aujourd'hui* (*The Men of Today*). Explaining the theory of optical mixture and exploring its advantages, Fénéon signaled the collaboration between Signac and Henry on two of the latter's publications for which Signac supplied plates and diagrams.[22] Signac, praised by Fénéon as the "young glory of Neo-Impressionism," was creating a decorative art "that sacrifices anecdote to arabesque, nomenclature to synthesis, and the fleeting to the permanent."[23]

In his portrait of Fénéon, Signac was returning the favor, as in June 1890 he confessed to Fénéon his desire to execute a "painted biography" that was to be both a portrait of Fénéon and a demonstration of Neo-Impressionist theory—in short, a "Félix décoratif."[24] Pleased with the news, Fénéon replied that he hoped the image would be an "Effigie absolument de face"—a full-faced effigy.[25] Although Signac did not comply with Fénéon's wish for the pose, rendering the sitter in profile, the two men collaborated on the painting much as they did on Fénéon's biography of Signac. Fénéon forms an angular and rigid contrast to the swirling background, based on a Japanese woodblock print in Signac's collection. He is rendered as a dandy, an esthete, proffering a cyclamen to someone outside the painting, perhaps Signac or Henry.

Fénéon's desire to be presented frontally as a "full-faced effigy" repeats the term he used to discuss the first Neo-Impressionist portraits of Dubois-Pillet. At this moment, as we have seen, Émile Verhaeren employed the term *effigie* to describe an ingredient used by the greatest portraitists, those who painted ideas.[26] The Larousse encyclopedia defines effigie as a "representation in painted wax or in painting of a person, famous person or a convict" and, second, as an "impression on a coin or a medal representing the head of a king, prince or famous person."[27] An effigie is a likeness, then, that is abstracted to some degree. Signac, with Fénéon's approval, was attempting to render the essence of his friend's nature.

Two years later, Signac completed his *Woman Arranging Her Hair* (see plate 37). Although this is a portrait of his companion, Berthe Roblès, the sitter's unconventional pose seen from the rear reveals her facial details only schematically in the mirror before which she primps. The painting's subtitle, *Arabesques for a Dressing Room* (*Arabesques pour une salle de toilette*), is revealing: having depicted a decorative Félix, he now opted for a decorative Berthe. The medium chosen, encaustic, was new to the artist. The technique, where pigments are mixed with molten wax on a warm palette, had been used by ancient Greek and Roman artists and eventually gave way to tempera and oil painting only to see a revival in the mid-eighteenth century. In the nineteenth century, artists such as Puvis de Chavannes and Eugène Delacroix experimented with the wax medium, which was particularly well suited to mural painting. The influential theorist Charles Blanc had explored this technique and made it popular in his *Grammar of the Arts of Design* (*Grammaire des arts du dessin*), published in 1867.

In 1884, another theorist who was avidly read by Seurat and Signac, Charles Henry, published *Encaustic and Other Methods Used by the Ancients* (*L'encaustique et les autres procédés de peinture chez les anciens*).[28] Along with providing new recipes for artists eager to try out this revived technique, the authors published a selection of effigy mummy portraits from Fayum, Egypt, executed in encaustic (fig. 15). Fénéon, who reviewed this book in the summer of 1889, was familiar with the encaustic technique and its advantages as well as with the portrait discoveries from Fayum.[29] Signac was attracted to the medium's relatively permanent colors, a great concern to him since he had seen disturbing changes in the colors of *La Grande Jatte*. Signac tried to interest Théo van Rysselberghe in the technique in 1892, but

Van Rysselberghe complained of how tiring and difficult the new medium was "because the color dried too quickly and the brush had to be reheated with nearly each application, nearly for each stroke, and it is horribly tiring."[30]

Although Berthe served as the model for this work, she acted as the catalyst for Signac's exploration of fresh colors permitted by encaustic. Signac reveled not only in the beautiful yellows and mauves but also in the patterns formed by the chignon on Berthe's hair, the partially revealed Japanese fans, the crisscross patterning of her corset stays, and the dance of her fingers, which match the liveliness of the bows on her shoulders. Even the abstract floral motifs on the pitcher and bowl seem to vibrate in their swaying movements. Signac responded to both the encaustic medium and the Fayum portraits as vehicles to explore an art that was "primitive," transcending conventional Western art and putting him in touch with the basic instincts of pre-academic art.

Fig. 15. *Funerary Portrait of a Young Woman*, c. 161–80 CE. Encaustic on wood, 13 × 7⅜ in. (33 × 18.8 cm). Musée du Louvre, Paris.

For his third portrait, Signac abandoned the encaustic technique as too laborious and rendered his mother, Héloïse (1842–1911; see plate 38), in oil. Once again, he emphasized the two-dimensional, capturing the patterning of his mother's dress, the frilly collar and cuffs, as well as the billowing sleeve echoed by swirling and abstracted vegetation behind her. Signac exhibited this work at the first Neo-Impressionist exhibition, held from December 2, 1892, to January 8, 1893, not as *Portrait of My Mother* but simply as *Effigy* (*Effigie*), clearly stating his interest in presenting his mother's essence through the simplification and flatness of the canvas.[31] The painting was important enough to him that he exhibited it twice more in 1893, at Les XX in February and several months later at the Association pour l'art in Antwerp. The following year he sent it back to Brussels for La Libre Esthétique and finally offered it to the Paris Independents of the same year.

For his final portrait, Signac returned to the subject of Berthe, posing her with a parasol (fig. 16). Again, the decorative aspect of the painting equals the portrayal of the person with whom the artist had shared his life for ten years and whom he married in November 1892.[32] The huge umbrella encompasses Berthe, who stands outdoors before a chair, while the orange fabric encasing her seems to spread from her gigantic puffed green sleeves. Her left arm appears detached from her body, so lively are the contours of the sleeve. The extreme stylization is complete with the V shape of her neckline, crescent pin, and undulating radial spokes of the umbrella. By removing the context and manipulating line and color,

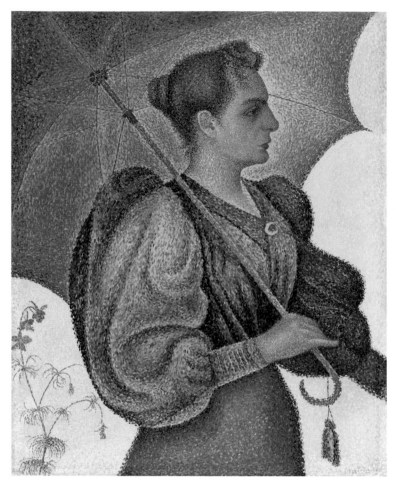

Fig. 16. Paul Signac (French, 1863–1935), *Woman with a Parasol, Opus 243* (*Femme à l'ombrelle. Opus 243*) (Berthe Roblès, first wife of Signac), 1893. Oil on canvas, 32¼ × 26⅜ in. (82 × 67 cm). Musée d'Orsay, Paris.

Signac has rendered Berthe timeless. We are, in fact, confronted with an effigy as haunting and as elusive as the Fayum paintings.

EXPANDING THE FRENCH CANON: PETITJEAN, LUCE, AND LAUGÉ

The portrait possibilities of figural compositions, effigy, and surface pattern—introduced by Seurat, precociously explored by Dubois-Pillet, and developed by Signac—were further investigated in the 1890s in the work of three French followers: Hippolyte Petitjean, Maximilien Luce, and Achille Laugé.

Following his academic training and early career, Petitjean turned to Neo-Impressionism in 1891. A year later, he painted his first divisionist portraits that follow the approach of Dubois-Pillet and Signac and, coming first in 1892, already show influence from Brussels. Among this small number are several of his wife, Louise Claire Chardon.[33] In *Young Woman Seated* (*Jeune femme assise,* 1892; see plate 30), the least formal and most intimate of these, Louise turns to face us, sitting in a simple chair, the only context provided by the artist. In the abstraction of form and background it harkens back to Seurat's *Young Woman Powdering Herself.* The *petits points* in Petitjean's portrait are visible on the sitter's face, a passage often

rendered less pointillist in some Neo-Impressionist portraits. However, the plasticity of her head and the psychological penetration of the sitter also bring to mind works by the Belgian artist Georges Lemmen, while the palette of delicate pinks, blues, and greens recalls Lemmen's *Mademoiselle L. (Portrait of the Artist's Sister)* of the same year (see plate 20). Although a direct link is possible, the similarity reveals that the Neo-Impressionist technique emphasizing extreme stylization and decoration could be coupled with a psychological intensity and lead to similar results in separate developments. Following this promising start, by 1895 Petitjean had given up Neo-Impressionism.

Despite a longstanding interest in portraiture, from his *Aunt Octavie* (1876) to a late portrait of Fénéon (c. 1910), as well as a deep-seated commitment to Neo-Impressionism, Maximilien Luce created only a handful of individualized portraits using the divisionist technique.[34] Yet he used the human figure in many of his early Neo-Impressionist works. The lineage leading to Luce came from Seurat's "portraits" of activity seen in his mother embroidering and *Young Woman Powdering Herself* and the large figural compositions. Such paintings by Luce as *Le Chauffeur, Le Balayeur,* and *Le Chiffonnier* also reveal his sympathies for the workingman and his allegiance to anarcho-communism, a branch of anarchist thought.[35] Typical of these is *Morning, Interior* (1890; see plate 27), depicting his fellow painter and friend Gustave Perrot, which merges portraiture with a domestic interior to create a hybrid that could be labeled a Neo-Impressionist genre portrait. Only in his depiction of another friend and painter, Henri-Edmond Cross, at age forty-two (1898), did Luce create a portrait in which the sitter's individuality is the subject (fig. 17).[36] Its subject rendered in three-dimensional form and, perhaps, conventional nature, this late painting clearly responds to the work of the Belgian Van Rysselberghe, who had become the principal Neo-Impressionist portraitist. It also betrays its date by the loosening of the rigors of Divisionism.

Achille Laugé presents the case of a figure who participated in the Neo-Impressionist movement from afar, both literally and figuratively. Unlike Dubois-Pillet, who was directly involved in the movement, Laugé, who lived in Paris in 1881–88, was not among the inner circle of Seurat, Signac, or the other Neo-Impressionists. In fact, Laugé turned to

Fig. 17. Maximilien Luce (French, 1858–1941), *Portrait of Henri-Edmond Cross,* 1898. Oil on canvas, 39⅜ × 31⅞ in. (100 × 81 cm). Musée d'Orsay, Paris.

Neo-Impressionism only after he returned to his native region of the Aude in 1888. He first exhibited at the Independents in 1893, showing three landscapes, and returned in 1894 with three portraits.

One of Laugé's first Neo-Impressionist works was the full-length *Portrait of Madame Astre* (1892; see plate 6), the first wife of his close friend Achille Astre. Laugé made the flatness of Seurat's figures more sculptural while retaining their stiffness and apparent naivety. Yet the space remains constricted; Mme Astre rests her hands on a table tilted so high as to make the items on the lower shelf tip forward. The hieratic qualities present in Seurat's and Signac's oeuvre have been assimilated into a personal idiom of a blocklike monumentality. This heroic quality, with subjects bathed in a tranquil light, is manifested in two additional works for which his wife served as a model: *Before the Window* (*Devant la fenêtre;* see plate 11) and *Against the Light: Portrait of the Artist's Wife* (*Contre-jour: Portrait de la femme de l'artiste;* see plate 10). In the latter, Madame Laugé is presented in an iconic pose holding a staff, the contemporary equivalent of Demeter/Ceres, the goddess of the fields. In all three works Laugé emphasizes the volume of forms harking back to the reductivist treatment of figures by the early Renaissance artist Piero della Francesca while combining subtle gradations of divided color and varying the strokes using small dots, cross strokes, and stippling.

CROSS, DELAVALLÉE, VAN GOGH, AND LUCIEN PISSARRO

One remarkable French Neo-Impressionist portrait defies this tracing of lineage from Seurat through Signac. In the year in which Seurat died, Henri-Edmond Cross sent an ambitious Neo-Impressionist portrait to the Independents—*Madame Hector France* (1891; see plate 1). Like Laugé, Cross came to Neo-Impressionism later than his colleagues; unlike Laugé, Cross had already submitted work to almost every Independents exhibition since the first in 1884. Immediately apparent is the melding of pointillist color theory with a nineteenth-century academic conception of portraiture. We need only compare the work with Carolus-Duran's full-length portrait *Woman with a Glove* (see fig. 2) to see the continuity of academic tradition in this avant-garde composition, and his exposure by 1891 to the first pointillist portrait of Van Rysselberghe, of Alice Sèthe, shown at Les XX in 1889 (see plate 46). Cross's work is a radical departure from the portraits of Seurat, Signac, and Dubois-Pillet, not only in the handling of space but in the placement of the figure in a cultural setting.

After the portrait of Mme France, Cross produced many figural compositions set in Edenic landscapes that resembled monumental antique sculptures and moved away from a strict application of Neo-Impressionist technique.[37] Yet in 1901 he returned to portraying Mme France—now his wife—seated outdoors wearing a frilly hat, producing a work more in the lineage of the French Neo-Impressionist portraits, and painted in riotous purples, pinks, reds, and greens.[38]

In addition to the major French Neo-Impressionists are those artists, such as Henri Delavallée and Vincent van Gogh, who adopted Neo-Impressionism only briefly as a means of liberation from naturalistic color and line. Delavallée, remembered today as a

Pont-Aven artist and printmaker, created a series of rigorous Neo-Impressionist landscapes between 1887 and 1890, and an engaging portrait of a boot polisher that, while more representational than many of the French portraits, still possesses a simplified, decorative quality (see plate 2). Van Gogh, who was living in Paris in 1887 when Seurat's invention first captivated the city, was immediately drawn to experimenting with the idea. His self-portrait shows the artist's understanding of the Neo-Impressionists' use of complementary colors applied not with uniform dots but through his characteristic brushstrokes (see plate 44). Van Gogh's own image provides perhaps the earliest example of a pointillist self-portrait—a subject undertaken by only a few Neo-Impressionists, including Georges Lemmen, Achille Laugé, and Charles Angrand, but with less ferocity than Van Gogh.

Finally, painters for whom portraiture was never central and who turned to Neo-Impressionism only for a short time, such as Lucien Pissarro, have left us a smattering of works on the periphery of our subject. Pissarro's image of his younger brother Georges combines a kind of portraiture with genre painting. Indeed, the title of the painting, *Interior of the Studio,* focuses on the location—their father's studio in Eragny—as opposed to the model (see plate 31). The Eragny landscape visible through the window was a cherished subject of both Lucien and Camille and served to portray Georges as much as does capturing his physiognomy.

French Neo-Impressionist portraiture, while encompassing a variety of possibilities, fundamentally contributed to the divisionist canon by approaching the sitter as an abstracted effigy who was part of a greater decorative whole. In the best French examples, figure and ground worked together to reveal the essence of the sitter.

Contemporary Traditions: The Neo-Impressionist Portrait in Belgium

Among the dozen artists who practiced Neo-Impressionism in Belgium, seven created portraits. Four of them—the Spanish Vingtiste Darío de Regoyos, the elusive William Jelley, the Dutchman Jan Toorop, and the Flamand George Morren—created only one or two portraits among their few divisionist works. For Henry van de Velde, Neo-Impressionism played a more formative role in his artistic development but was only a short-lived phase, producing a group of figural works that skirt the edges of individualized portraiture. However, two artists—Lemmen and Van Rysselberghe—explored the Neo-Impressionist portrait in such great depth that the results are central to our understanding of their art and of the movement itself. Although Lemmen found he could adhere to this vision for only four years, the half-dozen portraits he produced between 1891 and 1894 are among his greatest works. Van Rysselberghe, for his part, sustained a commitment to the movement for fifteen years to produce nearly three dozen Neo-Impressionist portraits, the greatest number of any artist, French or Belgian.

The first three Belgian Neo-Impressionist portraits, works by Van Rysselberghe and Van de Velde, were shown at Les XX in 1889. During the next four years at Les XX there were seventeen Neo-Impressionist portraits on display by Belgian artists, compared

with eight by French artists.[39] Their subjects were often friends or family, such as Van Rysselberghe's colleague Anna Boch (see plate 53), Lemmen's sister Julie (see plate 20), or Van de Velde's brother Laurent (see plate 41).[40] Only Van Rysselberghe was able to find a progressive clientele, such as Dr. Auguste Weber (see plate 55), who commissioned portraits that, until 1904, would be rendered in divided color.

HENRY VAN DE VELDE

Van de Velde's portraits before his Neo-Impressionist phase were mainly of his family, including his sister Jeanne (1883) and his father (1884), both cast in a realist manner.[41] Under the influence of Jean-François Millet, Van de Velde began painting peasants at work, a subject he continued to explore in the Neo-Impressionist manner beginning in 1888. Within five years, Van de Velde's growing interest in the decorative arts and architecture led him to abandon painting altogether while his proselytizing zeal for the social and political implications of the applied arts directed his energies toward writing and speaking. As Van Rysselberghe wrote in exasperation to Signac in late 1894, Van de Velde "no longer paints. He makes ornaments and gives lectures."[42]

Van de Velde produced five Neo-Impressionist figural canvases between 1888 and 1891. The earliest of the group, showing his brother Laurent reading at the seashore at Blankenberghe, is a transitional work between Impressionism and Neo-Impressionism (see plate 41). The foreground reveals a variety of brushstrokes, while the background contains distinct dots of paint. Despite Laurent's placement and downward gaze, he emerges as an individual, relaxed in casual attire. Shortly thereafter, Van de Velde created his first fully Neo-Impressionist painting, *Beach at Blankenberghe with Cabins* (*Blankenberghe. Août 1888*).[43] The abstraction in this non-figural design is unprecedented in Van de Velde's work but was to be developed in his subsequent figural compositions.

In *Portrait of a Woman* (*Portrait d'une dame;* see plate 42), also painted in late 1888, an elderly (and unidentified) woman sits indoors reading.[44] Warm light streams through the window while the sitter is bathed in somber dark blue and purple tones. Like Laurent, she seems to be unaware of the viewer. While the Neo-Impressionist technique is more fully utilized than in the portrait of Laurent, it dematerializes many of the forms, such as her shoulders and arms, which meld into the background. During 1889, Van de Velde further mastered the divisionist technique, exhibiting in 1890 at Les XX a third portrait, *The Girl Darning* (*La fille qui remaille,* known also as *La ravaudeuse*), which depicts his sister Jeanne mending outdoors. As one of eight paintings in a series dealing with small-town life, *Faits du village,* the image was meant to reveal the harmonious union of a figure with a rural setting, a seamless meshing of Neo-Impressionist landscape with figural representation.[45]

Another canvas in this series, *Woman Seated at the Window* (*Femme assise à la fenêtre;* fig. 18), is the most tightly organized and consistently controlled of the group; in short, the most like a work by Seurat himself. The sitter, rigidly posed, her head and hands bathed in light, represents an entire social and economic class.[46] The painting is a catalyst for con-

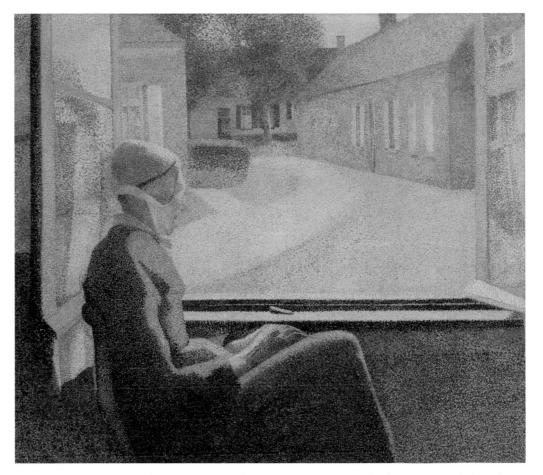

Fig. 18. Henry van de Velde (Belgian, 1863–1957), *Woman Seated at the Window* (*Femme assise à la fenêtre*), 1889. Oil on canvas, 43¾ × 49¼ in. (111 × 125 cm). Koninklijk Museum voor Schone Kunsten, Antwerp.

templating the purity and simplicity of a peasant, sanctified and invested with a symbolic meaning honoring the eternal cycle of peasant life.[47]

Van de Velde's last Neo-Impressionist portrait presents a fitting climax to the group. Known as *Père Biart Reading in the Garden,* it shows his sister Jeanne's father-in-law, Émile Biart, perched on a chair holding his reading material at arm's length (see plate 43). With considerable emphasis on the two-dimensionality of the work and its decorative qualities, Van de Velde stressed the curvature of the path, the scroll-like quality of the armrests, and the sitter's hat. The spatial ambiguity reveals that Van de Velde chose to privilege abstraction and overall surface design over plasticity—in the middle of which Père Biart calmly reads on.

GEORGES LEMMEN

The subjects of Lemmen's many portraits, regardless of style, were invariably family or friends from his intimate circle, whose particular physiognomies he used to explore a range of emotions and inner thoughts. A work titled *The Visitor* (*Dame en visite,* 1889), executed before Lemmen's conversion to Neo-Impressionism, shows his sister Julie seated in an

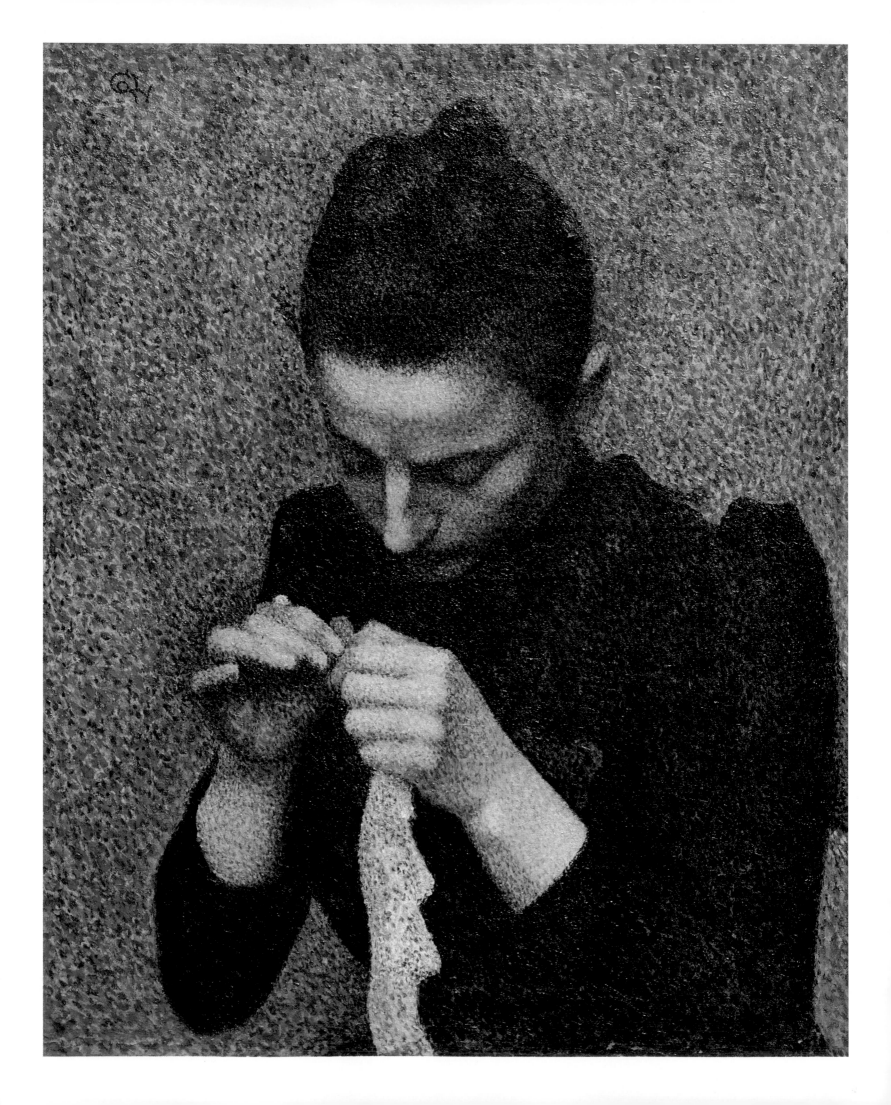

interior dressed in her outer garments, including her hand muff.[48] Light falls across her in what is otherwise a dark interior. While the style typifies a kind of Belgian Impressionism in its loose brushwork, the title evokes a story whose contents we are not privy to, while the presentation is almost Symbolist. It suggests such paintings by Lemmen's older colleague James Ensor as *The Sad Woman* (*La Dame sombre*) (1881), which also, through its title and dark coloring, projects a sense of foreboding and psychological drama; similarly to Lemmen's subject, Ensor's model was, in fact, his sister.

Lemmen carried this sense of psychological intensity and probing—an affinity he shared with Edgar Degas, another artist he greatly admired—to his works in a manner not found in other Neo-Impressionist portraits. The Belgian writer Camille Lemonnier aptly characterized Lemmen as the "painter of silence, of thought, of trust, of the discrete life of things in a tender and familial milieu."[49] His portraits share traits with his own personality. According to the wife of Octave Maus, Madeleine, Lemmen was "cold and disconcerting, thoroughly turned inward and on his art, a very personal, intimate and meditative art. He spoke and lived mutedly."[50] The space in Lemmen's portraits is typically shallow. The figures appear frozen in time and seem to speak to us of their inner strengths and frailties. Lemmen was drawn to such Northern Renaissance masters as Jan van Eyck, Rogier van der Weyden, and Hans Memling. After viewing a large exhibition devoted to the "Flemish Primitives" in Bruges in 1902, Lemmen enthused to his close friend Willy Finch about "several portraits by Memling that are marvelous." He further opined that "it is . . . in the domain of the portrait that this school is incomparable."[51] A decade before, he was already incorporating elements of this ancient lineage into portrait compositions on the cutting edge of contemporary art.

Lemmen entered the Neo-Impressionist fray in 1890 with two oils and three drawings shown at Les XX in spring 1891 that directly responded to Seurat's achievements. His first divisionist portrait, *Young Woman Crocheting* (*Jeune femme faisant du crochet*; fig. 19), while seeming to reflect a simple subject dear to nineteenth-century painters, is once again a portrait of his sister Julie.[52] To achieve a heightened intensity of feeling by concentrating on Julie, Lemmen stripped away all indication of setting except for a chair back to the left (which, painted in the same hues as Julie's dress, almost goes unnoticed). He brightened the tones on Julie's hands and forehead to create the effect of complete concentration. Lemmen's paring down of form recalls such portraits by Hans Memling as *Barbara van Vlaenderberch Moreel* (c. 1482; fig. 20), where the sitter is lost in the act of praying. The art critic Émile Verhaeren praised Lemmen's portrait of Julie as "acute, meticulous, patient and tenacious observation" and perceptively compared it to the work of "the primitives."[53]

Lemmen's conté crayon drawing of his friend Jan Toorop (see plate 12), was inspired by such works of Seurat as his portraits of Paul Alexis and Edmond-François Aman-Jean.

Fig. 19. Georges Lemmen (Belgian, 1865–1916), *Young Woman Crocheting* (*Jeune femme faisant du crochet*) (Julie Lemmen), 1890–91. Oil on canvas, 18½ × 15 in. (47 × 38 cm). Private collection.

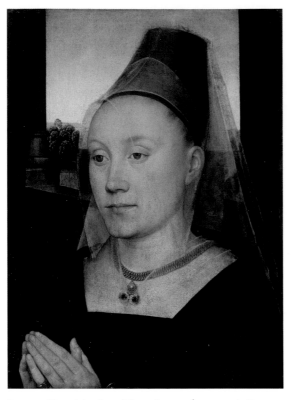

Fig. 20. Hans Memling (Flemish, 1425/40–1494), *Portrait of Barbara Van Vlaenderberch Moreel,* c. 1482. Oil on wood, 15⅜ × 11¾ × ¼ in. (39 × 29.7 × 0.7 cm). Musées royaux des Beaux-Arts de Belgique, Brussels.

Toorop, caught in a moment of relaxation, smokes his pipe and reads the newspaper. Lemmen explores the contrast of dark and light, and an overall patterning of strokes that enliven the surface. Calling it "nearly a work of improvisation," Verhaeren praised Lemmen's "amazing talent and lively mastery of drawing, which can only lead to (continued) slow and steadfast study."[54]

Finally, Lemmen sent an *intimiste* composition in oil, *Bourgeois Interior* (now lost), and two studies for it. Although ultimately derived from Seurat's conté crayon drawings, the figures in one of Lemmen's studies remain distinct, recognizable individuals where attention is lavished on their unique features and, in this instance, on the simple objects gathered on the table (see plate 14). This sumptuously textured work creates a sense of intimacy and ritual that transcends the ordinariness of the domestic scene.

The following year, 1892, Lemmen returned to Les XX as a master of Neo-Impressionism, exhibiting his major figural composition, *Carnival* (*Fête foraine*), as well as two portraits and a landscape.[55] His portrait of Verhaeren (see plate 15) captures his friend in a moment of Symbolist meditation, his head inclined and eyes shut. Although we can discern the corner of the room and floorboard, all concentration is on the poet's cerebral musings. The border and frame—a rare survival of a Neo-Impressionist original—serve to add a sense of compression, emphasizing the poet's thought. The darkened aureole around Verhaeren's inclined head, further isolated by his white collar, creates an ambiance of consecration and veneration, in effect paying homage to a literary saint of Symbolism.

In his second portrait shown in 1892, Lemmen sought to capture the femininity of his future wife, Aline Maréchal (see plate 17). By posing her with supplicant's hands and modest gaze while concentrating on the roundness of her face, abdomen, and the curve of her neck and back, he renders her as a secularized Madonna. The fullness of her form is repeated by the arched curve of the surviving original frame. Coupled with the muted still life of the vessel on the étagère, the composition evokes images by the Flemish master Roger Campin. When the work was shown at Les XX, critics compared it to Seurat's *Young Woman Powdering Herself* and parodied both portraits (fig. 21). Although neither figure

could be accused of anorexia, one critic was still so confounded by the Neo-Impressionist style that he showed each as emaciated, Maréchal's supposed exaggerated neck the result of an attempted suicide by hanging and Knoblock's features not to be improved no matter how much Socialist rouge she applied.

Later in the spring, Lemmen was able to add yet another Neo-Impressionist portrait to his submissions to the Association pour l'art in Antwerp. A remarkable record of most of this group is preserved in a documentary photograph (fig. 22). Between *Carnival* and the portraits of Toorop and Verhaeren is a new portrait of Julie (see plate 20).[56] In contrast to the portrait painted a year earlier, the subject is now Julie herself rather than her activity. In this slightly smaller painting there is a greater indication of setting: the chair on which Julie sits is more prominent, while the billowing folds at the right suggest a curtain. By regularizing the brushstroke and muting the colors, the artist presents a greater sense of gravity and psychological penetration to this later portrayal of his sister.

Although Lemmen created a number of Neo-Impressionist landscapes and marine-scapes in the next few years, while turning his attention to the book arts as well, he painted no oil portraits for several years. He did create a remarkable conté crayon portrait of the dancer Loïe Fuller as she emerges from a dark background as a source of light and movement (see plate 21). Lemmen captured Fuller not by recording her individual physiognomy

Fig. 21. "Exposition des XX," in *Le Patriote illustré* (detail), February 21, 1892. Bibliothèque royale de Belgique, Brussels.

Fig. 22. Partial view of Georges Lemmen's works shown at the Antwerp Association pour l'art, 1892. Photograph. Archives et Musée de la littérature, FSC 157/10, Bibliothèque royale de Belgique, Brussels.

but by interpreting her signature dance, evoking the essence of this original performer as she swirls through the air.[57]

In 1894, Lemmen returned to a full-scale oil portrait that is one of his most extraordinary works—a double portrait capturing two of the three daughters of Edmond and Marie Serruys (see plate 24). Lemmen places eight-year-old Jenny and twelve-year-old Berthe in a rich but abbreviated interior setting. The children wear matching dresses, underlining their close bond. Not a sentimentalized image of childhood, it reflects Lemmen's deep empathy for his young subjects. The work combines fully realized portrayals of the two, their haunting stares replete with Symbolist overtones, with a still life and tablecloth worthy of Van Eyck, brilliantly executed with pointillist precision, and melded into an abstracted and decorative yet deeply expressive whole.

Lemmen moved away from Neo-Impressionism in the fall of 1894. As he complained some years later to Willy Finch, "It seems to me that a too strict observance of principles removes all emotion, all fever, all passion from the works." While we might argue that Lemmen's portraits contain generous amounts of implied emotion and fever, the shadow of Seurat had proved to be too much for the sensitive artist. "It's not the method which displeases me in Neo-Impressionism, but rather that no one but Seurat knew how to dominate and tame it, to make it *his thing,* in short, so that the *craft* is forgotten entirely, and disappears before the personality."[58]

Fig. 23. Théo van Rysselberghe's entries for the Antwerp Association pour l'art, 1892. Photograph. Archives et Musée de la littérature, FSC 11/18, Bibliothèque royale de Belgique, Brussels.

THÉO VAN RYSSELBERGHE

Van Rysselberghe was a committed portraitist before he turned to Neo-Impressionism. His early role model was James McNeill Whistler, whose highly aestheticized portraits, with their geometric backdrops and their explorations of the subtleties of black, were shown at Les XX in 1884, 1886, and 1888.[59] Van Rysselberghe's two portraits of 1886 showing the Van Mons sisters, Marguerite and Camille, are particularly Whistlerian.[60]

In 1885, Van Rysselberghe wrote to Octave Maus that, because he had no commissions and no money to pay his models, he was doing portraits of his friends and family.[61] By 1895 his situation had changed so drastically that commissioned portraits provided him with a dependable source of income. Portraiture became so central to Van Rysselberghe that at Les XX in 1886 he exhibited eight portraits out of his eleven submissions. By 1892 he was so at ease with the application of the pointillist technique to his subjects that his only entries—all of them Neo-Impressionist—appeared under the single label "Portraits."[62] A documentary photograph taken in Antwerp at the exhibition of the Association pour l'art two months later shows that his entries consisted of five portraits: four oils and a pointillist drawing (fig. 23).

Van Rysselberghe's fame spread to Germany partly through the good graces of Henry van de Velde, who had clients in Berlin by 1897. The following year Van Rysselberghe exhibited at the Keller & Reiner gallery, newly remodeled by Van de Velde. In 1899 and 1900 he

had successful showings at the Vienna Secession. By then Van Rysselberghe had established himself as the leading Neo-Impressionist portraitist, partly through his success with the genre and partly because he was one of the few who remained true to the style. This dichotomy is revealed in an encounter with a potential German client who, wanting to commission the fashionable artist, did not want to be rendered in the unfashionable style. Rebuffing the request, Van Rysselberghe informed Van de Velde, "I politely told him to fly a kite. Nothing irritates me more when these big shots tell me, 'I really love what you do, but make me something else.'"[63] In fact, Van Rysselberghe was so successful as a portraitist that he confessed to Signac that he feared being limited by this classification.[64] The resulting fees, of course, allowed him the freedom to take on such major projects as *Sunset* (*L'Heure embrasée*), begun in 1896.

In 1899, when Signac and other Neo-Impressionists exhibited at the Parisian gallery Durand-Ruel, Van Rysselberghe's three submissions were all portraits.[65] Signac, seeming to resent Van Rysselberghe's facility with portraiture, recorded in his diary, "All the success of our room is due to Théo." Criticizing their popularity—"He has made all the concessions required for that"—Signac concluded: "His portraits are eminently graceful; they could be signed by any painter of the Champ-de-Mars."[66] Signac's major concern was Van Rysselberghe's abandonment of the strict principles of contrast and division, his gradual retreat from Neo-Impressionism.[67]

While Lemmen's portraits probe their subjects' inner life, Van Rysselberghe's portraits accentuate beautiful surfaces and palpable presences. In reminiscences published in 1938, Van Rysselberghe's wife, Maria, provided insight into her husband's psyche: "Théo had no hidden agenda, he was always transparent."[68] She recalled that "there was a sort of incompatibility between his gifts of spirit, bursts of enthusiasm, and spontaneity; and his need for perfection and the complete materialization that his personality imposed on his ideal."[69] Perhaps this need to check his expressive impulses explained Van Rysselberghe's attraction to Seurat's method, as Maria further suggested: "Wasn't it to the tyrannical method of Neo-Impressionism, which satisfied his need for rigor all the while containing it, that he owed some of his best paintings?"[70]

Yet this natural attraction was not the result of an inherently theoretical mind. In 1894, Van Rysselberghe confessed to Signac that he was incapable of theorizing like Signac and attributed this to his more instinctive temperament. The only solution Van Rysselberghe saw was to "work, work always, which was for me the best school; reflection seems to me to come through working, and does so more surely."[71] Van Rysselberghe admitted, albeit much later, that his desire to portray those close to him was because "my models impassion me the more I get to know them—and I spend my life digging always further in this knowledge of the study of familiar figures."[72]

Although Van Rysselberghe's work shows some chronological progression, especially regarding his palette, he consistently approached his subjects according to personal preferences; that is, his portraits can be better understood by grouping them according to gender and number of sitters rather than by date.

Portraits of Women

Van Rysselberghe's first Neo-Impressionist oil portraits were female subjects, and by 1904 he had depicted over two dozen women, considerably more than male subjects. According to the artist's wife, "Théo loved the company of women, whom he shielded with tender protection; not only did he capture their charm and their finery, but he loved them for their inherent qualities and their nature."[73]

Van Rysselberghe painted his first two Neo-Impressionist portraits in order to exhibit them in April 1889 at Les XX. Both sitters—Alice Sèthe and Madame Edmond Picard—were among the artist's intimates. Alice married the Vingtiste sculptor Paul Dubois while her portrait was on view (see plate 46); Adèle Olin Picard was the spouse of Edmond Picard, one of the principal defenders of *L'Art moderne* and a leading art patron. The latter work, now lost, was, according to the press at the time, an "irradiated portrait" in which "the laws of divided color were completely observed."[74] Both were full-length portraits; in fact, *Madame Picard* was referred to as "the pendant," as if they were a pair.[75] The most complete description of the work, published by Octave Maus in a Parisian review, described the model, shown at home surrounded with expensive furniture, sculptures, and paintings, as wearing a black dress of mourning and carrying her miniature toy terrier in her arms.[76] However, *Alice Sèthe* received the majority of praise, extolled by one critic as "the most complete work on view,"[77] while another described the subject as "a young blond girl, entirely blond, charming, marvelously dressed, with fine and delicate tones, fresh and young."[78] The painting was the triumph of the exhibition, its academic pose and composition ameliorating its expression in the new radical manner.

By the following year, 1890—when Van Rysselberghe's full-length portrait of his niece, *Little Denise* (*La Petite Denise;* fig. 24), and the conté crayon pointillist drawing of three young women sitting around a table now known as *Interior, Evening* (see plate 47) were displayed at Les XX—critic Eugène Demolder declared, "Monsieur Van Rysselberghe will become our best portraitist."[79] In *Little Denise,* Van Rysselberghe eliminated the academic conventions present in *Alice Sèthe.* Recalling Whistlerian geometry, he reduced the interior elements to a minimum and framed his diminutive subject leaning against a wall. Her horizontal belt, the roller of the kakemono print, and the

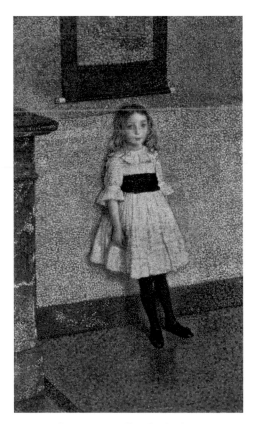

Fig. 24. Théo van Rysselberghe (Belgian, 1862–1926), *Little Denise* (*La Petite Denise*), 1889. Oil on canvas, 40⅛ × 23⅝ in. (102 × 60 cm). Private collection.

wainscoting of the floor provide horizontal anchors, contrasting with the vertical elements of the console and her own figure.

The next year at Les XX, 1891, in addition to a major figural composition, *In July, Before Noon* (see plate 48), Van Rysselberghe showed the portrait of Madame Charles Maus, née Victoire Dutreux (1820–1905; fig. 25). The mother of Octave Maus, Mme Maus is firmly aware of her place in society as the wife of a councilor to the court of appeals in Brussels. As with Alice Sèthe, she is shown amid her bourgeois possessions, but now they appear in a highly simplified and flattened manner that will be the prototype for many future portraits.

For Les XX of 1892, Van Rysselberghe submitted both *Maria Sèthe at the Harmonium* (see plate 51) and a full-length portrait of his wife, Maria, which he also showed at the Paris Independents in the same year and at the Antwerp Association pour l'art (visible in fig. 23). Posed before a bouquet of flowers and framed by two of her husband's works, Maria Van Rysselberghe has momentarily stopped walking, as indicated by her right foot extending from beneath her dress.

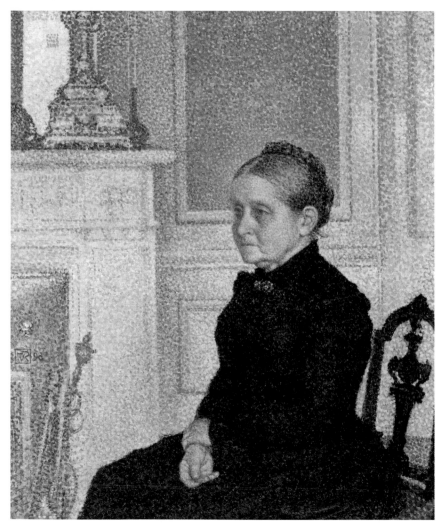

Fig. 25. Théo van Rysselberghe (Belgian, 1862–1926), *Portrait of Madame Charles Maus,* 1890. Oil on canvas, 22 × 18½ in. (56 × 47 cm). Musées royaux des Beaux-Arts de Belgique, Brussels.

The popular success of Alice Sèthe's portrait encouraged the family to return to Van Rysselberghe two years later to depict the eldest sister, Maria. The girls were raised in an haute bourgeoise household of wide-ranging musical and artistic sensibilities. Seated at her harmonium, Maria has paused for a moment and turned to the left in a state of contemplation. The swirling pattern of the wall covering, the tassel, cello scroll, as well as the folds in her sumptuous lilac dress are the painterly equivalent of musical phrases. The presence of the cello and the framed artwork on the wall, also attest to the cultural attainment of Maria.

Another full-length portrait of a female subject, the painter Anna Boch (1848–1936), was completed by March 1892, when it was shown at the Independents (see plate 53). Caught up by Seurat's work shown at Les XX and under the influence of Van Rysselberghe, Boch herself painted briefly in the pointillist style. Placed in her atelier actively engaged in creative work, Boch holds her palette and brush while contemplating a canvas out of the viewer's sight. Like its predecessors among Van Rysselberghe's portraits, it reveals much about the sitter through the inclusion of details of architecture and cultural possessions, expressed in an abstract, simplified geometry, shallow space, and skillful application of Neo-Impressionist technique.

Van Rysselberghe painted a third Sèthe daughter, Irma, in 1894 at the height of his interest in Neo-Impressionism. The thousands of rigorously applied dots faithfully follow Seurat's tenets. A violin virtuoso on the brink of an international career, Irma is shown in the act of playing. The standing, active Irma is counterbalanced by a seated passive listener partially visible in the adjoining room. This dichotomy is strengthened pictorially through Neo-Impressionist color oppositions: the pinks and greens that define Irma's world contrast with the lavenders and oranges of the auditor's space. Van Rysselberghe was enthusiastic about this portrait, as he explained to Signac: "I am working like a crazy person. I have begun a new interesting portrait: a young violinist, very decorative with graceful and supple gestures, wearing a full exquisite pink dress, pearly blond skin tones."[80]

Signac took great pleasure in the work, noting in his diary, "From Van Rysselberghe, a delicious portrait of Mlle Sèthe."[81] Camille Pissarro, as might be expected from the rigorous application of Neo-Impressionist technique, complained to his son Lucien that Van Rysselberghe "had lost all sense of the unexpected, it is much too cold and systematic."[82] Van Rysselberghe himself so highly prized the portraits of the Sèthe daughters that he sent all three to the prestigious Vienna Secession in 1899.[83]

Portraits of Men

Van Rysselberghe executed fewer Neo-Impressionist oil portraits of men than women and began capturing his male sitters fully four years after his first female Neo-Impressionist portrait of Alice Sèthe in 1888. He followed the 1892 portrait of Verhaeren (see plate 52) with portraits of Auguste Descamps, Michel Van Mons, and, in 1893–94, that of Auguste Weber. After this time only two divisionist oil portraits of men have come to light: *Paul Signac*

at the Helm of Olympia (Paul Signac à la barre de l'Olympe, 1896) and the portrait of architect Louis Bonnier (1903).

The two seated portraits, of *Auguste Weber* (see plate 55) and *Auguste Descamps,* were influenced by the revival of interest in the works of Frans Hals earlier in the nineteenth century. Van Rysselberghe was drawn to the spontaneity of Hals's poses seen in the *Portrait of W. Van Heythuysen* (fig. 26), an informality reflected in both sitters' relaxed poses.[84] Historians have linked scholarship by Théophile Thoré to the creation of the Frans Hals Museum in Haarlem, Holland, in July 1862. Van Rysselberghe, who visited the museum in August 1883 and August 1885, praised Hals as a modern painter belonging to our time, and urged readers of *L'Art moderne* to visit the museum.[85]

The portrait of Auguste Descamps, the uncle of the painter's wife, was exhibited at Les XX and the Paris Independents in 1892.[86] Unlike the more elaborate settings for his female figures, this one is quite barren except for a detail of the chair on which the sitter rests his arm. The half-length portrait *Auguste Weber,* although shown in an undefined space, is more descriptive, including two chairs and an artwork. Unlike Descamps's portrait, Dr. Weber's was not exhibited and undoubtedly went directly into the client's collection. For this private commission the artist was not concerned with revealing the sitter's distinguished medical career, concentrating instead on his kindly countenance.

Van Rysselberghe's only full-length Neo-Impressionist male portrait shows Michel van Mons (1818–1906), Verhaeren's uncle (fig. 27). The scale and pose suggest that the painting was commissioned by Van Mons. Unlike the full-length portrait of Maria van Rysselberghe, there is very little indication of setting. Surrounded by a dark pointillist inner frame that is wider at the bottom than the sides, the painting in effect places Van Mons on a pedestal, reinforcing his dignified stance.[87] Van Rysselberghe reported to Signac that Van Mons had specifically requested such a setting: "He is the first bourgeois who asked that I make a frame for his portrait, a simple flat

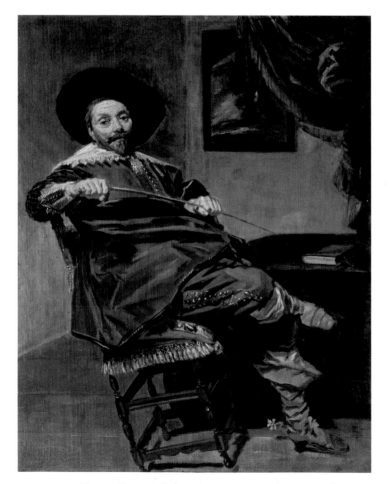

Fig. 26. Frans Hals (Dutch, c. 1580–1666), *Portrait of W. Van Heythuysen.* Oil on wood, 18¼ × 14¾ in. (46.5 × 37.5 cm). Musées royaux des Beaux-Arts de Belgique, Brussels.

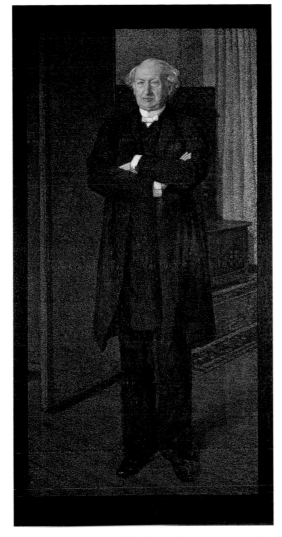

Fig. 27. Théo van Rysselberghe (Belgian, 1862–1926), *Portrait of Michel van Mons*, 1892. Oil on canvas, 79½ × 39⅜ in. (202 × 100 cm). Private collection.

band of dark colors;—his eye is used to the atelier and he declares that it is more harmonious, more beautiful than those with gold or plaster."[88]

Unlike the portraits of Weber, Descamps, and Van Mons, which have undefined contexts, the portrait of Verhaeren is site specific—the inner sanctum of the poet. Verhaeren, working at night, gazes at the viewer with a vaguely startled look. His face is strongly lit, making him seem otherworldly and spectral, while his illuminated head and hands call attention to his intellect and his creative works. Maria van Rysselberghe's memories of Verhaeren could serve as a description of her husband's portrait: "His total spiritual being, summoned up, was revealed in a single moment, visible and radiant."[89] Showing Verhaeren in the act of artistic inspiration and activity, the tone of this work differs from the more contemplative mood set by Georges Lemmen's nearly beatific portrait of the year before (see plate 15).

Paul Signac at the Helm of Olympia (fig. 28) is a pictorial homage to the friendship of Van Rysselberghe and Signac. The painting commemorates the voyage aboard Signac's sailboat, which the two artists made from Bordeaux to the Mediterranean Sea in 1892 and reflects their mutual love for the coastal village of Saint-Tropez, where in 1896 the Van Rysselberghes visited Signac.[90] The artist immortalized his friend not in the act of painting but as captain of his sailboat. The heroic presentation evokes Signac's pivotal role as leader of the Neo-Impressionist movement, charting the uncertain course of its practitioners after the death of Seurat. Ironically the painting reveals Van Rysselberghe moving away from the rigors of the technique. The water is no longer painted in dots, and the dots that exist vary in size and are larger than those employed in his earlier portraits. Although it is a stylistic leap from David's public, emblematic rendering of Bonaparte's exploits (see fig. 1) to Van Rysselberghe's private homage to Signac, the approach to portraiture is similar: an active celebration of their qualities of leadership. Van Rysselberghe

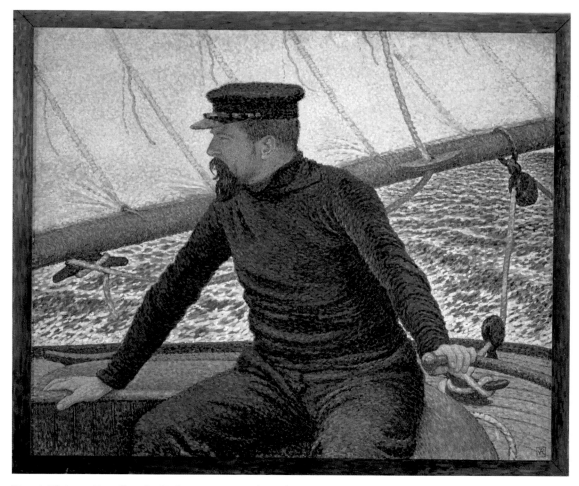

Fig. 28. Théo van Rysselberghe (Belgian, 1862–1926), *Paul Signac at the Helm of Olympia* (*Paul Signac à la barre de l'Olympe*), 1896. Oil on canvas, 36¼ × 44⅝ in. (92.2 × 113.5 cm). Private collection.

presented the painting to Signac in Brussels in November 1897, and Signac kept it among his most treasured possessions.[91]

Van Rysselberghe characteristically provided sparser settings for his male sitters, save Verhaeren in his study and Signac on his sailboat, than for females. Perhaps the artist deemed these as unnecessary and superfluous because the audience would automatically assume significant social standing for the men, while the women required an enhanced setting to fulfill the viewer's and their own societal roles and expectations. Or perhaps he took more pleasure in painting them. Whatever the reason, there is a noticeable difference in Van Rysselberghe's approach to male and female subjects.

Group Portraits

In the mid-1890s, Van Rysselberghe began working, with some relief, on the large canvas of bathers called *Sunset*. As he wrote to Signac in 1895, he was becoming too dependent on the portrait niche: "I am happy, my old dear friend, truly happy to leave my narrow shell, for I am afraid of where the 'specialty' of the portrait might take me."[92] His solution regarding commissions was to expand the scope of his portraiture to include groupings of people, often engaged in some activity, yet still described as individuals.

Van Rysselberghe had tried such a composition once before. Among his Neo-Impressionist portraits created between 1888 and 1895 is a single work containing more than one figure, *In July, Before Noon* (see plate 48). Painted in 1890, the large canvas shows four of the artist's close acquaintances, including his young wife, Maria, and Maria Sèthe, enjoying a summer's day at his mother-in-law's retreat at Thuin. A recently discovered photograph depicts the artist painting the group portrait outdoors while the sitters pose for him (fig. 29). However, the photographic version differs from the surviving canvas; among other things, it shows Maria Sèthe leaning against a tree as opposed to being seated.[93] Recalling the numerous small intimiste scenes of evening activities rendered in conté crayon by Van Rysselberghe and Lemmen (see plates 47 and 14), it differs from them in being a large-scale oil painting. As successful as this painting was, Van Rysselberghe did not return to the idea of a large composition of multiple portraits for several years.

Part of the challenge in turning to bigger works involved Neo-Impressionism itself, a complaint Van Rysselberghe voiced to Signac as early as August 1892. While assuring Signac that "there is too much logic in our art [Neo-Impressionism] for it not to survive," he explained that "the goal will be, I believe, to enlarge our technique to be able to cover large surfaces without the apparatus of the craft being too noticeable and confusing. Think of the *Poseuses* of poor Seurat. A year and what slave labor! It's too much." Van Rysselberghe concluded that a new dichotomy was now required: "For smaller works, I consider our

Fig. 29. Unknown photographer, Théo van Rysselberghe painting *En juillet, avant-midi,* c. 1890. Photograph. Private collection.

technique complete; all can be accomplished in a relatively short time. But with a large work it becomes atrociously complicated!"[94] He finally resolved that a less rigorous application of divided color was called for in tackling large-scale works.

Following the success of *Sunset,* Van Rysselberghe began a series of multifigured portraits, almost all of them women, including his wife and daughter (1899), the three Guinotte daughters (1901; see plate 58), three women at tea (1901), and Maria van de Velde and her three children (1903). One of the most inventive of this series, *The Promenade* (1901; see plate 59), shows four women strolling on the beach at Ambleteuse on the English Channel. In this large canvas, measuring some three by four feet (97 × 120 cm), Van Rysselberghe used broad strokes instead of small dots of color, and produced an overall tonality of blue and pink interspersed with contrasting colors of violet, green, and orange. Each person held a personal significance for the painter: the poet Marie Closset; Madame Victor Willem, wife of a well-known scientist; the artist's wife, Maria; and Laure Flé, an accomplished singer and pianist.

The culmination of Van Rysselberghe's Neo-Impressionist portraits and the largest group portrait of his career (approximately six by eight feet) is *A Reading* (*Une Lecture,* 1903; see plate 60), in which he depicted eight of his closest friends, including the celebrated poet Émile Verhaeren, who reads aloud to an all-male group of auditors. Although we can recognize details from Verhaeren's study at Saint-Cloud, near Paris, the work reflects, in great measure, the Monday literary and artistic gatherings held at the Van Rysselberghes' Paris apartment. The eight figures drawn from science, literature, and art are painted in a loose Neo-Impressionist manner with large strokes of color.

A Reading stands alone among Van Rysselberghe's work in terms of its ambition and scale. His one contemporary work with which it can be compared, *A Reading in the Garden* (see fig. 12), while sharing its narrative of public recitation, is not a group portrait. Late in 1902 the artist prepared a mural composition for Victor Horta's recently completed Hôtel Solvay, a work whose function was architectural decoration, not portraiture.[95] The enormous canvas measures roughly 10½ × 14½ feet. This reading occurs not in a compressed, hermetic interior but in a garden, where a group of women more akin to classical sculpture than to flesh-and-blood people stroll. There are no men. Although we can identify several figures in the work, *who* is being depicted is not as important as *what* is being shown: the act of listening itself.[96] As if to underscore the two important components of communication—speaking and listening—the reader's gesticulation is answered by one of the auditors, who points to her ear. For his portrait of Verhaeren and his circle, Van Rysselberghe wanted to demonstrate that the individuals assembled for the occasion were as important as the message.[97]

Painted some sixteen years after the introduction of the revolutionary work of Georges Seurat into Brussels, which Van Rysselberghe himself had further developed through a series of several dozen Neo-Impressionist portraits and group portraits, *A Reading* is his final work of this type. This grand canvas is the fitting climax—if not the swansong—of the Belgian pointillist movement.

Conclusion

The portraits created between 1886 and 1904 in the Neo-Impressionist style in France and Belgium, reflecting each artist's psyche and proclivities, reveal the range of possibilities of Neo-Impressionism and its application to portraiture. The French Neo-Impressionists responded to the abstract and decorative qualities inherent in Seurat's style. Although Dubois-Pillet was the first to couple the Neo-Impressionist style with portraiture, Seurat tested this combination with *Young Woman Powdering Herself,* turning the portrait of an individual into a near abstraction and an ironic parody. Signac relished the geometric and reductivist tendencies in the Neo-Impressionist method and allied it to the freshness of the Fayum portrait effigies of ancient Egypt. He even briefly adopted the encaustic technique of these effigies and distilled the essence of the individual depicted into a universal statement. Laugé's interest in the abstraction of form and the geometry of his settings owes much to Signac. To Luce goes the inventive combination of Neo-Impressionist portraiture with genre painting imbued with social and political overtones.

Among the Belgians, Van de Velde, Lemmen, and Van Rysselberghe each made important contributions to Neo-Impressionist portraiture, eschewing the model of the effigy in favor of other sources. Van de Velde used the method to depict a stratum of society that illustrated his social philosophy. Lemmen focused his attention on the internalized world of the sitter. Van Rysselberghe explored the cultural milieu of his subjects. Perhaps the difference in mood between a portrait by Lemmen and one by Van Rysselberghe can be further explained by the emulation of different artistic models: Van Rysselberghe was attracted to such exuberant seventeenth-century masters as Frans Hals and Peter Paul Rubens, whereas Lemmen's interests lay in the more sober work of Jan Van Eyck and Hans Memling. French artists such as Petitjean and Cross looked to Lemmen and Van Rysselberghe for a more naturalistic melding of Pointillism with portraiture. However, the majority of the French Neo-Impressionists favored a purer distillation of the method than the Belgians. Lemmen and Van Rysselberghe, steeped in a Flemish realist portrait tradition, upheld the depiction of the individual as paramount even while responding to the decorative qualities of the technique.

Among the Neo-Impressionists only Signac and Van Rysselberghe soldiered on into the twentieth century, with Van Rysselberghe finally abandoning the style around 1904, seeking freedom from its perceived tyranny, as so many before him had. Yet by then Van Rysselberghe and his Belgian colleagues had explored and developed Neo-Impressionist portraiture in a new light, amplifying the contributions of their French counterparts. A century after the last of these works, during which portraiture has continued to engage the contemporary artist—from Picabia to Picasso, and from Andy Warhol to Chuck Close— the Neo-Impressionists still have much to teach us about the place of the individual in the modern world.

Notes

1. In 1883, Jules Laforgue argued that the Impressionists had rid themselves of academic tradition in order to develop better their primitive eye—or a superior way of seeing and capturing their impressions. See Jules Laforgue, "L'Impressionnisme," in *Oeuvres complètes,* (Lausanne: Éditions l'Âge d'Homme, 2000), 3: 329–36.

2. Letter from Camille Pissarro to Lucien, March 15, 1883, Bailly-Herzberg, *Correspondance de Camille Pissarro,* 1: 183. Other letters followed throughout 1883, urging Lucien to look at the works of Egyptian sculptors, for example, July 8, 1883, 229.

3. For a discussion of the concept of Primitivism and the idea of "cultural superiority," see Robert Goldwater, *Primitivism in Modern Art,* rev. ed. (New York: Vintage, 1986).

4. Bailly-Herzberg, *Correspondance de Camille Pissarro,* vol. 1, December 9, 1883, 259. John Rewald, ed., *Camille Pissarro: Lettres à son fils Lucien* (Paris: Éditions Albin Michel, 1950), 109, July 30, 1886. Pissarro was referring to his painting *Vue de ma fenêtre par temps gris.* "It appears that the subject did not sell because of the red roof and farm yard, exactly what gives all the character to this canvas, which has a *modern primitive stamp.*" Of course the Neo-Impressionist interest in the "primitive" matched Paul Gauguin's and Vincent van Gogh's similar interests.

5. Martha Ward made the Neo-Impressionists' connection between Primitivism and awkwardness in *Pissarro, Neo-Impressionism, and the Spaces of the Avant-Garde,* 64–87.

6. Herbert, *Neo-Impressionism* (1968), 72. More recently, Neo-Impressionist portraits have received increasing attention. See Ferretti Bocquillon, *Le Néo-impressionnisme: De Seurat à Paul Klee* and *Radiance: The Neo-Impressionists.*

7. "Elle (cette abstention) autorise les sots à dire: les 'petits points' ça va pour les paysages; mais ça ne peut pas aller pour les figures." Thus a disgusted Signac confided to Van Rysselberghe concerning the 1904 Libre Esthétique exhibition organized by Octave Maus in Brussels. The "Exhibition of Impressionist Painters" (February 25–March 29) included seven works of Georges Seurat, but Maus chose only to exhibit Seurat's seascapes. These were *La Rade de Grandcamp; Le Bec du Hoc, Grandcamp; L'Hospice et le phare d'Honfleur; Bords de la Seine, île de la Grande Jatte; Temps gris, île de la Grande Jatte; Le Chenal de Gravelines, direction de la mer;* and *Le Chenal de Gravelines, un soir.* The latter painting was owned by Van Rysselberghe. Letter sold at public auction at Fontainebleau, February 21, 1988, no. 24, "Très important ensemble de dessins, aquarelles, gouaches et pastels Néo-impressionnistes." Maître Jean-Pierre Osenat, purchased by the Getty Research Institute.

8. "C'est une sottise et une faiblesse de n'avoir présenté au public que le Seurat paysagiste, et d'avoir escamoté le Seurat, peintre de figures, et décorateur. Il est un des rares peintres modernes dont les figures aient atteint au style—et seules les grandes oeuvres de Seurat peuvent renseigner sur son apport à l'Art Contemporain. Il ne tenait lui même ses marines et ses paysages que comme des exercices et se réclamait de ses compositions." Paul Signac to Théo van Rysselberghe, ibid.

9. C.f. Octave Maus, "Les Vingtistes parisiens," *L'Art moderne,* June 27, 1886, 204. Robert Herbert has emphasized Seurat's collection of popular broadsides, which display unusual proportions and a certain rigidity of poses; Herbert, *Georges Seurat, 1859–1891* (New York: Abrams, 1991), 175.

10. Anthea Callen, "Hors-d'oeuvre: Edges, Boundaries, and Marginality, with Particular Reference to Seurat's Drawings," in Smith, *Seurat Re-Viewed,* 31.

11. The portraits of Signac and the critic Paul Alexis were most probably executed for publication in two reviews: the former for a piece by Félix Fénéon on Signac published in *Les Hommes d'aujourd'hui,* May 1890, no. 373, and the latter for *La Vie moderne* of June 17, 1888. The conté crayons of Signac and Alexis were first exhibited at the Independents in 1890.

12. Unlike the Aman-Jean portrait, however, it was rejected. For a reproduction, see Jodi Hauptman, *Georges Seurat: The Drawings* (New York: Museum of Modern Art, 2007), 77.

13. For a fuller account, see Herbert, *Georges Seurat,* 333–36.

14. Félix Fénéon, "Le Néo-Impressionnisme," in *Oeuvres plus que complètes,* 1: 75. This was originally published in *L'Art moderne,* May 1, 1887, 140. Although Dubois-Pillet exhibited two portraits at the Independents in 1886, it has not been possible to identify them, hence to know how pointillist they might have been. It is more likely that 1887 marked the creation of Dubois-Pillet's first divisionist portraits.

15. Fénéon, "L'Impressionnisme," *Oeuvres plus que complètes,* 1: 67. The article originally appeared in *L'Émancipation sociale,* April 3, 1887.

16. "Ses effigies,—les féminines surtout, vivent. Une subtile joie polychrome se difflue en arabesques sur les fonds." Fénéon, "Le Néo-impressionnisme," *Oeuvres plus que complètes,* 1: 75.

17. My thanks to Claire Maingon for answering my queries about Dubois-Pillet. Along with Patrick Offenstadt, Maingon is preparing a catalogue raisonné on the artist.

18. See Marina Ferretti Bocquillon's convincing interpretations of *La Salle à manger* and *Un Dimanche* in *Signac, 1863–1935* (Paris: Réunion des musées nationaux, 2001), 165–68, 190–97.

19. There is also a fifth portrait if one considers the small oil study of Berthe, *Femme lisant* (1887); see *Signac, 1863–1935*, 164.

20. See Signac (2000), *Étude Asnières (Charles Torquet vu de dos)*, 1883, no. 31, 152. *Mon grand-père. Jardin*, 1884, no. 81, 163.

21. The portrait has been decoded by Ferretti Bocquillon in *Signac* (2001), 202–5.

22. Charles Henry, *Application de nouveaux instruments de précision (cercle chromatique, rapporteur et triple-décimètre esthétiques) à l'archéologie* (Paris: Leroux, 1890) and *L'Ésthétique des formes,* a four-part article appearing in *La Revue Blanche* in August (118–29), October (308–22), and December (511–25) 1894 and February (116–20) 1895.

23. Félix Fénéon, "Signac," *Les Hommes d'aujourd'hui,* 1890, no. 373.

24. "Une biographie peinte," letter from Signac to Fénéon, June 18, 1890, Bibliothèque centrale des musées nationaux, Paris, no. 408; also cited in Ferretti Bocquillon, *Signac* (2001), 205n9.

25. Fénéon to Signac, end of July 1890, Signac Archive, Paris.

26. See n. 16. By 1948, Bernard Berenson regarded the term "effigy" negatively when compared with "portrait." For Berenson, Rembrandt painted portraits because he depicted the individual, whereas John Singer Sargent and Léon Bonnat painted effigies, or the "social aspects of the subject." See Berenson, *Aesthetics and History in the Visual Arts* (New York: Pantheon, 1948), 199–200.

27. *Larousse du XXème siècle* (Paris: Larousse, 1930), 3: 65: The 1835 Dictionary of the French Academy defines the term in the same way and adds briefly, "Figure, representation of a person, be it in relief or in painting." *Dictionnaire de l'Académie française,* 6th ed. (Paris: Imprimerie et Librairie de Firmin Didot Frères, 1835), 1: 611.

28. Henry Cros and Charles Henry, *L'encaustique et les autres procédés de peinture chez les anciens* (Paris: J. Rouam, 1884).

29. Félix Fénéon, "Portraits antiques," *Oeuvres plus que complètes,* 1, 160–61; first published in *La Vogue,* July 1889.

30. "La couleur sèche trop vite: il faut en effet chauffer le pinceau presque à chaque touche et c'est horriblement fatiguant." Van Rysselberghe to Signac, [1892], Signac Archive, Paris.

31. Exposition des Peintres Néo-Impressionnistes was held at the Hôtel Brébant. The painting is also inscribed, bottom right, "Op. 235."

32. A contemporary photograph reveals the liberties Signac took pursuing an art free from the constraints of pictorial illusion; reproduced in Marina Ferretti Bocquillon's entry on the work in *Signac, 1863–1935* (Paris: Réunion des musées nationaux, 2001), 237, fig. 2.

33. See appendix.

34. For a reproduction of *Aunt Octavie,* see Denise Bazetoux, *Maximilien Luce Catalogue de l'oeuvre peint* (Paris: Éditions JBL, 1986), 2: 7, no. 4, and for the portrait of Félix Fénéon, 184, no. 730.

35. For more on anarcho-communism and the ideas of its proponents, Peter Kropotkin and Elisée Reclus, see Herbert, *Artist and Social Reform;* Hutton, *Neo-Impressionism and the Search for Solid Ground,* esp. chapter 2; and Roslak, *Neo-Impressionism and Anarchism in Fin-de-Siècle France.* Although it might be supposed that an anarcho-communist philosophy would be less concerned with the individual, leaders of the movement, including Jean Grave, Kropotkin, and Reclus, championed the role of the individual in the utopian state as a means of achieving social change.

36. There are approximately eight Neo-Impressionist portraits that precede those of Cross; see appendix and Bazetoux, *Maximilien Luce,* vol. 2 (Paris: Éditions JBL, 1986).

37. Compin, *Henri Edmond Cross, Excursion,* 135, no. 45, and *Nocturne,* 146, no. 56.

38. For an illustration, see ibid., 180, no. 88.

39. In 1894, the first year of La Libre Esthétique, the successor to Les XX, four portraits were shown by Belgians as compared to one by a French artist.

40. The Van de Velde portrait was exhibited at Les XX as *Laurent V. de V,* no. 6.

41. For illustrations, see Canning, *Paintings and Drawings* (1987), 103 and 113.

42. "Van de Velde ne peint plus. Il ornemente et conférencie." Van Rysselberghe to Signac, undated letter (end of 1894), Signac Archive, Paris.

43. Canning, *Paintings and Drawings,* 145.

44. Canning believes the sitter may be Phil, wife of the innkeeper at the De Keiser tavern in Wechelderzande where Van de Velde stayed and painted. Ibid., 148.

45. For an illustration, see ibid., 155.

46. Canning, once again, believes the model may be Phil. Ibid., 153.

47. Intrigued with the subject of the peasant, in 1891 Van de Velde gave a lecture at Les XX, "On the Peasant in Painting," where he rejected the sentimentalized version

of Jean-François Millet's peasants in favor of Camille Pissarro's more realistic tillers of the soil. See Canning, *Paintings and Drawings,* 236–38, for the abbreviated version of the text, "Du paysan en peinture," reproduced from *L'Art moderne,* February 22, 1891, 60–62. The full text was published in *L'Avenir social* (August–October 1899). One year later the review issued the text as a separate publication with Van de Velde supplying the decoration and initial letters.

48. For a deeper understanding of Lemmen's work, I am indebted to Roger Cardon; see his *Georges Lemmen (1865–1916)* (1990) and the retrospective exhibition he organized at the Ixelles Museum, *Georges Lemmen 1865–1916* (1997). For a reproduction of *Dame en visite,* see Cardon, 1997, 93.

49. "Le peintre du silence, de la pensée, de la confiance, de la vie discrète des choses dans un milieu tendre et familial." Camille Lemonnier, *L'École belge de peinture* (Brussels: G. Van Oest, 1906), 185.

50. Madeleine Octave Maus, *Trente années de lutte pour l'art* (Brussels: Lebeer Hossmann, 1980), 85. This is a reprint of the original 1926 edition published by the Librairie l'Oiseau Bleu in Brussels.

51. Georges Lemmen to Willy Finch, September 22, 1902, Archives de l'art contemporain, 21.809/IV, Musées royaux des Beaux-Arts de Belgique, Brussels.

52. In 2008, the author was privileged to locate this painting, which had been lost from view since it was last sold in 1960. It is reproduced here in color for the first time.

53. Émile Verhaeren, "Les XX," *Société nouvelle,* February 28, 1891, 250, reprinted in Aron, *Émile Verhaeren: Écrits sur l'art,* 1: 405.

54. Émile Verhaeren, "Les XX," *La Nation,* February 10, 1891, reprinted in Aron, *Émile Verhaeren: Écrits sur l'art,* 1: 394.

55. Following the Les XX exhibition, Lemmen sent nearly the same group to the Paris Independents show held in March and April.

56. See Block, "Study in Belgian Neo-Impressionist Portraiture."

57. For more on Loïe Fuller, see Giovanni Lista, *Loïe Fuller, danseuse de la Belle Époque* (Paris: Stock-Éditions d'art Somogy, 1994) and *Loïe Fuller, danseuse de l'art nouveau* (Paris: Réunion des musées nationaux, 2002).

58. "Il semble que l'observance trop stricte des 'principes' leur ôte, toute émotion, toute fièvre, toute naïveté. . . . Ce n'est pas la méthode qui me déplaît dans le néo-Impressionnisme, mais c'est qu'aucun, —sauf Seurat, — n'a su la dominer et l'assouplir, en faire *sa chose* en un mot, de telle sorte que le *métier* s'oublie entièrement, s'efface devant la personnalité." Georges Lemmen to Willy Finch, September 1901, Archives de l'art contem-

porain, 21809/VI, Musées royaux des Beaux-Arts de Belgique, Brussels. Emphasis in original.

59. Van Rysselberghe's continuing respect for Whistler is present in his last group portrait, *Une Lecture* (1903), where a photograph of Whistler's Carlyle hangs above the fireplace.

60. See my analysis of these two portraits, "Twee Sleutelwerken van Théo van Rysselberghe," in *200 Jaar Verzamelen: Collectieboek Museum voor Schone Kunsten Gent* (Ghent: Ludion, 2000), 195–201.

61. Van Rysselberghe to Octave Maus, October 2, 1885, Archives de l'art contemporain, II.978, Musées royaux des Beaux-Arts de Belgique, Brussels.

62. Among them were Maria Sèthe (see plate 51), Maria van Rysselberghe, and Auguste Descamps; one critic found Van Rysselberghe's works to be "enchantments for the eye and that one experiences a true physical enjoyment before his paintings." Pierre-M. Olin, "Les XX," *Mercure de France,* April 1892, 342.

63. The original text reads, "Je l'ai poliment envoyé faire caca; rien ne m'irrite comme quand des bonzes me disent, 'j'aime énormément ce que vous faites, cependant faites-moi autre chose!'" Van Rysselberghe to Van de Velde, November 11, 1900, Van de Velde Archive, FSX 800/8, Archives et Musée de la littérature, Bibliothèque royale de Belgique, Brussels.

64. "J'ai atrocement peur de la 'spécialité'—où pourrait me mener le portrait." Van Rysselberghe to Signac, undated [1895], Signac Archive, Paris.

65. The exhibition ran March 10–31, 1899. The other Neo-Impressionists exhibiting with Signac and Van Rysselberghe were Angrand, Cross, Luce, and Petitjean. Van Rysselberghe's three portraits on display were Laure Flé, Marthe Verhaeren, and Paul Signac.

66. "Tout le succès de notre salle est pour Théo. Il a d'ailleurs fait toutes les concessions qu'il faut pour cela. Ses portraits sont éminemment gracieux, ils pourraient être signés de n'importe quel peintre du Champ-de-Mars." The entry is dated March 15, 1899. "Extraits du journal inédit de Paul Signac," part III, ed. John Rewald, *Gazette des Beaux-Arts* 42 (July–August 1953): 46. For more on the relationship between Signac and Van Rysselberghe, see Marina Ferretti Bocquillon, "Signac and Van Rysselberghe: The story of a friendship, 1887–1907," *Apollo* 147 (June 1998): 11–18.

67. *Gazette des Beaux-Arts* 42 (July–August 1953): 46. Signac was even more critical of the portraits of Petitjean, which made Théo's work seem "nearly intransigent."

68. Maria van Rysselberghe, *Il y a quarante ans suivi de Galerie privée, strophes pour un rossignol* (Brussels: Éditions Labor, 2005), 133. The original edition was published in 1938 by Gallimard.

69. Ibid., 135.

70. "Ne serait-ce pas parce que le métier tyrannique du néo-impressionnisme satisfaisait sa rigueur tout en la limitant qu'il lui fut redevable de quelques-unes de ses meilleures toiles?" Ibid.

71. "Travailler, travailler toujours, c'est là pour moi la meilleure école; la reflexion me semble venir par le travail même, et plus sûrement." Van Rysselberghe to Signac, July 19, 1894, Signac Archive, Paris.

72. "Mes modèles me passionnent davantage à mesure que je les connais mieux—et je passerais ma vie à creuser toujours plus avant dans la connaissance, dans l'étude des figures familières." Van Rysselberghe to Émile van Mons, letter dated June 20, 1914, private collection, Brussels.

73. Maria van Rysselberghe, *Il y a quarante ans* (2005), 133.

74. "Portraits irradiants de Mlle Sèthe et de Mme Picard," Victor Arnould, "Les XX," *La Nation,* March 4, 1889, 1; "Les lois de la division sont observées entières," from "Aux XX," *L'Art moderne,* February 10, 1889, 42. The portrait was referred to by the critic of *L'Indépendance belge* of February 4, 1889, in "Le Salon des Vingt," as being executed in the "system of flicks that makes the painting resemble a mosaic of the time (système de tapotement qui arrive à faire ressembler la peinture à de la mosaïque du temps)."

75. A.-J. W. (Wauters), "Aux XX," *La Gazette,* February 2, 1889.

76. Octave Maus, "Le Salon des XX, à Bruxelles," *La Cravache,* February 16, 1889, 1.

77. S.T.R. Chèque, "Les XX de Bruxelles," *L'Escaut,* February 5, 1889.

78. (Wauters), *La Gazette,* February 2, 1889.

79. "M. Van Rysselberghe deviendra notre meilleur portraitiste." Eugène Demolder, "Chronique artistique: Le Salon des XX," *Société nouvelle,* January 1890, 114.

80. "Je vais travailler comme un enragé. J'ai à faire un nouveau portrait intéressant: une jeune violoniste, très décorative aux gestes souples et gracieux, vêtue d'une ample robe d'un rose exquis, nacrant les chairs blondes." Van Rysselberghe to Signac [1893], Signac Archive, Paris.

81. "De van Rysselberghe, délicieux portrait de Mlle Sèthe." John Rewald, "Extraits du journal inédit de Paul Signac, Part 1, 1894–1895," *Gazette des Beaux-Arts* 36 (July–September 1949): 118.

82. Pissarro to Lucien Pissarro, April 11, 1895, cited in Bailly-Herzberg, *Correspondance de Camille Pissarro,* 4: 61. Verhaeren expressed similar concerns three years later when the work was exhibited at La Libre Esthétique; see Aron, *Émile Verhaeren: Écrits sur l'art,* 2: 736. The article originally appeared in *L'Art moderne,* March 13, 1898, 85–87.

83. Katalog der III Kunst-Ausstellung der Vereinigung Bildender Künstler Österreichs, January 12 to February 20, 1899, nos. 44, 46, and 49. Van Rysselberghe was allotted an entire room where he displayed thirty-two works, among them, in addition to the three Sèthe sisters, the portraits of Émile Verhaeren and Georges Flé, and Signac on his boat. *Ver Sacrum,* the periodical of the Vienna Secession, devoted a major article written by Émile Verhaeren to Van Rysselberghe's entries, reproducing Irma Sèthe, Signac, and Verhaeren; "Théo van Rysselberghe," *Ver Sacrum* 2 (1899): 1–31.

84. In recent years Hals's authorship of this work has been challenged, but in Van Rysselberghe's time it was considered an important work by Hals.

85. Petra Ten-Doesschate Chu, "Nineteenth-Century Visitors to the Frans Hals Museum," in *The Documented Image: Visions in Art History,* ed. Gabriel Weisberg and Laurinda S. Dixon (New York: Syracuse University Press, 1987), 137–38. For the reawakening of interest in Hals and Dutch portraiture in general, see Frances Suzman Jowell, "Thoré-Bürger and the revival of Frans Hals," *Art Bulletin* 56 (1974): 101–17. During his second visit, Van Rysselberghe worked on a copy of a Hals painting as a commission; Octave Maus to Eugène Boch, Archives de l'art contemporain, 3.898, Musées royaux des Beaux-Arts de Belgique, Brussels. This is confirmed by the article "Frans Hals et Manet," *L'Art moderne,* September 30, 1883, 311. Van Rysselberghe's unsigned article, "Le modernisme de Frans Hals," appeared in *L'Art moderne,* September 23, 1883, 301–3.

86. See Feltkamp, *Théo van Rysselberghe, 1862–1926,* 297.

87. Edwin Becker, "White, Blue and Gold in Search of New Harmony," 188, in *In Perfect Harmony* (Zwolle: Waanders Uitgevers, 1995). Becker notes that this painted strip "makes the figure appear to be raised on a plinth, within the picture, underlining the upright, dignified pose of the sitter."

88. "C'est le premier bourgeois qui me *demande* que je fasse à son portrait un cadre, simple bande plate à couleurs sombres, réactionnaires—son oeil s'y est habitué à l'atelier et il déclare cela plus harmonieux, plus beau, que les ors, les plâtres." Van Rysselberghe to Signac, November 6 [1893], Signac Archive, Paris. As Van Rysselberghe revealed to Signac, he was not able to complete the work in time for the Paris Independents in 1894 because of a curious technical miscalculation: "The portrait of the old man advances painfully. I made a mistake by using a canvas of very large weave, difficult to cover and leaving a crowd of small black interstices, excessively bothersome. (Le portrait du vieillard avance péniblement; j'ai eu le tort d'employer une toile à *très gros grain,* difficile à couvrir et laissant une foule de petits *interstices noirs,* excessivement gênants)."

Undated letter from Van Rysselberghe to Signac, Signac Archive, Paris.

89. Maria van Rysselberghe, "Émile Verhaeren," *Il y a quarante ans,* 63. "Sa totalité spirituelle ramassée entrait en même temps: tout était là d'un coup, offert et lumineux."

90. By this time Signac was already living for much of the year in Saint-Tropez, where he would eventually purchase his house and studio, La Hune.

91. Cachin, *Signac: Catalogue raisonné de l'oeuvre peint,* 368.

92. "Je suis heureux, mon vieux cher, vraiment heureux de sortir de ma coquille, par trop étroite et j'ai atrocement peur de la 'spécialité'—où pourrait me mener le portrait." Van Rysselberghe to Signac, [1895], Signac Archive, Paris.

93. My thanks to Raphaël Dupouy, who first used this photograph in his film *Théo van Rysselberghe: Du Nord au Sud* (Réseau Lalan, 2012), and to Catherine Gide for allowing me to publish this image.

94. "Il y a dans notre art trop de logique pour qu'il ne soit durable. Le point sera, je crois, d'élargir notre technique pour arriver à couvrir de grandes surfaces sans que le mécanisme du métier apparaisse trop et trouble. Pensez aux *Poseuses* du pauvre Seurat. *Un an,* et de quel travail acharné! C'est trop. . . . Pour des petites dimensions, je considère que notre technique est complète; on peut donner tout et en un temps relativement court. Mais un grand, cela devient atrocement compliqué!" Van Rysselberghe to Signac, August 19 [1892], Signac Archive, Paris.

95. See the illustration in Hoozee and Lauwaert, *Théo van Rysselberghe, néo-impressionniste,* 132.

96. The artist's wife, Maria, is seated on the bench at the left, next to Maria van de Velde, wife of Henry van de Velde. The artist's daughter Elisabeth holds a basket at the far right.

97. The group portrait has a long tradition in Western art. Fantin-Latour's *Le Coin de Table* (1872) serves as one possible prototype for the Van Rysselberghe.

Plates

PLATE 1

Henri-Edmond Cross

French, 1856–1910

Madame Hector France, 1891

Oil on canvas, 81⅞ × 58⅝ in. (208 × 149 cm)
Signed and dated lower left: 1891/Henri Edmond Cross
Musée d'Orsay, Paris

With this full-length image of his future wife, Henri-Edmond Cross clothed the traditional society portrait in the finery of his newly adopted avant-garde style. The painting, presented at the 1891 annual exhibition of the Independents, signaled the dramatic debut of Cross's conversion to Neo-Impressionism. A founder and steady participant in the no-jury, no-awards exhibitions of the Independents, Cross was familiar with Neo-Impressionism and friendly with its advocates Paul Signac, Charles Angrand, Théo van Rysselberghe, and Georges Seurat. Prior to 1891, however, he had resisted their approach.

Cross's earliest artistic training came as the ten-year-old pupil of Émile Carolus-Duran (1837–1917) in Lille, shortly before Carolus-Duran departed for Paris and a career painting elegant portraits of privileged Parisians. His submission to the Salon of 1869, *Woman with a Glove* (see fig. 2), became the critical toast of the town, earning him a medal and widespread praise.[1] It is hard to resist seeing this signature work, a portrait of Carolus-Duran's wife, as a prototype for Cross's ambitious portrait, which casts the traditional elements of fashion, décor, and still life through a divisionist filter.

Cross participated in the more conservative exhibition forums in Paris before turning to outdoor painting in the later 1880s. When his interest in color and light moved him to join the ranks of the Neo-Impressionists in 1891, it was a critical moment—after the death of Dubois-Pillet in August 1890, the loss of Seurat in March 1891, and the defection of Camille Pissarro. With *Madame Hector France,* Cross showed his mastery of pointillist brushwork, building his composition with consistent, rounded touches of the brush. While not all areas of color can be considered divided, the recent adept did choose basic Neo-Impressionist harmonies of contrasting warm and cool hues.

A preparatory pencil drawing of Madame France suggests Cross's careful work to transfer her profile to the large scale of the canvas (fig. 30). While the painting is certainly a portrait, the figure, in spite of her voluminous dress and formal pose, must compete for attention within Cross's highly detailed setting. A remarkable fusion of geometric forms, the composition

Fig. 30. Henri-Edmond Cross, *Study for a Portrait of Madame Hector France.* Graphite on paper, 12⅛ × 8⅞ in. (30.9 × 22.5 cm). Musée du Louvre, Paris.

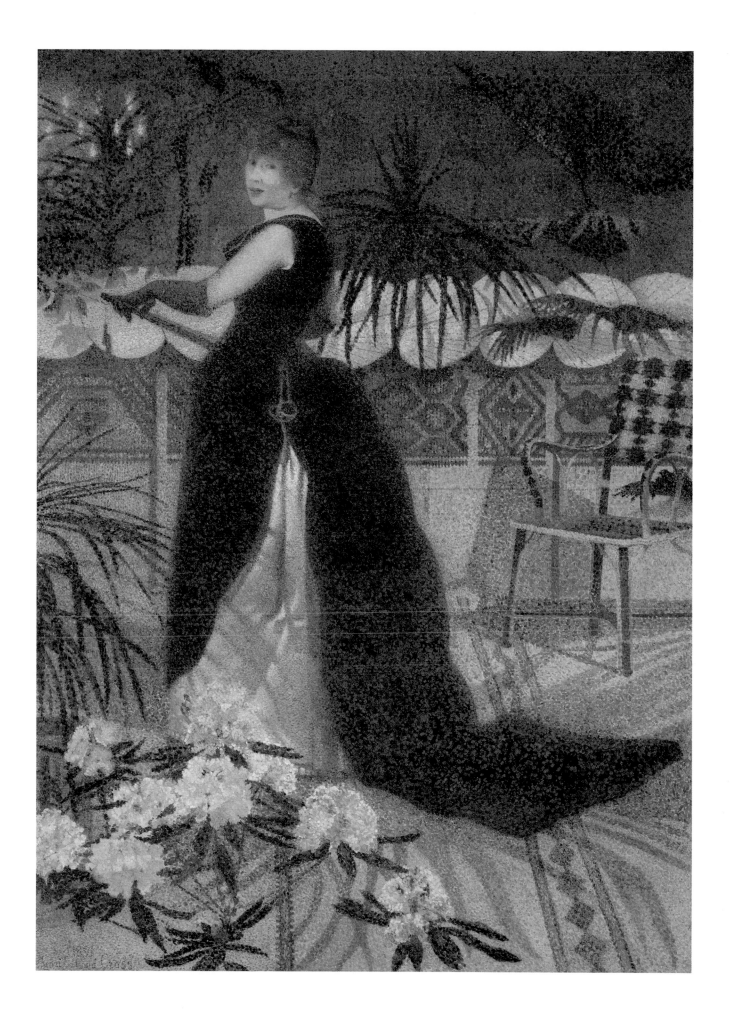

coordinates the diamond shapes on the floor with the horizontal bands of the white fans and the patterned motif below them. Even the woven armchair contributes to the intricacy of the scene. A liberal distribution of palm fronds adds to the *horror vacui* and offers some gentle curves to match the silhouette of the gown. Floating in the foreground are the natural forms of the rhododendron, an artful device probably inspired by the Japanese woodblock prints so admired by artists of the Post-Impressionist era.[2]

Who was the woman at the heart of this decorous tableau? Irma Clare (1849–1933) married the novelist and journalist Hector France, whom Cross would have known through his associations within Parisian literary circles.[3] In 1888 the writer purchased a work by Cross, and the artist moved to a street near Irma's home.[4] By the time Cross's chronic rheumatism drove him to settle in the south of France in autumn 1891, Irma was with him. They married in 1893. Apparently the artist's friends differed in their affection for her, but most found Irma to be a gracious hostess and devoted companion.[5] She is the subject of a work unique within the oeuvre of Henri-Edmond Cross. His other portraits are rare, and none possesses the impact inspired by Irma Clare Cross and the tenets of Neo-Impressionism. EWL

PROVENANCE: Mme Henri-Edmond Cross; Mme Gastine, her daughter; Mme Rabier, her daughter; acquired by the Musée national d'art moderne, Paris, 1955; transferred to the Musée d'Orsay, Paris, 1977.

EXHIBITIONS: Independents, Paris, 1891, no. 279; Musée Municipal, Douai, *Henri-Edmond Cross et ses amis: Seurat, Signac, Angrand, Luce, Lucie Cousturier, Van Rysselberghe*, 1956; Musée d'Orsay, Paris, *Le Néo-impressionnisme, de Seurat à Paul Klee*, 2005, 214–15; Fine Arts Museums of San Francisco, *Van Gogh, Gauguin, Cézanne, and Beyond: Post-Impressionist Masterpieces from the Musée d'Orsay*, 2010–11, no. 52.

BIBLIOGRAPHY: "Le Salon des Indépendants," *La Revue indépendante* (April 1891); Jules Antoine, "Critique d'art de l'exposition des artistes indépendants," *La Plume*, May 1, 1891, 156; Jules Leclerq, "Aux Indépendants," *Mercure de France* (May 1891): 298; Maurice Denis, Preface, *Catalogue de l'Exposition Henri-Edmond Cross* (Paris: Galerie Bernheim, 1910); Lucie Cousturier, "H. E. Cross," *L'Art décoratif* (March 1913): 129; Lucie Cousturier, *H. E. Cross* (Paris: G. Crès, 1932), 12; Isabelle Compin, *Henri Edmond Cross: Catalogue raisonné* (Paris: Quatre-Chemins-Editart, 1964), no. 29; Claire Maingon, "Seurat et les origines du neó-impressionnisme: Au delà de l'impressionnisme?" in *Henri-Edmond Cross et le néo-impressionnisme: De Seurat à Matisse*, ed. Emmanuelle Levesque (Paris: Hazan, 2011), 39–41.

1. *Salon*, Paris, 1869, no. 18.
2. Sylvie Carlier, "Madame Hector France," in Ferretti Bocquillon, *Le Néo-impressionnisme: De Seurat à Paul Klee*, 214.
3. Compin, *Henri Edmond Cross*, 31.
4. Françoise Baligand and Roland Perruchon, "Chronologie," in Baligand et al., *Henri-Edmond Cross et le néo-impressionnisme*, 221.
5. Compin, *Henri Edmond Cross*, 32.

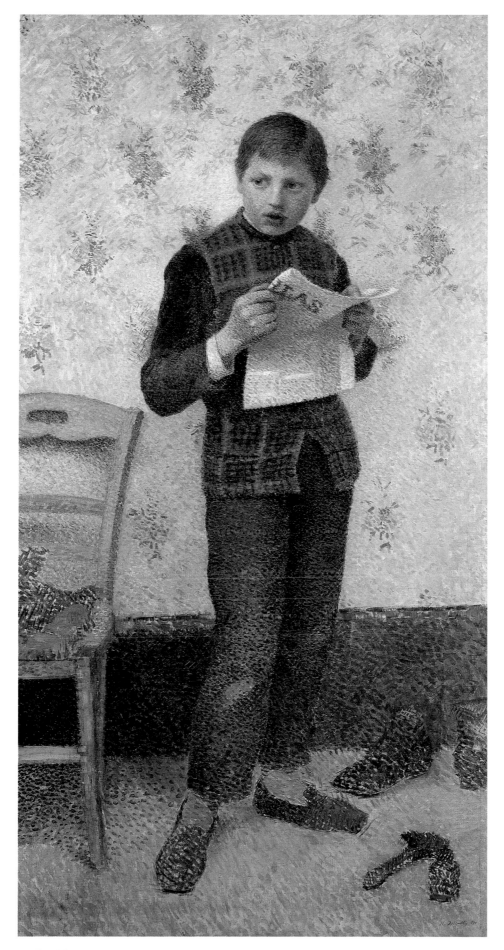

PLATE 2

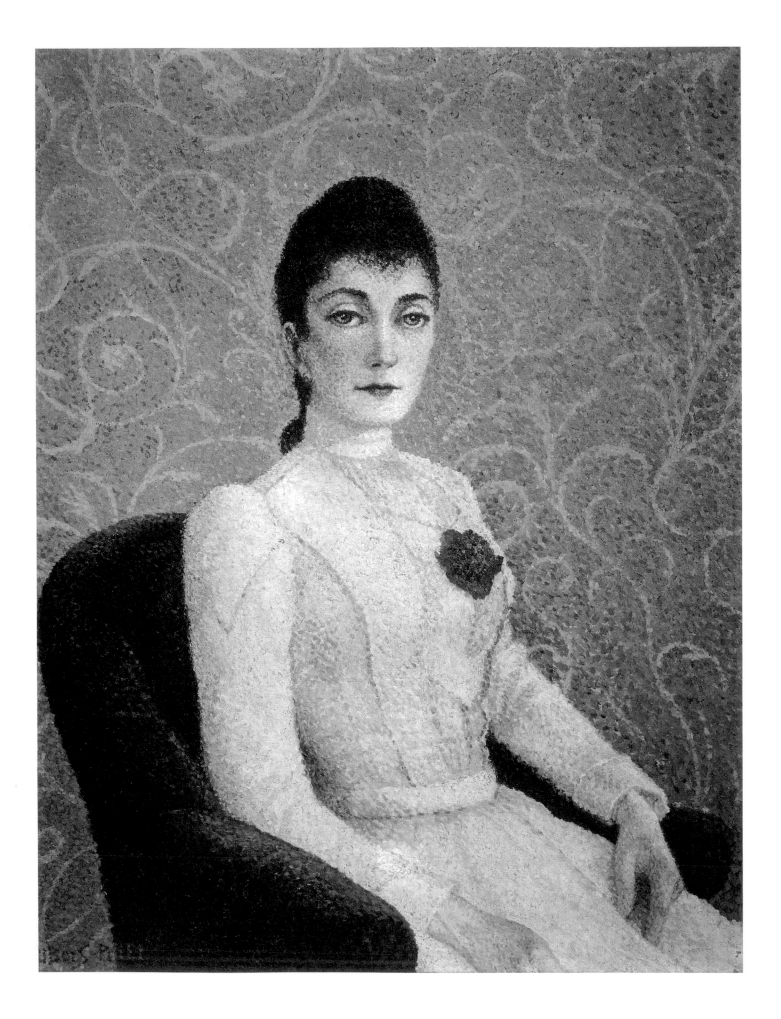

brushwork to portraits. His May 1, 1887, description of the artist's portraiture easily applies to *Mademoiselle B.:* "The first, he applied the systematic division of tone to portraiture. His effigies,—the feminine ones especially,—live. A subtle, multi-colored joy diffuses in arabesques in the backgrounds."[4] Indeed, this portrait, with its highly decorative arrangement of sinuous line, reflects the artist's preference for strongly patterned backdrops. The stillness and restraint of Mademoiselle B. are only enhanced by the lively turns of the scrolls swirling behind her.

Dubois-Pillet's color scheme shows little evidence of the typical Neo-Impressionist harmonies of complementary hues. His small but powerful contrasting device is the delicate flower arrangement near the center of the composition. Its green leaves and purple violets resonate with the ivory and warm red tones of Mademoiselle B.'s dress and setting. While the changing colors in the letters of Dubois-Pillet's signature at lower left may have been prompted by a simple desire for legibility, they could also be a tentative foray into the arena of Neo-Impressionist color contrast. The model's skin and dress provide areas for the artist to explore issues of reflected color. Yet the careful dots that compose the model's face do not explain her gravitas; they yield no clues to the thought or emotion behind the imperturbable countenance. EWL

PROVENANCE: Joseph Majola; by bequest to the Musée d'art moderne de Saint-Étienne Métropole, 1918.

EXHIBITIONS: Independents, Paris, 1887, no. 148, as *Portrait de Mlle B.;* Les XX, Brussels, 1888, no. 1, as *Portrait de Melle B.;* Possibly Les XX, Brussels, 1890, no. 9, as *Portrait de Mme P.;* Possibly Independents, Paris, 1890, no. 315, as *Portrait de Mme P.;* possibly Independents, Paris, 1891, no. 458, as *Portrait de Mme P.;* Independents, Paris, *Les premiers Indépendants, Rétrospective, 1884–1894,* 1965, no. 64, as *Portrait de Melle M. D.;* Musée National d'Histoire et d'Art du Grand Duché du Luxembourg, *Collection du Musée d'art moderne de Saint-Étienne,* 1991; Santa Barbara Museum of Art, *Discoveries! French Masterpieces from Saint-Étienne,* 1992.

BIBLIOGRAPHY: Félix Fénéon, "L'impressionnisme, 1887," *L'Émancipation sociale,* April 3, 1887; Jules Christophe, "Dubois-Pillet," *Les Hommes d'aujourd'hui* 8, no. 370 (1890); L. Peyret, *Catalogue des peintures du Musée d'art et d'industrie de Saint-Étienne (mémoire de l'École du Louvre),* vol. 1 (1946), fig. 184; Roger Gounot, "Le peintre Dubois-Pillet," *Cahiers de la Haute-Loire* (1969): 124, as *Portrait de Mlle B.,* 126, as *Portrait de Mme P.,* 139; René Huygue and Jean Rudel, *L'art et le monde moderne,* vol. 1 (Paris: Larousse, 1969), 103; Lily Bazalgette, "Albert Dubois-Pillet, 1846–1890," in Jean Sutter, ed., *The Neo-Impressionists* (Greenwich, CT: New York Graphic Society, 1970), 137, as *Portrait of Mlle M. D.;* Louis Hautecoeur, *Seurat* (Milan: F. Fabbri, 1972), 75; Lily Bazalgette, *Albert Dubois-Pillet, sa vie et son oeuvre (1846–1890)* (Paris: Gründ Diffusion, 1976), 87, 168, as *Portrait de Mlle M. D.;* Blandine Chavanne, *Catalogue raisonné des peintures anciennes du Musée d'art et d'industrie de Saint Étienne (mémoire de l'École du Louvre),* vol. 2 (1981), 278; Jacques Beauffet, ed., *L'art ancien au musée d'art moderne de Saint-Étienne Métropole* (Paris: Un, Deux . . . Quatre Éditions, 2007), 144, 274.

1. Félix Fénéon, "L'impressionnisme, 1887," *L'Émancipation sociale,* April 3, 1887.
2. "Dubois-Pillet. Des portraits: le capitaine Pool, roide, et ses chamarres professionnelles; un jeune homme sur un vieux tapis d'Asie; mademoiselle B. dans un crapaud; un enfant blond assis près de son cheval à roulettes; mais surtout le portrait de l'auteur et son mouvement pressenti." Ibid.
3. The other three images, including a self-portrait with the artist wearing a top hat and monocle, have never been found.
4. "Le premier, il appliqua au portrait la division systématique du ton. Ses effigies,—les féminines surtout,—vivent. Une subtile joie polychrome se difflue en arabesques sur les fonds." Félix Fénéon, "Le néo-impressionnisme," *L'Art moderne,* May 1, 1887.

PLATE 4

Albert Dubois-Pillet

French, 1846–1890

Portrait of Monsieur Pool, 1887

Oil on canvas, 21⅝ × 18⅛ in. (55 × 46 cm)
Inscribed, signed, and dated lower right: à mon ami Pool/DUBOIS PILLET/1887
Indianapolis Museum of Art, Susan Keckler Mallinson Art Purchase Fund

This sober likeness is an unusual case of the rapport between artist and sitter: both parties were soldiers in the midst of distinguished military careers. Dubois-Pillet, a self-taught artist, was a veteran of the Franco-Prussian war and a captain in the infantry of the Garde Républicaine stationed in Paris. His friend Laurent Bernard Pool (1841–1904), also a captain, was named a chevalier of the Légion d'Honneur on June 24, 1886; on July 16, 1886, Capitaine Pool actually took possession of his decoration.[1] His receipt of the award was presumably the impetus for painting this portrait. Hanging beneath the impeccably arranged braids of his crisp uniform are the red ribbon and cross of France's distinctive honor.

The portrait is one of five that Dubois-Pillet exhibited at the Independents in the spring of 1887, and it demonstrates his early commitment to Neo-Impressionist portraiture. "Capitaine Pool, stiff, with his professional decorations" caught the attention of the astute critic Félix Fénéon.[2] Intent and alert, this dignified soldier with the meticulously groomed mustache is carefully depicted through Dubois-Pillet's deft and consistent pointillist brushwork. Working with the principles of Neo-Impressionist color behavior, Dubois-Pillet applied flecks of orange against the soldier's dark blue uniform and deposited the blue reflections of the jacket on his neck and chin. He set himself the additional challenge of a densely patterned backdrop: a Caucasian prayer rug, visible on the floor of the artist's studio in an 1884 painting entitled *Interior* (Musée d'art moderne de Saint-Étienne Métropole).

Like Seurat, Dubois-Pillet experimented with the frames for his paintings. When this portrait entered the collection of the Indianapolis Museum of Art it was accompanied by a frame that had clearly been on the picture for many years. Ornate and powder blue, it was an unusual choice given the subject and the artist's preference for Neo-Impressionist framing treatments. Happily, the frame also enclosed a sheet of glass that covered the canvas and preserved its unvarnished surface, leaving this portrait in a condition that must approach how it appeared when the artist inscribed it to his friend.

In July 1887, just a few months after completing the portrait, Dubois-Pillet was relieved of his post in the Garde Républicaine. The official cause was described as the military's need to economize by thinning their ranks, but the real motivation appears to have been their discomfort with Dubois-Pillet's involvement with the Independents and other members of the Parisian avant-garde. The artist maintained his devotion to painting, and his achievements as an officer led to his reinstatement the following year.

The portrait of Capitaine Pool was one of seventeen works that Dubois-Pillet exhibited in a one-person show in the offices of *La Revue indépendante,* a Parisian journal, in autumn 1888. Reviewing the exhibition, Fénéon described Dubois-Pillet's portraits as "revealing the human beings behind the masks."[3] Indeed, despite the soldier's formal pose, official uniform, and serious expression, Dubois-Pillet still hints that a thinking, feeling person resides behind the carefully painted face. EWL

PROVENANCE: Given by the artist to Capitaine Pool, 1887; descendants of Capitaine Pool, Normandy; Beaussant & Lefèvre, Paris, June 29, 2001, no. 89, as *Monsieur Pool en grand uniforme;* Brett Morris Ross, Paris; purchased by the Indianapolis Museum of Art, 2002.

EXHIBITIONS: Independents, Paris, 1887, no. 146, as *Portrait de M. P.;* Ve Salon des XX, Brussels, 1888, no. 2, as *Portrait de M. P.;* La Revue indépendante, Paris, Albert Dubois-Pillet exhibition, 1888.

BIBLIOGRAPHY: Félix Fénéon, *L'Émancipation sociale,* April 3, 1887; Félix Fénéon, "Les Expositions. I. Treize toiles et quatre dessins de M. Albert Dubois-Pillet," *La Revue indépendante* (October 1888): 134–37; Jules Christophe, "Dubois-Pillet," *Les Hommes d'aujourd'hui* 8, no. 370 (1890): 2; Roger Gounot, "Le peintre Dubois-Pillet," *Cahiers de la Haute-Loire* (1969): 110, 124; Lily Bazalgette, *Albert Dubois-Pillet, sa vie et son oeuvre (1846–1890)* (Paris: Gründ Diffusion, 1976), 98–99.

1. Musée national de la Légion d'Honneur et des ordres de chevalerie, file 34.392; for details of Pool's career, see Centre d'accueil et de recherche des Archives nationales, Paris, Laurent Bernard Pool, file LH/2199/77.
2. "Le capitaine Pool, roide, et ses chamarres professionnelles." Félix Fénéon, *L'Émancipation sociale,* April 3, 1887.
3. "Portraits révélateurs d'êtres derrière les masques." Félix Fénéon, "Les Expositions. I. Treize toiles et quatre dessins de M. Albert Dubois-Pillet," *La Revue indépendante* (October 1888): 137.

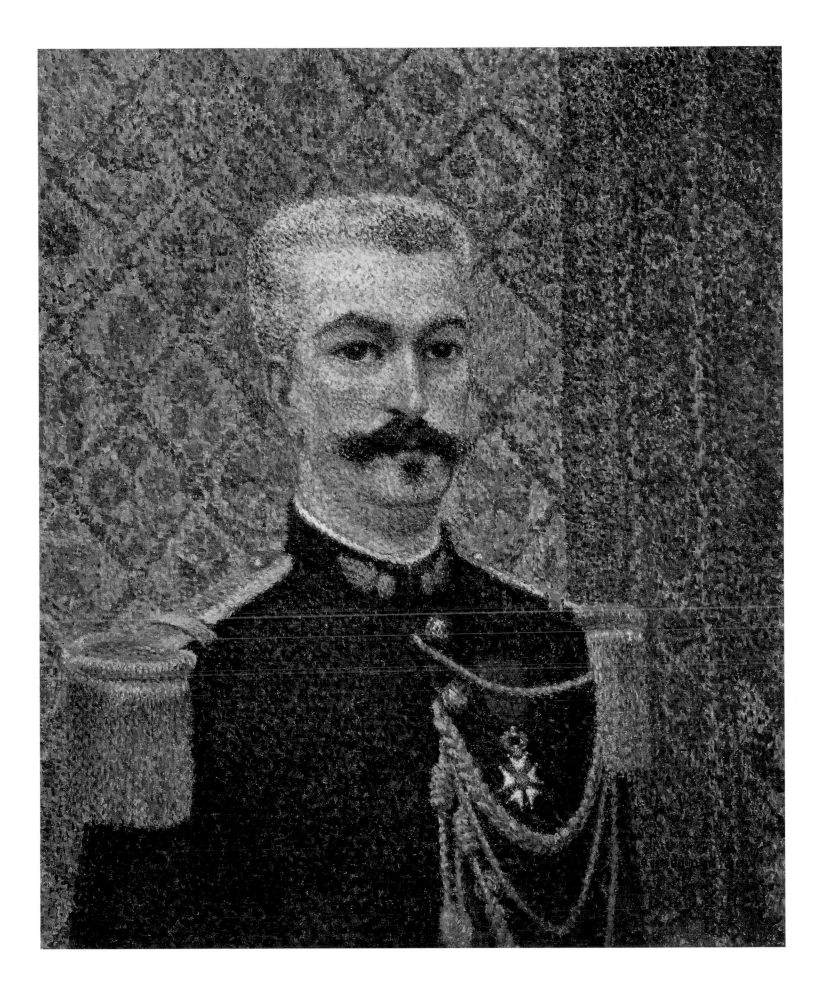

PLATE 5

William Jelley

Belgian, 1856–1932

Portrait of Alfred Verhaeren, [c. 1890]

Oil on cardboard, 14 × 10½ in. (35.6 × 26.7 cm)
Indianapolis Museum of Art, Beeler Fund

Only two known Neo-Impressionist works by William Jelley have come to light, and they are both portraits: this depiction of the artist Alfred Verhaeren and one of Jelley's young daughter, Adolphine, painted in 1890 (private collection).[1] The portrait reveals the attraction of Neo-Impressionism even to artists who were not part of the avant-garde. Although Jelley maintained a presence in the Belgian art scene, he was not a member of Les XX and did not show with its successor, La Libre Esthétique, a far more open venue.

The subject, the painter Alfred Verhaeren (1849–1924), shown in fig. 31, was a cousin of the poet Émile Verhaeren. With a reputation as a painter based on solid craftsmanship and a fine sense of color and richness of texture, Verhaeren was known for his realistic paintings of interiors, his still lifes, and his portraits. Jelley shows Verhaeren at the height of his powers with a lively turn of his head, reddish mustache, beard, and piercing eyes. The shelves filled with books, an artwork whose green frame contrasts with its reddish mat, and a sculpture rising above Verhaeren's head all were probably part of Jelley's studio. Among a variety of brushstrokes, Jelley applied a screen of small dotlike applications across the canvas.

Both Jelley and Verhaeren participated in exhibitions of the Pour l'Art group founded in Brussels in 1892. The painter no doubt appreciated this portrait by Jelley, because it remained in the Verhaeren family until 1986. JB

PROVENANCE: Verhaeren family, until 1986; Miromesnil Fine Art, Paris; Connaught Brown, London, June 1988; Paul and Ellen Josefowitz, London, November 1988; Galerie Hopkins-Thomas, Paris, by 1997; purchased by the Indianapolis Museum of Art, 1997.

EXHIBITIONS: L'Essor, Brussels, 1890, no. 2, as *Portrait de Monsieur V.;* Indianapolis Museum of Art, *The Art of Collecting: A Decade of Treasures,* 1998.

BIBLIOGRAPHY: Jean Morjan, *L'Académie et l'art nouveau* (Brussels: Les Amis de l'Académie royale des Beaux-Arts de Bruxelles, 1996), 164-69; *Gazette des Beaux-Arts* 131 (March 1998): 63.

1. Adolphine's portrait was exhibited at *Un demi-siècle de peinture et de sculpture* (Saint-Josse-ten-Noode: Hôtel Charlier, 1969), 34.

Fig. 31. Eugène Guérin, photograph of the artist (Alfred Verhaeren). Carte-de-visite, image: 3⅝ × 2¼ in. (9.3 × 5.7 cm); card: 4⅛ × 2½ in. (10.4 × 6.3 cm). Collection of the author.

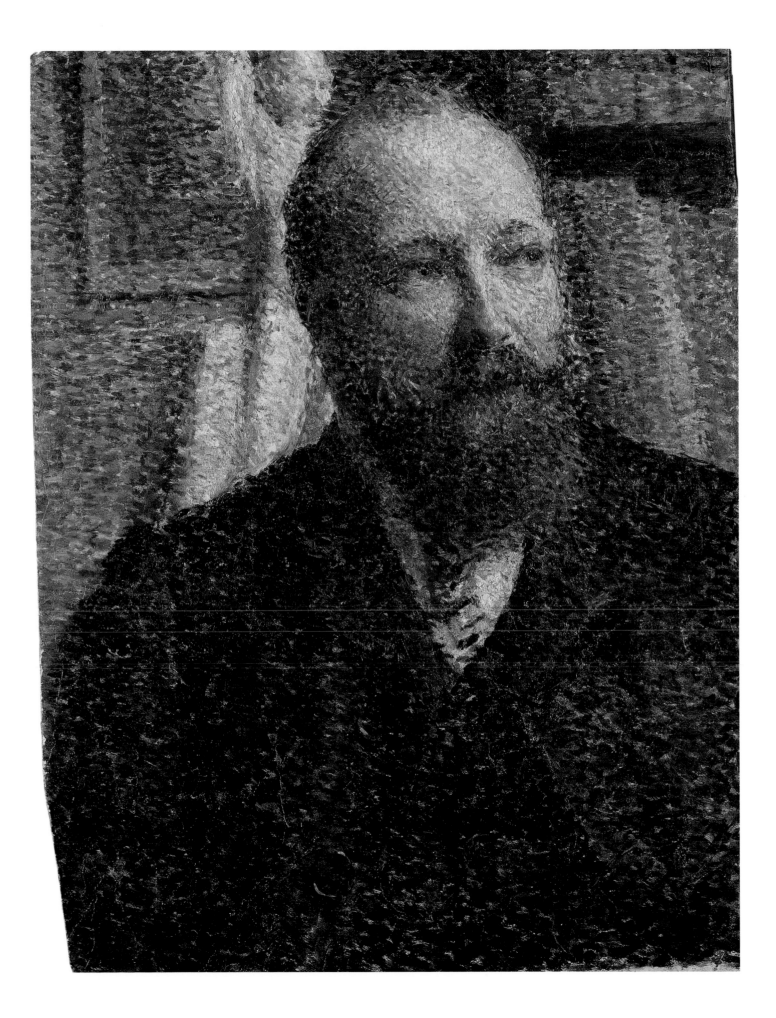

PLATE 6

Achille Laugé

French, 1861–1944

Portrait of Madame Astre, 1892

Oil on canvas, 78 × 52⅜ in. (198 × 133 cm)
Signed and dated upper right: A Laugé 92
Musée des Beaux-Arts de Carcassonne, gift of the artist

This work is one of five canvases that Laugé exhibited at the Independents in Paris in 1894, under the title *Portrait de Mme B.* He had already painted the model, Marie Salvan, in 1889, during the early years of her marriage, three years before he executed this imposing life-size image. She was the first wife of Achille Astre (1859–1945), an art collector who was exceptionally open to modernism.[1] His collection included works by Willette, Chéret, Hermann-Paul, De Feure, Ibels, and Toulouse-Lautrec, prints by Renoir, Redon, Bonnard, and Vuillard, and several pieces by Laugé.

This canvas evoked contrasting reactions when it was exhibited in the 1894 Independents, along with two other portraits and two flower still lifes:

> Mr. Laugé . . . exhibited flowers of remarkable delicacy and a portrait of an exquisitely charming young woman, although its overall tonalities tend toward gray. (*La Dépêche*, April 23, 1894)

> We note the scientific approach of the pointillist Laugé. (*Gil Blas*, April 10, 1894)

> In the third room of drawings we took particular note of flower pieces and the portrait of a young woman that reveal a very strong talent. (*La Justice*, April 11, 1894)

But along with this praise came vigorous criticism:

> Mr. Laugé, who is from Carcassonne, shows us his Mme B. . . . Yet another challenge! Carcassonne makes a stab at astonishing Paris. *Pointisiste* or *pointilliste.* One might refer to it as *La Dame aux confetti.* It's what one might call the apotheosis of some ugly rash or smallpox. A vaccination should be required before viewing this contraption. (*L'avenir de Trouville*, April 29, 1894)

> Not far away, the same technique is executed by an inexperienced brush, and the portraits by Mr. Laugé are no better than mannequins on which he has rained confetti. (*Echo de Paris,* April 8, 1894)

An ambitious work, *Portrait of Madame Astre* can be compared to two other life-size portraits in Laugé's oeuvre: *Portrait of Mademoiselle Jeanjean* (private collection) and, most importantly, *Portrait of Jeanne Sarraut* (location unknown, fig. 32), with which it has many similarities. Both young women are dressed in white, one standing, the other seated, by a small piece of furniture against a blank background. In each case these paintings were commissioned by very close friends who recognized

Fig. 32. Achille Laugé, *Portrait of Jeanne Sarraut*, c. 1892. Oil on canvas, 72½ × 49¼ in. (184 × 125 cm). Location unknown.

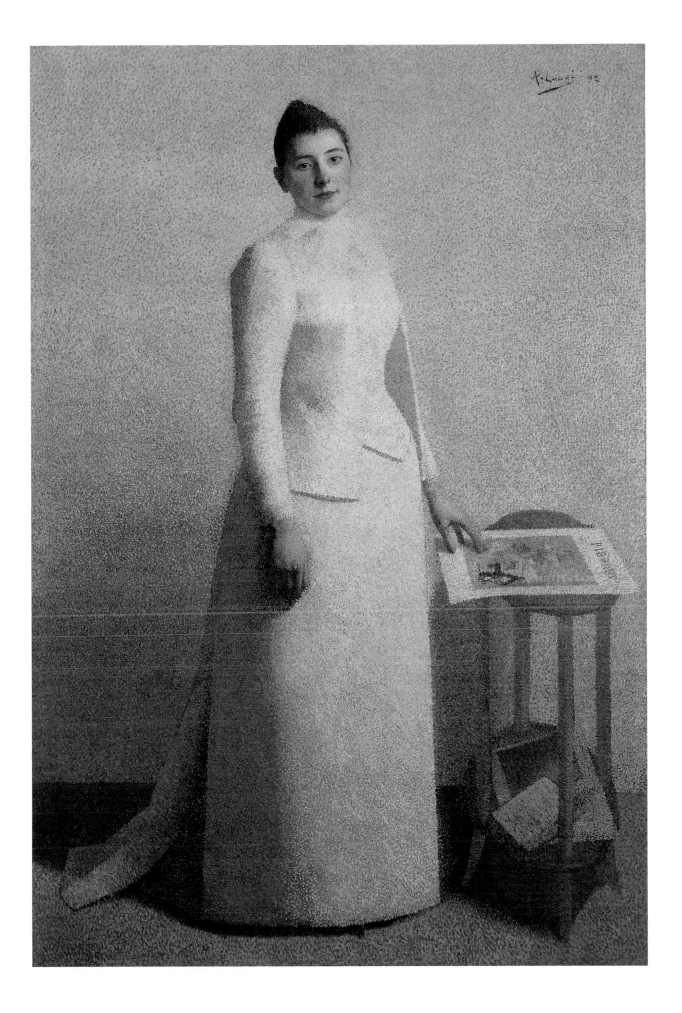

and supported the originality of Laugé's talent; this vote of confidence allowed the artist to employ a technique that was considered bold for the period and locale in a large-scale portrait.

It was Gustave Geffroy who best described the *Portrait de Madame Astre:*

> A tall woman, with a small, round head, her hair gathered up in a bun, her eyes weary but wide open, a mouth that ambiguously expresses both sensitivity and irony. . . . Everything seems effortless, unstaged by the painter, all embraced by the immobility and silence that surround masterworks of portraiture. This portrait is indeed a masterpiece by virtue of its pure harmony, its profound expressiveness. . . . Laugé is a simplifier who finds a way to show anything; all he needs to do to make the form and the volume of this body perceptible is to model those wonderful hands, both the one resting on the little table and the other that hangs over the dress, a hand whose weight suggests the blood that flows within. . . . The barely visible black tip of her toe seems to peek as furtively as a mouse from the rim of shadow cast by her gown.[2]

If the simple contours suggest the draftsmanship of Puvis de Chavannes, the definition of volumes is closer to the work of Piero della Francesca. There is something sculptural in this body that is treated as a single block, and the technique of closely painted small dots creates a sense of monumentality. During his student days in Toulouse and Paris, Laugé was a close friend of Aristide Maillol (1861–1944) and Antoine Bourdelle (1861–1929). Both artists became sculptors whose mature work was distinguished by a solidity and volume not unlike the monolithic quality Laugé achieved in the form of Madame Astre.

Laugé employs economy in the details; there is no jewelry or ornament, no pattern in the gown or the background. The seemingly motionless pose and slightly stiff attitude of the model make this figure, like those of Seurat and Signac, the archetype of an era. Absent here, however, are the graceful curves of mutton sleeves or the bustles that add such a decorative note to the female figures of Parisian painters. No fold in the skirt catches the light; only the gray border of the jacket and bodice allow us to discern the various parts of her costume. The portrait's harmonies of white on a white ground are an opportunity for a subtle shading of gray-blue and bronze tonalities. Punctuated with areas of yellowish-orange in the light, the white takes on a violet-red tinge in the shadow. The painting's background—where the ochre preparatory coat can be seen in some areas—is treated with interlaced crosshatchings, a technique that became characteristic of Laugé's work between 1895 and 1899, while the hands and face are broken down into tiny dots. The vivid red stroke of the mouth—whose lower lip is touched with yellow since it is moist and captures the light—is echoed in the signature. Emphasized in this way, Laugé's handwriting becomes an element of the composition, in the manner of Japanese prints.

The portrait was sometimes nicknamed *Le Pierrot,* the title of Adolphe Willette's review, posed on a pedestal like a wink of the eye to Achille Astre's Parisian circle.[3] Laugé's treatment of the table recalls the work of Cézanne, whom Laugé may have met during his time in Paris. Its surfaces are foreshortened against the canvas's vertical plane, and the legs, if viewed separately, do not correspond to the surface above. Multiple points of view, arbitrary definition of lines, inconsistency in rendering shadows: all these challenges to traditional perspective, so typical of the master from Aix, were also addressed by Seurat in *La Grande Jatte* and in *Models* (*Les Poseuses*) (1888, Barnes Foundation, Philadelphia).

In the 1890s, Laugé's portraits shared the same sense of silence and luminous space that characterizes his landscapes. Monumentality and sensibility define this work, which demonstrates to what degree Laugé had grasped the lessons of Seurat. NT

PROVENANCE: Achille Astre Collection; returned to Laugé by A. Astre at the time of his divorce and departure from Carcassonne in 1905; gift of the artist to the museum, 1930.

EXHIBITIONS: Independents, Paris, 1894, no. 452, as *Portrait de Mme B.*; Grande salle de la Mairie, Carcassonne, *Exposition languedocienne, section des Beaux-Arts,* 1897, as *Portrait de Mme B.*; Musée Petiet, Limoux, *Art vivant d'hier et d'aujourd'hui: Hommage à Laugé,* 1958, no. 3; Musée des Augustins, Toulouse, *Achille Laugé et ses amis Bourdelle et Maillol,* 1961, no. 15; Chambre de Commerce, Carcassonne, 1963; Musée de l'Annonciade, Saint Tropez, 1990; Musée des Beaux-Arts, Carcassonne, 1990, *Achille Laugé (1861–1944): Portraits pointillistes,* no. 3; Musée Paul Dupuy, Toulouse, *1900: Toulouse et l'art moderne,* 1990–91, no. 14; Museum of Art, Kochi, Utsunomiya Museum of Art, National Museum of Modern Art, Kyoto, Seiji Togo Memorial Yasuda Kasai Museum of Art, Tokyo, *Georges Seurat et le Néo-Impressionnisme, 1885–1905,* 2002, no. 101; Palazzo Reale, Milan, *Georges Seurat, Paul Signac e i neoimpressionisti,* 2008–9, no. 58; Musée des Beaux-Arts, Carcassonne, *Du portrait au XIX*ᵉ *siècle dans les collections du musée des Beaux-Arts de Carcassonne,* 2009, no. 39; Musée des Beaux-Arts, Carcassonne, Musée Petiet, Limoux, Musée de la Chartreuse, Douai, *Achille Laugé: le point, la ligne, la lumière,* 2009–10, no. 9; National Gallery of Victoria, Melbourne, *Radiance: The Neo-Impressionists,* 2012–13, 96–97 and 106.

BIBLIOGRAPHY: Gustave Geffroy, "Introduction," in *Exposition de quelques dernières peintures d'Achille Laugé,* exh. cat. (Paris: Galerie Achille Astre, 1907), 10–11; Achille Astre, "Achille Laugé, peintre et lithographe," *Souvenirs d'art et de littérature* (Paris: Éditions du Cygne, 1930), 63–64; *Catalogue du musée des Beaux-Arts de Carcassonne* (1948), no. 687; Pierre Cabanne, "Achille Laugé et la lumière," *Jardin des arts* 180 (November 1969): 34–37; Nicole Tamburini, *Achille Laugé,* mémoire de 3ᵉᵐᵉ cycle de l'École du Louvre (1989), 104–20.

1. After he and his wife divorced in 1905, Achille Astre opened a painting gallery in Paris, at 52 rue Laffitte, and later moved to rue des Orfèvres. In 1908 he joined the Gobelins Manufactory as secretary to Gustave Geffroy, a post he held until Geffroy died in 1926. Astre wrote many articles and books. He called the attention of Geffroy, who was also an art critic, to the work of his friend Laugé, whom he ardently supported. Astre was also a friend of Raoul Ponchon, who produced little shows for the *Chat Noir,* the cabaret in Montmartre, in collaboration with Henri Rivière and Adolphe Willette.
2. Gustave Geffroy, "Introduction," in *Exposition de quelques dernières peintures d'Achille Laugé,* exh. cat. (Paris: Galerie Achille Astre, 1907), 10–11.
3. We recognize the cover of the review's first issue, dated July 6, 1888. Adolphe Willette, who was himself nicknamed Pierrot, identified with this character at the Chat Noir, for which he created the *Journal.* He published this four-page weekly, illustrated with his satirical drawings, until March 1891, the date of its bankruptcy. When it entered the public domain, the title was revived by François-Rupert Carabin, who retained his friend Willette as designer.

PLATE 7

Achille Laugé

French, 1861–1944

Profile of Madame Laugé, c. 1894

Pastel on paper, 19 × 24¼ in. (48.3 × 61.5 cm)
Blue studio stamp lower right: A Laugé
Galerie Moulins, Toulouse

As an accomplished pastel artist, Laugé took full advantage of the medium's subtleties and bold expressive possibilities. Many late nineteenth-century artists were intrigued by the potential of pastels. The medium experienced a significant revival and attracted renewed interest from the avant-garde generation (including Degas, Gauguin, Redon, and Toulouse-Lautrec), as well as from many traditional painters of southwestern France. Véronique Gautherin has noted that since the sixteenth century Toulouse had owed its prosperity to the production of pigmented sticks of calcium carbonate in a wide array of colors.[1] Regional artists' affection for pastels probably derives from this tradition.

Laugé sometimes prepared canvas for his pastels, preferring to work on brushed cotton supports rather than on paper. He rarely blended stumps in his drawings, thus preserving a sense of vigor on his surface. Crosshatched with nervous, taut lines, his pastels are reminiscent of Jean-François Millet's work, and never indistinct. He juxtaposed and interwove successive threads of color in vivid, luminous combinations. Traces of the pencil underdrawing can often be discerned.

Among Laugé's many pastel portraits, several correspond to his painted works, although we cannot be certain whether they were truly preparatory sketches. In Laugé's case, it would seem more appropriate to speak of variations on a single theme, a view that is consistent with his treatment of landscapes. In this case, there is another portrait of Madame Laugé, painted in oil on canvas (undated, private collection), that presents the model in the same pose as in the pastel, with a similar hairstyle and dress.

The pastel's monochromatic purple palette suggests that Laugé deliberately limited this work to contrasting values,

following Seurat's approach to drawing. The modulated, delicate crosshatching makes the forms seem to leap out from the paper. The flower studies in the border are drawn freehand in vivid yet delicate tones; they give the composition a hint of Japonisme and evoke Odilon Redon's mysterious flowers. It is not certain that Laugé was familiar with Redon's work at this time, but the artist was well represented in the region between Béziers and Carcassonne, in the collections of Maurice Fabre de Gasparets and Gustave Fayet, the future owner of Fontfroide Abbey. These collectors had ties with Georges-Daniel de Monfreid, Gauguin's confidant, through Aristide Maillol, a friend of Laugé's during his youth.

It is interesting to note that in 1912 Gustave Geffroy, the director of the Gobelins Manufactory, commissioned models of flowers to be used in tapestry cartoons from two artists: Odilon Redon and Achille Laugé. As Gabriel Sarraute has suggested, Geffroy was probably well aware of the intriguing contrast between "Laugé, with his naturalistic flowers, as closely studied as human faces," and "Redon, whose flowers are the stuff of dreams."[2] NT

PROVENANCE: Yvonne Tan Bunzl, London; Galerie Moulins, Toulouse.

EXHIBITIONS: Musée des Beaux-Arts, Carcassonne, Musée Petiet, Limoux, Musée de la Chartreuse, Douai, *Achille Laugé: Le point, la ligne, la lumière,* 2009–10, no. 13.

BIBLIOGRAPHY: Yvonne Tan Bunzl, *Master Drawings* (London, 2003), no. 38, as *Portrait of a Woman.*

1. Véronique Gautherin, "Émile Antoine Bourdelle, oeuvres graphiques," *Bulletin du musée Ingres* 10 (January 1962): 11.
2. Gabriel Sarraute, "Introduction," in *Art vivant d'hier et d'aujourd'hui, Hommage à Laugé,* exh. cat. (Limoux: Musée Petiet, 1958), n.p.

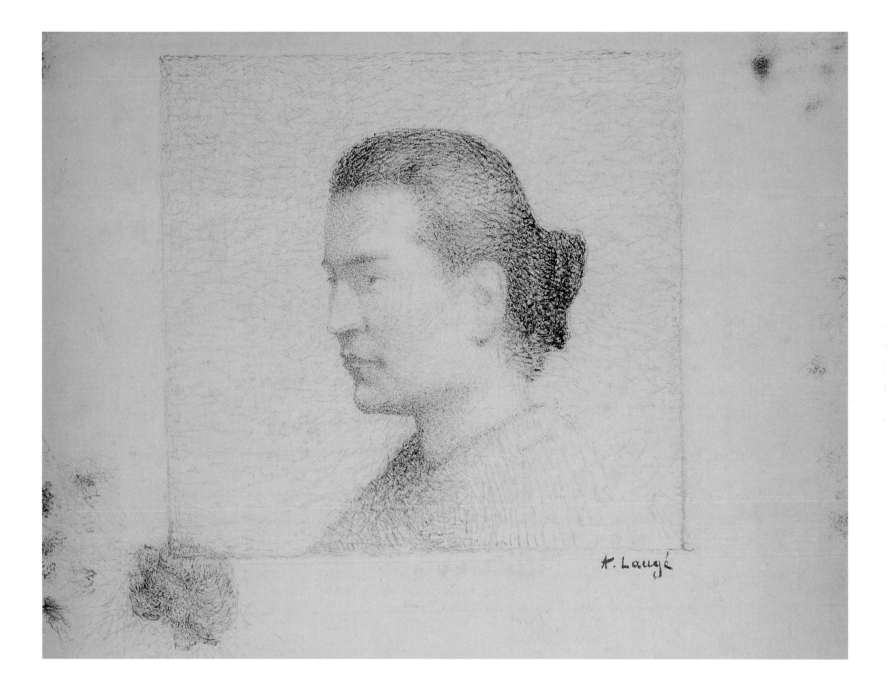

PLATE 8

Achille Laugé
French, 1861–1944

Portrait of the Artist's Mother (*Portrait de la mère de l'artiste*), c. 1894–95

Charcoal with chalk highlights on paper, 17¾ × 15¾ in. (45 × 40 cm)
Blue studio stamp lower left: A Laugé
National Gallery of Art, Washington, Purchased as a Gift in Memory of Melvin R. Seiden, 2013

Even from his youth, Laugé's artistic training included diligent drawing practice, particularly in charcoal. He generally confined his use of this medium to portraiture for stand-alone works; they were not preparatory sketches for paintings. In his recollections of the years 1889–91, Achille Astre recalled, "Under the lamp that lit the room where we gathered at nighttime, Laugé would explore the features of one of us, creating a faithful likeness."[1]

Laugé's close friend Antoine Bourdelle had already emphasized his talent in this area, as Bourdelle's friend J. Girou later recounted: "Bourdelle wanted to show me his portrait by Achille Laugé; the charcoal had captured him young, just as he was starting out, when they were sharing the same room and the same loaf of bread together; he called my attention to the enveloping gentleness that haloed the features; it was the result of stumping by Henri Marre just before the drawing was sent to the Salon. 'Laugé's work was sharper, more vigorous,' he emphasized; 'He's a great artist, not sufficiently recognized: his time will come.'"[2]

Catherine Laugé, born Catherine Gazel in 1819, was forty-two at the birth of Achille, her youngest child. She was about seventy-five years old at the time of this portrait, which Laugé exhibited at the third Salon in Carcassonne in 1895. Light is powerfully evoked by strong contrast, as geometry is marked by a sense of volume; both are typical of the powerful expression of Laugé's charcoal portraits. The elements that constitute the architecture of the face are not defined by outlines; they are created through volume, and individual details are elided. The dots and hatchings do more than merely fill in the forms—they actually create the forms through the interplay of shades. With its contrasts of light and shadow perfectly intact, this drawing represents a magnificently preserved example of a Neo-Impressionist portrait drawing.

In his review of the salon for *La Revue méridionale,* Albert Sarraut, writing under the pseudonym de Rozario, commented: "First a charcoal by Laugé; a portrait of an elderly woman, robust and strong, superbly lit, full of life, with impeccable draftsmanship."[3] Victor Gastilleur also admired the work: "It is a miracle of elegance and observation; we can study the lean,

delicate face of this elderly lady with unmitigated delight. Life, a life that is drawing to a close, illuminates the timeworn face with a shimmering, ephemeral glow. It pervades everything: the small, bright, inquisitive eyes, where it is most intense; the thin, pale lips; the fragile, delicate bones of her prominent aquiline nose. . . . The traditional white coiffe worn by the women of Razès frames her expressive face like a halo, adding to the charm."[4]

With his meticulous technique of finely crosshatched lines, the artist explores the entire range of grays, from deepest black to pure white, which he achieves by leaving parts of the paper blank, then using white chalk to highlight the immaculate coiffe. The model's intense, direct gaze accentuates the evocative power of this image, where the contrasts and the simplification of form do not detract from the sensitivity of the psychological analysis. The artist's mother exudes both energy and serenity, observing her son—and thus the viewer—with a sense of resolve that is also found in Laugé's self-portraits. NT

PROVENANCE: Achille Laugé studio, second sale, Mes Audap, Godeau, Solanet, Paris, March 11, 1977, no. 21; Maître Lucien Solanet, Paris, 1977; his descendants by inheritance; PIASA, Paris, March 27, 2008, no. 73; W. M. Brady & Co., New York, 2009; James T. Dyke, 2011; purchased by the National Gallery of Art, Washington, DC, 2013.

EXHIBITIONS: Grande salle de la Mairie, Carcassonne, *3ème Salon carcassonnais,* 1895; Musée des Beaux-Arts, Carcassonne, Musée Petiet, Limoux, Musée de la Chartreuse, Douai, *Achille Laugé: Le point, la ligne, la lumière,* 2009-10, no. 99 (exhibited in Douai only); Musée des impressionnismes, Giverny, 2012, *De Delacroix à Signac: Dessins de la collection Dyke,* National Gallery of Art, Washington, DC, *French Drawings, Watercolors, and Pastels from Delacroix to Signac,* 2012-13, no. 80.

BIBLIOGRAPHY: *La Revue méridionale* (Carcassonne: Servière, 1895), 51; Victor Gastilleur, *Achille Laugé, peintre languedocien,* preface by Albert Sarraut (Carcassonne: Éditions Servière et Patau, 1906), 15-16; *Connaissance des Arts* 303 (May 1977): 139; Nicole Tamburini, *Achille Laugé,* mémoire de 3ème cycle de l'École du Louvre (1989), 100-101; *Drawings and Oil Sketches, 1700-1900* (New York: W. M. Brady, 2009), no. 28, as *Mme Catherine Laugé (née Gazel), the Artist's Mother.*

1. Achille Astre, "Achille Laugé, peintre et lithographe," *Souvenirs d'art et de littérature* (Paris: Éditions du Cygne, 1930), 59-60.
2. Jean Girou, *Profils occitans* (Carcassonne, 1930), 28.
3. *La Revue méridionale* (Carcassonne: Servière, 1895), 51.
4. Victor Gastilleur, *Achille Laugé, peintre languedocien* (Carcassonne: Éditions Servière et Patau, 1906), 15-16.

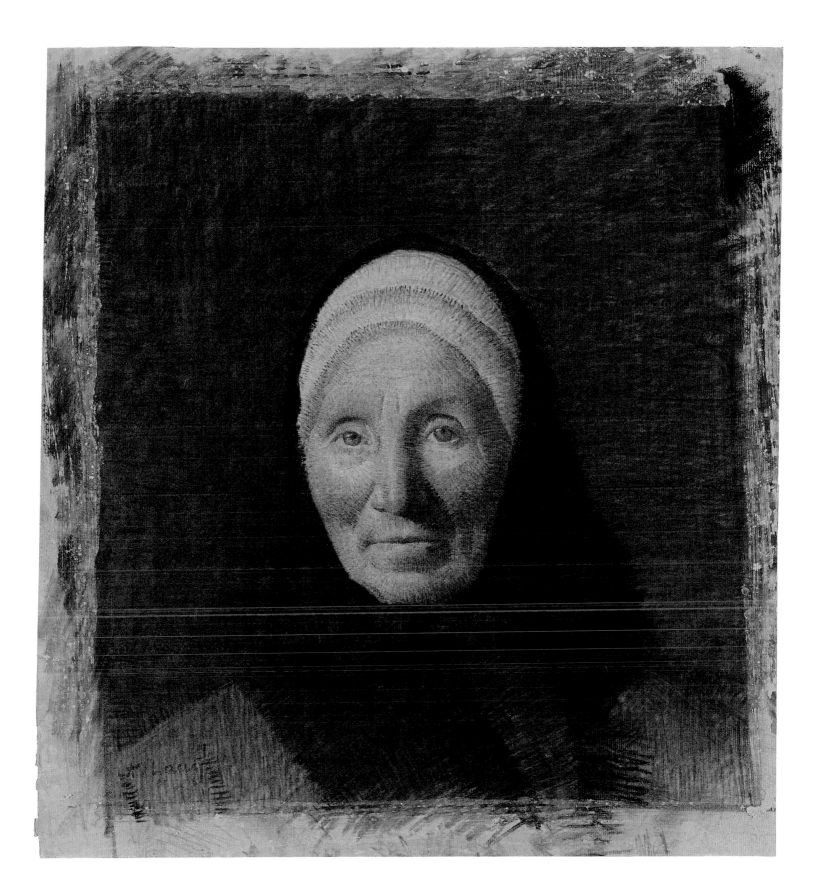

PLATE 9

Achille Laugé

French, 1861–1944

Self-Portrait in a White Beret (*Autoportrait au béret blanc*), c. 1895–96

Oil on canvas, 15⅜ × 19¼ in. (39 × 49 cm)
Apocryphal signature, applied between 1961 and 1969, lower left: A Laugé
Collection of Robert Bachmann, Lisbon

With its divisionist use of color and purity of form, *Self-Portrait in a White Beret* features the basics of Laugé's work. Volumes are simplified and treated as large masses in order to focus attention on the essential. While Laugé was using dots of color in 1892–93, by 1895–96 he began to favor a system of delicate crosshatched lines, a network of interwoven and overlapping strokes that juxtaposed colors, allowing the eye to blend the pigments. He followed the precepts articulated by Signac: "Divisionism does not by any means require use of a stroke in the form of a dot. . . . To avoid muddiness of color, the size of the divided touch must be in proportion to the dimensions of the work. The divided brushstroke is flickering, vibrant, 'light,' not a uniform, lifeless, 'material' dot."[1]

A masterly demonstration of this new technique, *Self-Portrait in a White Beret* shows the artist's command of the Neo-Impressionist fragmentation of color. Laugé's palette was very restrained throughout his life, confined to primary colors (blue, red, and yellow) and their complements (orange, green, and violet). Red and yellow predominate in luminous areas, while violet and green prevail in the shadowed sections. Based on this simplified approach, the painter devised the contrasts of hues and tonalities, modulating the shading and juxtaposing complementary colors.

The art student's traditional black beret, transformed here into dazzling white, is another example of the dexterity demonstrated in his great female portraits of 1892–93. Brushstrokes, interlaced with a sure, swift hand, render the artist's likeness at the age of about thirty-five. The alertness of his expression and keenness of his gaze show us the determination of this man, as described by his friend Jean Girou: "His character was entirely of a piece, unbending and plainspoken. Laugé is curt, brusque, and as straight as a broom plant that's been stripped of its floral finery. He is unpretentious, but perhaps capable of a certain unassuming pride. Beneath his austere, reserved demeanor, Laugé has a big heart that commands a forthright honesty and an enduring, unwavering dedication to friendship."[2]

Laugé rendered the passage of time through a series of self-portraits, from the young artist with the open gaze and determined brow of the 1890s to the mature man whose weary face had softened with the passing years. More than ten portraits have been identified. Do they represent deep introspection and a desire to tell his life's story, as is the case with other artists, or was he simply content to find an ever-willing and available model facing him in the mirror? A deeply private man, Laugé revealed very few of his thoughts; painting seems to have been almost his sole means of communication. His self-portraits scrupulously adhere to representational accuracy, but they give only a hint of the soul beneath.

Sometime between 1930 and 1937 he painted *Self-Portrait in a Round Hat,* a painting that seems to be a moving response to *Self-Portrait in a White Beret.* Like Rembrandt in his last self-portraits, the painter depicts himself without artifice, remote from the vanities of the world, with the simplicity and lucidity of maturity. In this late work Laugé assumed his divisionist style, using the juxtaposed brushstrokes in four colors that were the foundation of his work. "I'm beginning to see what it is that I want to do, and in a little while, I'll do it better," Laugé mischievously confided to Jean Mistler in June 1927, during an exhibition of his work at the Galerie Georges Petit.[3] Very few Neo-Impressionist artists who had adopted Seurat's technique in the 1890s persevered with the divisionist style in their brushstrokes and colors as late as the 1930s.　　NT

PROVENANCE: Achille Laugé studio sale, Mes Audap, Godeau, Solanet, Paris, March 5, 1976, no. 55; Robert Bachmann, Lisbon.

EXHIBITIONS: Musée des Augustins, Toulouse, *Achille Laugé et ses amis Bourdelle et Maillol,* 1961, no. 22, unsigned; Galerie Marcel Flavian, Paris, *Rétrospective Achille Laugé, 1861–1944, Peintre néo-impressionniste,* 1969, no. 5, signed; Musée des Beaux-Arts, Carcassonne, Musée Petiet, Limoux, Musée de la Chartreuse, Douai, *Achille Laugé: Le point, la ligne, la lumière,* 2009–10, no. 1.

BIBLIOGRAPHY: Pierre Cabanne, "Achille Laugé et la lumière," *Jardin des arts* 180 (November 1969): 36; Nicole Tamburini, *Achille Laugé,* mémoire de 3ème cycle de l'École du Louvre (1989), 126-27.

1. Signac, *D'Eugène Delacroix au néo-impressionnisme* (1987 ed.), 121–22.
2. Jean Girou, "Achille Laugé," *Peintres du Midi* (Paris: Librairie Floury, 1938), 117.
3. Quoted in the preface of the catalogue.

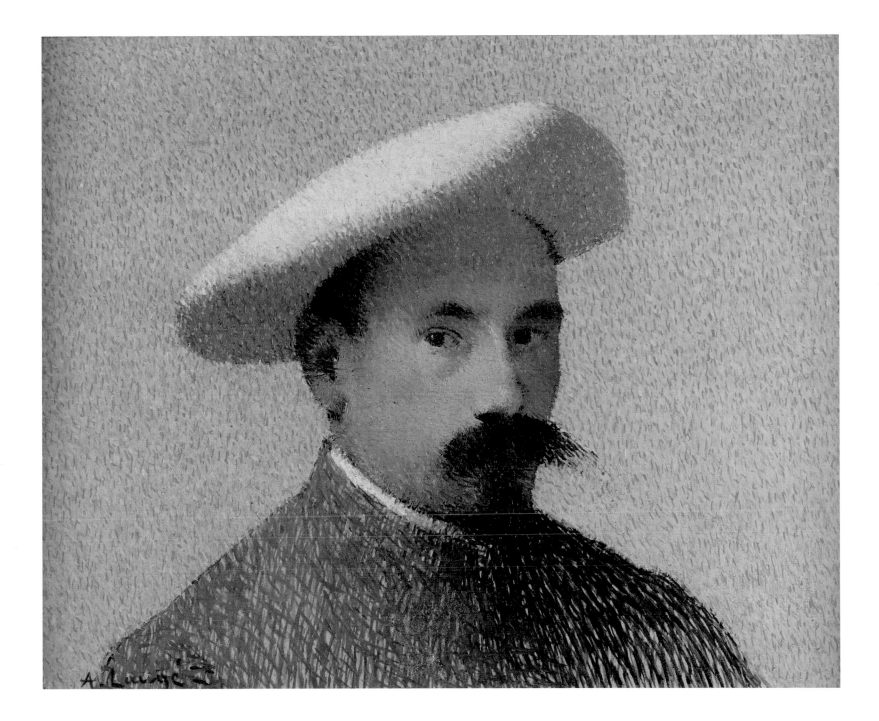

PLATE 10

Achille Laugé

French, 1861–1944

Against the Light—Portrait of the Artist's Wife (*Contre-jour—Portrait de la femme de l'artiste*), 1899

Oil on canvas, 36⅝ × 44⅛ in. (93 × 112 cm)
Signed and dated lower left: A Laugé 99
Musée d'Orsay, Paris (on deposit at the Musée de Grenoble)

Laugé sent this picture to Paris to be exhibited at the Salon de la Société Nationale des Beaux-Arts in 1900, but it was rejected, along with his *Before the Window* (*Devant la fenêtre*) (see plate 11). The figure is posed against a landscape backdrop, which was unusual in Laugé's work but very common in that of his friends Aristide Maillol and Henri Martin.

Laugé's wife is depicted seated in front of the garden of their house, L'Alouette, on the outskirts of Cailhau. Rejecting the traditional use of a window as a framing element, Laugé sets his model directly in front of the landscape. There is no area of shadow on the ground, and no suggestion of any awning that would explain the backlighting of the painting's foreground. These features, combined with Madame Laugé's impassive expression and hieratic pose, halfway between the Mona Lisa and Juno brandishing her sceptre, contribute to the painting's aura of strangeness.

The influence of Laugé's first teacher, Jean Jalabert (1815–1900), his drawing professor in Carcassonne, is present in the composition's striking geometry and the model's frontal pose beside the tall flowers. *Against the Light* also presents certain similarities with Douanier Rousseau's large portraits of women.[1] However, there are profound differences between these two artists: Laugé's subtle pictorial technique in this work confronts issues very different from those of Rousseau. Laugé was by no means the "naïf" of Neo-Impressionism, least of all in this work.

Against the Light is a novel example of a portrait in which the artist presents himself with a major challenge; by placing the figure in the deeply shadowed foreground, while the landscape in the background is flooded with sunshine, he risks "sacrificing" his model. The fact that she is his wife implies that this portrait is an experiment, which would have been impossible to attempt in a commissioned work. The backlighting in this painting is inseparable from issues raised by photography: this medium was one of the major preoccupations of the period's artists, particularly the Neo-Impressionists, who were fascinated by the interaction of color and light. In this painting Laugé demonstrated the superiority of the human eye over the camera's lens: even against backlighting, the eye can discern details within the shadows that photography cannot render. This ocular superiority can be shown only if the Neo-Impressionist technique is applied with the utmost rigor. Laugé, who sometimes worked from photographs, experimented here with the opportunities offered by this pictorial style, using an approach that was just as scientific and demanding as that of the originators of Neo-Impressionism.

Numerous preparatory studies (sketchbook, isolated larger-format drawings) attest to Laugé's extensive research on how best to depict the face and hands, the figure's pose, and the hollyhocks. Laugé did not shrink from the challenges of Divisionism, using it in works that were large-format portraits. Perhaps he was thinking of Seurat's *Models* (*Les Poseuses*) (1888, Philadelphia, Barnes Foundation). Similarly, both artists created a direct link with another ambitious composition painted during the same time: *La Grande Jatte* for Seurat, which can be seen in the background of *Models,* and *Before the Window* in Laugé's case, where his wife was depicted with the same hairstyle and dress.

The contrast between the sundrenched landscape and the figure's shadow-theater effect, the absence of perspective, the graceful silhouettes of the hollyhocks, the precision in the outlines of the trees, the dress, and even the model's little black chignon, all evoke the influence of the Japanese print. The superimposed picture planes of sky, fields, road, hedges, and terrace are treated in delicate harmonies of blue, yellow, green, and pink, slightly muted by the intense sunshine and punctuated by the verticality of the almond trees, the willow, and the vividly colored hollyhocks. The model's serenity is echoed in the horizontality of a landscape sweltering in the heat of a summer day. NT

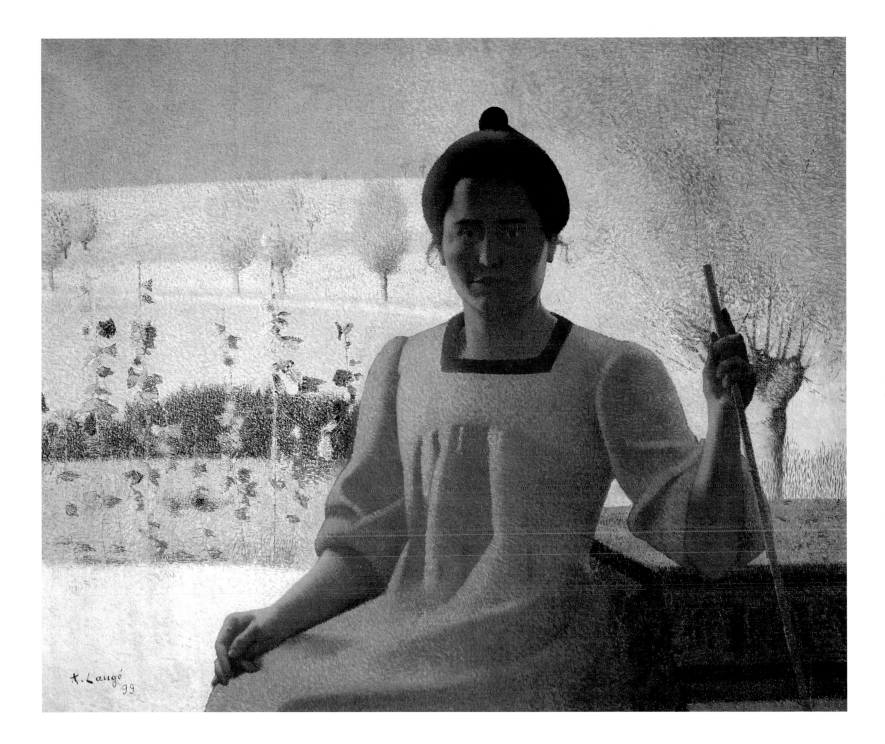

PROVENANCE: Achille Laugé studio sale, Mes Audap, Godeau, Solanet, Paris, March 5, 1976, no. 63; purchased by the Réunion des Musées Nationaux; transferred to Musée du Jeu de Paume; transferred to Musée d'Orsay, Paris, 1977; on loan to the Musée de Grenoble.

EXHIBITIONS: Musée des Augustins, Toulouse, *Achille Laugé et ses amis Bourdelle et Maillol,* 1961, no. 26; Galerie Marcel Flavian, Paris, *Rétrospective Achille Laugé, 1861–1944, Peintre néo-impressionniste,* 1969, no. 2; Centre culturel Sejong, Seoul, *Le postimpressionnisme,* 1978, no. 11; Musée de l'Annonciade, Saint-Tropez, 1990; Musée des Beaux-Arts, Carcassonne, 1990, *Achille Laugé (1861–1944): Portraits pointillistes,* no. 13; Musée de l'Hermitage, Lausanne, Municipal Museum of Art, Takamatsu, Musée des Beaux-Arts, Ishikawa, Musée de Mitsukoshi, Shinjuku, *De David à Picasso: les chefs d'oeuvre du musée de Grenoble,* 1992–93, no. 36; Wallraf-Richartz Museum, Cologne, Fondation de l'Hermitage, Lausanne, *Pointillisme: Sur les traces de Seurat,* 1997–98, no. 63; Musée des Beaux-Arts, Valence, *Le portrait, XIXème–XXème siècles,* 2001; Musée d'Orsay, Paris, *Le néo-impressionnisme, de Seurat à Paul Klee,* 2005, 223; Fundación MAPFRE, Madrid, *Neoimpresionismo, la eclosión de la modernidad,* 2007, no. 33; Musée des Beaux-Arts, Carcassonne, Musée Petiet, Limoux, Musée de la Chartreuse, Douai, *Achille Laugé: Le point, la ligne, la lumière,* 2009–10, no. 22.

BIBLIOGRAPHY: Raymond Escholier, "Achille Laugé, peintre de la lumière langue-docienne," *L'Art vivant* (February 15, 1928): 153; *Revue du Louvre* 2 (1977): 97; Nicole Tamburini, *Achille Laugé,* mémoire de 3ème cycle de l'École du Louvre (1989), 128–31; Catherine Chevillot and Serge Lemoine, *Peintures et sculptures du XIXème siècle: La collection du musée de Grenoble* (Paris: Réunions des musées nationaux, 1995), 202; Association Rhône-Alpes des Conservateurs, *Portrait: Le portrait dans les collections des musées Rhône-Alpes* (Paris: Réunions des musées nationaux, 2001), 238 and 336.

1. Laugé could have seen Rousseau's work at the Salon des Indépendants, particularly in 1886, 1887, and 1888. However, it is impossible to know whether the artist became familiar with Rousseau's great *Portrait of a Woman (Portrait de femme)* (c. 1895–97, Musée d'Orsay, Paris) during his brief visits. In Rousseau's portrait, the figure stands out as a majestic presence, an impassive dark silhouette against a light background, grasping an umbrella in front of a meticulously rendered, dense vegetation.

PLATE 11

Achille Laugé

French, 1861–1944

Before the Window (Devant la fenêtre), 1899

Oil on canvas, 48⅜ × 59 in. (123 × 150 cm)
Signed and dated lower right: A Laugé 99
Petit Palais, Musée d'art moderne, Geneva

The only interior currently known in the artist's body of work, *Before the Window* combines the many facets of Laugé's talent: portraiture, still life, and landscape. Madame Laugé knits as her niece tends to ironing; they are in the painter's studio in his home in Cailhau. From the window we see the neighboring house, La Gardie, which the artist painted on so many occasions. Easily recognizable is the allée of almond trees that leads to the house surrounded by cypresses, just as it appears in *La Gardie, near Cailhau (La Gardie, près de Cailhau)* (1902, Musée d'Orsay, Paris).

As usual, Laugé conveys a precise rendering of the landscape's light and season—here, it is very early spring. The almond trees of La Gardie are in flower, but the elm in front of the studio is still leafless. However, the bouquet of autumnal chrysanthemums on the table does not correspond to the season, showing the painter's willingness to make the interior scene remote from actual time and space. The immediate impression of the natural world outside contrasts with the rendering of timeless figures within; Laugé thus embraces the Neo-Impressionist approach of combining the momentary with the eternal. *Before the Window* is a work that exemplifies the dual nature of Laugé's art, with elements of both Impressionism and Neo-Impressionism.

The format and complexity of the composition of this ambitious work demonstrate the artist's determination to make his paintings part of the grand artistic tradition; there are many allusions here.[1] Like Seurat's *Models (Les Poseuses)* (1888, Philadelphia, Barnes Foundation), which he may have seen at the Independents, this is a representation, on a grand scale, of the painter's studio when the artist himself is not present. *Models* also includes figures, a still life, a landscape, and sketches on the wall; in this case, the drawing in the picture's background is an homage to Laugé's illustrious predecessor, the Carcassonne painter Jacques Gamelin (1738–1803).[2]

Although they may be actual portraits, the figures seem to have no psychological interaction; their mouths closed, their eyes downcast, the two women have retreated into themselves, concentrating on their work. This approach is a powerful reminder of the similarity of Laugé's work to Signac's, particu-

larly the latter's *The Dining Room, Opus 152 (La salle à manger. Opus 152)* (fig. 33), which was in turn inspired by Caillebotte's *The Luncheon (Le déjeuner)* (1876, private collection).

In contrast to the formal domestic rituals of the bourgeoisie depicted by Caillebotte's and Signac's middle-class repasts, here we witness the labor-intensive occupations of rural life. Laugé may have seen Signac's picture, which was exhibited in the Independents in the Pavillon de la Ville de Paris in 1887. In this painting we find foreshortened perspective, geometric silhouettes, static poses, and gravity and solemnity in figural representation that recall the grandeur of the Quattrocento. Madame Laugé's figure is shown in profile in the foreground, backlit, like the man in Signac's painting; the woman ironing, with her oval face, bends forward, recalling the young woman—in a dark bodice and drinking a cup of coffee—who stands out against the luminous window in *The Dining Room, Opus 152*.

As Françoise Cachin points out: "Seurat and Signac deliberately painted inexpressive figures, since 'all movements of joy or sorrow are transient'; they sought to create images and types rather than portraits. . . . Expressiveness was not permitted to

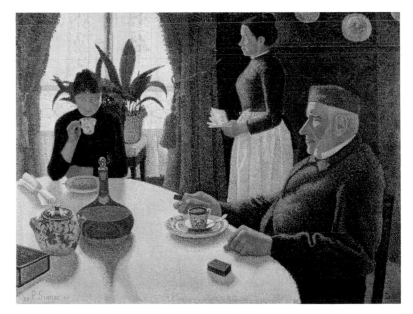

Fig. 33. Paul Signac, *The Dining Room, Opus 152 (La Salle à manger. Opus 152)*, 1886–87. Oil on canvas, 35¼ × 45⅞ in. (89.5 × 116.5 cm). Collection Kröller-Müller Museum, Otterlo.

detract from the style[,] and the pleasure or interest that the picture might evoke must come only from its lines, contrasting values, and colors."[3]

In this work, which is far removed from the ephemeral, spontaneous Impressionist vision, the simplification of forms is associated with meticulous brushwork: spiky for the chrysanthemums, fleecy on the hair at the nape of Madame Laugé's neck, and crisscrossed on the tablecloth. The colors are restricted to a minimalist palette, broken down in large areas; zones of white shaded with mauve alternate with shades of red verging on orange. The composition's lines, an interplay of parallel elements, echo those of the window and the mantel, continuing with the surface of the table. They form a balance of contrasts, and the rigor of these disciplined lines alone can fully absorb the viewer's attention. This traditional genre scene is so stylized that it becomes almost dehumanized, no doubt explaining the work's rejection by the Salon de la Société Nationale des Beaux-Arts in 1900, along with Laugé's *Against the Light—Portrait of the Artist's Wife* (*Contre-jour—Portrait de la femme de l'artiste*) (see plate 10). NT

PROVENANCE: Achille Laugé studio sale, Mes Audap, Godeau, Solanet, Paris, March 5, 1976, no. 69; Oscar Ghez, Geneva; Petit Palais, Musée d'art moderne, Geneva.

EXHIBITIONS: Musée des Augustins, Toulouse, *Achille Laugé et ses amis Bourdelle et Maillol,* 1961, no. 29; Galerie Marcel Flavian, Paris, *Rétrospective Achille Laugé, 1861-1944, Peintre néo-impressionniste,* 1969, no. 1, as *Marie, the Artist's Wife and a Woman Ironing* (*Marie, la femme de l'artiste et la repasseuse*); Petit Palais, Musée d'art moderne, Geneva, *La femme corps et âme,* 1986, no. 25; Musée de l'Annonciade, Saint-Tropez, 1990; Musée des Beaux-Arts, Carcassonne, 1990, *Achille Laugé (1861-1944): Portraits pointillistes,* no. 12; Wallraf-Richartz Museum,

Cologne, *Bildwelten des Impressionismus—Meisterwerke aus der Sammlung des Petit Palais in Genf,* 1994, no. 74; Petit Palais, Musée d'art moderne, Geneva, *Le Pointillisme,* 1996, no. 62; Wallraf-Richartz Museum, Cologne, Fondation de l'Hermitage, Lausanne, *Pointillisme: Sur les traces de Seurat,* 1997-98, no. 62; Musée Jacquemart-André, Paris, *De Caillebotte à Picasso—Chefs-d'oeuvre de la collection Oscar Ghez,* 2002-3, 68-69; Palazzo Martinengo, Brescia, *Da Caillebotte a Picasso—Capolavori della Oscar Ghez dal Museo del Petit Palais di Ginevra,* 2003, 71; Kunsthal, Rotterdam, *Shilders van Parijs, Van Renoir tot Picasso, Meesterwerken uit de collectie Oscar Ghez,* 2004-5, 144; Musée national des Beaux-Arts, Québec, *De Caillebotte à Picasso—Chefs-d'oeuvre de la collection Oscar Ghez,* 2006-7, no. 22; Musée des Beaux-Arts, Carcassonne, Musée Petiet, Limoux, Musée de la Chartreuse, Douai, *Achille Laugé: Le point, la ligne, la lumière,* 2009-10, no. 23; National Gallery of Victoria, Melbourne, *Radiance: The Neo-Impressionists,* 2012-13, 104.

BIBLIOGRAPHY: Pierre Cabanne, "Achille Laugé et la lumière," *Jardin des arts* 180 (November 1969): 34, as *L'épouse de l'artiste et la repasseuse; Alliance culturelle romande* 22 (November 1976): 110; *L'Amateur d'art* 662 (July–August 1980): 39; Germain Bazin, *L'univers impressionniste* (Paris: Éditions Somogy, 1981), 272; *629 oeuvres de Renoir à Picasso,* Musée du Petit Palais, Geneva (1981), no. 372; *Tribune des arts,* magazine of *La Tribune de Genève* 36 (March 1983): 8; René Huyghe, *Un siècle d'art moderne: L'histoire du Salon des Indépendants, 1884-1984* (Paris: Éditions Denoël, 1984), 103; Nicole Tamburini, *Achille Laugé,* mémoire de 3ème cycle de l'École du Louvre (1989), 86-89; A. Zahlreiche, "Erfrischende Schau der Schönen Bilder," *Kölner Stadt-Anzeiger,* no. 149, June 30, 1994, 37; *Faz,* August 2, 1994; Carole Varvier, "Il manque des points aux pointillistes du Petit Palais: Malgré un titre prometteur," *Tribune des arts* 241 (September 1996): 8.

1. Perhaps Laugé was thinking of the masterpiece by his compatriot Marie Petiet (1854-1893), *The Laundresses* (*Les Blanchisseuses*) (1882, Musée Petiet, Limoux). Petiet, one of the few women painters to be recognized in the nineteenth century, was married to Étienne Dujardin-Beaumetz.
2. The work above the mantel in Laugé's canvas is the engraving of a drawing by Gamelin in the Musée des Beaux-Arts de Carcassonne: *Cavalry Combat in Front of a Fortress* (*Combat de cavalerie devant une forteresse*). The engraving, probably by Jacques Lavallée, is certainly the same one shown here. Laugé himself engraved *Cabaret Scene* (*Scène de cabaret*) after Gamelin.
3. Françoise Cachin, *Paul Signac* (Paris: Bibliothèque des Arts, 1971), 22-23.

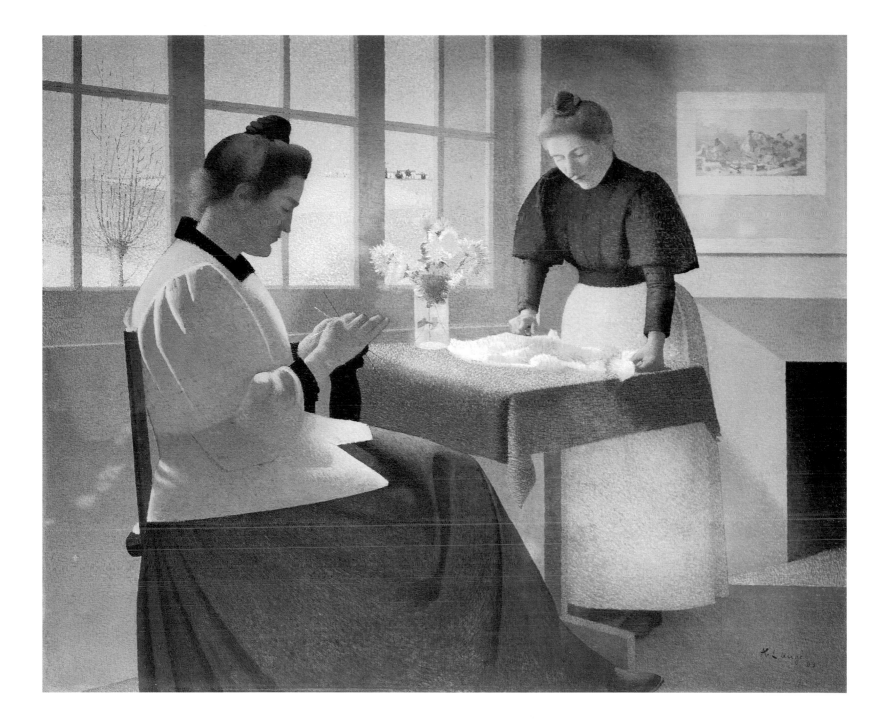

PLATE 12

Georges Lemmen
Belgian, 1865–1916

Jan Toorop, [1890]

Conté crayon on paper, heightened with white chalk, 21⅛ × 15⅜ in. (53.5 × 39 cm)
Stichting Hannema-de Stuers Fundatie, Heino, The Netherlands

In one of his first pointillist drawings, Lemmen shows the artist Jan Toorop (1858–1928) seated in profile, smoking his pipe and reading in an oversized chair in a moment of relaxation. Light gently filters through the window and bathes Toorop in a soft glow. Born in Java to Dutch parents with roots in Asia, Toorop had features that appeared distinctly exotic to his fellow Europeans. During a trip to London with Émile Verhaeren, the poet described Toorop affectionately as "this big boy with olive skin" who astounded Londoners with his "black head of hair with its steel reflections."[1] Despite the basic regularity of the dots, Lemmen captured the texture of Toorop's thick curly hair, his distinctive beard and mustache, and his dark complexion. Using white chalk, Lemmen emphasized the voluminous billowing curtain and its folds, the lamp, and Toorop's pocket handkerchief, shirt collar, and cuffs.

Lemmen and Toorop probably first met in Brussels as a result of their debut at the exhibition society L'Essor in 1883. Although not yet members of Les XX, both artists attended the funeral of Vingtiste Périclès Pantazis the next year.[2] Toorop became a member of Les XX in December 1884, four years before Lemmen. His Neo-Impressionist works date from 1888 and were first exhibited at Les XX in 1889. Toorop helped introduce the work of Seurat and the members of Les XX to Holland through an exhibition at the Panorama Society in 1889 in Amsterdam and the Art Circle (Kunstkring) in 1892 at The Hague.

Lemmen must have begun work on Toorop's portrait, which was created in Brussels, in late 1890, for he first exhibited it at Les XX in January 1891. Toorop's own entries that year consisted of Neo-Impressionist canvases as well as his new artistic shift toward Symbolism. Lemmen's portrait was praised by their friend, the poet and art critic Émile Verhaeren, for its improvisational quality and gift of "vivid penetration."[3] Promised the drawing by Lemmen, Toorop anxiously queried Octave Maus, guiding secretary of Les XX, about when he would receive it.[4] Lemmen kept the drawing for another year, submitting it in 1892 to the Association pour l'art in Antwerp, where it hung opposite Toorop's own works (see fig. 22). Lemmen complimented Toorop on his submissions, praising the Antwerp venue

as "truly the most artistic one we have in Belgium—devoid of the nonentities one finds at Les XX and the Independents in Paris—all the entries are interesting."[5] After the Antwerp exhibition Lemmen sent the work on to the Kunstkring exhibition at The Hague, for which Toorop was one of the principal organizers. Only after the close of the exhibition at The Hague could Toorop take possession of his prized portrait. JB

PROVENANCE: Jan Toorop; Kunsthandel Huinck en Scherjon, Amsterdam, 1952.

EXHIBITIONS: Les XX, Brussels, 1891, no. 3; Independents, Paris, 1891, no. 755; Association pour l'art, Antwerp, 1892, no. 13; *Tentoonstelling van Schilderijen en Teekeningen van eeningen uit de "XX" en uit de "Association pour l'art,"* Haagschen Kunstkring, The Hague, 1892, 20; Stedelijk Museum de Lakenhal, Leiden, *Moderne Belgische Kunst uit Nederlands Bezit,* 1955, no. 32; Kunstkring de Waag, Almelo, *Van Daumier tot Picasso,* 1956, 47, 78; E. J. van Wisselingh & Co., Amsterdam, *Johannes Theodor Toorop, Exposition de quelques tableaux aquarelles et dessins provenant de musées et collections privées néerlandaises,* 1970, no. 1; Horta Museum, Brussels, *Jan Toorop, 1858–1928,* 1970, no. 23; Gemeentemuseum, The Hague, *Licht door kleur: Nederlandse luministen,* 1976, no. 26; Institut Néerlandais, Paris, *Jan Toorop, 1858–1928,* 1977, no. 16 (the attribution date of 1886 is incorrect); Stichting Katwijks Museum, Katwijk, *Jan Toorop in Katwijk aan Zee,* 1985, no. 2; Rijksmuseum Vincent van Gogh, Amsterdam, *Neo-Impressionisten Seurat tot Struycken,* 1988, no. 56; Musée d'Ixelles, Brussels, *Georges Lemmen, 1865–1916,* 1997, no. 32.

BIBLIOGRAPHY: H. P. Bremmer, *Moderne Kunstwerken* (Amsterdam: W. Versluys, 1903), no. 48; A. Mak, *Oeuvres par Jan Toorop,* public auction, Amsterdam, May 15, 1928, no. 8; "Biografische Index," in *Nationale Herdenking, 1813–1963: 150 jaar Nederlandse Kunst* (Amsterdam: Stedelijk Museum, 1963); Dirk Hannema, *Beschrijvende catalogus van de schilderijen, beeldhouwwerken, aquarellen en tekeningen* (Rotterdam: Ad. Donker, 1967), no. 187, reproduction no. 227; Jane Block, "A Study in Belgian Neo-Impressionist Portraiture," *Art Institute of Chicago Museum Studies* 13 (1987): 44; Roger Cardon, *Georges Lemmen, 1865–1916* (Antwerp: Pandora, 1990), 83, 85; William Rothuizen, *Jan Toorop in zijn tijd (1858–1928)* (Amsterdam: Boxhorn, 1998), 20.

1. Émile Verhaeren, "Londres," *L'Art moderne,* September 27, 1885, 311.
2. Pantazis died on January 27, 1884; see "Nécrologie," *L'Avant-Garde,* January 31, 1884.
3. Émile Verhaeren, "Les XX," *La Nation,* February 10, 1891.
4. Toorop to Maus, January 19, 1891, Archives de l'art contemporain, 5739, Musées royaux des Beaux-Arts de Belgique, Brussels. Reproduced in Mertens, "De brieven van Jan Toorop aan Octave Maus," 180.
5. "C'est vraiment l'exposition la plus entièrement artiste que nous avons eue en Belgique; pas de non valeurs comme aux XX ou comme aux Indépendents à Paris: tous les envois sont intéressants." Lemmen to Toorop (1892), 12.422, Koninklijke Bibliotheek, The Hague.

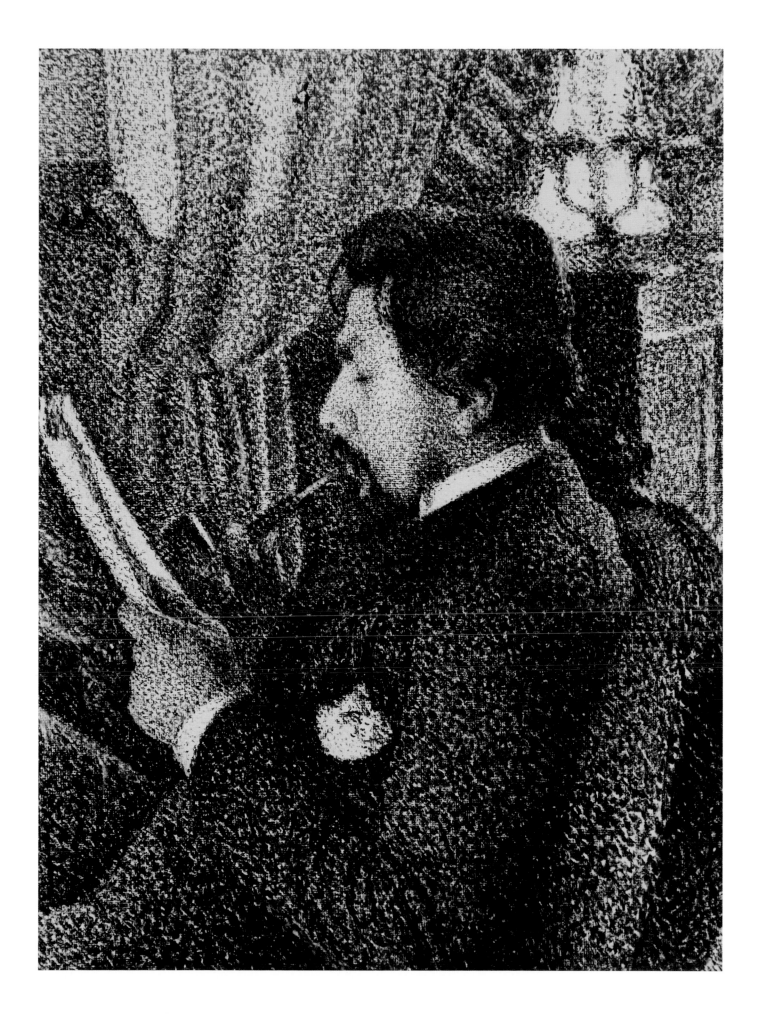

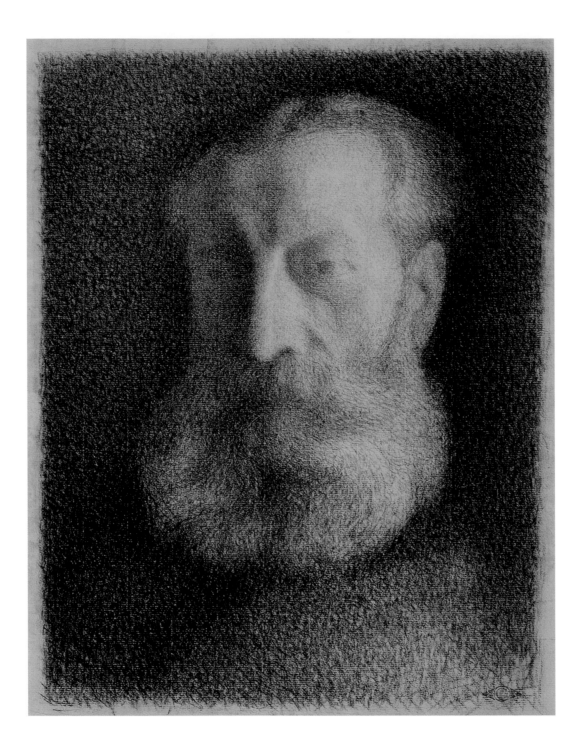

PLATE 13

Georges Lemmen

Belgian, 1865–1916

The Artist's Father (*Le Père de l'artiste*), 1890–91

Conté crayon on paper, 16¾ × 13¼ in. (42.7 × 33.5 cm)
Monogrammed stamp lower right: GL
Private collection

This dramatic portrait head presents the artist's seventy-year-old, heavily bearded father with an unfocused downcast stare, lost in thought. A retired engineer who headed the office of the Administration of the National Railroads, Frédéric Lemmen was also, according to family members, an amateur painter. His son portrays his stern visage emerging from dark shadows composed of dense crisscrossed strokes. Light cast from the right reveals a depressed lozenge on his furrowed brow that contrasts with his long aquiline nose above his soft beard. Despite the intensity of his gaze and demeanor, his countenance seems to soften as we explore the many subtleties of Lemmen's presentation of his father.

Born in Termonde, Belgium, about seventeen miles northwest of Brussels, Frédéric François Lemmen (1820–1897) married Caroline Sybille Gambon (1824–1924) in July 1849. Their union produced four children: two boys and two girls. Their eldest child and daughter, Laurence Julie (1851–1879), died when their youngest, Georges, was just a teenager. For most of Georges's life he lived at 156 rue Verte, Brussels, with his mother, father, and sister Julie (1852–1940). For several years after his marriage to Aline Maréchal in August 1893 he lived in a separate flat nearby, but after his father's death on October 30, 1897, Georges and Aline moved back to the family household with their two sons.[1]

The artist had included his father in many of the versions of *The Lamp* and the *Bourgeois Interior* and as early as 1887 had attempted his likeness in profile in an oil portrait.[2] Despite its size and finished quality, Lemmen never exhibited this drawing.　　　　　　　　　JB

PROVENANCE: Atelier of the artist; public auction, April 27, 1998, Pascal de Sadeleer, no. 100, 35–36; private collection.

EXHIBITIONS: Musée d'Ixelles, Brussels, *Georges Lemmen, 1865-1916,* 1997, no. 37.

BIBLIOGRAPHY: Roger Cardon, *Georges Lemmen, 1865-1916* (Antwerp: Pandora, 1990), 144.

1.　Their son Jacques was nearly two months old when the artist's father died, thus giving the elder Lemmen the pleasure of knowing his two grandsons. The third child, Elisabeth, was born in 1902. In 1915, Lemmen purchased two contiguous houses at 94 and 96 rue Coghen in Uccle, one for his mother and sister Julie and the other for his own family. He died the next year at age fifty-one.

2.　For the versions of *The Lamp* (*La Lampe*), see Cardon, *Georges Lemmen* (1997), 94 and 95; for the oil painting, 67.

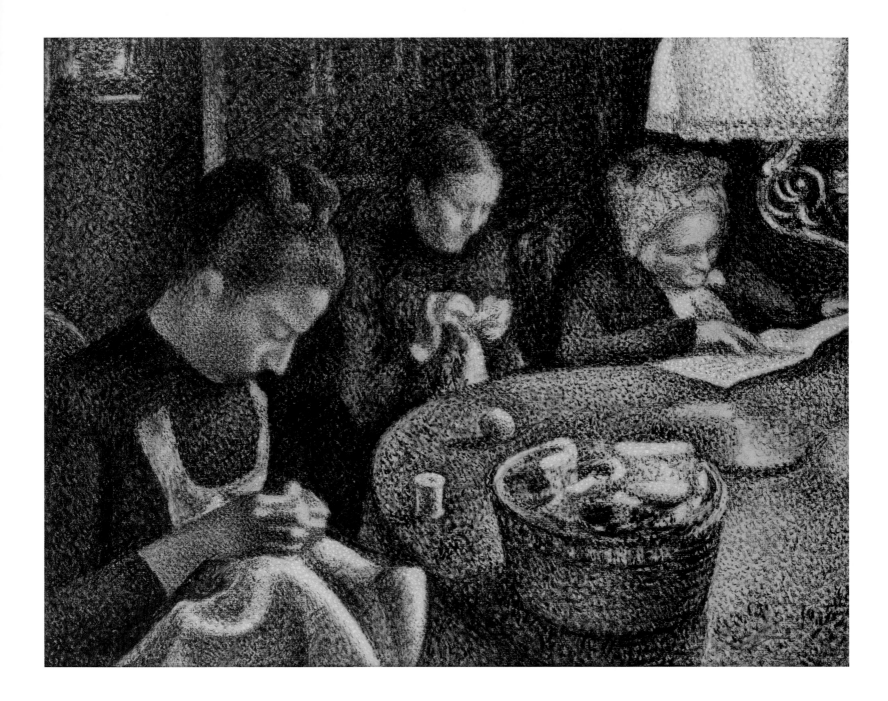

PLATE 14

Georges Lemmen

Belgian, 1865–1916

Study for Bourgeois Interior (Intérieur bourgeois), 1890–91

Conté crayon with charcoal and white gouache on paper, 18⅝ × 23⅜ in. (47.2 × 59.5 cm)
Inscribed verso, in graphite: Georges Lemmen/No. 5 Étude pour le No 1
Private collection

In 1891 Lemmen exhibited his first Neo-Impressionist works at Les XX. His five submissions were two oils, *Bourgeois Interior* and *Young Woman Crocheting* (see fig. 19), and three pointillist drawings—the portrait of Jan Toorop (see plate 12) and two studies for *Bourgeois Interior,* including the present work. Although the oil, described in the press as a "bourgeois interior, where the father, mother and two young girls are grouped around a table lit by a suspended lamp,"[1] has not come to light, this study of three women at a table, fully finished in the Neo-Impressionist manner, presumably gives us a very good idea of what it looked like.

Lemmen had been depicting *intimiste* scenes of his family members since 1886. For example, a detailed drawing dated June 12 and July 19, 1890, shows his parents, grandmother, and sister Julie sitting around the table in the evening, while a sketch dated a few months later, September 3, 1890, shows the same family members from a different angle.[2] Indeed, the artist recorded the scene in the sitting room of the Lemmen apartment on the rue Verte in Brussels in a multitude of conté crayon, sanguine, and ink drawings, studies in sketchbooks, some dating as late as January 1891, just before his exhibition of the oil at Les XX.[3]

Our "study" shows three generations of the Lemmen family: Julie in the foreground with head bent, sewing; their mother (Caroline Gambon) in the middle, sewing; and their maternal grandmother (Julia Courtoy), reading. Although Lemmen titled this work a study (*étude*), it is in every sense a self-sufficient and complete work. A true sketch, dated January 8, 1891, does survive, showing only Julie and her mother and executed in a quick manner and sinuous line.[4] In our drawing the artist has eliminated the linearity and concentrated on an overall patterned and cohesive effect. The lamp illuminates the faces, hands, and table. The varying shades of velvety black make this one of the artist's most elegant and subtle pointillist drawings. Each family member is contained and separated by a physical space and involved in a distinct task. The elements of silence and interiority link the drawing to the Symbolist movement.

The Parisian collector Édouard Kohn purchased both studies shown at the Les XX exhibition. The second study, listed in the Paris Independents catalogue as *Young Woman Sewing (Jeune femme cousant)* has not come to light.[5] JB

PROVENANCE: Purchased at Les XX, 1891, by Édouard Kohn; Kunsthandlung Gauss, Munich; Allan Frumkin, Chicago; Frumkin family, New York (1963–2007); Jill Newhouse, New York, 2007; Art Research, Feldmeilen, Switzerland.

EXHIBITIONS: Les XX, Brussels, 1891, no. 5, Étude pour le no. 1 (*Intérieur bourgeois*); Independents, Paris, 1891, no. 757, Étude pour le no. 1.

BIBLIOGRAPHY: Art Institute of Chicago, *Chicago Collectors* (Chicago: Art Institute, 1963), 6; *Selected Paintings and Works on Paper* (London: Neffe-Degandt Fine Art, and New York: Jill Newhouse, 2007), 80–81.

1. "Un *Intérieur bourgeois* où le père, la mère et deux jeunes filles sont groupés autour d'une table éclairée par la lampe qui supporte une suspension." "L'Exposition des Vingt," *L'Indépendance belge*, February 9, 1891. A second description survives: "A bourgeois salon, lit by a lamp suspended from the ceiling, with various people lit or placed in shadow (Un salon bourgeois, l'éclairage d'une lampe suspendue au plafond avec divers personnages éclairés ou placés dans l'ombre)," E. V. [Ernest Verlant], "L'Exposition des 'XX,'" *L'Émancipation belge*, March 3, 1891.
2. For reproductions of these two works, see Roger Cardon, *Georges Lemmen, 1865-1916* (Antwerp: Pandora, 1990), 86 and 87. The scene is rendered also in a lithograph entitled *La Lampe* (370–71).
3. Ibid., 372–73, lists many of these works.
4. For a reproduction, see *Selections from the Collection of Freddy and Regina T. Homburger* (Cambridge, MA: Harvard University, Fogg Art Museum, 1971), 142.
5. "Aux XX," *L'Art moderne,* April 19, 1891, 128, lists the two studies for *Intérieur bourgeois* as having been purchased. Both works were shown at the Paris Independents in 1891 as being owned by Édouard Kohn. Lemmen gave instructions to Paul Signac on April 14, 1891, that at the close of the Independents, a representative of Kohn would come to reclaim the works (Signac Archive, Paris). Kohn was born in Neuwallisdorf, Bohemia, January 1, 1825, and died in Paris April 11, 1895. He was an international financier, philanthropist, recipient of the Chevalier of the Legion of Honor on May 9, 1873, and cofounder of the Kohn-Reinach Bank founded with his brother-in-law, Baron Jacob Adolph Reinach, known as Jacques de Reinach. Reinach's father, Adolphe de Reinach (1814-1879), was the Belgian consul in Frankfurt. Kohn was married to the sister of Jacques de Reinach's wife. Kohn hired William Bouwens as his architect for his house at 110 avenue de Wagram, Paris, which was completed in 1880. See Louis Bergeron, *Les Rothschild et les autres: La gloire des banquiers* (Paris: Perrin, 1991), 145-46. See also his obituary, in *Jewish Chronicle,* April 19, 1895, 7, and Lucien Wolf, *Essays in Jewish History* (London: Jewish Historical Society of England, 1934), 55-59.

Georges Lemmen
Belgian, 1865–1916

Émile Verhaeren, 1891

Oil on panel, 14¼ × 12¼ in. (36.2 × 31 cm); with frame painted by the artist, 20⅛ × 18⅛ in. (51 × 45.9 cm)
Monogrammed upper left: GL
Museum Plantin-Moretus, Antwerp

Study for the Portrait of Émile Verhaeren, 1891

Watercolor on paper, 8⅝ × 7¼ in. (22 × 18.5 cm)
Monogrammed stamp lower left (under frame): GL
Dated lower left: déc. 1891, and lower right: août 91
Private collection

Lemmen has depicted his friend, the Symbolist poet and art critic Émile Verhaeren (1855–1916), with head bent in a pose suggesting meditation. With his deep interest in poetry and art criticism, Lemmen was naturally drawn to the charismatic Verhaeren, who had ardently defended the art of Les XX and the Neo-Impressionists. In September 1890, Lemmen wrote to Verhaeren, who had contributed art criticism to *L'Art moderne* since 1882 and had been codirector since 1888, asking if he could review the next Brussels Salon.[1] By the following July, Verhaeren was sitting for the portrait.[2] In August, Lemmen had begun a captivating watercolor in red and brown that captured Verhaeren's pose as well as the contemplative and reverential mood of the oil. The thick brown border, representing the oil's pointillist inner frame, compresses the poet's space and concentrates attention on his inclined head and intense meditative expression. The insistent and repeating strokes behind the sitter's head, as well as the darkened halo, further emphasize Lemmen's attempt to illustrate Verhaeren's almost fevered imagination. The color intensifies the mood, which in the oil becomes less strained and lyrical, with a touch of melancholy expressed in blues and grays. The implied perspective lines of the background are less developed in the sketch than in the oil.

Once Lemmen had finished planning the composition in August he could begin the painting. He concentrated all the visual energy on the head of the sitter to emphasize Verhaeren's intellect. He "severed" Verhaeren's head from his body through the instrument of the starched white collar while locking it in place through the compression of the frame and the vertical band of the background. The blue outline of the head creates a contrast with the orange of the background and an intentional halo effect. The artist reveals Verhaeren as a sainted figure of the literary movement, suggesting his inner quietude and need for solitude. The decorative and playful GL monogram on the upper left is echoed by the pince-nez cord that responds also to the curvature of the aureole behind the poet. The painted border and outer frame provide an excellent example of the Neo-Impressionists' intent to effect a subtle transition between the canvas and the wall. With its red and blue stippling, the frame resonates with the canvas's mood of contemplation and isolation.

The painting was ready for the Les XX exhibition in February 1892. It was shown later that year with Van Rysselberghe's portrait of Verhaeren in his study (see plate 52) at the Paris Independents, the Antwerp Association pour l'art and The Hague's exhibition featuring Les XX. Lemmen probed the inner worlds of his sitters in other works, including *Mademoiselle Maréchal* (see plate 17) and *The Serruys Sisters* (see plate 24). Lemmen's concentration on Verhaeren's psyche contrasts with Van Rysselberghe's preference for filling his canvas with details of Verhaeren's life and art. JB

Émile Verhaeren

PROVENANCE: Émile Verhaeren; René Vandevoir donation to the Plantin-Moretus Museum, Antwerp.

EXHIBITIONS: Les XX, Brussels, 1892, no. 3; Independents, Paris, 1892, no. 696; Association pour l'art, Antwerp, 1892, no. 3; *Tentoonstelling van Schilderijen en Teekeningen van eenigen uit de "XX" en uit de "Asssociation pour l'art,"* Haagschen Kunstkring, The Hague, 1892, no. 18; Musée d'Ixelles, Brussels, *L'Impressionnisme et le fauvisme en Belgique,* 1990, 134. Royal Academy of Arts, London, *Impressionism to Symbolism: The Belgian Avant-Garde, 1880–1900,* 1994, 169–70; Van Gogh Museum, Amsterdam, *In Perfect Harmony: Picture + Frame, 1850–1920,* 1995, 194; Musée d'Ixelles, Brussels, *Georges Lemmen, 1865–1916,* 1997, 31 and 108–9.

BIBLIOGRAPHY: *Vente publique d'une collection de tableaux modernes des écoles belges et françaises provenant de feu Émile Verhaeren et d'autres réalisations,* auction cat. (Brussels: Galeries Breckpot, March 13, 1933), no. 26 (the artist is listed incorrectly as Georges Lemmens); *Le Salon Émile Verhaeren; Donation du Président René Vandevoir au Musée Plantin-Moretus à Anvers* (Antwerp: Museum Plantin-Moretus, 1987), 644, 645; Roger Cardon, *Georges Lemmen, 1865–1916* (Antwerp: Pandora, 1990), 91; Serge Goyens de Heusch, *L'Impressionnisme et le fauvisme en Belgique* (Brussels: Ludion, 1990), 63.

Study for the Portrait of Émile Verhaeren

PROVENANCE: Family of the artist; Galerie Vendel, Brussels; private collection, 1979.

EXHIBITIONS: Spencer Museum of Art, Lawrence, KS, *Les XX and the Belgian Avant-Garde: Prints, Drawings, and Books ca. 1890,* 1992, 249; Musée d'Ixelles, Brussels, *Georges Lemmen, 1865–1916,* 1997, no. 49.

BIBLIOGRAPHY: *Centenaire de Verhaeren* (Brussels: Bibliothèque royale de Belgique, 1955), 67; Roger Cardon, *Georges Lemmen, 1865–1916* (Antwerp: Pandora, 1990), 91.

1. Lemmen did not review the next Salon in *L'Art moderne* but did contribute two articles on Walter Crane in 1891 on March 1 and 15; respectively, 67–69 and 83–86. (Lemmen to Verhaeren, September 13, 1890, Archives et Musée de la littérature, F.S XVI, 148/654, Bibliothèque royale de Belgique, Brussels.) Lemmen also enclosed for Verhaeren's interest Léon Bloy's review of the proto-surrealist *Chants de Maldoror* by the Comte de Lautreamont, which had appeared in the French review *La Plume,* September 1, 1890, 151–54. The letter is reproduced in Cardon, *Georges Lemmen* (1997), 196.

2. On July 6, 1891, Verhaeren reported to his fiancée, Marthe Massin, that he was sitting for the portrait and intended to return "chez Lemmen" the following day. "This afternoon I was at Lemmen's. He asked to paint my head and I immediately gave it to him." Published in *À Marthe Verhaeren: Deux cent dix-neuf lettres inédites, 1889–1916* (Paris: Mercure de France, 1937), 371, 372. See also my entry in Goddard, *Les XX and the Belgian Avant-Garde,* 249.

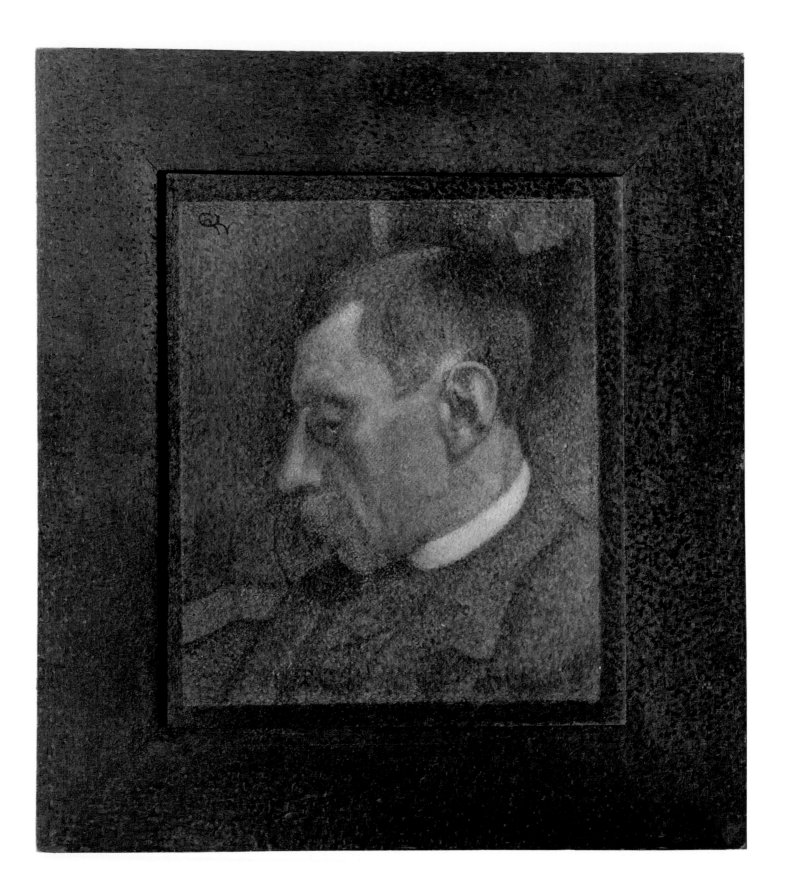

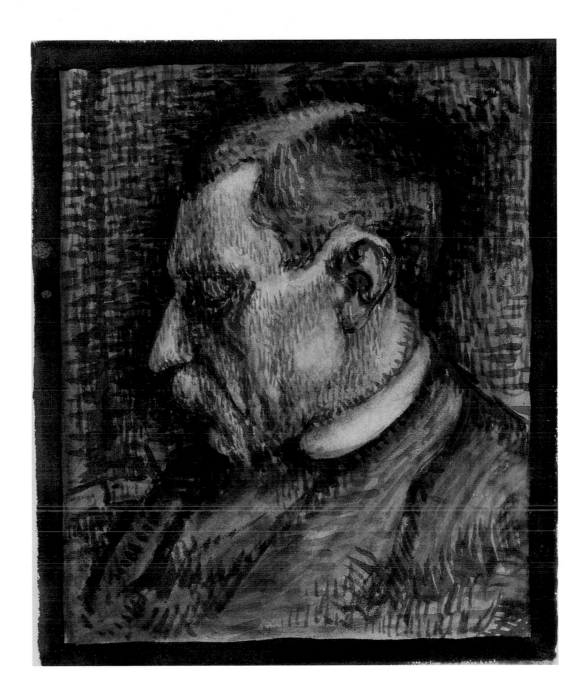

PLATE 17

Georges Lemmen

Belgian, 1865–1916

Mademoiselle Maréchal, [1891–92]

Oil on canvas, 23⅝ × 20⅛ in. (60 × 51 cm)
Monogrammed lower left: GL
Musée d'Orsay, Paris

Lemmen became engaged to the subject of this portrait, Marie Aline Maréchal (1868–1938), in 1890, and the couple wed on August 9, 1893 (fig. 34).[1] From the moment he met her, Lemmen was fascinated with Aline, as she was called, as a subject for his art. Soon she surpassed his mother, grandmother, and sister in the sheer number of his sketches. Following his first Neo-Impressionist oil portrait of his sister Julie crocheting in 1890 (see fig. 19), Lemmen wished to represent Aline in a similar work. In February and March 1891 he prepared a notebook of sketches, replete with indications for color, for a portrait of her that was finalized in the composition titled *The Cup of Tea* (*La tasse de thé*) (fig. 35). This work was never painted. Instead, Lemmen decided to confront his fiancée in a simplified portrait

of her gazing directly toward the viewer. While early preparatory drawings for this work have not come to light, a late oil sketch shows the final composition (fig. 36). Like the similar watercolor sketch of Verhaeren, prepared the same year (see plate 16), it not only presents the elements as arranged in the final painting but includes an indication of the colored border.

In a muted autumnal palette Lemmen shows Aline as a doe-eyed pale beauty with an elongated neck emerging seamlessly from the curve of her blue dress. The decorative pleats of Aline's dress and puffy sleeves reflect the art nouveau lines of Lemmen's contemporary graphic works, such as the cover for the 1891 Les XX catalogue. Even Aline's wisps of hair echo the gentle curves and arabesques of her form and the still-life

Fig. 34. Aline and Georges Lemmen, 1893. Photograph. Private collection.

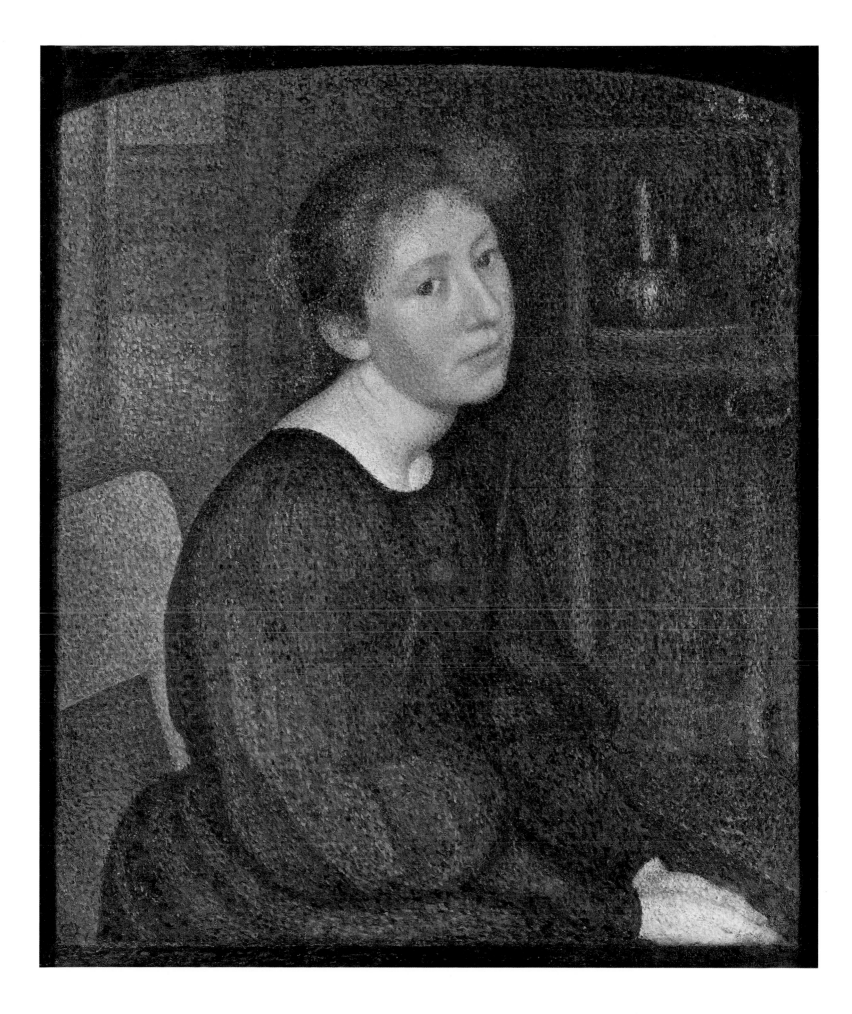

elements. These are offset by the vertical lines of the background walls and furnishings. The étagère and copper vessel to the right recall similar pieces in *The Cup of Tea,* but the differences are striking. The earlier representations are plastic and illusionistic, while here they are flat, geometric abstractions without strong shading.

While the linear quality of Aline's neck and back suggests Ingres's portraits of females with graceful and boneless arms and limbs, the still-life elements, muted as they are, recall the work of the Northern Renaissance master Roger Campin, as does the association of the intact vessel with the purity of the

Virgin Mary and, thus, of Aline. With the turn of her head, tender countenance, slouched posture, and hands nearly clasped, Aline seems to be asking for understanding from her intended, whom she made wait for three years before marrying him.[2] In many respects the work is analogous to Seurat's *Young Woman Powdering Herself,* the oil portrait of his lover Madeleine Knoblock (plate 33). The downward curve of the frame in the Lemmen reflects the device seen in Seurat's portrait of Knoblock.[3] The paintings were both shown at Les XX in 1892 and in fact were juxtaposed in a parody published in the press (see fig. 21). JB

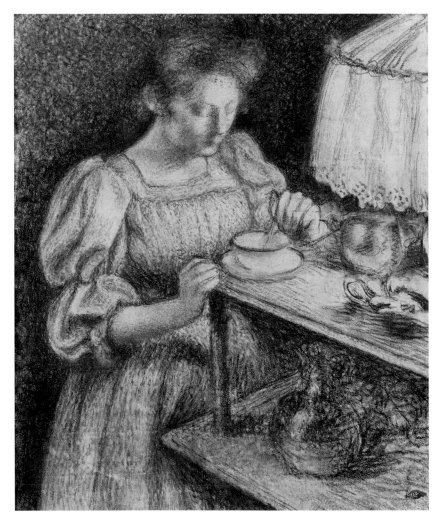

Fig. 35. Georges Lemmen, *The Cup of Tea* (*La tasse de thé*), 1891. Conté crayon and charcoal on paper, 22⅛ × 18 in. (56.3 × 45.8 cm). Musées royaux des Beaux–Arts de Belgique, Brussels.

PROVENANCE: Aline Maréchal Lemmen; Elisabeth Thévenin-Lemmen, Toulon, until 1984; acquired 1984 for the Musée d'Orsay.

EXHIBITIONS: Les XX, Brussels, 1892, no. 2, *Mlle Maréchal;* Independents, Paris, 1892, no. 695, *Portrait de jeune fille;* Association pour l'art, Antwerp, 1892, no. 2, *Mademoiselle M.;* Galerie André Maurice, Paris, *Georges Lemmen,* 1959, no. 5, *Mme Lemmen;* Musée de l'île de France, Sceaux, and Palais des Beaux-Arts, Brussels, *Île de France/Brabant,* 1962, no. 232, 86 and pl. LXX; Grand Palais, Paris, *Les Premiers Indépendants, 1884–1894* (76ème exposition), 1965, no. 110; Galerie Hervé, Paris, *Quelques tableaux de Maîtres néo-impressionnistes,* 1967, no. 25, *Portrait de Madame Lemmen;* Musée Pissarro, Pontoise, *Peintures néo-impressionnistes,* 1985, no. 27, *Portrait de Mme Lemmen;* Musée d'Ixelles, Brussels, *L'Impressionnisme et le fauvisme en Belgique,* 1990, no. 65; Musée d'Ixelles, Brussels, *Georges Lemmen, 1865–1916,* 1997, 110, 112; Museum of Art, Kochi, *Georges Seurat et le Néo-Impressionnisme, 1885–1905,* 2002, no. 83.

BIBLIOGRAPHY: E(rnest) V(erlant), "Le Salon des XX," *L'Emancipation belge,* March 5, 1892; Marcel Nyns, *Georges Lemmen* (Antwerp, 1954), no. 6; Ellen Wardwell Lee, *The Aura of Neo-Impressionism: The W. J. Holliday Collection* (Indianapolis: Indianapolis Museum of Art, 1983), 46; "Autres Acquisitions ou dons récents," *Gazette des Beaux-Arts* 105 (March 1985): 71, see also supplement, 11 (ill. 52); Robert Rosenblum, *Paintings in the Musée d'Orsay* (New York: Stewart, Tabori, and Chang, 1989), 457; Roger Cardon, *Georges Lemmen, 1865–1916* (Antwerp: Pandora, 1990), 96, 97, 104n9.

1. Through this alliance the artist became an in-law of fellow Vingtiste Théo van Rysselberghe. Aline's brother, Dr. Édouard Amédée Maréchal, was married to Irma Monnom, Van Rysselberghe's sister-in-law. Cardon, *Georges Lemmen* (1990), 87.
2. Lemmen, in fact, referred to Aline as his "petit Bourreau" (little torturer) in a conté crayon drawing dated August 1, 1890, where these lines are dedicated to her. For an illustration, see Cardon, *Georges Lemmen* (1997), 95.
3. Indeed, the chief difference in composition between Lemmen's sketch and his finished work is the painted curve at the top. Seurat made oil sketches similar to Lemmen's for many of his paintings, including *Young Woman Powdering Herself.*

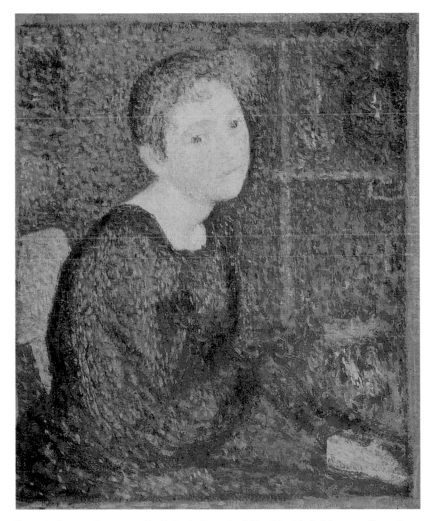

Fig. 36. Georges Lemmen, *Study for the Portrait of Aline Maréchal.* Oil on cardboard, 13¼ × 10⅞ in. (33.5 × 27.5 cm). Private collection.

PLATE 18

Georges Lemmen

Belgian, 1865–1916

Mademoiselle Maréchal, 1891–92

Lithograph, 12½ × 11 in. (31.8 × 27.8 cm)
Bibliothèque royale de Belgique, Brussels

Georges Lemmen's portraits, both paintings and graphic works, are his greatest contribution to Neo-Impressionism. His sitters were taken entirely from his circle of friends and relatives and often consisted of members of his immediate household. This lithograph of his fiancée, Aline Maréchal (1868–1938), is no exception. The artist began using her as a subject as early as August 1, 1890, the date he inscribed on one of his first pointillist drawings.[1] He further recorded its setting as "À Thuin" which was the summer gathering spot for the Van Rysselberghe family and friends.[2] Lemmen probably met Aline through Van Rysselberghe, a fellow member of Les XX. Thuin was the setting for Van Rysselberghe's drawing *Interior, Evening* (see plate 47), 1889, which includes both his own wife and Aline Maréchal. Enchanted as he was with Mlle Maréchal, Lemmen captured her twice in oil portraits in 1891 (see plate 17). Georges and Aline were finally married on August 9, 1893, with Van Rysselberghe as one of the witnesses.[3]

According to Roger Cardon, this lithograph, drawn in a pointillist technique on a stone and printed, "seems to be the only Neo-Impressionist portrait in the entire history of the print."[4] The elimination of any extraneous detail, the complete focus on the sitter, as well as the unusual downward perspective, give the work an enigmatic and mysterious quality. Its beauty emanates from the play of light and dark, produced by distinct dots on her head and shoulders and through a grattage (scraping) technique on her dress and background. This scraping away of the blacks produced the white kinetic quality

to the left of Aline and added the decorative elements of the pleats of her dress and sleeves, and the curls of her hair. Aline appears lost in dreamy contemplation, yet her aura is ablaze with vitality and youth. The artist's examination of the psyche of the individual and his psychological probing in such works are defining characteristics of Lemmen's best portraits.

Lemmen considered the lithograph important enough to include as the only pointillist work among his decorative arts published in 1899 in the French journal *L'Art décoratif* as well as its German counterpart, *Dekorative Kunst.* JB

PROVENANCE: Purchased by the Bibliothèque royale de Belgique, Brussels, from Lemmen's widow, November 18, 1916.

EXHIBITIONS: Bibliothèque royale de Belgique, Brussels, *Georges Lemmen, 1865-1916: Dessins estampes,* 1965, no. 64; Galerie CGER, Brussels, *Fin de Siècle: Dessins, pastels et estampes en Belgique de 1885 à 1905,* 1991, no. 108.

BIBLIOGRAPHY: *L'Art décoratif* 2 (September 1899): 247; *Dekorative Kunst* 4 (September 1899): 227; Roger Cardon, *Georges Lemmen, 1865-1916* (Antwerp: Pandora, 1990), 376-77; Jane Block, "Mademoiselle Maréchal," in *Les XX and the Belgian Avant-Garde, Prints, Drawings, and Books, ca. 1890,* ed. Stephen Goddard (Lawrence : Spencer Museum of Art, University of Kansas, 1992), 248; Roger Cardon, *Georges Lemmen, 1865-1916* (Ghent: Snoeck-Ducaju and Zoon; Antwerp: Pandora, 1997), 187.

1. For an illustration, see Cardon, *Georges Lemmen* (1990), 81.
2. Lemmen returned to Thuin and from there addressed a letter to Émile Verhaeren dated September 13, 1890.
3. Cardon, *Georges Lemmen* (1990), 118.
4. Ibid., 377.

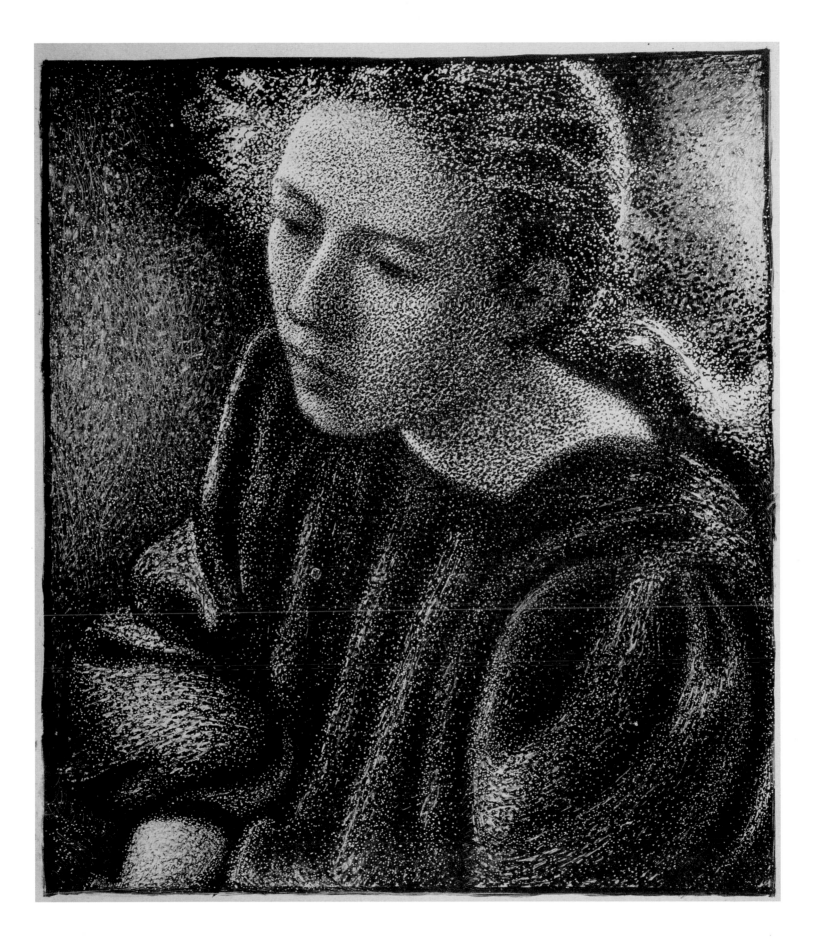

PLATE 19

Georges Lemmen
Belgian, 1865–1916

Silhouettes of Women Walking (Silhouettes de femmes en promenade), 1892

Pen and ink on paper, 9¼ × 10⅞ in. (23.5 × 27.5 cm)
Monogrammed lower left: GL.
Inscribed and dated lower right: aux demoiselles Van Mons./février 1892.
Private collection

In this country scene Lemmen humorously shows us the rear silhouettes of three women sporting hats and full-length dresses with puffed sleeves marching down an allée toward a villa or an outbuilding. Identifying the women would seem to be a bit difficult. However, this drawing carries the dedication "aux demoiselles Van Mons" (to the Van Mons women) and the date February 1892. The dedication would lead us to believe that two of the three might be the daughters of Émile van Mons, cousin to the poet Émile Verhaeren and patron of Théo van Rysselberghe. The two sisters, Camille (1875–1960) and Marguerite (1876–1919), were painted as young girls by Van Rysselberghe in 1886 at their family home at 25 rue des Chevaliers, Brussels.[1] As Pascal de Sadeleer has pointed out, the unusual signature of the artist, "GL" followed by a period, appears on the Les XX catalogue cover of 1892.[2] The monogram without the period also appears in two of the artist's portraits, those of Émile Verhaeren, 1891 (plate 15) and Aline Maréchal, 1891–92 (plate 17).[3]

The determined pace of the three aligned figures contrasts with the solid row of leaning trees. The drawing's mood of intimacy is further reinforced by the compression provided by the rectangular format. Lemmen captures the femininity of the three women through their curved waists, as they gracefully raise their hemlines to facilitate walking. The artist reinforces the rhythm of their steps through vigorous stippling with India ink. In addition, the angled trees add to the sense of depth and infinity and give this small drawing a sense of monumentality. JB

PROVENANCE: Van Mons family; sold in 1998 at auction, Pascal de Sadeleer, *Les Pantins,* to present owner (see n. 2).

BIBLIOGRAPHY: Pascal de Sadeleer, *Les Pantins,* public auction, Brussels, April 27, 1998, 26 and 37.

1. For a study of the portrait of Marguerite in the Ghent Museum voor Schone Kunsten, see Jane Block, "Twee Sleutelwerken van Théo Van Rysselberghe," in *200 Jaar Verzamelen: Collectieboek Museum voor Schone Kunsten Gent* (Ghent: Ludion, 2000), 195–97. For reproductions of the portraits, see Feltkamp, *Théo van Rysselberghe,* 269. Camille would marry the philosopher Georges de Craene, and Marguerite the poet Thomas Braun. When Camille married, in 1899, the couple commissioned Henry van de Velde to provide furnishings and decorations for their townhouse. See Léon Ploegeaerts and Pierre Puttemans, *L'Oeuvre architecturale de Henry Van de Velde* (Brussels: Atelier Vokaer, 1987), 271. Lemmen would later supply the cover and title-page designs for Braun's *Fumée d'Ardenne.* Van Rysselberghe would paint Marguerite and Thomas Braun's three daughters in 1904, *Les Enfants en rose.*

2. De Sadeleer, *Les Pantins,* 26.

3. It also appears in 1893 as the drawing for the cover of the weekly Brussels review *L'Art moderne.*

PLATE 20

Georges Lemmen

Belgian, 1865–1916

Mademoiselle L. (Portrait of the Artist's Sister), [1892]

Oil on canvas, 24⁷⁄₁₆ × 20¹⁄₁₆ in. (62 × 51 cm)
The Art Institute of Chicago, A. A. McKay Fund

In this diminutive portrait, the artist's unmarried older sister, Julie Frédérique Lemmen (1852–1940), sits on the edge of a spindly chair.[1] Although Lemmen depicted Julie on numerous occasions, including the previous year in his first Neo-Impressionist portrait (see fig. 19, *Young Woman Crocheting*), this remains perhaps his most probing psychological portrait of her. A contemporary photograph of Julie, in which she appears to be wearing a similar dress and brooch to that in the painting, shows that her brother has convincingly rendered her physiognomy (fig. 37). But he has done so much more, capturing some of what his daughter called Julie's "biting" (*tranchant*) personality in the rigidity of her pose and her hardened expression. Yet he simultaneously suggests, through her physical leanness

and demurely clasped hands, as well as by the austerity of the composition, that Julie has a more fragile, delicate side.[2]

Formally, the portrait is a Neo-Impressionist masterpiece. The pinks, reds, and greens present in the earlier pointillist depiction of Julie are muted to a more somber yet unified palette of blues and reds for the dress, gold and blue in the chair, and red and orange, liberally interspersed with a striking green, in the background. Compared with the energetic brushstrokes of the earlier painting, the pointillist strokes have given way to a more rigorous handling of the technique, with more uniform dots of color blending into a harmonious whole.

The composition is similarly unified. Julie of the earlier portrait, with head bent, intent on her task, now sits bolt

Fig. 37. C. E. Dulière, Julie Lemmen, c. 1895. Photograph.
Archives de l'art contemporain, Musées royaux des Beaux-Arts
de Belgique, Brussels.

upright without narrative details, save the chair from the family's salon.[3] Lemmen emphasizes the silhouette of Julie's form and attire. The motif of her cap-like puffy shoulders is echoed in the finial of the gilded chair, the coif, and the abstract pattern in the background.

Julie's position in the Lemmen household is key to understanding this particular portrait. She lived for many years in the same building as the artist, his family, and their parents on the rue Verte in Brussels. In addition to serving as nanny for her brother's children, Julie cared for her mother, who died at the age of one hundred in 1924 when Julie was seventy-two. Julie, then, was the domestic spinster sister of many nineteenth-century bourgeois households. Her psychological predicament is the real focus of her brother's painting. He explores the opposing forces within Julie, laying bare her impenetrability yet vulnerability. We simultaneously look at and into Julie, who, in her turn, looks not at us, but rather beyond us, all too aware, perhaps, of her restricted stature in the family hierarchy.

The painting was not finished by the time of the Les XX exhibition in February 1892, where portraits of the artist's future wife, Aline Maréchal (see plate 17), and of Émile Verhaeren (see plate 15) were shown, nor was it ready for the Paris Independents in March. Rather, it was first displayed in May at the exhibition Association pour l'art, held in Antwerp (see fig. 22). A photograph of Lemmen's submissions reveals that it bore an outer pointillist frame designed by the artist, as did his *Carnival* (*Fête foraine*) and the portrait of Verhaeren. The inner frame, painted on the canvas, served as a transition between the painting and the frame.

Mademoiselle L. remained with the family until the early 1960s.

<div align="right">JB</div>

PROVENANCE: Lemmen family, until early 1960s; Allan Frumkin Gallery, 1961; purchased by the Art Institute of Chicago, 1961.

EXHIBITIONS: Association pour l'art, Antwerp, 1892, no. 4. *Mlle L.; Tentoonstelling van Schilderijen en teekeningen van eeningen uit de "X" en de "Association pour l'art,"* The Hague, 1892, Haagschen Kunstkring, no. 16; Guggenheim Museum, New York, *Neo-Impressionism,* 1968, no. 126; Brooklyn Museum, *Belgian Art, 1880-1914,* 1980, no. 48; Seibu Museum of Art, Tokyo, *The Impressionist Tradition: Masterpieces from the Art Institute of Chicago,* 1985, no. 47; Musée d'Ixelles, Brussels, *Georges Lemmen, 1865-1916,* 1997, no. 52; Fondation de l'Hermitage, Lausanne, *Pointillisme: Sur les traces de Seurat,* 1998, no. 69.

BIBLIOGRAPHY: Jane Block, "A Study in Belgian Neo-Impressionist Portraiture," *Art Institute of Chicago Museum Studies* 13 (1987): 36–51; Richard Brettell, *Post-Impressionists* (Chicago: Art Institute of Chicago, 1987), 47, 49; Roger Cardon, *Georges Lemmen, 1865-1916* (Antwerp: Pandora, 1990), 108.

1. This painting is the subject of the author's much longer analysis "A Study in Belgian Neo-Impressionist Portraiture."
2. Elisabeth Thévénin, daughter of the artist and niece of Julie, recalled, "Physically, she was thin, angular, and her character was biting (Physiquement, elle était maigre, anguleuse et son caractère était très tranchant)." Letter to the author, January 20, 1985.
3. Ibid.

PLATE 21

PLATE 21

Georges Lemmen
Belgian, 1865–1916

Loïe Fuller, 1893–94

Conté crayon on paper, 18⅛ × 27⅜ in. (46 × 69.5 cm)
Stamped monogram lower right: GL
Greta van Broeckhoven

The American dancer Loïe Fuller (1862–1928) took Europe by storm in the 1890s, having invented a revolutionary manner of dancing. Part choreography and part innovative theater, it featured a new use of lighting against a black background combined with the manipulation of her enormous silk veils synchronized with her rhythmic dance steps. After her continental tour in 1892, Fuller was hired by the director of the Parisian music hall Folies-Bergère, where she danced four of her creations: the Serpentine, the Violet, the Butterfly, and the enigmatic "XXXX." Artists attempted to catch her likeness in a variety of media. Jean-Léon Gérôme sculpted and painted her; François-Rupert Carabin created six bronzes to celebrate her contribution; Raoul-François Larche paid homage with a series of lamps; Toulouse-Lautrec with his lithographs emphasized swirling movement around her head; and the American artist Will Bradley humorously depicted only her feet emerging from a whiplash line of veils.[1] Clearly Lemmen could not resist the challenge of capturing her essence. The artist may well have seen her dance in Paris in 1892 or 1893, but Fuller herself did not visit Brussels until May 1894.[2]

In 1893 the Symbolist poet Stéphane Mallarmé, enthralled with her innovative dancing, called her an "enchantress," while three years later the Belgian poet Georges Rodenbach compared Loïe Fuller to the blank canvas upon which an artwork would be created.[3] Rodenbach summed up Fuller's appeal in a formulation worthy of Mallarmé: "The Dance is a suggestion. It is thus that it is the supreme poem. A sculptural, colored, rhythmic poem where the body is no more than a white page, a page where the poem will be written."[4] Rodenbach and Mallarmé both seized on the incorporeality of Fuller as she performed and on the dance as metaphor.

Choosing the most sinuous and linear of her dances, the Serpentine, Lemmen created a portrait of Loïe Fuller by portraying her dance itself. This exquisite drawing at first appears to be an abstraction, with large areas of swirling whites sur-

rounded by patches of black and gray. The white is actually her enormous veils, from which Fuller herself barely emerges. She seems to flit and whirl, defying gravity; she is all light, energy, and movement. In his portrait, Lemmen captured the spirit of the artist through the embodiment of her dance and made a unique contribution to Neo-Impressionism through representing dynamic motion and dissolving form.[5] JB

PROVENANCE: Berthe and Louis Wittamer, Brussels.

EXHIBITIONS: Rice University, Houston, *Art Nouveau, Belgium, France,* 1976, no. 52; Virginia Museum, Richmond, *Loïe Fuller: Magician of Light,* 1979, no. 47; Galerie CGER, Brussels, *Fin de Siècle: Dessins, pastels et estampes en Belgique de 1885 à 1905,* 1991, no. 122; Musée d'Ixelles, Brussels, *Georges Lemmen, 1865–1916,* 1997, 33 and no. 53.

BIBLIOGRAPHY: Francine-Claire Legrand, *Le Symbolisme en Belgique* (Brussels: Laconti, 1971), 195; Giovanni Lista, *Loïe Fuller, danseuse de la Belle Époque* (Paris: Stock-Éditions d'art Somogy, 1994), 434; Roger Cardon, *Georges Lemmen, 1865–1916* (Ghent: Snoeck-Ducaju and Zoon; Antwerp: Pandora, 1997), 33 and no. 53, 112; Jane Block, "Le carrousel et le monde de la fête foraine," in Cardon, *Georges Lemmen* (1997), 79.

1. For reproductions of many images of Loïe Fuller, see *Loïe Fuller, danseuse de l'art nouveau* (Nancy: Musée des Beaux-Arts, 2002).
2. Sylvius, "Lettre de Belgique," *Le Figaro,* May 30, 1894, 4. "La Loïe Fuller n'avait jamais paru à Bruxelles. Elle vient de s'y révéler sur la scène de l'Alcazar." Roger Cardon cites appearances of Fuller emulators in Brussels in 1892 and 1893. See his *Georges Lemmen* (1990), 144n12.
3. "L'enchanteresse," Stéphane Mallarmé, "Considérations sur l'art du Ballet et la Loïe Fuller," in *Oeuvres complètes,* vol. 2 (Paris: Gallimard, 2003), 313. The essay was originally published May 13, 1893, in the *National Observer.*
4. "La danse est une suggestion. C'est ainsi qu'elle est le plus suprême des poèmes. Poème de plastique, de couleurs, de rythmes, où le corps n'est plus qu'une page blanche, la page où le poème va s'écrire." The Rodenbach quotation comes from his article "Danseuses," in *Le Figaro,* May 5, 1896. Mallarmé makes reference to the Rodenbach piece in his own essay "Crayonné au théâtre," in *Oeuvres complètes,* 2: 177. My thanks to Donald Friedman for helping me to locate this citation.
5. As Roger Cardon has noted, there is a static quality to most Neo-Impressionist works, a trait greatly contradicted by this pointillist drawing; Cardon, *Georges Lemmen* (1997), 33.

PLATE 22

Georges Lemmen

Belgian, 1865–1916

Portrait of Anna Boch, 1894

Conté crayon on off-white laid paper, 13⅜ × 11¾ in. (34 × 29.8 cm)
Monogrammed and dated upper right: GL. 94
The Art Institute of Chicago, Suzanne and Marjorie Pochter Fund

This superb pointillist portrait bust shows Anna Boch (1848–1936)—painter, amateur musician, art collector, and wealthy daughter of the porcelain manufacturer Frédéric Victor Boch and his cousin Anne-Marie Lucie Boch. A pupil of the Belgian Impressionist painter Isidore Verheyden, Boch was considerably older than her colleagues when she was elected to Les XX in 1885, first exhibiting with the group in 1886 and continuing to submit work to its successor organization, La Libre Esthétique (1894–1914). As a Vingtiste she became close to Georges Lemmen and Théo van Rysselberghe, with whom she studied for a brief time. The weekly musical soirées held at the family château, La Closière in La Louvière, were attended by Lemmen, Van Rysselberghe, other members of Les XX, and such literati as Émile Verhaeren. There she and her cousin Octave Maus often played piano duets to entertain the distinguished assembled guests.

When Lemmen made this drawing, Van Rysselberghe was still attempting to complete an oil portrait of Boch amid the trappings of her atelier (see plate 53). Lemmen chose to remove her from her studio and, by presenting only her head and shoulders, to concentrate on her contemplative gaze. Lemmen shows his subject in half profile, perhaps to minimize attention to her long aquiline nose.[1] The artist feminizes his subject by showing her in a frilly blouse with puffy shoulders and dark collar. Lemmen also playfully features a spit curl on her forehead, which softens her face and corresponds to the playful whiplash of "GL. 94," the signature in the upper right corner. The right side of her face is cast in shadow but illuminated by the halo formed around her head, whereas the left side is bathed in light and contrasted with the black collar and darker strokes around Anna's ear.

Boch's art collection was extraordinary and well known.[2] She owned two works by Vincent van Gogh, *The Red Vineyard* (*La Vigne rouge à Montmajour*) and *The Plain at Crau with Flowering Peach Trees* (*La Plaine de la Crau avec pêchers en fleurs*), the first purchased when Van Gogh exhibited with Les XX in 1890, the other after his death. She also owned a pointillist oil by Georges Seurat, *The Seine at the Island of La Grande Jatte* (*La Seine à la Grande Jatte*), 1888, shown at Les XX in 1892 at the posthumous exhibition dedicated to Seurat. Boch was also attracted to works by members of the Pont-Aven circle, acquiring a Paul Gauguin shown at Les XX in 1889, *Le Pouldu,* and commissioned a folding screen from Émile Bernard showing *The Four Seasons* (*Les Quatres Saisons*) on one side and *The Impoverished Woodcutters* (*Les Bûcherons misérables*) on the other.[3] Anna became a member of the Brussels art circle Vie et Lumière in May 1903 to promote luminism in painting and joined ranks with Lemmen, Émile Claus, George Morren, and others.[4] JB

PROVENANCE: Paul Van der Perre; Patrick Lancz; Eric Gillis; purchased by the Art Institute of Chicago, 2011.

BIBLIOGRAPHY: Thérèse Thomas and Cécile Dulière, *Anna Boch, 1848-1936* (Tournai: La Renaissance du Livre, 2000); Thérèse Thomas et al., *Anna Boch: Catalogue raisonné* (Brussels: Éditions Racine, 2005).

1. This is the only known portrait of Anna Boch by Lemmen. Another work by Lemmen, entitled *Portrait d'Anna Boch,* appears in many of the monographs devoted to Boch, but is not a portrait of her. See, for example, Thérèse Thomas et al., *Anna Boch: Catalogue raisonné* (Brussels: Éditions Racine, 2005), 158.
2. See "Une Mécène Clairvoyante," 65-79, in Thérèse Thomas and Cécile Dulière, *Anna Boch, 1848-1936* (Tournai: La Renaissance du Livre, 2000).
3. Bernard exhibited this screen at Les XX in 1893, where Boch showed her own four-paneled screen. See *Émile Bernard: Les lettres d'un artiste (1884-1891)* (Dijon: Les presses du réel, 2012), 146, 201.
4. For more on this group, see Danièlle Derrey-Capon, "'Vie et Lumière': Prémices sur un air nationaliste et débuts prometteurs," in *Belgium: The Golden Decades, 1880-1914,* ed. Jane Block (New York: Peter Lang, 1997), 99-138.

PLATE 22

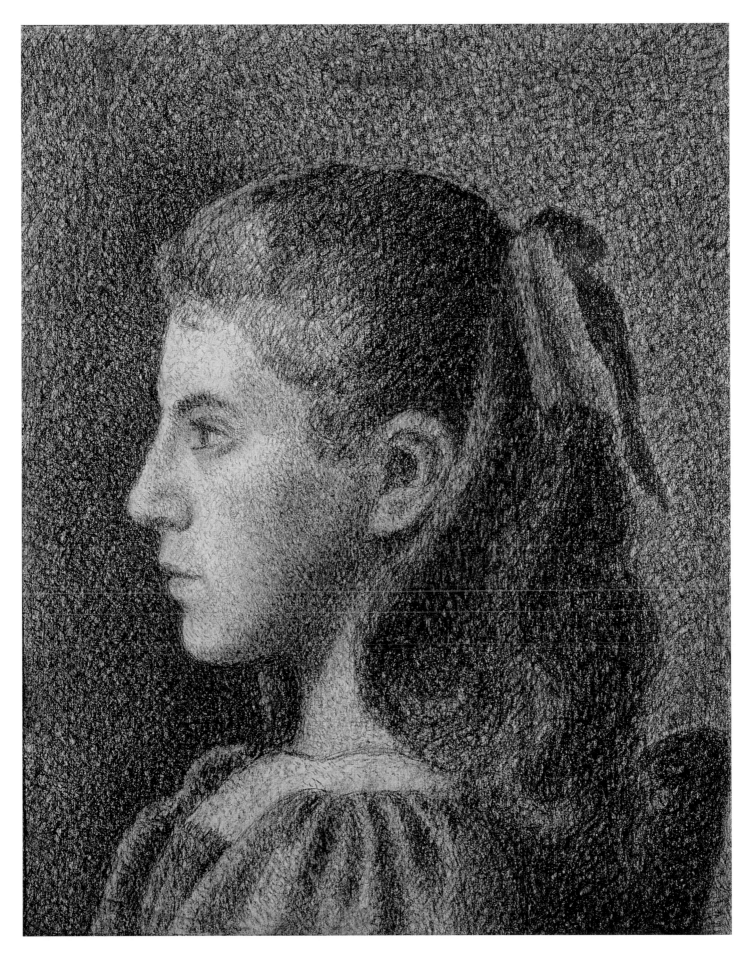

PLATE 23

Georges Lemmen

Belgian, 1865–1916

Portrait of Berthe Serruys, [1894]

Conté crayon on cream wove paper, 14⅝ × 11⅜ in. (37 × 29 cm)
The Art Institute of Chicago, Margaret Maw Blettner Memorial Fund

The Two Sisters or *The Serruys Sisters,* 1894

Oil on canvas, 23⅝ × 27½ in. (60 × 70 cm); with painted frame 26¾ × 31⅜ in. (68.1 × 79.8 cm)
Stenciled monogram lower left of canvas and lower right of frame: GL; dated on upper stretcher bar: août–sept. 1894
Indianapolis Museum of Art, The Holliday Collection

Georges Lemmen began his double portrait of the Serruys sisters while visiting the family in Menin, Belgium, on the Leie (Lys) River near the French border. Edmond Serruys (1843–1917), a prosperous textile manufacturer whose mill was in nearby Tourcoing, France, was a personal friend of Émile Vandervelde's, a founder of the socialist party in Belgium. Lemmen, however, came in contact with the family through the oldest sister, Yvonne, who had studied painting with him.[1] Although Yvonne chose to pursue sculpture, the artist remained a family friend; in 1894 he captured Yvonne's two younger sisters, twelve-year-old Berthe (1882–1926) and eight-year-old Jenny (1886–1983), in this unusual double portrait.[2]

The painting, Lemmen's last pointillist portrait, is a tour-de-force of Neo-Impressionist principles put into practice. Lemmen uses simultaneous contrast—the immediate juxtaposition of complementary colors—throughout the painting. For example, contrasting dots of red and green are placed side by side within the sisters' smocks, while contrasting orange and blues enliven the background. Lemmen employs successive contrast by setting the blue background against the reddish orange of the girls' smocks. He has also given the sisters Neo-Impressionist "haloes" that distinguish them from their setting.

The two sisters are held in their compressed space by the convex frame, which survives intact. The frame not only cuts off the money plant at the upper left but binds the sisters both physically and psychologically. Their familial relationship is revealed by their close proximity, Berthe's embracing arm, and their identical smocks.[3] Their divergent gazes and different complexions, as well as their comparative sizes, suggest quite separate identities. The downward tilt of Berthe's head and her

fixed gaze perhaps give us some thoughts about the anxiety of adolescence, but this is counterbalanced by the colorful tablecloth and the golden vase holding the shimmering money plant, alluding to the joys of childhood.

The original frame serves as a transition between the painting and the surrounding wall space. We know of four earlier paintings in which Lemmen employed Neo-Impressionist frames: the portraits of Émile Verhaeren and Aline Maréchal (both 1891) and of Julie Lemmen (1892), and *Carnival* (*Fête foraine,* 1890–92). The latter two frames are no longer extant, but we recognize them from a photograph documenting Lemmen's contribution to the 1892 exhibition of the Association pour l'art held in Antwerp (see fig. 22), which also shows the frame around the portrait of Verhaeren. The shape of the arched frame of Maréchal's portrait (plate 17) comes closest to the frame of the Serruys sisters, and both respond to Seurat's arched frames in *Young Woman Powdering Herself* and *Chahut.*

Lemmen's inclusion of a still life—the dried seedpods of a money plant set in a copper vase—placed on a colored tablecloth recalls the Flemish antecedents of much late nineteenth-century Belgian art, avant-garde or otherwise. The emphasis on the eyes and the rigidity of the poses further suggest a Pre-Raphaelite influence through the work of Edward Burne-Jones, an artist admired greatly by Lemmen.

Lemmen's completed portraits were preceded by preparatory studies. However, only a few such drawings have come to light. A related study shows Berthe rendered in profile and wearing the same dress as in the completed oil. Without the accoutrements present in the double portrait, Lemmen focuses entirely on the physiognomy and persona of Berthe. As in the

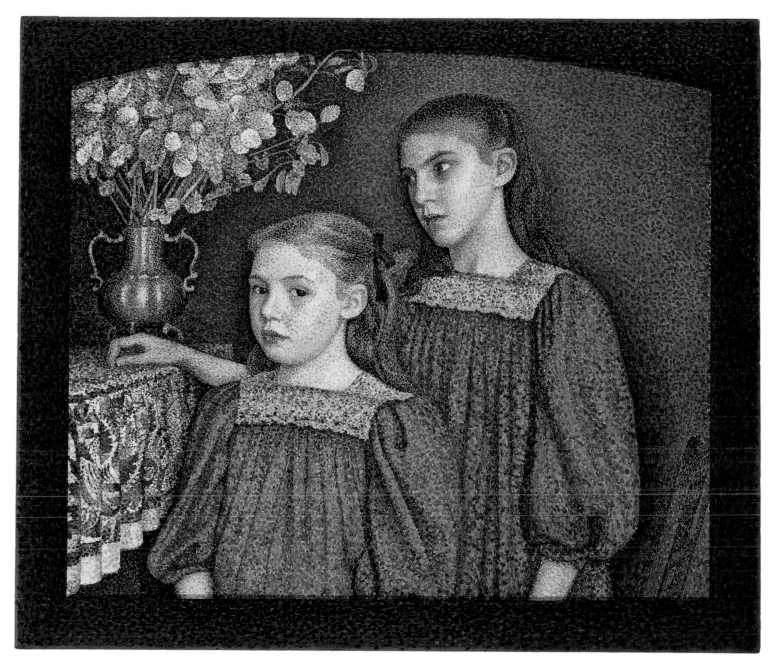

PLATE 24

oil painting, the intensity of her gaze catches our attention. Although Lemmen uses Seurat's "successive contrast" in the stark darks and lights around Berthe's face, his depiction is more three-dimensional than most of Seurat's conté crayon portraits.

An additional charcoal sketch similarly presents Jenny in profile.[4] It is not clear whether Lemmen made the undated drawings prior to completing his oil portrait; nonetheless, they reveal the artist's interest in his sitters. In fact, four months after their oil portrait was completed, Lemmen drew them together again in an India ink drawing dated January 23, 1895.[5] Once again, it is Berthe's stare that remains with us.

Both girls led interesting lives, as the family moved to Paris after their father retired. Jenny married the American literary editor William Aspenwall Bradley (1878–1939) on November 30, 1921. Bradley is best remembered as the agent for Gertrude Stein's *Autobiography of Alice B. Toklas* and Henry Miller's *Tropic of Cancer*. After her husband's death, Jenny continued to serve as agent to his clientele and also translated English fiction into French, including James Joyce's *Les Exilés* (Paris: Gallimard, 1950). In 1908 Berthe married Joseph–Fernand Grenard (1866–1945), whose life as a French diplomat enabled her to travel to foreign locales, including Moscow, where in 1917

Grenard was serving as the French ambassador when the Russian revolution began.[6] Jenny kept the oil portrait in her possession until the 1960s. The studies remained with the artist's family. 　　　　　　　　　　　　　　　　　　JB

Portrait of Berthe Serruys

PROVENANCE: J. C. Bellier, Paris; Daniel Varenne, Switzerland; B. C. Holland Gallery, Chicago; purchased by the Art Institute of Chicago, 1982.

EXHIBITIONS: Spencer Museum of Art, Lawrence, KS, *Les XX and the Belgian Avant-Garde: Prints, Drawings, and Books ca. 1890,* 1992, 256.

BIBLIOGRAPHY: Jane Block, "A Study in Belgian Neo-Impressionist Portraiture," *Art Institute of Chicago Museum Studies* 13 (1987): 46, 48 (the drawing is mistakenly identified as the sitter's sister, Jenny Serruys); Ellen Wardwell Lee, *The Aura of Neo-Impressionism: The W. J. Holliday Collection* (Indianapolis: Indianapolis Museum of Art, 1983), 47; Roger Cardon, *Georges Lemmen, 1865–1916* (Antwerp: Pandora, 1990), 142–43; Roger Cardon, *Georges Lemmen, 1865–1916* (Ghent: Snoeck-Ducaju and Zoon, 1997), 116–17.

The Two Sisters or The Serruys Sisters

PROVENANCE: Menin, Belgium, Serruys Family; Jenny Serruys Bradley, Paris; René de Gas and Galerie Daniel Malingue, Paris; Kaplan Gallery, London, 1966; Hammer Galleries, New York, 1967; W. J. Holliday, Indianapolis, 1969; bequest of W. J. Holliday to the Indianapolis Museum of Art, 1979.

EXHIBITIONS: Kaplan Gallery, London, *A Selection of Impressionist and Post-Impressionist Paintings, Watercolours, Pastels, and Drawings,* 1966, frontispiece; Kaplan Gallery, London, *Recent Acquisitions: French Impressionist Paintings,* 1967, no. 14; Hammer Galleries, New York, *40th Anniversary Loan Exhibition,* 1968, 34; Rijksmuseum Vincent van Gogh, Amsterdam, *Neo-Impressionisten, Seurat tot Struycken,* 1988, no. 58; Royal Academy of Arts, London, *Impressionism to Symbolism: The Belgian Avant-Garde, 1880–1900,* 1994, 171–72; Musée d'Ixelles, Brussels, *Georges Lemmen, 1865–1916,* 1997, no. 60; Musée d'Orsay, Paris, *Le néo-impressionnisme, de Seurat à Paul Klee,* 2005, 218–19 (the two sisters are incorrectly identified as the daughters of Yvonne Serruys); Palazzo Reale, Milan, *Georges Seurat, Paul Signac e i neoimpressionisti,* 2008, 214–15, no. 60.

BIBLIOGRAPHY: *Apollo* 83 (February 1966): xvii; *Connoisseur* 161 (February 1966): v; *Art Journal* 27 (Fall 1967): 89 (incorrectly listed as *Les Filles de l'artiste*); Jean Sutter, ed., *The Neo-Impressionists* (Greenwich, CT: New York Graphic Society, 1970), 204; Ellen Wardwell Lee, *The Aura of Neo-Impressionism: The W. J. Holliday Collection* (Indianapolis: Indianapolis Museum of Art, 1983), 44–47; Jane Block, "A Study in Belgian Neo-Impressionist Portraiture," *Art Institute of Chicago Museum Studies* 13 (1987): 36–51; Roger Cardon, *Georges Lemmen, 1865–1916* (Antwerp: Pandora, 1990), 126, 142–43; Michel Draguet, *Signac, Seurat: Le Néo-impressionnisme* (Paris: Éditions Hazan, 2001), 78.

1. Yvonne Serruys, "Comment je suis venue à la sculpture," *Les Cahiers nouveaux* (1937), 2. Yvonne married the French writer Pierre Mille (1864–1941). For Yvonne (1873–1953), see Nicole Vanraes-Van Camp, *Yvonne Serruys, 1873–1953* (Menen: Yvonne Serruys comité, 1987); Marjan Sterckx, *Yvonne Serruys (1873–1953), Belgische beeldhouwster in Parijs* (Menen: Stadsmuseum 't Schippershof, 2003); L. Dumont-Wilden, "Yvonne Serruys, Sculpteur, à propos d'une inauguration récente," *Gazette des Beaux-Arts* 63 (December 1921): 345–52; and André M. de Poncheville, "Yvonne Serruys," *Gand Artistique* 2 (August 1923): 185–91.

2. In addition to Jenny, Berthe, and Yvonne, there were two sons: Paul, a doctor, and Daniel, a noted philologist and economist.

3. The girls' father, Edmond Serruys, worked as an executive in several textile factories that wove jacquard fabric. The colorful dresses his daughters wear in Lemmen's portrait are of printed fabric and therefore were not made in his factories; communication to the author, April 14, 2008, from the Gratry Lorthiois île de France factory in Halluin, France.

4. For an illustration, see *Important 19th and 20th Century Drawings and Watercolors,* Sotheby Parke Bernet, New York, March 18, 1976, no. 66, where it is incorrectly titled *La Fille de l'artiste.*

5. Given the puzzling title of *Les Deux femmes,* the ink drawing was offered at auction, *Très importants tableaux modernes,* at the Palais Galliéra, Paris, on November 24, 1974, no. 9.

6. For Grenard, see *Dictionnaire Nationale des Contemporains,* vol. 3 (Paris: Robert La Jeunesse, Robert Vorms, 1939), 321. Although, according to Berthe's nephew, Grenard was detained for one month, "Berthe had left Moscow before the first events of the revolution, because her health was already bad." Indeed, Berthe died in Paris in 1926 at age forty-four. Because of her illness, her nephew explained, "her life in France was probably quite discreet"; personal correspondence, April 3, 2007.

PLATE 25

Maximilien Luce

French, 1858–1941

Paul Signac, 1889

Conté crayon on paper, 7½ × 6¼ in. (19 × 15.9 cm)
Signed and dated lower right: Luce/89
Inscribed lower left: Signac Herblay
The Dyke Collection

During August and September 1889, Maximilien Luce and Paul Signac spent several weeks painting together at Herblay, a market town on the Seine River, not far from Paris. Both artists were at the height of their commitment to Neo-Impressionism, and the landscapes and river scenes painted there demonstrate their devotion to capturing the effects of light and nuanced color.

During their sojourn at Herblay, Luce also made this informal portrait drawing of his colleague. Of the French Neo-Impressionists, Luce was the most prone to sketching and painting his friends and acquaintances, and he has left numerous images of his artistic coterie.[1] His training as an engraver no doubt enhanced his inclination to draw. Here he chose crosshatched strokes for Signac's face and longer lines to trace his profile and distinctive goatee. A related portrait by Luce (private collection), larger and executed in oil, hints at the object of Signac's attention in the conté crayon drawing. The colorful likeness, painted with short, loose strokes, suggests that Signac's gaze is focused on a canvas just outside the bounds of the painting.[2]

Luce and Signac were not only colleagues allied by a common aesthetic; they also shared strong political and philosophical convictions. Though Luce was more engaged in expressing his beliefs through illustrations for anarchist journals, both artists maintained concern for the conditions of working men and women, an idealistic faith in human nature, and a healthy distrust of authority. EWL

PROVENANCE: Félix Fénéon, Paris; Jacques Rodrigues-Henriques, Paris; Arthur G. Altschul, New York, 1961; Galerie Hopkins-Custot, Paris, not before 2002; purchased by James T. Dyke, 2003.

EXHIBITIONS: Musée Municipal d'Histoire et d'Art, Saint-Denis, *Maximilien Luce et les néo-impressionnistes,* 1958; Yale University Art Gallery, New Haven, *Neo-Impressionists and Nabis in the Collection of Arthur G. Altschul,* 1965, no. 4; Musée des impressionnismes Giverny, *Maximilien Luce, néo-impressionniste: Rétrospective,* 2010, no. 60; Musée des impressionnismes Giverny and National Gallery of Art, Washington, DC, *Color, Line, Light: French Drawings, Watercolors, and Pastels from Delacroix to Signac,* 2012–13, no. 77.

BIBLIOGRAPHY: *Bulletin de la vie artistique* 5 (April 15, 1924): 193; Jean Bouin-Luce and Denise Bazetoux, *Maximilien Luce: Catalogue raisonné de l'oeuvre peint,* vol. 2 (Paris: Éditions JBL, 1986), no. 763.

1. Ferretti Bocquillon, "Maximilien Luce, néo-impressionniste: Un 'Barbare mais robuste et hardi peintre,'" in *Maximilien Luce, néo-impressionniste: Rétrospective,* 12.
2. Marina Ferretti Bocquillon, "Neo-Impressionist Drawings," in *Color, Line, Light: French Drawings, Watercolors, and Pastels from Delacroix to Signac,* ed. Margaret Morgan Grasselli and Andrew Robison (Washington, DC: National Gallery of Art, 2012), 130–31.

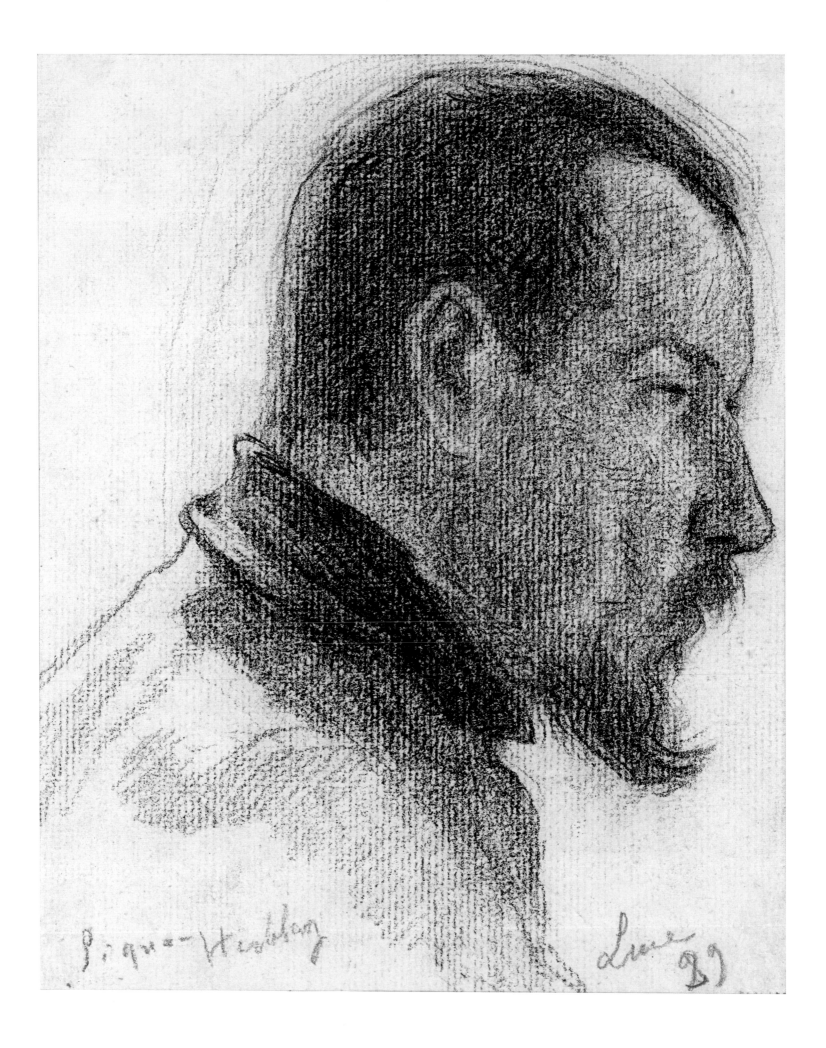

Signac-Westhoz Luce
 99

PLATE 26

Maximilien Luce

French, 1858–1941

Portrait of Georges Seurat, [1890]

Conté crayon on paper, 11¹¹⁄₁₆ × 8⅞ in. (29.6 × 22.5 cm)
Private collection

The ferment of ideas, together with the development of simplified printing processes, endowed late nineteenth-century Paris with a seemingly endless supply of journals devoted to artistic, political, social, and literary themes. Thanks to one such weekly periodical, *Les Hommes d'aujourd'hui* (*The Men of Today*), and its editorial focus on members of the Neo-Impressionist coterie in 1890, a rich source of information exists on Georges Seurat and his colleagues, just at the height of the movement. Various issues that year featured Seurat, Signac, Dubois-Pillet, and Luce, providing valuable documentation of their individual works and ideas.

The journal cover always carried a likeness of the artist, designed by one of his fellow painters. Thus we have Signac as drawn by Seurat, Luce by Signac, and Seurat by Luce. (Dubois-Pillet's issue, the exception, was based on a self-portrait.) This drawing was the preparation for the cover of vol. 8, no. 368, 1890, with a text on Seurat by Jules Christophe (fig. 38). Seurat is depicted, palette in one hand, with the other raised to an unseen project on the easel. His head and torso are more thoroughly drawn, while the hands and paintbrushes are just suggested with quick, energetic strokes.

For the finished product on the cover, Luce reinforced Seurat's palette and brushes and revealed more of the painting on the easel. The background panels coalesce into vertical bands that define the artist's profile. Less than a year after this issue appeared, Seurat died suddenly, and Luce's project for *Les Hommes d'aujourd'hui* became one of the rare records of his remarkable career. EWL

PROVENANCE: Victoria Fet, Paris; Mr. and Mrs. Arthur G. Altschul, New York, by 1964; Sotheby's, New York, November 8, 2006, no. 134; private collection.

EXHIBITIONS: Les XX, Brussels, 1892, no. 4; Yale University Art Gallery, New Haven, *Neo-Impressionists and Nabis in the Collection of Arthur G. Altschul,* 1965, no. 5; Palais des Beaux-Arts, Charleroi, *Maximilien Luce,* 1966, no. 108; Musée des impressionnismes Giverny, *Maximilien Luce, néo-impressionniste: Rétrospective,* 2010, no. 61.

BIBLIOGRAPHY: Richard Shone, *The Post-Impressionists* (London: Octopus, 1979), no. 4; Philippe Cazeau, *Maximilien Luce* (Lausanne: Bibliothèque des Arts, 1982), 55; Jean Bouin-Luce and Denise Bazetoux, *Maximilien Luce: Catalogue raisonné de l'oeuvre peint,* vol. 2 (Paris: Éditions JBL, 1986), no. 760.

Fig. 38. Maximilien Luce, *Georges Seurat, Les Hommes d'aujourd'hui* 8, no. 368 (April 1890).

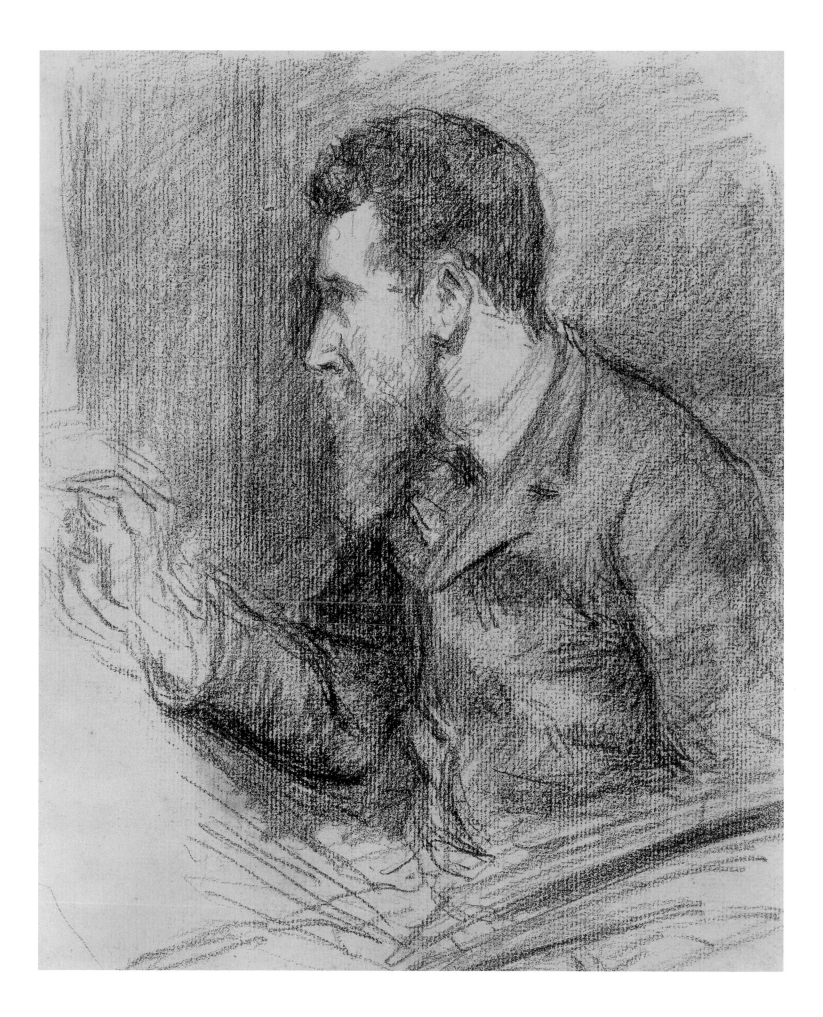

PLATE 27

Maximilien Luce

French, 1858–1941

Morning, Interior (Le Lever, intérieur), 1890

Oil on canvas, 25½ × 31⅞ in. (64.8 × 81 cm)
Signed and dated lower right: Luce 90
The Metropolitan Museum of Art, Bequest of Miss Adelaide Milton de Groot (1876–1967), 1967

Maximilien Luce painted *Morning, Interior* in 1890, a year critical to his commitment to Neo-Impressionism and to his passionate defense of the working man. As indicated by his submissions to the Independents in 1889 and 1890, Luce was painting lyrical landscapes and bustling urban scenes, as well as "interiors" that did double duty as genre scenes or quiet homages to the noble routine of labor. In the case of *Morning, Interior,* the painting is also a portrait of a friend.

The man in his spare garret lodging, leaning over to put on his shoe, was a fellow artist named Gustave Perrot. He occupies a room furnished with a flimsy cot, the bare necessities of pitcher and pot, and a few framed pictures and accessories.[1] Perrot and Luce painted together in Arcueil and Gentilly, small towns south of Paris. The records of the Independents indicate that Perrot was a productive participant in the society, exhibiting numerous landscapes and portraits from 1886 through 1891. After his untimely death in 1891 or 1892, the Independents featured fifteen of his paintings in their 1892 exhibition. Noted critic Paul Alexis had works by Perrot in his collection. Oddly, none of his pictures can be located today.

Perrot has also been identified as an "architectural gilder," and Robyn Roslak described *Morning, Interior* as typical of Luce's paintings of "artisan friends at home," exuding a "solemn, unsentimental . . . presence"—one of the gifted workers who dutifully continued their trade even as capitalism was rapidly devaluing their craft.[2] Germain Talence, in a 2008 exhibition catalogue devoted to Luce's commitment to themes of labor, commented that Luce's image could express the "poverty that envelops that mansard better than a trade union program communicating the condition of the working man."[3] Luce was also a frequent illustrator of journals supporting labor issues.

The painting's title and color scheme suggest that Perrot is rising at first light to begin his day's work. The setting, built up by Luce's highly regular and rounded brushwork, offers the surfaces that Neo-Impressionists seemed to relish in order to record the play of color and light across a floor or wall. Here Luce manipulated the light and shadow, creating the diagonal lines that lend angularity to the carefully constructed composition.

As light from the attic window invades Perrot's tiny room, Luce creates a vivid color scheme. The bedclothes at the center of the scene provide vibrant contrasts of orange, blue, red, and green, while the walls and floor offer a more subtle, pastel palette. Luce carefully recorded the reflections on Perrot's shirt, and, true to Neo-Impressionist practice, he punctuated the deep blue shadows of the cot with points of complementary orange hues. In *Morning, Interior,* Luce has achieved a multifaceted portrait that combines his understanding of Seurat's methods with his belief in the dignity of labor. EWL

PROVENANCE: Possibly Julien (père) Tanguy, Paris, until 1894; his widow, Paris; Madame Tanguy sale, Hôtel Drouot, Paris, June 2, 1894 (not in catalogue); purchased by Ambroise Vollard, Paris, 1894; Jacques Rodrigues-Henriques, Paris; Adelaide Milton de Groot, New York, by 1936; Adelaide Milton de Groot bequest, 1967.

EXHIBITIONS: Possibly Independents, Paris, 1891, no. 799, as *Intérieur;* Galerie des néo-impressionnistes, Paris, *Tableaux de M. Luce et Aquarelles de Paul Signac,* 1894, no. 14, as *Le Lever, intérieur;* Joe and Emily Lowe Art Gallery of the University of Miami, *Renoir to Picasso, 1914,* 1963, no. 78, as *Portrait of Feuillagiste Péraut;* Robert Lehman Collection, Metropolitan Museum of Art, New York, *Neo-Impressionism: The Friends and Followers of Georges Seurat,* 1991–92, no catalogue; Robert Lehman Collection, Metropolitan Museum of Art, *Neo-Impressionism: The Circle of Paul Signac,* 2001, no catalogue; Portland Museum of Art, Portland, Maine, *Neo-Impressionism: Artists on the Edge,* 2002, fig. 12; Museum of Fine Arts, Houston, and Neue Nationalgalerie, Berlin, *The Masterpieces of French Painting from The Metropolitan Museum of Art: 1800–1920,* 2007, no. 112; Musée de l'Annonciade, Saint-Tropez, *Maximilien Luce: Les Travaux et les Jours,* 2008.

BIBLIOGRAPHY: Jean Sutter, "Gustave Perrot," in Jean Sutter, ed., *The Neo-Impressionists* (Greenwich, CT: New York Graphic Society, 1970), 174, as *Interior: My Friend Perrot Getting Up;* Jean Bouin-Luce and Denise Bazetoux, *Maximilien Luce: Catalogue raisonné de l'oeuvre peint* (Paris: Éditions JBL, 1986) vol. 1, 71, 99; vol. 2, no. 563, 141, as *Portrait du Feuillagiste Perrot;* Philippe Cazeau, *Maximilien Luce: Époque néo-impressionniste, 1887–1903,* exh. cat. (Paris: Galerie H. Odermatt-Ph. Cazeau, 1987), no. 9, reproduces the study for this painting; Robyn Roslak, *Neo-Impressionism and Anarchism in Fin-de-Siècle France: Painting, Politics, and Landscape* (Aldershot, Eng.: Ashgate, 2007), 50–51.

1. An oil study for this painting is cited in Bouin-Luce and Bazetoux, *Maximilien Luce: Catalogue raisonné de l'oeuvre peint,* 3: no. 430.
2. Roslak, *Neo-Impressionism and Anarchism in Fin-de-Siècle France,* 50–51.
3. Germain Talence quoted in *Maximilien Luce: Les Travaux et les Jours* (Saint-Tropez: Musée de l'Annonciade, 2008), 77–78.

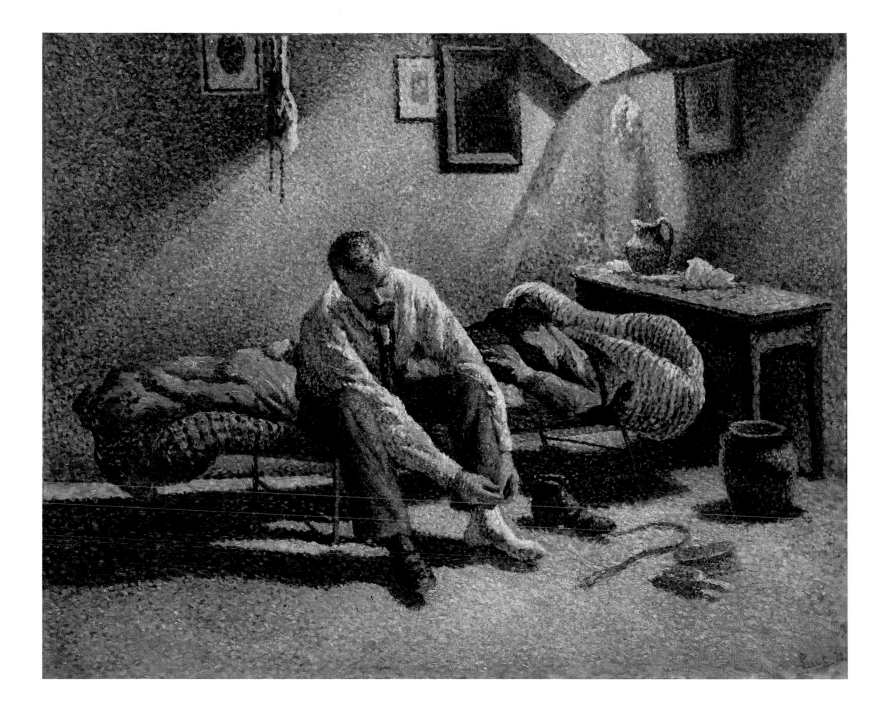

PLATE 28

George Morren

Belgian, 1868–1941

Sunday Afternoon (*Dimanche, après–midi, portrait*), 1892

Oil on canvas, 20 × 29⁵⁄₁₆ in. (50.8 × 74.5 cm)
Signed and dated lower right: George Morren 1892
Indianapolis Museum of Art, The Holliday Collection

The popular theme of a woman seated by the window, which can be traced in Western art from the Renaissance to the present, was treated by Belgian artists, including Henri de Braekeleer in *Teniersplaats of Antwerp* (1878) and Henry van de Velde in *Woman Seated at the Window* (see fig. 18).[1] De Braekeleer's seated woman looks out the window onto Antwerp's central town square. Van de Velde's elderly woman dressed in peasant garb gazes at the streetscape in her small village.

Morren's version of the subject, *Sunday Afternoon,* shows the seated woman but omits the object of her gaze. Morren provides so much detail about the elderly woman depicted in profile that we are confronted as much by her milieu as by her portrait. She is surrounded by glass domes holding souvenirs of her life. The animated curving objects to the right are the bars of a stove, which have a strange anthropomorphic quality.[2]

Morren made it clear, however, that this is a particular person, subtitling his painting "portrait." We do not know her relationship to Morren nor do we know her identity, but we can ascertain her employment as a domestic servant, given her dress and surroundings. Morren lavishes attention on her lace bonnet and paisley shawl, clearly her best Sunday attire. The sheer curtains are parted by a breeze, allowing golden light to fall on the front of her shawl while the back is cast in shadow. The attentive sitter perhaps is waiting for someone to take her out for a family visit, having just returned from church.

The canvas has an overall active surface decoration and vibrant colors of red, orange, and yellow that, ironically, give the static scene an animated quality. While conforming to Neo–Impressionist color theory, the great number of objects painted in their local colors suggests more a Pre–Raphaelite composition than the unified color schemes and abstractions of Lemmen and Van Rysselberghe. JB

PROVENANCE: Madame Orpha Buyssens, Paris; Madame Dagieu-Sully, Paris; Stephen Higgons, Paris; Hammer Galleries, New York, 1963; W. J. Holliday, 1964; bequest of W. J. Holliday to the Indianapolis Museum of Art, 1979.

EXHIBITIONS: Seconde exposition annuelle de l'Association pour l'art, Antwerp, 1893, no. 5, as *Dimanche après-midi, (portrait);* Salle Verlat, Antwerp, *Exposition d'oeuvres de Fernand Dubois, Georges Hobé, George Morren,* 1894, no. 23; Galerie Georges Giroux, Brussels, *Exposition George Morren,* 1926, no. 1; 66ème Exposition de la Société des Artistes Indépendants, Paris, *Hommage à Paul Signac et ses amis,* 1955, no. 48; Hammer Galleries, New York, *French Impressionist and Post-Impressionist Paintings,* 1963–64; Solomon R. Guggenheim Museum, New York, *Neo-Impressionism,* 1968, no. 132; University of Arizona Art Gallery, Tucson, California Palace of the Legion of Honor, San Francisco, Utah Museum of Fine Arts, Salt Lake City, *Homage to Seurat: Paintings, Watercolors, and Drawings by the Followers of Seurat Collected by Mr. and Mrs. W. J. Holliday,* 1968–69, no. 49; Museum of Fine Arts, St. Petersburg, Florida, Columbia Museum of Art, South Carolina, Lowe Art Gallery, University of Miami, Coral Gables, Florida, Cummer Gallery of Art, Jacksonville, Florida, *The Circle of Seurat: Paintings and Watercolors by the Followers of Georges Seurat from the Collection of Mr. and Mrs. W. J. Holliday of Indianapolis,* 1969–70; Musée national d'art occidental, Tokyo, *Exposition du Pointillisme,* 1985, no. 57; Rijksmuseum Vincent van Gogh, Amsterdam, *Neo-Impressionisten, Seurat tot Struycken,* 1988, no. 52; Royal Academy of Arts, London, *Impressionism to Symbolism: The Belgian Avant-Garde, 1880-1900,* 1994, no. 58; Galeries nationales du Grand Palais, Paris, *Paris-Bruxelles, Bruxelles-Paris,* 1997, no. 121; Musée d'Orsay, Paris, *Le néo-impressionnisme, de Seurat à Paul Klee,* 2005, 232–33.

BIBLIOGRAPHY: Ellen Lee, *The Aura of Neo-Impressionism: The W. J. Holliday Collection* (Indianapolis: Indianapolis Museum of Art, 1983), 55–57; Tony Calabrese, *George Morren, 1868-1941: Monographie générale suivie du catalogue raisonné de l'oeuvre* (Antwerp: Pandora, 1998), no. 13.

1. For an illustration, see Herwig Todts, *Henri de Braekeleer, 1840-1884* (Antwerp: Koninklijk Museum voor Schone Kunsten, 1989), 151.
2. The stove provided warmth as well as a way to cook meals. The curved handle was the means of raising the cover to insert more coal, whereas the horizontal bar was for drying linens.

PLATE 29

George Morren

Belgian, 1868–1941

Under the Lampshade (Sous l'abat-jour), 1892

Conté crayon on paper, 16⅛ × 22⅞ in. (41 × 58 cm)
Monogram and dated bottom right: 18GM92
Private collection

George Morren experimented with Neo-Impressionism from 1890 until 1893, both in drawings and in paintings. Although not an exhibitor at Les XX, Morren attended its annual exhibitions and was familiar with Seurat's works exhibited there in 1887, 1889, 1891, and at the retrospective exhibition of 1892. As this drawing reveals, Morren differed from Seurat in his nearly obsessive attention to detail compared with Seurat's more generalized figures, which seem to emerge from the paper shrouded in mystery. The black of Morren's drawing is particularly velvety and rich. When this work was exhibited at the Association pour l'art in Antwerp in May 1893, Henry van de Velde proclaimed to readers of *L'Art moderne,* "We are putting the spotlight on an excellent drawing, 'Sous l'abat jour,'" a noteworthy work "which reveals an attentive observation and a persistent willpower."[1]

In this *intimiste* scene, a middle-aged couple—the artist's parents, as it turns out—read under the light of a large table lamp reflected in a mirror. The man, Morren's father, Arthur, (1835–1908), was a wealthy Flemish businessman.[2] This theme and composition was explored during this time in similar pointillist drawings by Lemmen and Van Rysselberghe (see plates 14 and 49). Lemmen further explored the theme in several Neo-Impressionist oil paintings.

This finely executed drawing is a study in curves. The undulating arms and back of the oversized chairs are echoed by the table's legs and flared edge as well as the puffy capped shoulders of the seated wife. The scalloped rococo lamp base responds to the rhythm of pleats on the lampshade. The figurine of the kissing couple and the putto set a playful tone amid this otherwise intimate and almost claustrophobic scene of domesticity.　JB

PROVENANCE: M. Eykelbergh, Antwerp; private collection.

EXHIBITIONS: Association pour l'art, Antwerp, 1893, no. 8, as *Sous l'abat-jour (attitudes), dessins;* Salle Verlat, Antwerp, *Exposition d'oeuvres de Fernand Dubois, Georges Hobé, George Morren,* 1894, no. 59(?), as *Sous l'abat-jour, Portraits* (no. 58 has the same title but portrait is in the singular); Museum of Art, Kochi, *Georges Seurat et le Néo-Impressionnisme, 1885–1905,* 2001, no. 91.

BIBLIOGRAPHY: Tony Calabrese, *George Morren, 1868–1941: Monographie générale suivie du catalogue raisonné de l'oeuvre* (Antwerp: Pandora, 1998), 46, 213, no. 26.

1. "L'Association pour l'art," *L'Art moderne,* May 14, 1893, 155. Tony Calabrese has identified Van de Velde as the anonymous author who reported on activities from Antwerp to *L'Art moderne;* letter to the author, March 7, 2007.
2. Calabrese postulated this identification in his catalogue raisonné, *George Morren,* 213. He believes that the inscription "à mon frère Marcel" to the left of the monogram is a dedication to one of the artist's brothers; letter to the author, February 21, 2007. The artist had three brothers: Paul (1864–1870), Marcel (1865–1941), and André (1871–1933); see Calabrese, *George Morren,* 17.

PLATE 30

Hippolyte Petitjean
French, 1854–1929

Young Woman Seated (Jeune femme assise), 1892

Oil on canvas, 28¾ × 23⅞ in. (73 × 60.5 cm)
Signed and dated upper right: hipp. Petitjean/1892
Musée d'Orsay, Paris (on deposit at the Musée des Beaux-Arts, Nancy)

The virtues of simplicity distinguish this graceful, understated portrait of Louise Claire Chardon, Petitjean's companion and future wife. The artist painted her many times over the course of their lives, but this image, painted at the height of his commitment to Neo-Impressionism, seems the most eloquent. Mademoiselle Chardon, born in 1864, regards the viewer calmly, without affectation. She has no accessories, and the setting is spare, with only a chair (which seems surprisingly ornate in this austere arena) to articulate the space.

In the catalogue for the Neo-Impressionist exhibition at the Musée d'Orsay in 2005, Emmanuelle Amiot-Saulnier observed that this portrait merits comparison with those of Van Rysselberghe, Lemmen, and Cross.[1] The paintings that Georges Lemmen made of his sister (see fig. 19 and plate 20), with their restrained poses and empty backgrounds, make an apt comparison. Pared to their essentials, the canvases offer commanding likenesses, but they also provide the raw materials for the fundamental analyses of color and light at the heart of Neo-Impressionism.[2] Petitjean has made a serious Neo-Impressionist effort, building his image with dotted brushwork and relying on contrasts of complementary colors. In the background area adjacent to the sitter's blue sleeves he has concentrated points of orange, the opposite hue on the color wheel, creating a halo effect and implementing the principle that the interaction of two opposites is always the most intense at the edges of the colored areas.

Two years later, in 1894, Petitjean made another Neo-Impressionist portrait of Mademoiselle Chardon (Musée d'Orsay, Paris). Presented standing, she is equally poised but shares the space with more objects, including the chair from the earlier image. Louise and Hippolyte did not marry until 1904, though they had known each other since 1879 and had a nine-year-old daughter. The impetus for their marriage was Petitjean's desire to put Louise in a position to benefit from a new law protecting the widows and children of civil servants.[3]

EWL

PROVENANCE: Madame Petitjean, Paris, until 1947; acquired by Les Musées nationaux pour le Musée national d'art moderne, 1947; assigned to the Musée du Louvre for transfer to the Musée d'Orsay, Paris, 1977; on deposit at the Musée des Beaux-Arts, Nancy, since 1998.

EXHIBITIONS: Independents, Paris, 1892, no. 906 or 907, as *Portrait;* Independents, Paris, *Rétrospective, 1884-1894,* 1965, no. 142; Palais du Tokyo, Musée d'art et d'essai, Paris, *Visages et portraits de Manet à Matisse,* 1981; Musée d'Orsay, Paris, *Le Néo-impressionnisme, de Seurat à Paul Klee,* 2005, 216–17; Fundación MAPFRE, Madrid, *Néo-impressionismo: La Eclosión de la Modernidad,* 2007, no. 29; Palazzo Reale, Milan, *Georges Seurat, Paul Signac e i neoimpressionisti,* 2008, no. 61.

BIBLIOGRAPHY: Bernard Dorival, "Un an d'activité au Musée d'art moderne: II. Les achats des Musées nationaux," *Musées de France* (December 1948): 295–96; John Rewald, *Post-Impressionism from Van Gogh to Gauguin* (New York: Museum of Modern Art, 1956), 118; Isabelle Compin and Anne Roquebert, *Catalogue sommaire illustré des peintures du Musée du Louvre et du Musée d'Orsay,* vol. 4 (Paris: Réunion des musées nationaux, 1986), 130; Isabelle Compin, Geneviève Lacambre, and Anne Roquebert, *Musée d'Orsay: Catalogue sommaire illustré des peintures,* vol. 2 (Paris: Réunion des musées nationaux, 1990), 358.

1. Emmannuelle Amiot-Saulnier, "Hippolyte Petitjean, *Jeune Femme assise,*" in Ferretti Bocquillon, *Le Néo-Impressionnisme: De Seurat à Paul Klee,* 216.
2. Ibid.
3. In 1898 the city of Paris had made him a drawing teacher at two local schools. Lily Bazalgette, "Hippolyte Petitjean, 1854-1929," in Sutter, *The Neo-Impressionists,* 120.

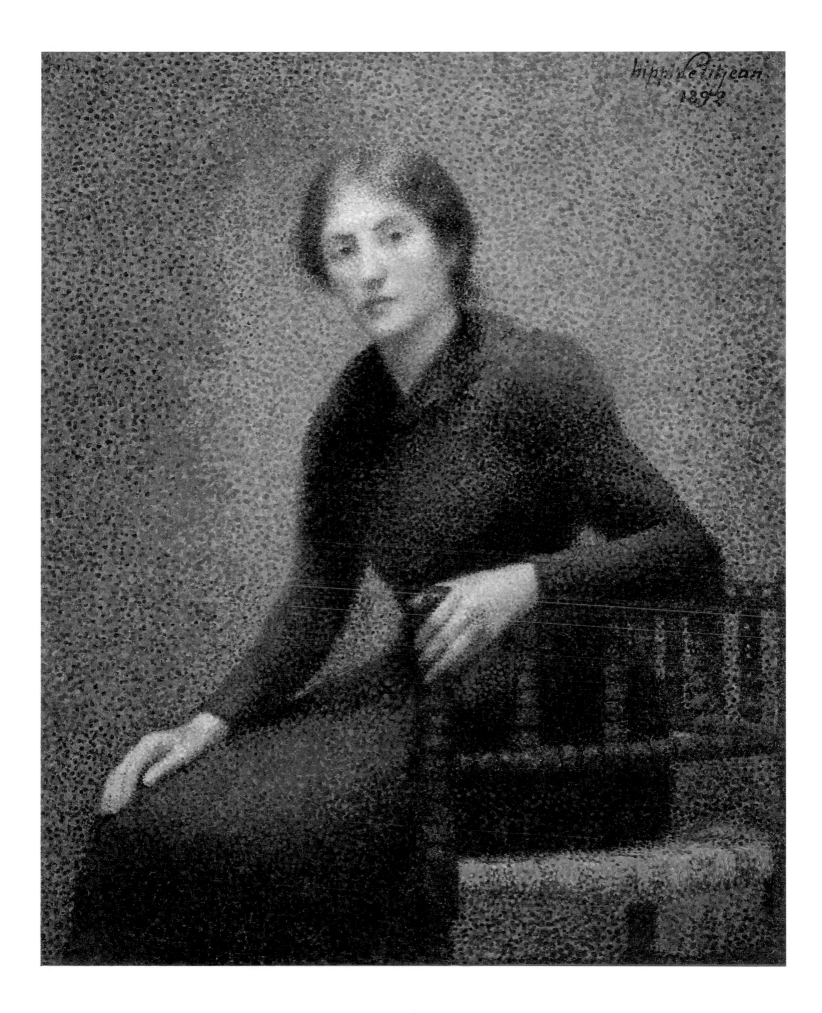

PLATE 31

Lucien Pissarro

French, 1863–1944

Interior of the Studio (L'Intérieur d'atelier), 1887

Oil on canvas, 25¼ × 31½ in. (64.1 × 80 cm)
Signed and dated lower left: Lucien Pissarro/1887
Indianapolis Museum of Art, Gift in memory of Robert S. Ashby by his family and friends

Perhaps because of his move to England in 1890, Lucien Pissarro has received less attention than the other vanguard members of the Neo-Impressionist movement. The eldest son of Camille Pissarro, Lucien and his father met Seurat, Signac, and Félix Fénéon in 1885, as the ideas for the new approach were developing. During 1886 he painted with Signac and created his first divisionist landscapes. By 1887 the young artist had completed this ambitious canvas, which demonstrates his understanding of Neo-Impressionist methods and his early devotion to the movement.

Interior of the Studio presents the artist's sixteen-year-old brother Georges working intently in the second-floor studio of the family home in Eragny, forty-five miles northwest of Paris.[1] While the painting is indeed a portrait, it also encompasses interior and still-life subjects, as Lucien applied his prowess to other genres. The complex composition called for the orches-tration of rectilinear window elements with curvilinear wrought iron, a patterned textile with decorated ceramics, and curving vegetation with the strict angles of an easel. Further, Lucien took on the challenge of backlighting, painting an interior invaded by natural light—an appropriate undertaking for an artist absorbed by the relationships of color and light. Meticulous points of luminous color shimmer across the studio floor, while the basic Neo-Impressionist harmony of green versus red in the furniture adds a brilliant contrast to the gentler hues of the color scheme.

At least four preparatory works precede Lucien's finished product of 1887—three drawings (Ashmolean Museum, Oxford) and one canvas, *Corner of the Studio (Coin d'atelier,* fig. 39)—further evidence of the importance he attached to the painting. Early the next year Lucien exhibited the final version of the subject at the Independents in Paris, and later he gave it to a

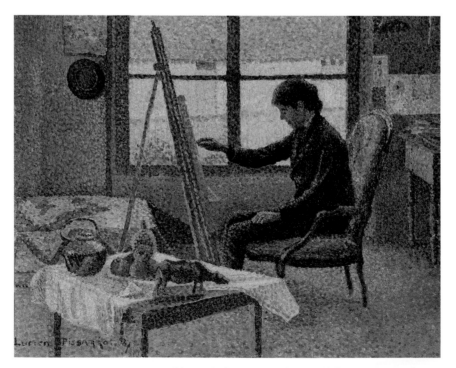

Fig. 39. Lucien Pissarro, *Corner of the Studio (Coin d'atelier)*, 1887. Oil on canvas, 12⅝ × 15¾ in. (32 × 40 cm). Private collection.

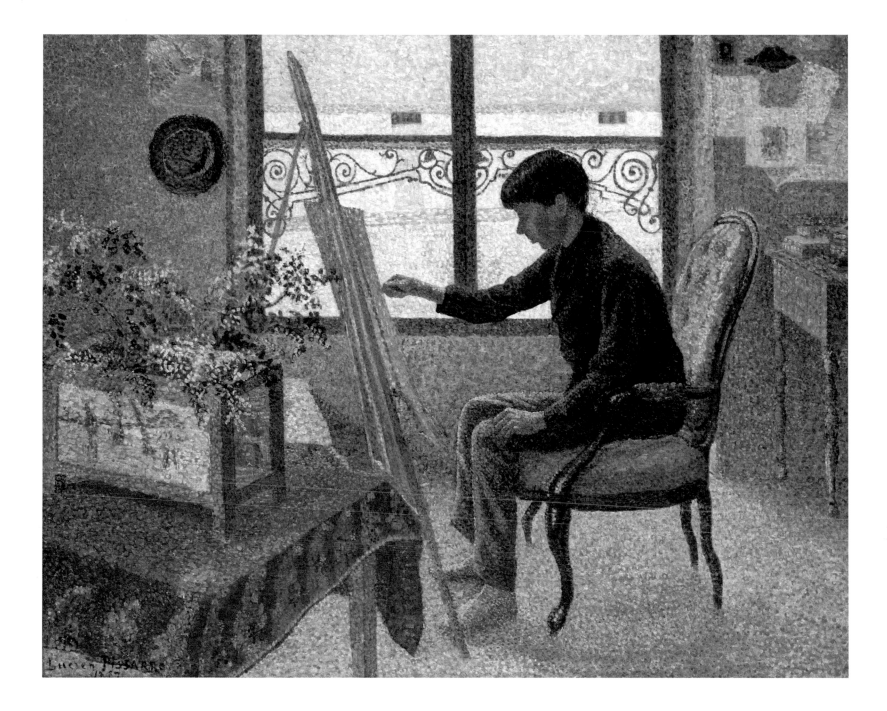

cousin, probably as a wedding gift. The painting disappeared from public and scholarly awareness until it resurfaced on the international art market in 1995.

Ironically, it was the smaller oil version of the subject that helped obscure the existence of *Interior of the Studio.* Any references to a studio interior by Lucien were assumed to be citations of the smaller, well-documented canvas. The most obvious differences between the two works are the decorative ironwork at the window and still-life elements in the left foreground. However, an X-ray (fig. 40) of *Interior of the Studio* reveals that Lucien revised the composition, having originally used the same arrangement of objects found in the left foreground of the earlier work. Perhaps the young artist concluded that turning the table made the composition more dynamic and that changing to a red tablecloth reinforced the Neo-Impressionist credo of complementary colors. The replacement of the mundane objects on the table with a ceramic planter, however, is an unmistakable allusion to his father, the patriarch. The jardinière, composed of four tiles, is one of Camille's rare forays into painting on ceramic, probably dating from the mid-

1880s.[2] From the prominent planter to Camille's hat hanging beside the window to the images and notes tacked to the wall, *Interior of the Studio* is not just a record of brother Georges at work but a portrait of one family's way of life.　　EWL

PROVENANCE: Gift of the artist to his cousin, Eugénie Estruc LeBoeuf (1863–1931), Pontoise; by descent in the family, England; Sotheby's, London, November 22, 1995, no. 15; purchased by the Indianapolis Museum of Art, 1995.

EXHIBITIONS: Independents, Paris, 1888, no. 559; Musée d'Orsay, Paris, *Le Néo-impressionnisme, de Seurat à Paul Klee,* 2005, 212–13; Palazzo Reale, Milan, *Georges Seurat, Paul Signac e i neoimpressionisti,* 2008, no. 56.

BIBLIOGRAPHY: Ellen W. Lee, "Research, Rediscovery, Renewal: Important Pissarro Canvas 'Comes to Light' at the IMA," *Previews,* Indianapolis Museum of Art (Fall 1996): 7–9; Ellen W. Lee, "Neo-Impressionist Acquisitions for the Indianapolis Museum of Art," *Apollo* (December 2002): 11.

1.　At this time the family's studio was on the second floor of their home, in a room offering northern and western exposures. Camille did not convert the barn next door into a studio until 1892.
2.　The tile visible in the painting is *Apple Picking;* see Ludovic Rodo Pissarro and Lionello Venturi, *Camille Pissarro: Son Art—Son Oeuvre,* Paris, 1939, vol. 1, 310, no. 1665, vol. 2, 312. The other scenes on the jardinière are *The Potato Harvest, Peasant Woman in a Cabbage Field,* and *The Saint-Martin at Pontoise.*

Fig. 40. Lucien Pissarro, *Interior of the Studio,* 1887 (digital x-radiograph). Oil on canvas, 25¼ × 31½ in. (64.1 × 70 cm). Indianapolis Museum of Art. Gift in memory of Robert S. Ashby by his family and friends.

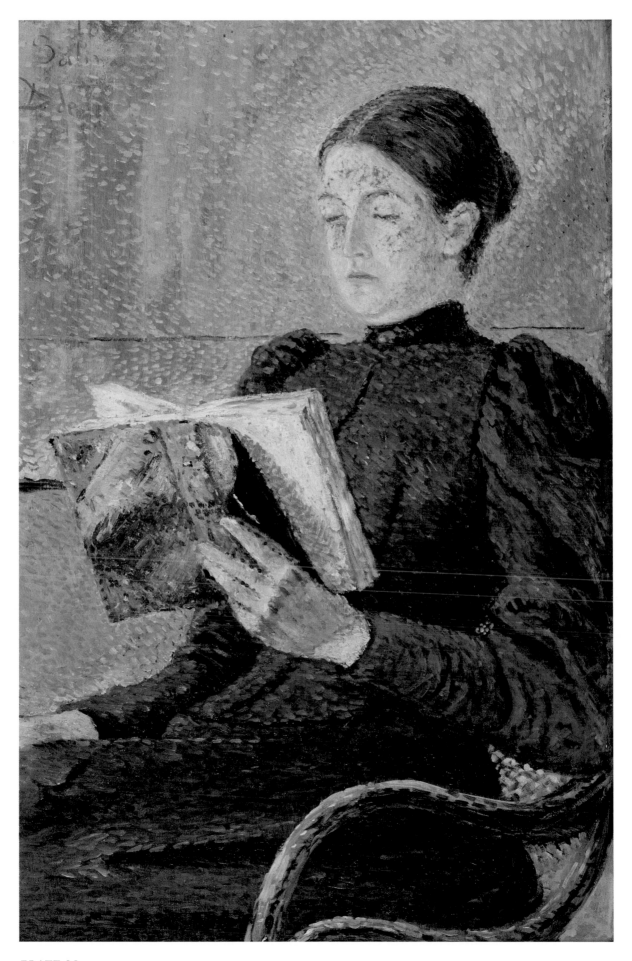

PLATE 32

PLATE 32

Darío de Regoyos

Spanish, 1857–1913

Portrait of Dolores Otaño, 1892

Oil on board, 21⅝ × 13¾ in. (55 × 35 cm)
Dated, inscribed, and initialed upper left: 1892/ Salinas/ D de R
Museo Nacional Centro de Arte Reina Sofía, Madrid

The only known Neo-Impressionist oil portrait by landscape painter Darío de Regoyos is that of family friend Maria Dolores Otaño (1865–1962), painted when she was twenty-seven years of age. Family tradition holds that Darío was attracted to the beautiful Dolores (fig. 41), but that she did not return those sentiments. Shown in three-quarter pose with downcast eyes, she is absorbed in her book, or perhaps merely trying to avoid eye contact with the smitten artist. Otaño was the daughter of a well-regarded doctor who lived in San Sebastian, on the northeastern coast of Spain, where Regoyos resided in the 1890s.[1] The painting is inscribed "Salinas," a beach resort town on the Asturias coast near San Sebastian. Dolores, an amateur painter who was given a refined education, moved to Burgos after her marriage.

Although Regoyos experimented with the pointillist technique as early as 1887, he did not turn to Neo-Impressionism seriously until 1892, the date of this portrait.[2] The artist shows his subject in a dark-blue dress composed of horizontal brick-like strokes that contrast with the halo of lighter blue around her head. The mosaic strokes also define the arms of the chair while adding to the dynamism of the composition. The interstices between the sitter's elbow and the chair reveal the pattern of the caning. The area encircling her head is enlivened with small strokes almost dotlike in shape.

The painting remained in the family until it was donated in 1957 to the Prado Museum, Madrid. JB

PROVENANCE: Otaño family; Prado Museum, and transferred by the Prado to the Reina Sofía.

EXHIBITIONS: Exposición Nacional de Bellas Artes, Madrid, *Un Siglo de arte español,* 1955, no. 349; Palais des Beaux-Arts, Brussels, *Le Portrait espagñol du XIV* au XIX* siècle,* 1970, no. 86; Sala de Exposiciones de la Fundación Caja de Pensiones, Madrid, *Darío de Regoyos, 1857–1913,* 1987, no. 46.

BIBLIOGRAPHY: Blanca Romera de Zumel, "Darío de Regoyos en el museo de Bilboa," *Cuadernos de historia del arte* 6 (1966–67): 55; Joaquin de la Puente, *Museo del Prado, Cason del Buen Retiro: Catálogo de las pinturas del siglo XIX* (Madrid: Ministerio de Cultura, 1985), 210–11; Juan San Nicolás, *Darío de Regoyos* (Barcelona: Edicíones Catalanes, 1990), 289; Javier Portús, *The Spanish Portrait from El Greco to Picasso* (London: Scala, 2004), 295; Francesc Fontbona, "Darío de Regoyos," in *Enciclopedia del Museo del Prado* (Madrid: Fundación amigos del Museo del Prado/TF Editores, 2006), 5: 1823.

1. My thanks to Herminia Allanegui for her reminiscences of her aunt. Correspondence with the author between April and June 1988. A published account with Allanegui regarding this portrait appears in Andrés Trapiello's *La Manía: Salon de Pasos Perdidos* (Valencia: Editorial Pre-Textos, 2007), 204–5. *Mémoires de l'Académie impériale des sciences, inscriptions et belles-lettres de Toulouse* (Toulouse: Imprimerie de Douladoure frères, 1860), 4: 565, cites an Otaño who would be roughly the same age as Dolores's father, "a young professor of physics at the University of Burgos, full of passion and scientific devotion." Fourteen years later, this Otaño is established in Saint Sebastian. (Paul Broca, *Mémoires d'anthropologie,* vol. 2 [Paris: C. Reinwald, 1874], 112.) The initials to his surname, M. J., are provided in the *General Catalogue of Printed Books British Museum* (London: Trustees of the British Museum, 1965), 179. Whether this is Dolores's father or another member of the family is not clear.

2. In a letter from Regoyos to Octave Maus dated October 3, 1887, Regoyos explained, "I've made an attempt at prismatic painting, unmixed dot strokes using a bristle brush." Archives de l'art contemporain, 5058, Musées royaux des Beaux-Arts de Belgique, Brussels.

Fig. 41. H. Sjovall, Dolores Otaño, c. 1895. Photograph, cabinet card, image: 5⅞ × 4 in. (14.9 × 10.2 cm); card: 9 × 6½ in. (22.9 × 16.4 cm). Collection of the author.

PLATE 33

Georges Seurat

French, 1859–1891

Young Woman Powdering Herself (*Jeune femme se poudrant*), 1889–90

Oil on canvas, 37⅝ × 31¼ in. (95.5 × 79.5 cm)
Signed lower right: Seurat
The Courtauld Gallery, London

Seurat first grappled with the subject of the Neo-Impressionist oil portrait in this work, and, because of his death a little more than a year later, it remained his only such exploration. It coincided with his return to portraiture in the form of two small conté crayon drawings of Paul Signac (see plate 34) and Paul Alexis. Unlike these, the painting is more hieratic than representational and raises the questions of what Seurat's intentions were with this admittedly enigmatic work, and in what sense it is a portrait.

We might begin by noting that, immediately after Seurat's death, the sitter herself referred to the painting as "mon portrait."[1] In fact, she was his lover, Madeleine Knoblock (1868–1903), and the mother of his short-lived son, Pierre Georges (b. February 16, 1890). Knoblock was born into poverty, which, coupled with her work as a professional model, made her unacceptable to Seurat's parents, and apparently even to his friends. Their relationship was kept a secret; only when Seurat was dying from diphtheria was the liaison revealed

Knoblock sits before her diminutive table (*la poudreuse*) in the process of applying powder to her bosom. A haloed swirl emanates from the powder puff, repeating the puff's roundness. The pink bow on the mirror finds its echo in the abstracted wallpaper pattern and in the potted plant barely visible behind the table. The suspension of the puff in midair, the frozen appearance of her other arm and her impassive expression, define the pose as iconic and ritualistic. Yet the face is a particular person's, rendered in detail, and provides a telling exception to Meyer Schapiro's well-known observation, "The figures in the late paintings are more and more impersonal and towards the end assume a caricatural simplicity or grotesqueness in expressing an emotion."[2] Seurat adds notes of humor and parody in displaying the tightly corseted Knoblock dwarfing her makeup table, much as the bow dwarfs her mirror. Yet the seriousness with which she goes about her task gives her great dignity and provides the tension that makes the work so riveting.

The refined palette and subtle elegance of Seurat's scheme contrasts the yellows, pinks, and oranges of the figure and objects with the blues and greens of the background to create a vibrating sensation, intensified by Seurat's practice of darkening the blues next to light edges and vice versa. Despite the sitter's corporeality, Seurat has reduced her stylistically to a series of decorative shapes, from the sweeping curves present in the triple pleats of her skirt to the rounded buns atop her head. These are answered by the reverse curves of the poudreuse.

The conventional theme of the woman at her toilette may be found in such works as François Boucher's portrait of the Marquise de Pompadour, 1758, who sits before her mirror applying rouge. Seurat's audience would have known similar works by Mary Cassatt, Edgar Degas, and Berthe Morisot, while the artist was further inspired by popular advertisements of the day showing women applying makeup at their toilettes.[3] Several artists carried the subject a step further: Edouard Manet's *Nana*, 1876, preens with powder puff before her glass in the presence of an admirer, while Henry Gervex's *Femme à sa Toilette*, 1880, includes the viewer, as we also peer into her mirror.[4] Such prurient conceits are entirely absent from Seurat's composition, which forthrightly separates us from Knoblock's space.

Seurat prepared a small sketch showing the basic composition on a wooden panel. In the finished painting he added the open mirror on the wall as well as the gentle curve at the top of the Neo-Impressionist border, a motif repeated on the contemporaneous *Chahut*.[5]

Young Woman Powdering Herself follows by several years Albert Dubois-Pillet's first Neo-Impressionist portraits, exhibited in Paris in 1887. Seurat would next have seen Théo van Rysselberghe's pointillist portrait of Alice Sèthe (see plate 46) and Henry van de Velde's of his brother Laurent (see plate 41) when he exhibited at Les XX in Brussels in 1889.[6] The following year Seurat submitted Knoblock's oil portrait, as well as the drawings of Signac and Alexis, to the Paris

Independents, where they joined portraits by the Belgians Van de Velde and Van Rysselberghe also painted in the new manner.[7] Thus Seurat found himself "one among many" rather than a leader. Although also manifestly abstract and decorative, the Belgian portraits did not share Seurat's sense of irony.

The Independents exhibition in 1891 saw a veritable explosion of Neo-Impressionist portraits now clearly influenced by Seurat's new interest, including Paul Signac's of Félix Fénéon (see plate 36), Henri-Edmond Cross's of Madame Hector France (see plate 1), Georges Lemmen's *Young Woman Crocheting* (see fig. 19), and Théo van Rysselberghe's depiction of Maria Sèthe (see plate 51). After Seurat's death the challenge of Madeleine Knoblock's portrait was applied more personally and intimately by Seurat's circle in portraits of three fiancées. Cross depicted his future wife combing her hair, which completely covers her face, in his *Hair (La Chevelure)*, 1891.[8] Signac's reinterpretation, *Woman Arranging Her Hair* (see plate 37), shows his own future wife from the rear as she arranges her coif, her visage reflected in the mirror. Lemmen was particularly affected by *Young Woman Powdering Herself* in his rendering of Aline Maréchal (see plate 17), 1891–92, even repeating the curved top of its pointillist border. Contemporaries saw the relationship between Lemmen's and Seurat's portraits when they were both shown at Les XX in 1892 and parodied in the press (see fig. 21).

Seurat's strange vanitas, with its opposing values of the individual and the universal, make this work an original and witty application of Neo-Impressionism to the portrait by the creator of the movement. JB

PROVENANCE: Madeleine Knoblock, Paris; Félix Fénéon, Paris; Dikran Khan Kélékian, Paris & New York; Eugene O. M. Liston, New York; Percy Moore Turner, London; John Quinn, New York; Paul Rosenberg, Paris; Samuel Courtauld, London, 1926; given to the Institute, 1932.

EXHIBITIONS: Independents, Paris, 1890, no. 727; Les XX, Musée d'art moderne, Brussels, 1892, no. 14; Independents, Paris, 1892, no. 1085; La Revue Blanche, Paris, *Georges Seurat: Oeuvres peintes et dessinées,* 1900, no. 35; Bernheim-Jeune, Paris, *Exposition Georges Seurat,* 1908–9, no. 73; Bernheim-Jeune, Paris, *Exposition Georges Seurat,* 1920, no. 30; Galleries of Joseph Brummer, New York, *Paintings and Drawings by Georges Seurat,* 1924, no. 18; Royal Academy of Arts, London, *Exhibition of French Art, 1200–1900,* 1932, no. 503; Wildenstein & Co., London, *Seurat and His Contemporaries,* 1937, no. 31; Art Institute of Chicago, *Seurat: Paintings and Drawings,* 1958, no. 147; Royal Academy of Arts, London, *Post-Impressionism: Cross Currents in European Painting,* 1979, no. 204; Cleveland Museum of Art, *Impressionist and Post-Impressionist Masterpieces: The Courtauld Collection,* 1987, no. 36; Metropolitan Museum of Art, New York, *Georges Seurat, 1859–1891,* 1991, no. 213.

BIBLIOGRAPHY: Henri Dorra and John Rewald, *Seurat* (Paris: Les Beaux-Arts, 1959), 247–49; César M. de Hauke, *Georges Seurat* (Paris: Gründ, 1961), no. 200; John House, "Meaning in Seurat's Figure Paintings," *Art History* 3 (September 1980): 345–56; Richard Thomson, *Seurat* (Oxford: Phaidon, 1985), 193–97; Robert L. Herbert, *Georges Seurat, 1859–1891* (New York: Metropolitan Museum of Art, 1991), 333–38; Michael F. Zimmermann, *Les Mondes de Seurat: Son oeuvre et le débat artistique de son temps* (Antwerp: Fonds Mercator, 1991), 356–62; Paul Smith, *Seurat and the Avant-Garde* (New Haven: Yale University Press, 1997), 119–21; Tamar Garb, "Powder and Paint: Framing the Feminine in Georges Seurat's *Young Woman Powdering Herself,*" in Garb, *Bodies of Modernity: Figure and Flesh in Fin-de-Siècle France* (New York: Thames and Hudson, 1998), 114–43; Tamar Garb, *The Painted Face: Portraits of Women in France, 1814–1914* (New Haven: Yale University Press, 2007), 1–17.

1. This attribution comes from a handwritten document prepared by Knoblock for the Neo-Impressionist painter Maximilien Luce, who was charged by Seurat's family to arrange for the disposition of works remaining in his studio; reproduced in de Hauke, *Seurat et son oeuvre,* 1: xxviii. The portrait was among the works Knoblock was keeping for herself.

2. Meyer Schapiro, "New Light on Seurat," *Art News* 57 (April 1958): 52.

3. Garb, *Painted Face,* 12. Garb reproduces one such advertisement, for Parfumerie Félix Potin, showing a woman with powder puff and holding her mirror.

4. For the Gervex, see *Female Form: Paintings, Drawings, and Sculpture from the 19th and 20th Centuries* (New York: Dickinson Roundell, 2001), 4–5. See also Garb, "Powder and Paint: Framing the Feminine in Georges Seurat's *Young Woman Powdering Herself,*" in Garb, *Bodies of Modernity: Figure and Flesh in Fin-de-Siècle France* (London: Thames and Hudson, 1998), 114–43, for a detailed and entertaining discussion of the context of the Seurat work.

5. For a reproduction of this work, now in the John A. and Audrey Jones Beck Collection, the Museum of Fine Arts, Houston, see Herbert, *Georges Seurat,* 335.

6. In addition, Luce exhibited his figural paintings of workers, such as *Chauffeur* and *Chiffonniers,* at the Independents in 1888 and at Les XX in 1889, where he also showed *La Toilette.* In 1890 he showed *Une Cuisine* at the Independents.

7. Van de Velde showed *The Seamstress (La Ravaudeuse)* and *Woman Seated at the Window (Femme assise à la fenêtre),* and Van Rysselberghe exhibited the portraits of Alice Sèthe and Denise Maréchal (fig. 24).

8. For a reproduction, see Baligand et al., *Henri-Edmond Cross* (1998), 53.

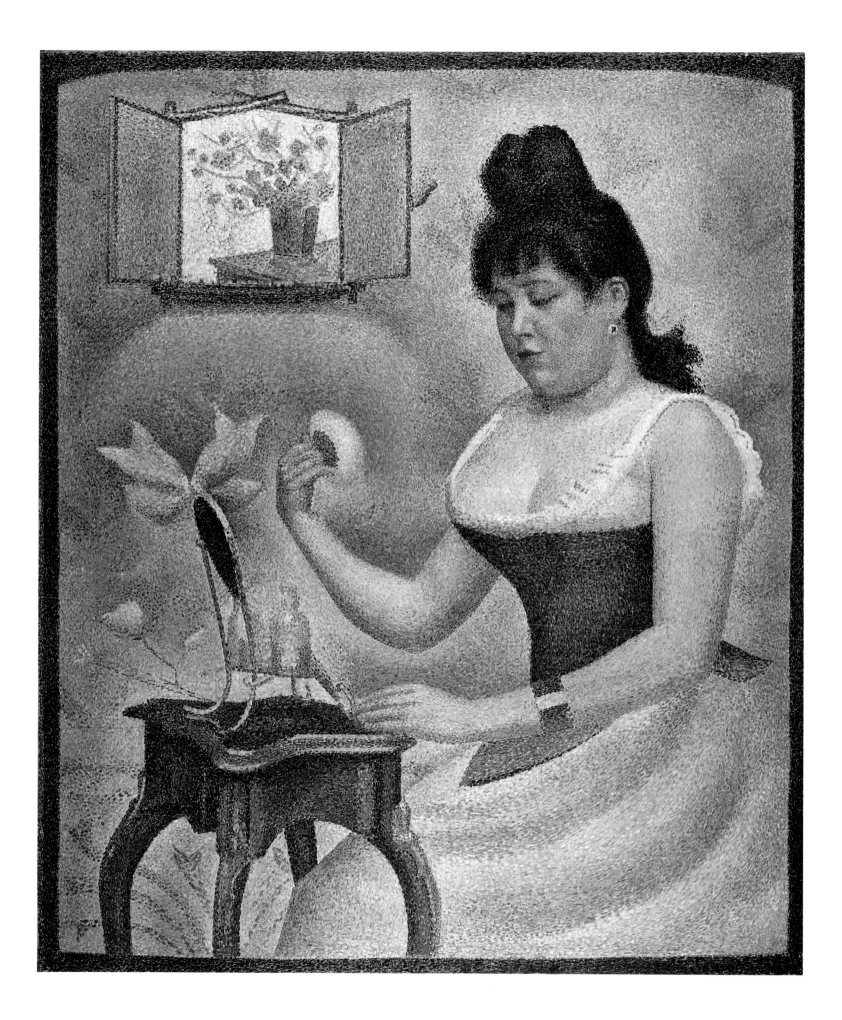

PLATE 34

Georges Seurat

French, 1859–1891

Paul Signac, [1890]

Conté crayon on paper, 14⅜ × 12½ in. (36.5 × 31.6 cm)
Private collection

Paul Signac as seen by Georges Seurat—this exquisite portrait drawing is a rare document of the connection between the two leading figures of the Neo-Impressionist movement: the reclusive founder and its gregarious advocate. Seurat made this drawing to illustrate the cover of the weekly journal *Les Hommes d'aujourd'hui,* which devoted many of the 1890 issues to features on the leading members of the Neo-Impressionist movement (fig. 42).[1]

No artist has understood better than Seurat how to control the effects of pushing a crayon against the surface of paper. While this drawing does not utilize the very dark blacks that characterize some of the artist's most evocative images, the subtle gradations of areas such as the contour of Signac's top hat, or the whisper of its shadow on the right, demonstrate his mastery of the medium. The portrait also reflects Seurat's consummate understanding of composition. Diagonals of curtain, cane, and hat deftly interact with the verticals of the backdrop, and as Robert Herbert has observed, the contour that rolls from Signac's forehead down his chest "is the very signature of Seurat's style and the element that gives the drawing its energy."[2]

Seurat chose to present his colleague not working at the easel or holding a sketchbook but outfitted in the elegant clothing he often wore. Here Signac, a political activist and member of the vanguard of modern art, appears with top hat, walking stick, and elegant cape. Seurat opted to exhibit this work at the Independents in 1890, submitting it under the same number as his portrait of leftist journalist Paul Alexis, who was an enthusiastic supporter of Seurat and Signac. The location of his clever and beautiful portrait of the writer is unknown.

The author of the Signac biography that accompanied his portrait in *Les Hommes d'aujourd'hui* was none other than Félix Fénéon, the perceptive critic and ally responsible for coining the term Neo-Impressionism. In 1886 he had made the effort to interview Seurat and discuss the revolutionary new methods the painter had developed. Ironically, and inexplicably, Fénéon's 1890 article on Signac and his art carried not a single reference to Seurat. Fénéon wrote that the new "optical paint-ing" method "seduced . . . several young painters," but he mentioned only Signac. The most positive outcome of this oversight is that Seurat was moved to write a detailed letter to Fénéon, providing details that established, as Seurat phrased it, his "paternity."[3] This letter is now regarded as a precious and revealing glimpse into the mind of an artist who left few clues to his art and life. EWL

PROVENANCE: Paul Signac, Paris, by 1892 at the latest, until 1935; Ginette Signac, Paris; by descent to the present owner.

EXHIBITIONS: Independents, Paris, 1890, no. 735; Les XX, Brussels, 1892, no. 22; Independents, Paris, 1892, no. 1124; *La Revue Blanche,* Paris, 1900, no. 52; Bernheim-Jeune, Paris, *Exposition Georges Seurat (1859–1891),* 1908, no. 204; Solomon R. Guggenheim Museum, New York, *Neo-Impressionism,* 1968, no. 88; Galeries nationales du Grand Palais, Paris, *Seurat,* no. 216; St. Louis Art Museum and Städelsches Kunstinstitut, Frankfurt, *Vincent van Gogh and the Painters of the Petit Boulevard,* 2001, 24, 243.

BIBLIOGRAPHY: César M. de Hauke, *Seurat et son oeuvre* (Paris: Gründ, 1961), no. 694.

1. *Les Hommes d'aujourd'hui* 8, no. 373, n.d. [May 1890].
2. Herbert, *Georges Seurat,* 339.
3. For more information on the oversight and the translated text of Seurat's written response to the article, see ibid., 383.

Fig. 42. Georges Seurat, *Paul Signac, Les Hommes d'aujourd'hui* 8, no. 373 (May 1890).

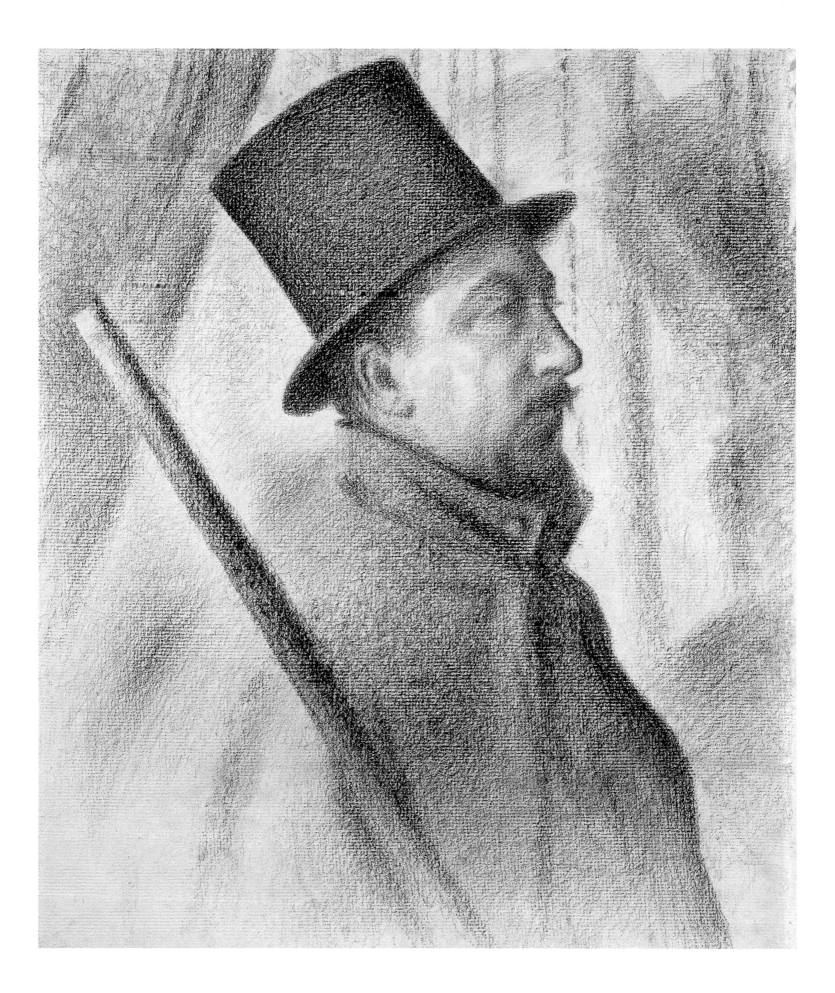

PLATE 35

Paul Signac

French, 1863–1935

Luce Reading "La Révolte" (final composition) (*Luce lisant "La Révolte"* [composition définitive]), [1890]

Pencil, India ink wash, and watercolor on paper, 10½ × 8 in. (26.8 × 20.3 cm)
Signed with monogram lower right: PS
Private collection

In July 1890, the review *Les Hommes d'aujourd'hui* published a special issue on the Neo-Impressionist painter Maximilien Luce.[1] Jules Christophe wrote one of the first biographies on the artist, and Signac created the portrait featured on the cover (fig. 43). There are several preparatory drawings for this portrait. An initial study in watercolor, gouache, and India ink, painted from the model, appeared on the Parisian art market in 2007. In this rendering Luce is already represented against a yellow background, his profile turned toward the right, but he is wearing a soft hat, a cigarette between his lips. This was followed by a second study in India ink wash that heralded the final composition in which the painter, now devoid of cigarette and hat, is shown reading the anarchist periodical *La Révolte*. The ink and watercolor drawing featured here adopts the same composition and adds color. It directly precedes the final composition, in which Luce regains his original cap. As Christophe began his text: "This Neo-Impressionist, a man in a crushed hat, is attentively reading *La Révolte*, an anarchist periodical, in a working class café. He has a prominent forehead, a Socratic

Fig. 43. Paul Signac, *Maximilien Luce, Les Hommes d'aujourd'hui* 8, no. 376 (July 1890).

nose, and a musician's ear; he's of medium height, with a round head, chestnut hair, and a red beard, golden, warm and melancholy eyes, and rather heavy, twisted lips. There's something of Vallès and Zola [radical supporters of the short-lived Paris Commune] in his expression, with the rancor you'd expect of a plebeian revolutionary. The grandson of a wheelwright from Picardy, he was born in Paris on March 13, 1858, to a Parisian father and a mother from the Beauce region."[2]

A genuine testament of friendship, this portrait reveals how close the relationship between the painters was in 1890. Signac and Luce had met three years earlier at the Independents. Luce was exhibiting there for the first time, and his submission included a scene of working-class life, *La Toilette* (1887, Petit Palais, Musée d'art moderne, Geneva); without actually dividing his colors, he was already using broken, repeated brushstrokes. Impressed, Signac purchased the canvas, thus inaugurating an enduring friendship. This meeting also marked the beginning of Luce's entrance into the ranks of the Neo-Impressionist cause. During the summer of 1889, Signac and Luce spent a few weeks in Herblay on the banks of the Seine, across from the forest of Saint-Germain. While there, they each painted remarkable divisionist landscapes that demonstrated their close artistic relationship. Luce did a portrait that showed his friend Signac in profile, backlit and in the process of painting a canvas (1889, private collection).

The friendship that bound these artists was based on their shared artistic choices, but it was further strengthened by their political convictions. A committed anarchist, like many of his fellow Neo-Impressionists, Luce was not only a reader of *La Révolte*, and later of the review *Les Temps nouveaux* that succeeded it in 1895. He also provided a number of propagandistic drawings to his friend Jean Grave, who edited the publication. In the final version of the portrait, a luminous circle suggests the opalescent globes that illuminated a "working class café"—if we agree with Christophe's description. Or perhaps the halo of light represents the solar disk so dear to Neo-Impressionist painters, or better yet the suggestion of a new dawn. The notion

of a radiant future was common in the iconography of anarchism; it appeared again a few years later in the lithograph entitled *The Demolishers* (*Les Démolisseurs*), submitted by Signac to *Les Temps nouveaux.* The first letters of the title of *La Révolte* are shown even in the preparatory study, indicating that Signac had decided to emphasize his comrade's anarchistic convictions from the outset. The two painters shared these beliefs with Félix Fénéon, who once owned this study. Their friend Fénéon, the perceptive critic who was the first to use the term Neo-Impressionist, in 1886, was also among the most ardent defenders of Luce's art. MFB

PROVENANCE: Félix Fénéon, Paris; Jacques Rodrigues-Henriques, Paris; Arthur G. Altschul, New York, 1961; Galerie Hopkins-Custot, Paris, after 2003; private collection.

EXHIBITIONS: Maison de la Pensée Française, Paris, *Maximilien Luce,* 1958; Musée Municipal d'Histoire et d'Art, Saint-Denis, *Luce et les néo-impressionnistes,* 1958, no. 138; Yale University Art Gallery, New Haven, *Neo-Impressionists and Nabis in the Collection of Arthur G. Altschul,* 1965, no. 12; Palais des Beaux-Arts, Charleroi, *Maximilien Luce,* 1966, no. 145; Krugier and Loeb Gallery, New York, *Paul Signac,* 1971; Neuberger Museum of Art, New York, *End Papers: 1890–1900 and 1990–2000,* 2000, 19; Kunsthaus, Zug, *Das Sehen sehen: Signac bis Eliasson,* 2008, 88.

BIBLIOGRAPHY: *Bulletin de la vie artistique* (April 15, 1924): 182; George Besson, *Paul Signac, 1863–1935* (Paris: Braun, 1954), pl. 13; Françoise Cachin, *Paul Signac* (Paris: Bibliothèque des Arts, 1971), 69; Vanessa Lecomte, in *Maximilien Luce, néo-impressionniste: Rétrospective* (Giverny: Musée des Impressionnismes, 2010), 118.

1. Jules Christophe, "Maximilien Luce," *Les Hommes d'aujourd'hui* 8, no. 376 (July 1890).
2. Ibid.

PLATE 36

Paul Signac
French, 1863–1935

Opus 217. Against the Enamel of a Background Rhythmic with Beats and Angles, Tones and Tints, Portrait of M. Félix Fénéon in 1890 (Opus 217. Sur l'émail d'un fond rythmique de mesures et d'angles, de tons et de teintes, Portrait de M. Félix Fénéon en 1890), 1890–91

Oil on canvas, 29 × 36½ in. (73.5 × 92.5 cm)
Signed and dated lower right: P. Signac 90
Inscribed lower left: Op 217
Museum of Modern Art, New York, fractional gift of Mr. and Mrs. David Rockefeller

This idiosyncratic portrait is an ode to Neo-Impressionism. The title, a virtual syllabus, echoes the theories of the very erudite Charles Henry (1859–1926), whose *Introduction à une esthétique scientifique* had a profound effect on Georges Seurat and Paul Signac in 1885. The colorfully abstract background refers to the work that Henry published in 1890, *Application de nouveaux instruments de précision (cercle chromatique, rapporteur et triple-décimètre esthétique) à l'archéologie;* Signac himself participated in its production. "I have just done forty plates for an aesthetic of lines, using Charles Henry's approach. . . . Since you've been laboring over the Degas works with a ruler and protractor, you'll understand how much effort is involved. . . . Now Henry and I are going to tackle color," he wrote to Félix Fénéon in 1889.[1] This group of young painters, critics, and writers, who were still in their twenties, were making numerous discoveries during this period. Japanese prints were equally important in influencing the geometric motifs in the portrait's background.[2]

In the spring of 1890, the first biography of Signac was published in the review *Les Hommes d'aujourd'hui.* Signac's friend Seurat drew the famous portrait of the young painter (see plate 34), seen in profile and wearing a top hat, which was reproduced on the cover. Fénéon had written the text with his customary precision, perspicacity, and sense of humor. He had alluded to the research of Charles Henry but did not exaggerate its impact on Signac's art: "He is not a slave to these graceful mathematics; he is well aware that a work of art is an inextricable whole." The painter expressed his profound gratitude to Fénéon upon its publication; he wanted to create a full-size pictorial biography in return. "It will not be an ordinary portrait, but a carefully planned composition meticulously constructed in terms of lines and colors. An angular, rhythmic pose. A decorative version of Félix, stepping forward with a hat or flower in hand."[3] Against a background that swirls with colors and designs, Fénéon's angular figure does indeed stand out

prominently, a cyclamen in his hand. The critic enters the scene, as if advancing to meet the artist. This painting does indeed evoke the abiding friendships during the "youthful splendor of Neo-Impressionism" and admirably depicts Fénéon, one of the most fascinating personalities of his time.[4]

Although he worked as a clerk in the War Ministry, Fénéon was an anarchist who launched several literary and artistic reviews in his youth and also played an essential role in the history of Neo-Impressionism. He wrote the manifesto for this new school, in which the term Neo-Impressionist first appeared: "The truth is that the Neo-Impressionist method demands an exceptionally sensitive eye."[5] He had an incomparable gift for uncovering fresh talent, notably Seurat, for whom he wrote a catalogue raisonné. He also discovered the poets Jules Laforgue and Arthur Rimbaud. In addition, he was the author of the sparklingly irreverent "nouvelles en trois lignes," news briefings written with an inimitable sense of humor. Hired in 1906 by the Galerie Bernheim-Jeune to oversee its contemporary art department, he organized exhibitions there for his Neo-Impressionist friends. He was literary editor of Éditions de la Sirène in the 1920s and is credited with publishing the first French edition of James Joyce. Fénéon dedicated his life to promoting the artistic talents of others; John Rewald justly referred to him as "the man who wanted to be forgotten."[6]

Fortunately, his friends did not allow this to transpire, and there are many written and painted tributes to the man. When gathered together, these testimonies were so numerous that they inspired Joan Ungersma Halperin to complete a very detailed biography.[7] The distinctive style of "F. F.," a dandy with charmingly eccentric attitudes, is familiar to historians of fin-de-siècle Paris. He was frequently photographed or sketched sporting a top hat or flaunting a dashing cape. Henri de Toulouse-Lautrec included him among the spectators observing the famous Moulin Rouge dancer known as La Goulue (1895, Musée d'Orsay, Paris). In contrast, Félix Vallotton and

Édouard Vuillard showed him hard at work, bent over the proofs of *La Revue Blanche* (1896, private collection; 1901, Solomon Guggenheim Museum, New York). Maximilien Luce depicted him as a collector, standing near Seurat's *Models* and a Japanese print (1903, Musée de Nevers). The foremost among the group, Signac, made him an iconic figure of Neo-Impressionism. MFB

PROVENANCE: Offered by the artist to Félix Fénéon, 1890; Félix Fénéon, Paris, until 1944; Mme Félix Fénéon, Paris; Marlborough, London, 1958; Emil Bührle, Zurich; private collection, Paris; Joshua Logan, New York; Sotheby's, London, July 1, 1964, no. 80; Samuel Josefowitz, Lausanne; Parke Bernet, New York, November 20, 1968, no. 52; David and Peggy Rockefeller, New York; fractional gift to Museum of Modern Art, New York, 1991.

EXHIBITIONS: Independents, Paris, 1891, no. 1107; Les XX, Brussels, 1892, no. 1; Galerie Georges Petit, Paris, *Exposition des portraits des écrivains et journalistes du siècle, 1793–1893,* no. 347; Petit Palais, Paris, 1934, no. 11; Paris, Le Musée d'art vivant, 1938; Musée national d'art moderne, Paris, 1951, no. 15; Musée national d'art moderne, Paris, 1960, no. 673; Musée du Louvre, Paris, *Signac,* 1963, no. 37; Solomon R. Guggenheim Museum, New York, *Neo-Impressionism,* 1968, no. 98; Cleveland Museum of Art, 1975, no. 39; Carnegie Institute of Art, Pittsburgh, *Celebration,* 1974–75; Royal Academy of Arts, London, and National Gallery of Art, Washington, DC, *Post-Impressionism,* 1979–80, no. 108; Musée national d'art occidental, Tokyo, *Exposition du Pointillisme,* 1985, no. 12; Museum of Modern Art, New York, *Masterpieces from the David and Peggy Rockefeller Collection, Manet to Picasso,* 1994, 38–39, 77–80; Metropolitan Museum of Art, New York, *Signac, 1863–1935,* 2001, no. 51.

BIBLIOGRAPHY: Francis Vielé-Griffin, *Entretiens politiques et littéraires,* February 1, 1891, 62; Arsène Alexandre, *Paris,* March 20, 1891, 2; M. F. (Marcel Fouquier), *Le XIX^e Siècle,* March 20, 1891, 2; Henri Gauthier-Villars, *Le Chat noir,* March 21, 1891; P***, *Le National,* March 21, 1891, 2; Alfred Ernst, *La Paix,* March 27, 1891, 2; Alphonse Germain, *Le Moniteur des arts,* March 1891, 543; William B., *La Revue Blanche* (Belgian edition; April 1891); Émile Verhaeren, *L'Art moderne,* April 5, 1891, 111; Jules Christophe, *Journal des artistes,* April 12, 1891, 100; Antoine de La Rochefoucauld, *Le Coeur,* May 1893, 5; Madeleine Maus, *Trente années de lutte pour l'art, 1884–1914* (Brussels: Librairie l'Oiseau bleu, 1926), 133; John Rewald, *Camille Pissarro: Letters to His Son Lucien* (New York: Pantheon, 1943); John Rewald, "Félix Fénéon I," *Gazette des Beaux-Arts,* July–August 1947, 49, 59; John Rewald, *Post-Impressionism from Van Gogh to Gauguin* (New York: Museum of Modern Art, 1978), 105, 125–26; Françoise Cachin, *Les Lettres françaises,* December 1–25, 1963; José Argüelles, "Paul Signac's Against the Enamel of a Background Rhythmic with Beats and Angles, Tones and Colors, Portrait of M. Félix Fénéon in 1890, Opus 217," *Journal of Aesthetics and Art Criticism* 28 (1969): 40–53; Joan Halperin, *Félix Fénéon: Aesthete and Anarchist in Fin-de-Siècle Paris* (New Haven: Yale University Press, 1988), 143–49; Françoise Cachin, *Signac: Catalogue raisonné de l'oeuvre peint* (Paris: Gallimard, 2000), no. 211.

1. Letter from Signac to Fénéon, Dijon, Hotel des Ventes, September 30, 1989, no. 198.
2. Françoise Cachin, "Le portrait de Fénéon par Signac: Une source inédite," *Revue de l'art,* no. 6 (1969): 90–91.
3. Letter from Signac to Fénéon, June 18, 1890, Paris, Bibliothèque centrale des musées nationaux.
4. Félix Fénéon, "Signac," *Les Hommes d'aujourd'hui* 8, no. 373, n.d. [May 1890], 2.
5. Félix Fénéon, "Les impressionnistes en 1886," *La Vogue,* September 19, 1886, 300–302.
6. J. Rewald, *Félix Fénéon: L'Homme qui désirait être oublié,* published in English in the *Gazette des Beaux-Arts,* July–August 1947 and February 1948, translated into French by Alice Bellony for Éditions de L'Échoppe, 2010.
7. Halperin, *Félix Fénéon.*

PLATE 37

Paul Signac

French, 1863–1935

Woman Arranging Her Hair, Opus 227 (Arabesques for a Dressing Room)
(Femme se coiffant. Opus 227 [arabesques pour une salle de toilette]), 1892

Encaustic on canvas mounted on canvas, 23¼ × 27½ in. (59 × 70 cm)
Signed, dated, and inscribed lower right: P Signac 92/Op 227
Private collection

In this consciously decorative work painted in encaustic, Paul Signac's mistress and future wife appears for the last time with her face hidden, as so often depicted in his earlier work.[1] The artist had always discreetly presented her with her face lowered or concealed by her hair, as in *The Red Stocking (Le Bas rouge)* (1883, private collection) or *The Milliners (Les Modistes)* (1885–86, Fondation Bührle, Zurich).

The model is Berthe Roblès (1862–1942). She is posed with her facial features blurred in the mirror's reflection, but those who knew her well would have easily recognized her by her chignon, with a few errant black curls, and the rounded contour of her shoulders. A distant cousin of Camille Pissarro, she was a milliner when Signac met her around 1882, and she continued to work until 1889. In 1892 they decided to spend part of the year in Saint-Tropez, where the mores were less liberal than they were to become a few decades later. The couple decided to marry, and the wedding took place on November 7, 1892, at the *mairie* of the eighteenth arrondissement in Paris. The witnesses were the painters Camille Pissarro and Maximilien Luce, the writer Georges Lecomte, and Alexandre Lemonnier, one of Signac's uncles. The following year Berthe finally appeared in Signac's work with her face uncovered, in *Woman with a Parasol, Opus 243* (see fig. 16).

Painted at a special moment in their life together, *Woman Arranging Her Hair* is a composition in which all the elements seem to be in communion, as a promise of happiness and a celebration of their engagement. Berthe is represented twice—from the back and from the front—in the privacy of her dressing room, where reality and its reflection echo within an intimate space. All around Berthe decorative objects are arranged two by two, and everything seems to function in pairs: the Japanese fans on the wall, the matching water pitcher and bowl, the glass bottles, the two handles of a hairbrush and toothbrush, and even the interlacing on the bodice and the model's fingers. The canvas's chromatic harmony is based on the predominating combination of yellow and blue, enlivened with white highlights and warmed by the orange tonalities of the wall and the perfume bottle. In the center, the darker tones of the corset and chignon emphasize the principal figure. Enhancing the sense of warmth and femininity, the artist took obvious pleasure in an abundance of curving lines, including the spiral in her hair, the arching fans, and the graceful leaves that decorate the ceramics, as well as the arabesques that outline the dressing table and the ruffled edges of her chemise.

When Signac began this painting in early 1892, he was busy organizing the posthumous exhibitions for Georges Seurat. They were held in the Salon des XX in Brussels in February, then at the Independents in Paris, where one of the last works of his deceased friend was displayed: *Young Woman Powdering Herself* (see plate 33). This painting, which shows Seurat's mistress, Madeleine Knoblock, in a composition that emphasized the young woman's "overabundant charms" by contrasting them with the graceful forms of the furniture surrounding her, would certainly have made an impression on Signac.[2] Seurat had left behind an actual portrait of the mistress he had concealed from friends and family, though he presents her with her face fully revealed. There are many similarities between *Young Woman Powdering Herself* and *Woman Arranging Her Hair*.[3] The clothes and accessories are comparable, though the mirror, which plays a unifying role in Signac's composition, in Seurat's scene reflects a still life outside the picture.[4] There is also the evocation of a traditional theme: the association of feminine intimacy with the vice of vanity, a constant in the history of painting, from Titian to Courbet.　　MFB

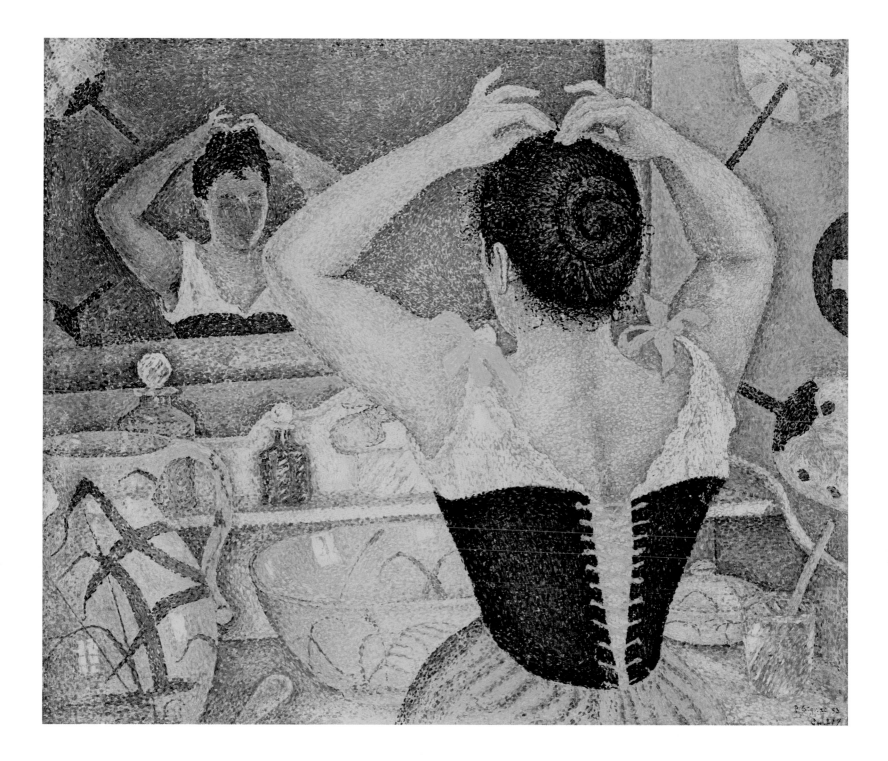

PROVENANCE: The artist; Berthe Signac, until 1942; private collection.

EXHIBITIONS: Independents, Paris, 1892, no. 1127; Hôtel Brébant, Paris, *Exposition des Peintres Néo-Impressionnistes,* 1892, no. 61; Les XX, Brussels, 1893, unnumbered; Bernheim-Jeune, Paris, *Exposition de la femme,* 1948, no. 8; Institut français, Vienna, *Peintres français impressionnistes,* 1949, no. 25; Musée national d'art moderne, Paris, *P. Signac,* 1951, no. 16; Musée des arts décoratifs, Paris, *Cinquante ans de peinture française dans les collections particulières de Cézanne à Matisse,* 1952, no. 164; Musée du Louvre, Paris, *Paul Signac,* 1963, no. 41; Musée d'Orsay, Paris, *1893: L'Europe des peintres,* 1993, no. 40; Galeries nationales du Grand Palais, Paris, Van Gogh Museum, Amsterdam, Metropolitan Museum of Art, New York, 2001, *Signac,* no. 57; Palazzo Reale, Milan, *Georges Seurat, Paul Signac e i neoimpressionisti,* 2008, no. 59.

BIBLIOGRAPHY: Anonymous, "Instantanés: Paul Signac," *Le Gil Blas,* March 20, 1892, 1; C. d'Hennebaut, "Le Salon des indépendants," *Le Moniteur des arts,* March 25, 1892, 1; Charles Saunier, "L'Art nouveau: II. Les Indépendants," *Le Revue indépendante,* April 1892, 43; Pierre Louis [Maurice Denis], "Notes sur l'exposition des indépendants," *La Revue Blanche* (April 1892): 232–34; Jules Christophe, "Certains chromatistes au Cours la Reine," *Journal des artistes,* April 3, 1892, 101; Jules Christophe, "Salon des indépendants," *La Plume,* May 1, 1892, 157; Charles Saunier, "Les peintres symbolistes," *L'Art moderne,* December 25, 1892, 412; Thadée Natanson, "Exposition des XX," *La Revue Blanche* (March 1893): 219, no. 17; George Besson, *Paul Signac, 1863–1935* (Paris: Braun, 1950 and 1954), pl. 47; André Warnod, "Du Salon des surindépendants au salon d'hiver," *Le Figaro,* October 29, 1951, 7; J. Bouret, "Signac aux eaux de la couleur pure," *Arts,* November 2, 1951, 5; Marie-Thérèse Lemoyne de Forges, *Signac* (Paris: Musée du Louvre, 1963), no. 41; Claude Roger-Marx, "Signac le marin magicien méthodique," *Le Figaro littéraire,*

December 12–24, 1963, 12; Waldemar George, "Triomphe de Signac," *Le Peintre,* January 1, 1964, 7; Giulia Veronesi, "Neo-impressionisti: Paul Signac, Theo van Rysselberghe," *Emporium* 139 (March 1964): 99; Annamaria Mura, *Paul Signac* (Milan: Maestri del colore, 1966), pl. vii; Max Kozloff, "Neo-Impressionism and the Dream of Analysis," *Art Forum,* April 1968, 45; Marie-Jeanne Chartrain-Hebbelinck, "Les lettres de Paul Signac à Octave Maus," *Bulletin des Musées royaux des Beaux-Arts de Belgique* 18 (1969): 74n3; Jean Sutter, ed., *The Neo-Impressionists* (Greenwich, CT: New York Graphic Society, 1970), 50; Françoise Cachin, *Paul Signac* (Paris: Bibliothèque des Arts, 1971), 47, 50; Louis Hautecoeur, *Georges Seurat* (Milan: F. Fabbri, 1972), 80; Françoise Cachin, "Les néo-impressionnistes et le japonisme," *Japonism in Art* (Tokyo, 1980), 235; Diane Kelder, *L'Héritage de l'impressionnisme: Les sources du XXᵉ siècle* (Paris: Bibliothèque des Arts, 1986), 89; Marina Ferretti Bocquillon, *Signac et Saint-Tropez, 1892–1913* (Saint-Tropez: Musée de l'Annonciade, 1992), 48; Françoise Cachin, *Signac: Catalogue raisonné de l'oeuvre peint* (Paris: Gallimard, 2000), no. 222.

1. See Ferretti Bocquillon, *Signac, 1863–1935,* 2001, 211.
2. Herbert, *Georges Seurat,* 333.
3. These two works are related to a third representation of a woman arranging her hair, *Hair (La Chevelure)* (c. 1891, Musée d'Orsay, Paris), painted by Henri-Edmond Cross. The subject was Irma Clare France, who had recently become his mistress and was to marry him in 1893. Her face is completely hidden by her loosened hair, which transforms the painting's surface into an almost abstract interplay of colored dots.
4. See Herbert's commentary on this topic in *Georges Seurat,* 378–80.

PLATE 38

Paul Signac

French, 1863–1935

Portrait of My Mother, Opus 235 (Portrait de ma mère. Opus 235), 1892

Oil on canvas, 25⅝ × 31⅞ in. (65 × 81 cm)
Signed and dated lower left: P Signac 92; inscribed lower right: Op 235
Private collection

Paul Signac rarely painted portraits, and he never worked on commission. The most famous example is the image of his friend Félix Fénéon (see plate 36), the author of the founding texts on the Neo-Impressionist school, as well as Signac's first biographer. The artist had done earlier portraits of his mother, Héloïse Signac, née Deudon (1842–1911), as well as of his wife, Berthe Roblès (see fig. 16). Héloïse had already posed, dressed in black, for the faceless figure quietly sitting next to the artist's grandfather in *The Dining Room. Opus 152 (La Salle à manger. Opus 152)* (1886–87, Rijksmuseum Kröller-Müller, Otterlo). Soon thereafter, her son decided to honor her with this portrait.

Héloïse Signac married Jules Signac in 1862. The couple lived at 33 rue Vivienne in Paris, where they owned a high-end saddlery business originally established by the artist's grandfather, who was also named Jules. Widowed in 1880, she left Paris and moved to Asnières with her father-in-law and seventeen-year-old son, Paul. Intelligent and cultivated, Héloïse was very close to her only child. She did not oppose his decision to become a painter and was always glad to welcome his friends, often purchasing their paintings. She had affectionate relationships with Camille Pissarro, Maximilien Luce, Henri-Edmond Cross, Théo van Rysselberghe, and Émile Verhaeren. She was also the one who welcomed Maurice Denis when he came to visit Signac's Saint-Tropez villa La Hune in February 1906; he remarked on "her very beautiful dark eyes."[1]

In May 1892, Signac landed in the little port of Saint-Tropez in the sailboat that he had christened *Olympia.* He was charmed by the spot and immediately decided to spend part of the year there. As Françoise Cachin commented, it was a "pragmatic son and lyrical painter" who shared his enthusiasm in a letter to his mother: "Since yesterday I've settled in and I'm beside myself with delight. Just five minutes from town, tucked away amidst pine trees and roses, I found a lovely little furnished cottage. . . . On the edge of the gulf's golden shore, blue waves break onto a little beach . . . my beach! . . . With the blue silhouettes of the Maures and Esterel in the background—I have enough to work on for the rest of my life—it's true happiness that I've just discovered here."[2] Héloïse wasted no

time in joining her son and daughter-in-law on the shores of the Mediterranean. It was in this setting, seated on the terrace of La Ramade in the shade of a pine tree (according to Charles Saunier) or a eucalyptus (according to Antoine de la Rochefoucauld), against the backdrop of an azure sea, that Signac decided to begin the portrait. Behind her we glimpse the little beach of Graniers and the beloved *Olympia,* moored in front of the horizon where the rocky silhouette of the Esterel mountains stands etched in relief.

Héloïse, who was fifty years old at the time, is painted half length in a three-quarter view, her head turned toward the left. Her eyes lowered, she smells a flower held in her right hand, her little finger conspicuously raised. This slightly precious gesture recalls that of Fénéon proffering a cyclamen in the portrait painted by Signac two years earlier. This time, the model holds a deep pink carnation. After the first celebration of May Day in 1890, the red carnation had come to stand for that socialist workers' holiday; however, the flower traditionally symbolized conjugal love and faithfulness. Long and elegant, Héloïse's left hand rests unaffectedly in the picture's foreground. Her hairstyle and costume are very simple, and the dark lace on her collar and sleeves reminds us of her widowhood. She wears no jewelry, save for perhaps a pearl in her ear. All of the painting's richness derives from its chromatic harmonies: the three primary colors—blue, yellow, and red—set off the contrast created by the green opposed against the red.

The artist has left us two versions of this portrait with the same measurements, an unusual event in his work: *Portrait of My Mother. Study (Héloïse Signac, 1st version) (Portrait de ma mère. Etude [Héloïse Signac, 1ère version])* (private collection) and *Portrait of My Mother, Opus 235,* both painted in 1892. The first is a hastily executed general sketch done in June 1892 upon Héloïse's arrival in Saint-Tropez. The second repeats the composition but handles the various elements in a more rigorously Neo-Impressionist manner. The brushstrokes are finer, more subtly modulating the colors. The areas of light and shadow, broadly distributed in the first study, are more precisely delineated in the second, and the contrasts are more pronounced. The forms are more overtly stylized, with an emphasis on the

curves and arabesques of the neck, the collar, the hairstyle, and the foliage.

Originally entitled *Image* (*Effigie*), the painting was displayed in the first Neo–Impressionist exhibition of 1892 in the salons of the Hôtel Brébant in Paris, before being hung in the Salon des XX in Brussels, and subsequently in the Association pour l'art show in Antwerp in 1893. It was on view again the following year at the first exhibition of the Libre Esthétique in Brussels and the Independents in Paris. Signac was particularly proud of this work, which he bestowed on his mother. This family portrait was not exhibited thereafter. This is the first time since 1894 that the work is again presented to the public. MFB

PROVENANCE: Given to Héloïse Signac, the artist's mother; Paul Signac, 1911; artist's studio, Saint-Tropez, 1935; private collection.

EXHIBITIONS: Brébant, Paris, 1892, no. 56; Les XX, Brussels, 1893, unnumbered; Association pour l'art, Antwerp, 1893; La Libre Esthétique, Brussels, 1894, no. 401; Independents, Paris, 1894, no. 766.

BIBLIOGRAPHY: Charles Saunier, *L'Art moderne,* December 25, 1892, 412; Alfred Ernst, *Journal des artistes,* January 1893, 14; Thadée Natanson, *La Revue Blanche* (March 1893): 219; Antoine de La Rochefoucauld, *Le Coeur,* May 1893, 5; George Besson, *Galerie des arts,* November 1963, 28; Marie-Jeanne Chartrain-Hebbelinck, "Les lettres de Paul Signac à Octave Maus," *Bulletin des Musées royaux des Beaux-Arts de Belgique* 18 (1969): 74; Sophie Monneret, *L'Impressionnisme et son époque: Dictionnaire international,* vol. 2 (Paris: Denoël, 1980), 257; Claire Frèches-Thory, "Paul Signac: Acquisitions récentes," *Revue du Louvre* 1 (1983): 35; Marina Ferretti Bocquillon, *Signac et Saint-Tropez, 1892–1913* (Saint-Tropez: Musée de l'Annonciade, 1992), 30; Françoise Cachin, *Signac: Catalogue raisonné de l'oeuvre peint* (Paris: Gallimard, 2000), no. 228.

1. Maurice Denis, *Journal,* T. II (Paris, 1957), 3.
2. Françoise Cachin, "L'Arrivée de Signac à Saint-Tropez," in Ferretti Bocquillon, *Signac et Saint-Tropez, 1892–1913* (Saint-Tropez: Musée de l'Annonciade, 1992), 15; letter from Signac to his mother, n.d., quoted in ibid.

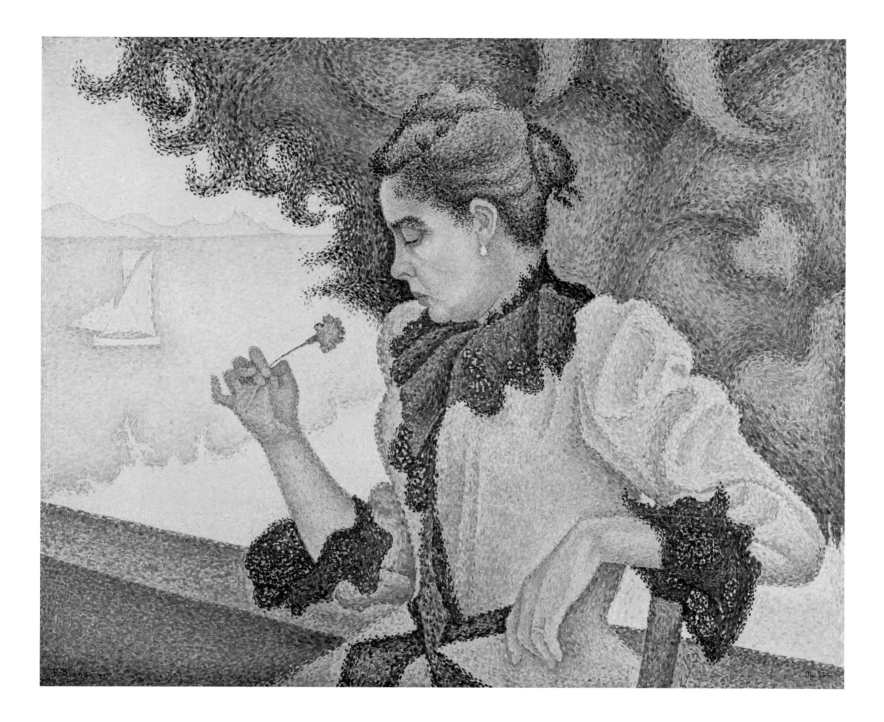

PLATE 39

Jan Toorop
Dutch, 1858–1928

Portrait of Marie Jeannette de Lange, 1900

Oil on canvas, 27¾ × 30½ in. (70.5 × 77.4 cm)
Signed and dated lower right: J. Toorop/1900
Rijksmuseum, Amsterdam, Purchased with the support of the Rembrandt Society, the BankGiro Lottery, and the Rijksmuseum Funds

Jan Toorop created only two Neo-Impressionist portraits—Marie Jeannette de Lange and Dr. Aegidius Timmerman—and both were painted in 1900. However, the artist was attracted to Neo-Impressionism some twelve years earlier, producing his first pointillist canvases of landscapes and socially charged scenes, such as *After the Strike,* 1889. Two years later, Toorop abandoned Neo-Impressionism for Symbolism, but he returned to painting in the Neo-Impressionist manner when he moved back to Katwijk, Holland, in 1899.

Jeannette de Lange (1865–1923) was born in Batavia (now Jakarta), where her father served as an engineer for the East Indies Geographical Services. In 1884 she married Jan Cornelis Bouman, an important official in the department of finance in Batavia, who relocated to The Hague and worked in the ministry of finance. Toorop and De Lange were united by their origins in the East Indies and by their love of art. De Lange was an amateur artist who studied with Maurits van der Valk and Philippe Zilcken.

Toorop may have met de Lange around the time of the National Exhibition of Women's Work on display in The Hague from July 9 to September 21, 1898, for which Toorop designed the poster.[1] De Lange was involved with the women's liberation movement in the Netherlands. She was chairwoman of the board of the Vereniging voor Verbetering van Vrouwekleding (Society for the Betterment of Women's Clothing), part of the Reform Dress movement, whose goal was the design of healthy and comfortable clothes for women.

Jeannette de Lange began sitting for her portrait in February 1900 in the drawing room of her home, located in an elegant district of The Hague.[2] De Lange recorded in her diary what was, for her, a novel way of painting: "He is stippling the portrait: divisionism they call it, in oils on smooth white canvas."[3] The artist depicts her close to the picture plane, engrossed in reading a book. She is featured in three-quarter profile wearing a pink dress and matching jacket, which she may have designed herself. Beside her on the flowered tablecloth sit two vases of fresh-cut flowers, and behind her on the wall is possibly a batik fabric.[4] The sitter is bathed in a gentle, almost ethereal light emanating from the oil lamp, and the contours are softened,

which makes reading of foreground and background more difficult. Bluish shadows fall across her face, and the whole is rendered as a decorative screen of dots. Toorop has communicated his appreciation of his sitter and an overall lyrical mood through the poetry of unconventional Neo-Impressionist color combinations. These, in turn, define Marie Jeannette de Lange as an elegant person and patron of the arts. JB

PROVENANCE: Family of Marie Jeannette de Lange; Christie's, Amsterdam, November 29, 2005, lot 244, purchased by the Rijksmuseum.

EXHIBITIONS: Kunstkring, The Hague, *Portretten van Nederlandse meesters,* 1900; Kunst en Kennis Society, Arnheim, *Jan Toorop,* 1901; Rotterdamse Kunstkring, *Schilderijen en Teekeningen van J. W. Toorop,* 1901, no. 8; La Libre Esthétique, Brussels, 1902, no. 267, incorrectly as *Mme Boisman;* Fr. Buffa & Zonen, Amsterdam, *Tentoonstelling van schilderijen, aquarellen en teekeningen door Jan Toorop,* 1904, no. 9; Kunsthandel Kruger, The Hague, *Tentoonstelling van schilderijen en teekeningen van Jan Toorop,* 1907, no. 59; Larensche Kunsthandel, Amsterdam, *Tentoonstelling Jan Toorop,* 1909, no. 19; Arti et Amicitiae Society, Amsterdam, *Eeere-tentoonstelling Jan Toorop,* 1919, no. 28; E. J. van Wisselingh, Amsterdam, *Johannes Theodorus Toorop: Exposition de quelques tableaux, aquarelles et dessins provenant de musées et collections privées néerlandaises,* 1970, no. 33; Gemeentemuseum, The Hague, *Licht door kleur: Nederlandse luministen,* 1976, no. 82; Institut Néerlandais, Paris, *Jan Toorop, 1858–1928: Impressionniste, symboliste, pointilliste,* 1977, no. 67; Rijksmuseum Kröller-Müller, Otterlo, *J. Th. Toorop: De jaren 1885 tot 1910,* 1978, no. 95; Gemeentemuseum, The Hague, *Jan Toorop, 1858–1928,* 1989, no. 77; Museum Het Valkhof, Nijmegen, *Jan Toorop, Portrettist,* 2003, no. 100.

BIBLIOGRAPHY: Willem Vogelsang, "Jan Toorop," *Onze Kunst* 3 (1904): 179, 186; Israël Querido, *Van den Akker* (Amsterdam: Scheltens and Giltay, 1910), 266; Albert Plasschaert, *Jan Toorop* (Amsterdam: J. H. de Bussy, 1925), 39; Phil Mertens, "De brieven van Jan Toorop aan Octave Maus," *Bulletin des Musées royaux des Beaux-Arts de Belgique* 18 (1969): 200, 201, 202; Victorine Hefting, *Jan Toorop: Een Kennismaking* (Amsterdam: Bakker, 1989), 145–46, 148, 174; Ad. de Visser, *Jan Toorop* (Nijmegen: SUN, 1991), 32–35; M. Bosma, ed., *Vier generaties: Een eeuw lang de kunstenaarsfamilie Toorop* (Fernhout: Centraal Museum Utrecht, 2001), 54n8; Jenny Reynaerts, "'From a Hygienic and Aesthetic Point of View': Jan Toorop, *Portrait of Marie Jeannette de Lange,* 1900," in *Rijksmuseum Bulletin* 57, no. 2 (2009): 114-35.

1. Much of my discussion is drawn from the illuminating article on the life of Marie Jeannette de Lange and her relationship to the painter by Reynaerts, "'From a Hygienic and Aesthetic Point of View.'"
2. Ibid., 115. The home, Vall'di Rhena, was at 31 Scheveningseweg.
3. Ibid. Diary entry, February 1900.
4. Ibid., 118, 119. The author reproduces a photograph of Jeannette de Lange's drawing room with the batik in evidence.

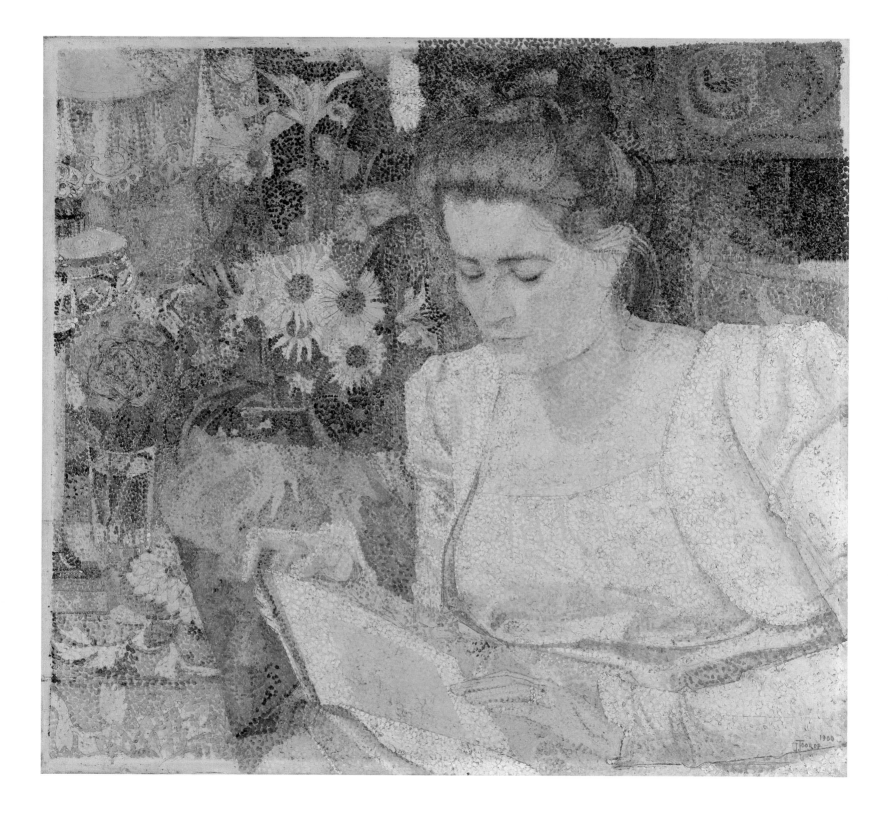

PLATE 40

Jan Toorop
Dutch, 1858–1928

The Print Lover (Dr. Aegidius Timmerman), 1900

Oil on canvas, 26⅛ × 31⅛ in. (66.5 × 76 cm)
Signed and dated lower right: J. TOOROP/1900
Collection Kröller–Müller Museum, Otterlo

In this late Neo–Impressionist portrait, the Dutch classical scholar Aegidius Timmerman (1858–1941) contemplates a lithograph from his own collection by Henri de Toulouse–Lautrec showing the French actress and dancer Marcelle Lender (Anne–Marie Marcelle Bastien).[1] Timmerman, who sat for his portrait in Toorop's studio, recounted amusingly in his autobiography *Tim's herinneringen* (*The Reminiscences of Tim*) how his sessions were continually interrupted by female fans of the artist.[2] Toorop depicts the connoisseur in the midst of the artist's cluttered if neatly arranged studio contents. Two framed pencil drawings by Toorop hang on the wall behind a low table, lamp, pipe and bowl, and book stack to the left, and a higher angled table, bud vase, and book cradle on the right.[3]

The space is constricted and ambiguous. The color values are so muted and similar that the surface becomes a complex geometric pattern. The color tonalities of lilac–pink, orange–red, and yellow–green are predominant. The mustached Aegidius in profile, wearing glasses and a green coat, is rendered in a decorative and abstract manner. Toorop plays with the color patches of the collector's scalp, the curve of his ear, and even his bony and sunken cheekbones. In several instances the pointillist dots are applied with an insistent, almost hypnotic quality, as on the ashtray's rim, the pleats of the lampshade, and the lilac–pink chair covering. JB

PROVENANCE: Aegidius Timmerman, from the artist, July 1919.

EXHIBITIONS: Rotterdam, *Catalogus van Schilderijen en Teekeningen van J. W. Toorop*, 1901, no. 18; La Libre Ésthétique, Brussels, 1902, no. 268; Hollandse Kunst, Krefeld, 1903; Wiesbadener Gesellschaft für Bildende Kunst, Holländische Secession, Wiesbaden, 1903, no. 50; Frans Buffa & Zonen, Amsterdam, *Tentoonstelling van schilderijen, aquarellen en teekeningen door Jan Toorop*, 1904, no. 8; Kunstzaal Reckers, Rotterdam, *Toorop-Tentoonstelling*, 1906, no. 41; Arti et Amicitiae, Amsterdam, *Eere-Tentoonstelling Jan Toorop*, 1919, no. 35; Museum Boymans, Rotterdam, Catalogus van Schilderijen uit de Divisionistische school van Georges Seurat tot Jan Toorop, 1936, no. 62; Stedelijk Museum, Amsterdam, *150 jaar Nederlandse Kunst*, 1963, no. 126; Gemeentemuseum, The Hague, *Licht door kleur: Nederlandse luministen*, 1976, no. 83; Institut Néerlandais, Paris, *Jan Toorop, 1858–1928: Impressionniste, symboliste, pointilliste*, 1977, no. 66; Rijksmuseum Kröller-Müller, Otterlo, *J. Th. Toorop. De jaren 1885 tot 1910*, 1978, no. 94; Musée national d'art occidental, Tokyo, *Exposition du Pointillisme*, 1985, no. 52; Gemeentemuseum, The Hague, *Jan Toorop, 1858–1928*, 1989, no. 78; Museum Het Valkhof, Nijmegen, *Jan Toorop, Portrettist*, 2003, no. 56b; Dordrechts Museum, *Portret in Portret in de Nederlandse Kunst, 1550–2012*, 2012, no. 89.

BIBLIOGRAPHY: Willem Vogelsang, "Jan Toorop," *Onze Kunst* 3 (1904): 179, 186; Vittorio Pica, "Artisti contemporanei: Jan Toorop," *Emporium* 22 (1905): 12–13; Israël Querido, *Van den Akker* (Amsterdam: Scheltens and Giltay, 1910), 169–71; Albert Plasschaert, *Johannes Theodorus Toorop* (Baarn: J. V. van de Ven, 1911), 17–18; John B. Knipping, *Jan Toorop* (Amsterdam: Becht, 1947), 30; Phil Mertens, "De brieven van Jan Toorop aan Octave Maus," *Bulletin des Musées royaux des Beaux-Arts de Belgique* 18 (1969): 167, 201–2; *Paintings of the Rijksmuseum Kröller-Müller* (Otterlo: Rijksmuseum Kröller-Müller, 1969), 266; Rudi van der Paardt, "Aegidius W. Timmerman," in *Klassieke Profilen* (Alkmaar: Uitgeverij de Doelenpers, 1988), 6–8; Victorine Hefting, *Jan Toorop: Een kennismaking* (Amsterdam: Bakker, 1989), 145–48; Jenny Reynaerts, "'From a Hygienic and Aesthetic Point of View': Jan Toorop, *Portrait of Marie Jeannette de Lange*, 1900," *Rijksmuseum Bulletin* 57 (2009): 117–20.

1. Lender was a favorite subject of Lautrec, who captured her in oil and fifteen lithographs. In 1895, Julius Meier-Graefe, the German art critic and editor of the Berlin-based *Pan,* arranged for Lautrec to publish this image in the review, in vol. 1, no. 3.
2. Aegidius Timmerman, *Tim's herinneringen* (Amsterdam and Paris, 1938), 171–77. Timmerman's admiration for Toorop by 1938 had turned to antipathy. Timmerman received his doctorate from the University of Amsterdam in 1893 for his thesis entitled *De Dionis et Timoleontis vitis capita quaedam: Specimen litterarium inaugurale quod.* In the 1930s he translated Homer's *Iliad* and *Odyssey.* In 1900 Toorop also did a dry point of Timmerman showing only his head and one hand clutching a book.
3. The figural composition behind the lamp is *The Strike*, 1899, and the marine scene *Procession of Souls by the Ocean*, 1900. These have been identified by Jenny Reynaerts in *Rijksmuseum Bulletin* 57 (2009): 131n12.

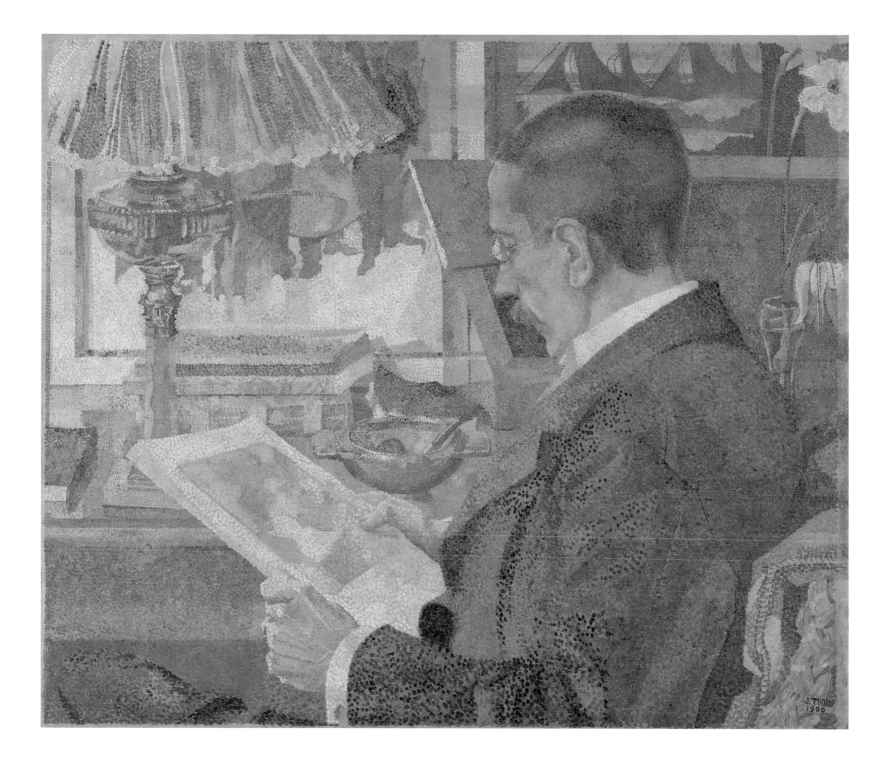

PLATE 41

Henry van de Velde

Belgian, 1863–1957

Portrait of Laurent in Blankenberghe, c. 1888

Oil on canvas, 17⅜ × 13⅜ in. (44 × 34 cm)
Groeningemuseum, Bruges

Henry van de Velde painted his younger brother, Laurent, at his rented villa at the coast in Blankenberghe, where the artist sought refuge in the summer of 1888 after their mother's death on July 22. The canvas conveys the warmth of an August day, with its yellows and decorative shadows rendered in violet blue. Absorbed with his book, Laurent ignores the tempting beach scene behind him, much as the figure in *Portrait of a Woman* (see plate 42) turns her back to the window. Laurent, placed off to the side, is framed by the opening of the porch. The parallel lines of the bench echo the earth and horizon lines, whereas the streetlight and post behind Laurent's head add vertical counterpoints.

The work reveals the artist in a transitional period, absorbing the principles of Neo-Impressionist color theory reflected in the landscape while painting the figure in an impressionistic technique characterized by emphatic and rapid brushstrokes. In the following year Van de Velde developed the littoral scene into a highly abstracted and consistently pointillist composition no longer dominated by a central figure in *The Beach at Blankenberghe* (Bremen, Kunsthalle).

Laurent (June 12, 1865—November 7, 1899) was the youngest child in a family of eight children born to Guillaume Charles van de Velde and Jeanne Aimée Aurore de Paepe. In 1887 he assisted his brother Henry by performing the duties of treasurer for the art society L'Art indépendant, a group patterned after Les XX, which Henry was instrumental in establishing. Laurent was a distributor of beverages in Uitkerke, a village on the outskirts of Blankenberghe, where he founded his company, L. Vandevelde & Cie.[1] A well-known poster commemorating the business was designed by Georges Lemmen, possibly with the assistance of Henry van de Velde. Although Laurent did not live in Blankenberghe, he rented the Villa des Bruyères on the Zeedijk in Blankenberghe as a second residence, which presumably is the setting for this work.[2] JB

PROVENANCE: Johanna van de Velde, sister of the artist; Christie's Amsterdam, June 5, 1996, lot 00226, *Modern and Contemporary Art,* incorrectly titled *A Portrait of Felix van de Velde.*

EXHIBITIONS: Les XX, Brussels, 1889, no. 6; Koninklijk Museum voor Schone Kunsten, Antwerp, *Henry van de Velde (1863–1957): Schilderijen en tekeningen—Paintings and drawings,* 1987, 146; Museum of Art, Kochi, *Georges Seurat et le Néo-Impressionnisme, 1885–1905,* 2002, 289, no. 88; Fondation de l'Hermitage, Lausanne, *Belgique dévoilée de l'impressionnisme à l'expressionnisme,* 2007, 52; Palazzo Reale, Milan, *Georges Seurat, Paul Signac e i neoimpressionisti,* 2008, 241, no. 55.

BIBLIOGRAPHY: Dirk De Vos, *Groeninge Museum Bruges* (Musea Nostra, 37) (Brussels: Crédit communal, 1996), 93; Dominique Marechal, "Groeningemuseum Bijzondere aanwinst," *Museum Bulletin* (Brugge Stedelijke Musea & Museum vrienden) 17, no. 2 (May 1997): 1–5; "La Chronique des arts, principales acquisitions des musées en 1997: Henry van de Velde, Portrait présumé de Laurent van de Velde à Blankenberghe," *Gazette des Beaux-Arts* 131 (March 1998): 35, no. 146; "Vermoedelijk portret van Laurent van de Velde te Blankenberge (ca. 1888)," *Jaarboek Stad Brugge Stedelijke Musea, 1997-99* (2000): 69–71; Irene Smets, *The Groeninge Museum, Bruges: A Selection of the Finest Works* (Ghent-Amsterdam: Ludion, 2000), 91.

1. Cardon, *Georges Lemmen* (1990), 481–82, has documented that the company was founded on January 25, 1897.

2. Letter from the archivist of Blankenberghe to Lieven Daenens, dated July 18, 2006. Courtesy of Lieven Daenens, director of the Design Museum, Ghent. According to Laurent's death certificate, he was unmarried and not registered in the municipal archives of Blankenberghe; most probably his official address was elsewhere. My thanks to Roger Cardon for sharing this information with me, which he obtained from the Commune of Blankenberghe. The date of death published in Van Loo and Van de Kerckhove, *Henry Van de Velde: Récit de ma vie,* 1: 405, is incorrectly given as March 12, 1896.

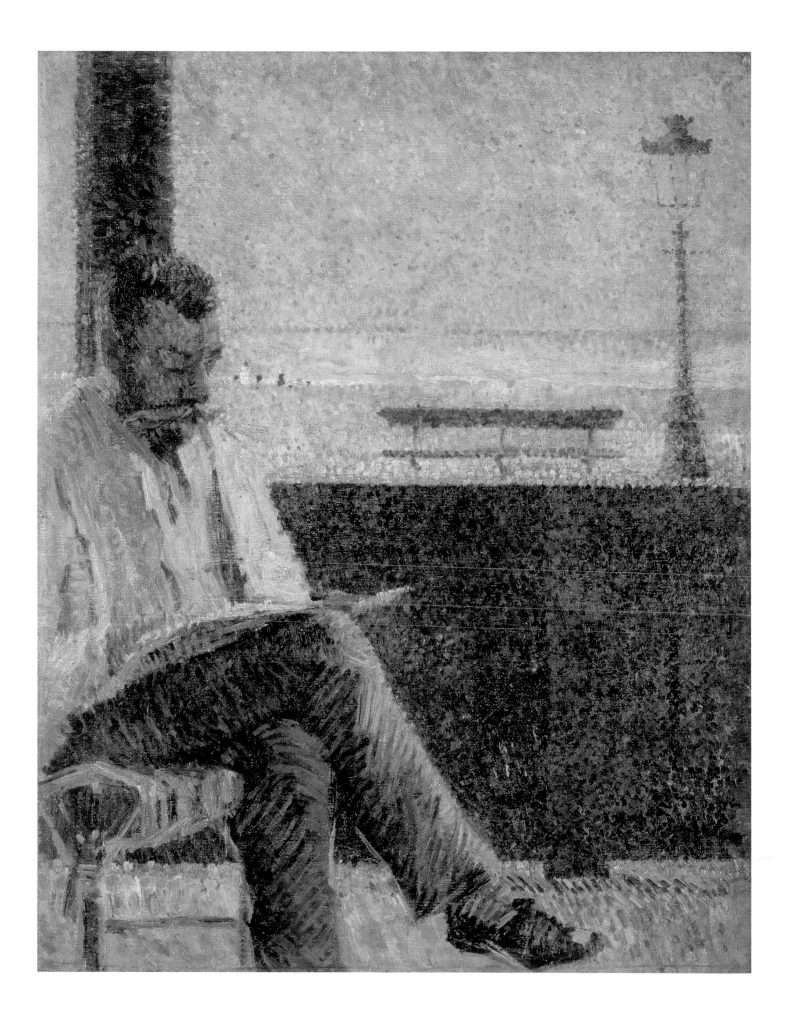

PLATE 42

Henry van de Velde

Belgian, 1863–1957

Portrait of a Woman, [1888]

Oil on canvas, 40⅝ × 31⅛ in. (103.1 × 79 cm)
Signed lower left: [H] (van) . . . de Ve . . . (lde)
Galerie Michael Haas, Berlin

Henry van de Velde executed two Neo-Impressionist portraits in 1888: his brother Laurent (see plate 41) and an unidentified woman reading before a window. Her back to the window, the seated woman ignores the world outside. She concentrates fully, head slightly inclined and eyelids lowered, on the reading material she holds. The artist is interested, however, in the golden glow of light through the window, which illuminates the sitter's face. He has applied a layer of dots over the window frame and sill, in pink, orange, and greens. Although the sitter has a large frame, portions of her seem to dematerialize into the sill and the chair.

Susan M. Canning has postulated that because Van de Velde applied a large amount of paint to the surface, he may have been reworking an older canvas.[1] However, an analysis of the painting performed in November 2000 revealed no earlier composition.[2] The colors are close to those of *Woman in an Orchard* of the same year, while the thickness of the strokes bears a relationship to Van de Velde's *Washerwoman* (1887). *Portrait of a Woman* is a transitional work between Van de Velde's Impressionist *Portrait of His Mother* and his masterful Neo-

Impressionist work *Woman Seated at the Window* (see fig. 18).[3] While a conclusive identification has not been made, we are in the presence of a particular individual whose personality may have been as large as the physical presence represented by her portrait.[4]
 JB

PROVENANCE: Bussum, Kunsthandel G. J. Scherpel; Christie's, Amsterdam, June 5, 1996, lot 00232, withdrawn; Berlin, Galerie Michael Haas.

BIBLIOGRAPHY: Susan M. Canning, *Henry van de Velde (1863-1957): Schilderijen en tekeningen, Paintings and Drawings* (Antwerp: Koninklijk Museum voor Schone Kunsten, 1987), 146-48.

1. Canning, *Paintings and Drawings,* 146.
2. Private communication to the author. The report was issued by the Doerner Institute at the Bayerische Staatsgemaldesammlungen, Munich, and is dated November 13, 2000.
3. For an illustration of *Portrait of His Mother*, see Canning, *Paintings and Drawings,* 137.
4. Canning has postulated that the figure may be the artist's maternal grandmother or Phil De Keiser, the wife of the proprietor of the inn De Keiser, in Wechelderzande, Belgium, where Van de Velde lodged. Canning reproduces photographic portraits of the artist's grandmother and Phil. Canning, *Paintings and Drawings,* 146, 148.

PLATE 43

Henry van de Velde

Belgian, 1863–1957

Père Biart Reading in the Garden, 1890–91

Oil on brown paper mounted to canvas, 24½ × 20⅜ in. (62.1 × 51.9 cm)
Signed with a floral emblem
Indianapolis Museum of Art, The Holliday Collection

Henry van de Velde, best known today as an architect and a designer of furniture, silver, and ceramics, began his career as a painter and was first drawn to the works of the Barbizon artist Jean-François Millet. After seeing Georges Seurat's *La Grande Jatte* exhibited at Les XX in the winter of 1887, he began to experiment with that style, creating his first pointillist works in the summer of 1888. *Père Biart,* one of five known Neo-Impressionist portraits by Van de Velde, is his last foray into the genre. A colorful pastel showing a figure seen from the rear in the same garden as our portrait, dating from 1892–93, consists of the kinetic long strokes Van de Velde used after he abandoned Neo-Impressionism.[1]

In the early 1890s, Van de Velde maintained an atelier at his sister Jeanne's summer home, Vogelenzang, at Kalmthout, twelve miles north of Antwerp. On July 30, 1881, Jeanne (1859–1907) married Léon Biart (1855–1912), a stockbroker.[2] The portrait shows Léon's father Émile Paul Henri Biart (April 1, 1827—September 14, 1910) reading in the garden at Vogelenzang. His arched eyebrows, drooped eyelids, and goatee decidedly convey an individual personality. A photograph of Père Biart taken some nineteen years later (fig. 44) shows the physiognomic accuracy of Van de Velde's portrayal.

The painting manifests Van de Velde's increasing interest in the decorative arts in its insistence on the two-dimensional qualities of the surface, the appealing arabesque of the lawn, and the tilted perspective angle of the path upon which Père Biart is placed. The lack of shadows under Père Biart's feet, the chair pad that slides forward, and the third chair leg masked behind the sitter's leg, as well as the shoe that seems detached from the leg, make Père Biart seem to float. The screen of large white, pink, and green dots reinforces the decorative aspect of the work. JB

PROVENANCE: Biart family, Antwerp and Kalmthout; Edgard Biart, Lausanne; Madame Ionesco, Paris; Hammer Galleries, New York, 1967; W. J. Holliday, 1969; bequest of W. J. Holliday to the Indianapolis Museum of Art, 1979.

EXHIBITIONS: Als ik kan, 1891, no. 262; Musée national d'art occidental, Tokyo, *Exposition du Pointillisme,* 1985, no. 54; Koninklijk Museum voor Schone Kunsten, Antwerp, *Henry van de Velde (1863-1957): Schilderijen en tekeningen, Paintings and Drawings,* 1987, 160–61; Rijksmuseum Vincent van Gogh, Amsterdam, *Neo-Impressionisten, Seurat tot Struycken,* 1988, no. 53; Royal Academy of Arts, London, *Impressionism to Symbolism,* 1994, 230–31; Fundación Cultural MAPFRE Vida, Madrid, *Los XX: El nacimiento de la pintura moderna en Bélgica,* 2001, 324–25.

BIBLIOGRAPHY: *Connoisseur* 166 (November 1967): lix; Abraham Marie Hammacher, *Le monde de Henry van de Velde* (Antwerp and Paris: Éditions Fonds Mercator and Librairie Hachette, 1967), 43, no. 22; Robert Herbert, *Neo-Impressionism* (New York: Solomon R. Guggenheim Museum, 1968), 187; Jean Sutter, ed., *The Neo-Impressionists* (Greenwich, CT: New York Graphic Society, 1970), 211; Ellen Lee, *The Aura of Neo-Impressionism: The W. J. Holliday Collection* (Indianapolis: Indianapolis Museum of Art, 1983), 74–75.

1. Illustrated in Abraham Marie Hammacher, *Le Monde de Henry van de Velde* (Antwerp and Paris: Éditions Fonds Mercator and Librairie Hachette, 1967), 15. The sitter is Léon Biart.
2. When this painting was created, Van de Velde was uncle to Edgard (born August 12, 1882) and Léonie (born September 22, 1888). Six to seven years later Van de Velde was to remodel the interior of Léon Biart's apartment in Brussels; see Léon Ploegaerts and Pierre Puttemans, *L'Oeuvre architecturale de Henry van de Velde* (Brussels: Atelier Vokaer, 1987), 262.

Fig. 44. Gustave Bule, Émile Paul Henri Biart, April 1909. Photograph. Private collection.

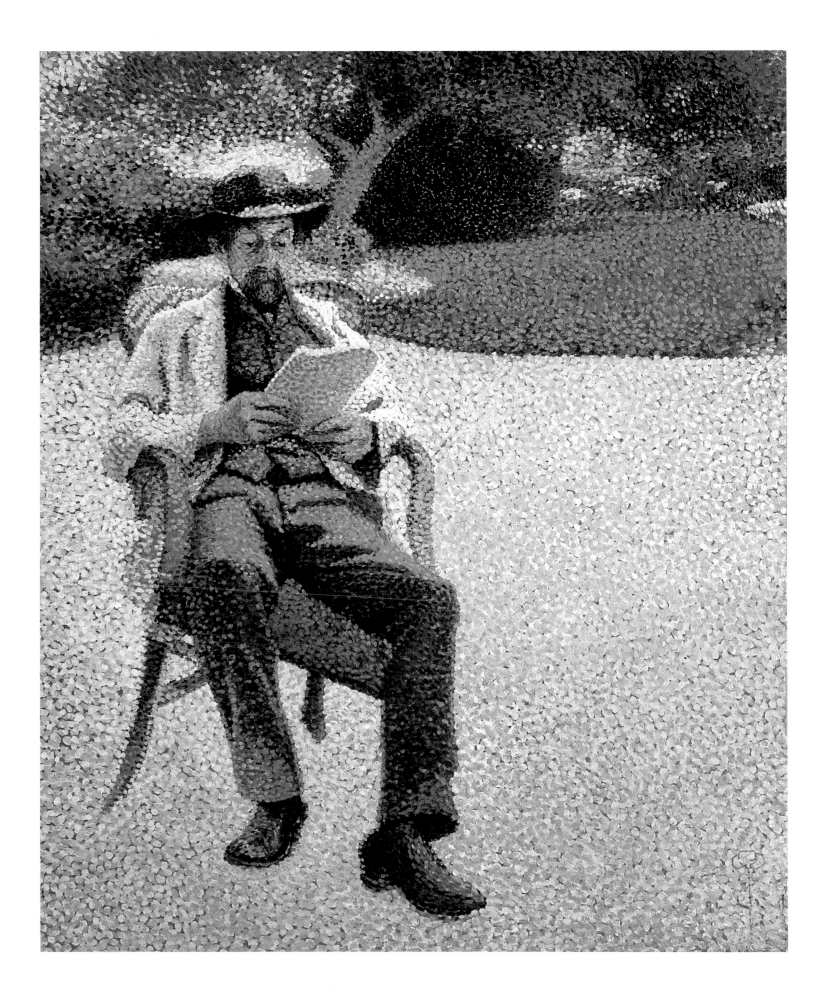

PLATE 44

Vincent van Gogh

Dutch, 1853–1890

Self-Portrait, [1887]

Oil on artist's board, mounted on cradled panel, 16⅛ × 13¼ in. (41 × 32.5 cm)
The Art Institute of Chicago, Joseph Winterbotham Collection

The inspiration for artists' self-portraits runs the creative gamut—from pragmatically providing a ready model to probing eternal questions of essence, being, or self-knowledge. Among those who attempted the challenge, Vincent van Gogh has left one of the most memorable legacies: forty paintings and drawings that provoke compassion, empathy, admiration, and curiosity. This three-quarter view of the face of the thirty-three-year-old painter has the sober gaze that characterizes most of his self-portraiture. It seems to embody fellow painter Émile Bernard's description of his friend—"a sharp glance and a mouth set incisively as if to speak."[1]

This self-portrait is one of twenty-four painted by Van Gogh during the two years he spent in Paris.[2] Van Gogh left the Antwerp Art Academy for Paris in early March 1886. There he lived with his brother Theo, an art dealer who moved in the circles of the avant-garde. The Art Institute of Chicago portrait was painted in the midst of Van Gogh's awakening to modernism, when he witnessed and experimented with the new aesthetic ideas animating the French capital. Studying at the Atelier Cormon, Van Gogh became familiar with Émile Bernard, Henri de Toulouse-Lautrec, and Louis Anquetin. He also met Georges Seurat, and by spring 1887, he and Paul Signac were taking painting excursions together to the outskirts of Paris. Describing his approach in a letter to a colleague, Van Gogh wrote that he was working with intense colors, "seeking oppositions of blue with orange, red and green, yellow and violet."[3] Painted during spring 1887, the Chicago image is the self-portrait in which Van Gogh most closely practiced the methods of the Neo-Impressionists. As such, it is also one of the earliest examples of their theories applied to portrait subjects.

Van Gogh used his self-image to experiment with the two basic elements of Neo-Impressionism: the use of contrasting hues and the application of stippled, somewhat regularized brushwork. The harmonies are built upon the contrast of the complementary colors red and green, orange and blue. The dominance of blue and green hues in the background corresponds to the orange and red colors of the artist's hair and beard. That background is alive with the swirling dots of color that surround the artist's head. A different, but still short, striated brushwork defines his jacket. Yet another rhythm occurs in the three-quarter view of the artist's face, where bands of parallel strokes define the profile of his nose and cheekbones and the coarseness of his hair and beard. Van Gogh's varied brushwork is a potent reminder that no matter how closely the artist may have wanted to essay Neo-Impressionist methods, his personal expression never allowed for fully consistent, meticulous touches of the brush. The emphasis on dotted technique, however, does nothing to diminish the effect of the artist's gaze. In fact, the strong color contrasts and vigorous brushwork seem to enhance the power of Van Gogh's self-examination. EWL

PROVENANCE: The artist; Johanna van Gogh-Bonger (his sister-in-law), Amsterdam; sold through Frankfurter Kunstverein to Leonhard Tietz, Cologne, 1912; Alfred Tietz (his son), Cologne, until at least 1930; E. J. van Wisselingh and Company, Amsterdam, 1933; Bignou Art Gallery, New York; purchased by Joseph Winterbotham, Burlington, VT, by 1935; given to the Art Institute of Chicago, 1954.

EXHIBITIONS: Städtische Ausstellungshalle am Aachener Tor, Cologne, *Internationale Kunstausstellung des Sonderbundes Westdeutscher Kunstfreunde und Künstler zu Cöln,* 1912, no. 11; Galerie Paul Cassirer, Berlin, *Ausstellung,* 1914, no. 28; Galerie M. Goldschmidt, Frankfurt-am-Main, *Vincent van Gogh,* 1928, no. 18; Galerie Paul Cassirer, Berlin, *Vincent van Gogh: Gemälde,* 1928, no. 29; Stedelijk Museum, Amsterdam, *Vincent van Gogh en zijn Tijdgenooten,* 1930, no. 25; E. J. van Wisselingh and Company, Amsterdam, *Exposition d'art française: Peinture du XIXᵉᵐᵉ et XXᵉᵐᵉ siècle,* 1933, no. 13; Museum of Modern Art, New York, *Vincent van Gogh,* 1935–36, no. 20; Museum of Fine Arts, Boston, *Art in New England: Paintings, Drawings, Prints from Private Collections in New England,* 1939, no. 53; Metropolitan Museum of Art, New York, *French Painting from David to Toulouse-Lautrec: Loans from French and American Museums and Collections,* 1941, no. 64A; Cleveland Museum of Art, *Works by Vincent van Gogh,* 1948, no. 4; Musée d'Orsay, Paris, *Van Gogh à Paris,* 1988, no. 37; Detroit Institute of Arts, Museum of Fine Arts, Boston, Philadelphia Museum of Art, *Van Gogh: Face to Face,* 2000-2001, no. 92; Art Institute of Chicago, Van Gogh Museum, Amsterdam, *Van Gogh and Gauguin: The Studio of the South,* 2001-2, no. 19; Toledo Museum of Art, *Van Gogh: Fields,* 2003, no. 1; Musée d'Orsay, Paris, *Le Néo-impressionnisme, de Seurat à Paul Klee,* 2005; Kimbell

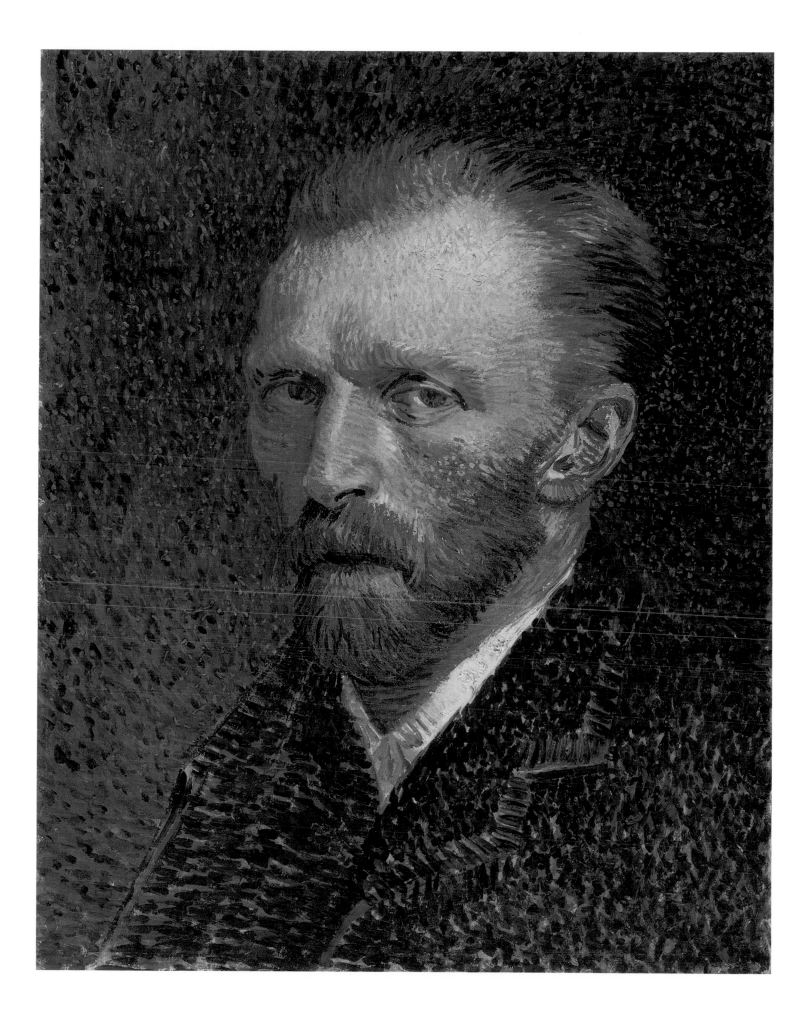

Museum of Art, Fort Worth, *The Impressionists: Master Paintings from the Art Institute of Chicago,* 2008, no. 57.

BIBLIOGRAPHY: Jacob-Baart de la Faille, *L'oeuvre de Vincent van Gogh: Catalogue raisonné* (Paris: Hyperion, 1928), 1: no. 345, 2: fig. 345; Katharina Bromig-Kolleritz von Novisancz, "Die Selbstbildnisse Vincent van Gogh: Versuch einer kunsthistorischen Erfassung der Darstellungen" (Ph.D. diss., Ludwig-Maximilians-Universität, 1954), 46–48, 101–2; Abraham Marie Hammacher, *Genius and Disaster: The Ten Creative Years of Vincent van Gogh* (New York, 1968), 37, 183; Fritz Erpel, *Die Selbstbildnisse Vincent van Goghs* (Berlin, 1963), no. 22 (English trans. Greenwich, 1969), no. 22; Bogomila Welsh-Ovcharov, *Vincent van Gogh: His Paris Period, 1886–1888* (Utrecht: Éditions Victorine, 1976), 225; Jan Hulsker, *The Complete van Gogh: Paintings, Drawings, Sketches* (New York: Abrams, 1977), 278–79, no. 1249; Paolo Lecaldano, ed., *L'opera pittorica completa di Van Gogh e i suoi nessi grafici: Da Etten a Parigi,* vol. 1 (Milan: Rizzoli, 1977), no. 369; Robert H. Pelfrey, *Art and Mass Media* (New York: Harper and Row, 1985), 182–83; Susan Alyson Stein, ed., *Van Gogh: A Retrospective* (New York: H. L. Levin, 1986), 15; Richard R. Brettell, *Post-Impressionists* (Chicago: Art Institute of Chicago, 1987), 8–9; Walter Feilchenfeldt, *Vincent van Gogh and Paul Cassirer, Berlin: The Reception of Van Gogh in Germany from 1901 to 1914* (Zwolle: Waanders, 1988), 89, 149, 150, 157; Ronald Pickvance, "Van Gogh en het pointillisme," in Ellen Wardwell Lee, *Neo-Impressionisten: Seurat tot Struycken* (Amsterdam: Rijksmuseum Vincent van Gogh, 1988), 94; Carol Zemel, *Vincent van Gogh* (New York: Rizzoli, 1993), 1; Bernard Denvir, *A Complete Portrait: All of Vincent van Gogh's Self-Portraits, with Excerpts from His Writings* (Philadelphia: Running Press, 1994), 34; Margherita Andreotti, "The Joseph Winterbotham Collection," *Museum Studies* 20, no. 2 (1994): 122–23; Uwe M. Schneede and Christoph Heinrich, *Van Gogh: Die Pariser Selbsbildnisse* (Hamburg: Hamburger Kunsthalle, 1995), 128, no. 10; Carol Zemel, *Van Gogh's Progress: Utopia, Modernity, and Late Nineteenth-Century Art* (Berkeley: University of California Press, 1997), 146–47; Naomi Margolis Maurer, *The Pursuit of Spiritual Wisdom: The Thought and Art of Vincent van Gogh and Paul Gauguin* (London: Associated University Presses, 1998), 58; George T. M. Shackelford, *Vincent van Gogh: The Painter and the Portrait* (New York: Universe, 2000), 22; Chris Stolwijk and Han Veenenbos, *Account Book of Theo van Gogh and Jo van Gogh-Bonger* (Amsterdam: Van Gogh Museum and Leiden: Primavera Pers, 2002), 11, 54, 130, 169; Walter Feilchenfeldt, *"By Appointment Only": Schriften zu Kunst und Kunsthandel: Cézanne und van Gogh* (Wändeswil am Zürichsee: Nimbus, 2005), 114.

1. Émile Bernard, "Vincent van Gogh," *La Plume,* September 1, 1891, 300, quoted in Carol Zemel, *Van Gogh's Progess: Utopia, Modernity, and Late-Nineteenth-Century Art* (Berkeley: University of California Press, 1997), 145.

2. Araxie Toutghalian, "Vincent van Gogh, *Portrait de l'artiste par lui-même,*" in Ferretti Bocquillon, *Le Néo-impressionnisme: De Seurat à Paul Klee,* 284.

3. Vincent van Gogh to English painter Horace Mann Livens, September–October 1886, in *Vincent van Gogh—The Letters: The Complete Illustrated and Annotated Edition,* ed. Leo Jansen, Hans Luijten, and Nienke Bakker (London: Thames and Hudson, 2009), letter 569.

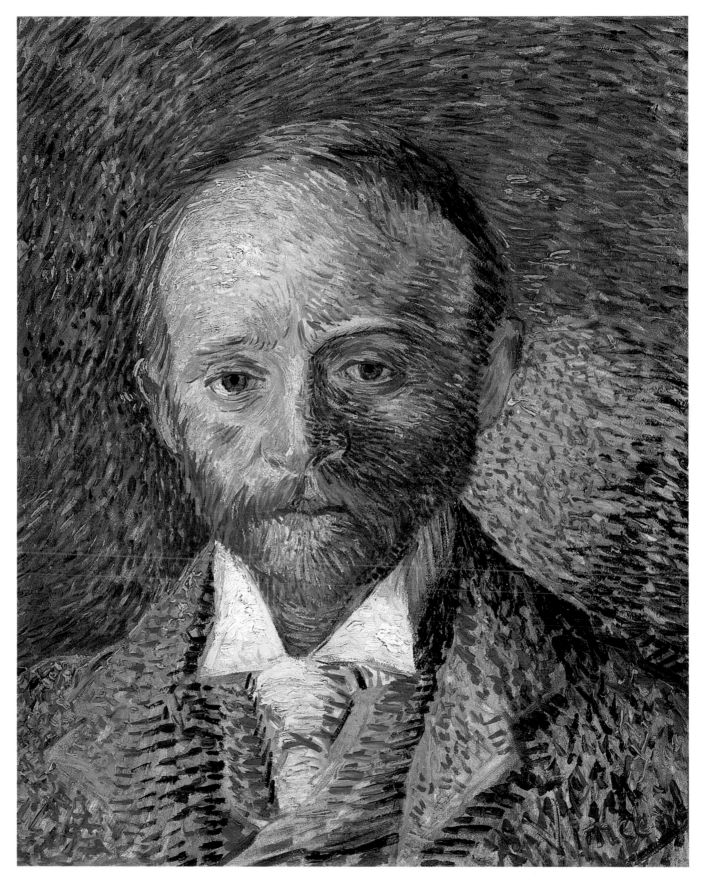

PLATE 45

PLATE 45

Vincent van Gogh

Dutch, 1853–1890

Portrait of Alexander Reid, [1887]

Oil on cardboard, 16½ × 13 in. (42 × 33 cm)
Signed lower right: Vincent
Kelvingrove Art Gallery and Museum, Glasgow, Bought with the aid of a special Government grant,
The Art Fund, an anonymous donor, and public subscription, 1974

Alexander Reid (1854–1928) was a Scottish art dealer who arrived in Paris in June or July 1886 to work at the gallery Boussod & Valadon (formerly Goupil & Cie.), where Vincent van Gogh's brother Theo was employed. The three men had similar artistic tastes, and together they visited galleries in Paris. Reid apparently appreciated Vincent's work and traded a work by Provençal painter Adolphe Monticelli for one of his still lifes.[1]

This likeness is the second that Van Gogh painted of his acquaintance. The earlier one is a full-figure portrait showing Reid seated in an armchair in the brothers' Montmartre apartment, which Reid shared with them for a few months.[2] The Glasgow image, from spring 1887, seems like a companion to Vincent's self-portrait (see plate 44), painted during the same period. The common points are all the more intriguing given the men's physical resemblance.[3] The dimensions and materials of the portraits correspond, and both offer bust-length views similarly proportioned within the overall composition.

This vibrant portrait of Reid is another example of Van Gogh's ability to experiment with the new Neo-Impressionist methods. Like the self-portrait, Reid's likeness is thoroughly grounded in color opposites, dominated in this instance by the contrast of the red background, as well as Reid's red hair and beard, with the green strokes of his suit. The form to the right of Reid's ear, also an element in the red-green relationship, is the back of the armchair in the Van Gogh apartment, also seen in the earlier Reid portrait.[4] The most violent color contrast occurs on Reid's proper left cheek, where bold stripes of red, orange, and green morph from elements of an alert, animated face to abstract bands of vibrant color. The background, treated with longer, more striated strokes than those of the self-portrait, sets up a virtual current of color, creating a powerful motion surging upward and to the right of the sitter. The variety and energy of Van Gogh's brushwork provides fair

warning that this artist would not permanently commit to the disciplined points of Neo-Impressionism. The effect of heightened and contrasting color, however, is a principle that became a permanent part of his aesthetic. And, finally, Reid's white collar performs the same function as in the self-portrait—providing an oasis of brilliant neutrality in the midst of this battle of color.

While there is some question about how and when Alexander Reid actually became the owner of his portrait, the painting is now at home in his native Scotland. Thanks to Van Gogh's eager plunge into the progressive art of Paris, Reid's role, and the artist's foray into Neo-Impressionism, is a matter of record. EWL

PROVENANCE: Alexander Reid, Glasgow; J. A. McNeil Collection, London; purchased by Glasgow, Art Gallery and Museum, 1974.

EXHIBITIONS: Paul Cassirer, Berlin, *Van Gogh Exhibition,* 1914, no. 36; Musée d'Orsay, Paris, *Van Gogh à Paris,* 1988, no. 38; Burrell Collection, Glasgow, and Van Gogh Museum, Amsterdam, *The Age of Van Gogh: Dutch Painting, 1880-1895,* 1990-91, no. 29; Detroit Institute of Arts, Museum of Fine Arts, Boston, and Philadelphia Museum of Art, *Van Gogh: Face to Face,* 2000-2001, no. 93; Speed Art Museum, Louisville, KY, *Millet to Matisse: Nineteenth- and Twentieth-Century French Painting from Kelvingrove Art Gallery, Glasgow,* 2002, no. 28; Compton Verney, Warwickshire, and Dean Gallery, Edinburgh, *Van Gogh and Britain: Pioneer Collectors,* 2006, no. 2; Royal Academy of Arts, London, *The Real Van Gogh: The Artist and His Letters,* 2010, no. 67; Complesso del Vittoriano, Rome, *Vincent van Gogh— Campagna senso tempo. Citta moderna,* 2011.

BIBLIOGRAPHY: J.-B. de la Faille, *The Works of Vincent van Gogh, His Paintings and Drawings,* rev. ed. (Amsterdam: Meulenhoff, 1970), no. 343; Douglas Cooper, "A Franco-Scottish Link with the Past," in *Alex Reid and Lefèvre, 1928-1976* (London: Lefèvre Gallery, 1976), 6; Francis Fowle, "The Hague School and the Scots: A Taste for Dutch Pictures," *Apollo* 134 (August 1991): 108–11; Andreas Blühm and Louise Lippincott, *Light! The Industrial Age, 1750-1900: Art and Science, Technology and Society* (Amsterdam: Rijksmuseum Vincent van Gogh, 2000), 90-91.

1. Bogomila Welsh-Ovcharov, in *Van Gogh à Paris* (Paris: Réunion des musées nationaux, 1988), 114n2.
2. For a reproduction of the portrait, see ibid., 114, no. 38, fig. a; Vincent van Gogh to Theo van Gogh, on or about February 24, 1888, in Jansen, Luijten, and Bakker, *Vincent van Gogh—The Letters,* letter 578.
3. This painting was thought to be a self-portrait for decades, until Alexander McNeil Reid recognized that it was a likeness of his father.
4. Welsh-Ovcharov, *Van Gogh à Paris,* 114.

PLATE 46

Théo van Rysselberghe

Belgian, 1862–1926

Mademoiselle Alice Sèthe, 1888

Oil on canvas, 76¾ × 38⅝ in. (195 × 98 cm)
Monogrammed and dated center left: TVR/1888
Musée départemental Maurice Denis, Saint-Germain-en-Laye

In the year that he began using Seurat's new method, Théo van Rysselberghe painted his first fully Neo-Impressionist portrait depicting Alice Sèthe, the middle of three daughters born to Gérard and Louise Sèthe. As a testimonial of his affection for her family, Van Rysselberghe inscribed a photograph of himself in 1888 "to my charming Sèthe friends."[1] He had much to be thankful for professionally; the portrait of Alice Sèthe served as a springboard for a series of portrait commissions.

Van Rysselberghe depicts Alice (July 5, 1869–May 27, 1944) in her evening dress wearing long gloves, her hand resting on the elaborate marble-topped table behind her. Reflected in the ornate mirror is her upswept blond coiffure and the swirling form of the wooden figure, a motif repeated by the elaborate curves of the console and the abstract patterning of the rug. Van Rysselberghe has captured the materiality of the fabric of the blue dress and Alice's transparent gloves. Alice's pose recalls the formality of conventional portraiture. While the technique is clearly Neo-Impressionist, the result is so plastic and sculptural—so illusionistic in an academic sense—as to seem somewhat at odds with the divisionist method. In the subsequent portraits of Alice's two sisters—Maria (see plate 51) and Irma (see plate 56)—Van Rysselberghe progressively flattened the image.

The painting was immediately well received by critics at Les XX. Émile Verhaeren lavished praise, exclaiming, "Seldom has a work been more successfully completed, with difficult lighting set as a challenge by the painter himself for the satisfaction of declaring himself triumphant."[2] The following year, when the work was shown at the Independents exhibition in Paris, Georges Lecomte was struck by the "intense light . . . radiating in the mirror," finding it a "celebration of gold and reddish-brown tones."[3] Nearly forty years later, Maurice Denis could still recall its impact, describing it as "clear, pointillist, well constructed, serious, and sumptuous."[4]

If the furniture speaks to the haute bourgeois conventions of the 1870s and 1880s, the Oriental figure reflects the particular taste of the Sèthes, who were drawn to the arts of Japan. Van Rysselberghe himself had become interested in Japanese woodblock prints at least by the fall of 1887. With Georges Lemmen and the collector Edmond Michotte, he lent prints by Hiroshige from their personal collections to the inaugural exhibition of Antwerp's Association pour l'art in 1892.[5] According to Professor Yoshi Shimizu, Princeton University, in Japanese homes wood carvings such as the Sèthes' figure would have been ubiquitous as *okimono,* things that are pleasing to the eye. Okimono would have been found in a sitting room or alcove. The figure of the old man with a cane, holding a gourd or a cloth sack, probably stands for longevity.[6]

Alice became the wife of the Belgian sculptor and Vingtiste Paul Dubois (1859–1938) on February 14, 1889.[7] Van Rysselberghe first displayed the portrait as *Mademoiselle Alice Sèthe* in 1889 at Les XX, where Dubois showed a bronze statue of Alice's sister Irma. It is tempting to think that either Dubois himself or the Sèthe parents commissioned the painting as a present for the engaged couple. A later photograph (fig. 45) shows the place of honor given to Alice's portrait in the house designed by her brother-in-law Henry van de Velde, which unfortunately has been demolished.[8]

Van Rysselberghe himself thought highly of the painting, borrowing it for his debut at the Paris Independents in 1890, for his one-man exhibitions at the Galerie Laffitte, Paris, in 1895, and at the Vienna Secession in 1899. As late as 1910 he asked Paul Dubois to lend it for a group exhibition of portraits and figures organized by l'Art contemporain, held in Antwerp. Of the three works he wished to show, Van Rysselberghe wrote to Dubois, "the portrait of your wife is to my eyes the most important."[9]

JB

PROVENANCE: Alice and Paul Dubois; Willy Dubois; Versailles, auction, Hôtel Rameau, June 17, 1967; London, Sotheby's auction, April 30, 1969, no. 54; Paris, Stephen Higgons Gallery.

EXHIBITIONS: Les XX, Brussels, 1889, *Mademoiselle Alice Sèthe,* no. II; Independents, Paris, 1890, no. 782, exhibited as *Portrait de Mme. D. B.;* Haagschen Kunstkring, The Hague, *Tentoonstelling van Schilderijen en Teekeningen,* 1892, no. 28, as *Portrait de Mme D. B.;* Galerie Laffitte, Paris, *Exposition de peintures, dessins et eaux-fortes de Théo van Rysselberghe,* 1895, no. 1; Katalog der III Kunst-Ausstellung der Vereinigung Bildender Künstler Österreichs Secession, Vienna, 1899, no. 49, as *Porträt der Frau du Bois;* L'Art contemporain, Antwerp, 1910;

Société royale des Beaux-Arts, Brussels, *Le Portrait belge au dix-neuvième siècle,* 1910, no. 110; Exposition universelle et internationale, Ghent, 1913, no. 517; Galerie Giroux, Brussels, 1922, no. 3; Galerie Giroux, Brussels, 1927, no. 16; Palais des Beaux-Arts, Brussels, *Exposition centennale de l'art belge, 1830–1930,* 1930, no. 417; Museum voor Schone Kunsten, Ghent, *Rétrospective Théo van Rysselberghe,* 1962, no. 46; Musée de l'Orangerie, Paris, 1970, *L'Art flamand d'Ensor à Permeke,* no. 147; Royal Academy of Arts, London, *Post-Impressionism: Cross-Currents in European Painting,* 1979, no. 408; Musée départemental Maurice Denis, Saint-Germain-en-Laye, *Symbolistes et Nabis: Maurice Denis et son temps,* 1980, no. 1; Musée d'Ixelles, *L'Impressionnisme et le fauvisme en Belgique,* 1990, no. 56; Museum voor Schone Kunsten, Ghent, *Théo van Rysselberghe, néo-impressionniste,* 1993, no. 29; Kunsthalle, Bremen, *Monet und Camille Frauenportraits im Impressionismus,* 2005, 180–83; Musée de Lodève, *Théo van Rysselberghe: L'instant sublimé,* 2012, 68–70; National Gallery of Victoria, Melbourne, *Radiance: The Neo-Impressionists,* 2012, 107.

BIBLIOGRAPHY: Georges Lecomte, "Société des Artistes Indépendants," *L'Art moderne,* March 30, 1890, 100; Paul Colin, *La Peinture belge depuis 1830* (Brussels: Éditions Cahiers de Belgique, 1930), plate 26; Gustave Van Zype, "Notice sur Théo van Rysselberghe," *Annuaire de l'Académie royale de Belgique* 98 (1932): 130; Paul Fierens, *Théo van Rysselberghe* (Brussels: Éditions de la Connaissance, 1937), 17–8, fig. 4; Luc Haesaerts, *Histoire du portrait de Navez à Ensor* (Brussels: Éditions du Cercle d'art, 1943), fig. XX; François Maret, *Les Peintres Luministes* (Brussels: Éditions du Cercle d'art, 1944), fig. 6; Jozef Muls, *Een eeuw portret* (Diest: Pro Arte, 1944), 127; Ronald Feltkamp, *Théo van Rysselberghe, 1862–1926* (Brussels: Éditions Racine, 2003), 282–83; Jane Block, "Au-delà de Paris: Le néo-impressionnisme en Belgique et en Hollande," *Le Néo-impressionnisme: De Seurat à Paul Klee* (Paris: Réunion des musées nationaux, 2005), 30; Dominique Lobstein, "Théo van Rysselberghe et les salons parisiens," in *Théo van Rysselberghe* (Brussels: Fonds Mercator and Belgian Art Research Institute, 2006), 114, 117.

1. The photograph is in the Archives et Musée de la littérature, FSX-80, Bibliothèque royale de Belgique, Brussels.

2. Émile Verhaeren, "Aux XX," *L'Art moderne,* February 10, 1889, 42. Reproduced in Émile Verhaeren, *Écrits sur l'art,* vol. 1, ed. Paul Aron (Brussels: Éditions Labor, 1997), 310.

3. Georges Lecomte, *Art et critique,* March 29, 1890, as cited by Dominique Lobstein, "Théo van Rysselberghe et les salons parisiens," in *Théo van Rysselberghe* (Brussels: Fonds Mercator and Belgian Art Research Institute, 2006), 116.

4. Maurice Denis, preface to *Théo van Rysselberghe* (Paris: Galerie Giroux, 1927), 5. Denis was recalling his introduction to the work of Van Rysselberghe and his appreciation of this portrait at the Independents.

5. Takagi Yoko, *Japonisme in Fin de Siècle Art in Belgium* (Brussels: Pandora, 2002), 131–36.

6. Yoshi Shimizu, communication with the author, April 26, 2007. According to Shimizu, the figure in Chinese would be called Fulaushou and in Japanese Fukurokuju. Another possibility posited by Shimizu is that the figure may be a tenth-century Chinese monk, Budai (Chinese) or Hotei (Japanese), who wandered the city of Fenghua and lived at a local temple. He is described as "ugly, fat and wearing torn clothes," and carried a wisteria wood cane and cloth bag (*budai*), hence his nickname. He is also known as the Laughing Buddha in popular culture of China and Japan. He was thought to be the reincarnation of the Future Buddha, Maitreya, a warning to Buddhist believers not to judge people by their appearance.

7. For more on Dubois, see Octave Maus, "La statuaire belge, Paul Dubois," *L'Art moderne,* September 9, 1900, 285–87.

8. For an illustration of the Dubois house, see Léon Ploegaerts and Pierre Puttemans, *L'Oeuvre architecturale de Henry Van de Velde* (Brussels: Atelier Vokaer, 1987), 272.

9. Théo van Rysselberghe to Paul Dubois, February 16, 1910, private collection, Brussels.

Fig. 45. Unknown photographer, Alice Sèthe Dubois before her portrait by Théo van Rysselberghe, c. 1935. Photograph. Private collection.

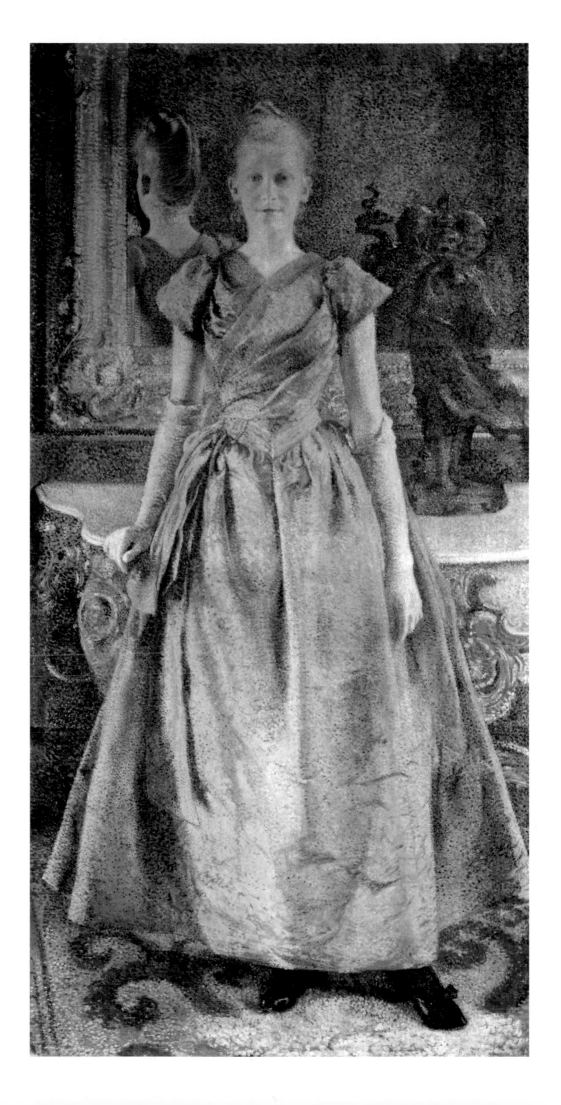

PLATE 47

Théo van Rysselberghe

Belgian, 1862–1926

Interior, Evening (*Intérieur le soir*), 1889

Conté crayon with touches of gouache on thick paper, 19½ × 25¼ in. (49.5 × 64 cm)
Watermark Van Gelder
Monogrammed and dated lower right: VR89
Private collection

This *intimiste* portrait drawing shows three young women seated around a table, each engaged in a different pastime: reading, napping, or sewing. Having drunk their evening tea and socialized, the women proceed to claim their own space, enjoying each other's company, but now in silence. Van Rysselberghe used touches of white gouache to highlight the lampshade and to show its reflection in the mirror behind. Emulating Seurat's conté crayon drawings, Van Rysselberghe makes the master's method less abstract and more pictorial, lavishing attention on the teapot, cups, fan on the mantel, and an artwork on the wall.

As recently as 2005 this work was erroneously identified as *Evening: The Three Sèthe Daughters,* referring to Alice, Maria, and Irma Sèthe, the daughters of Gérard and Louise Sèthe.[1] In fact, probably none of the Sèthes appear in this drawing. By the date of the drawing, Van Rysselberghe had painted a full-length portrait of Alice (see plate 46) but had yet to paint Maria and Irma (plates 50, 51, 56). However, the artist's fiancée, Maria Monnom (whom he married on September 16, 1889), is shown reading by lamplight. The figure sewing is Aline Maréchal, future wife of Georges Lemmen, whose brother, Dr. Édouard Maréchal, was married to Maria Monnom's older sister, Irma.[2] The sleeping sitter has yet to be identified. The setting for the work is Thuin, a picturesque Belgian town on the Sambre River, where Maria's mother, Sylvie Monnom–Descamps, rented a countryside property in summer.[3] It was a welcome setting for the circle of the Van Rysselberghe family.

A drawing entitled *The Seamstress,* sold at auction as a work by Georges Lemmen in 2007, shows the figure sewing identically posed, with needle in hand and head lowered. The close relationship to our conté crayon drawing and the insistent parallel charcoal strokes confirm that it is a preparatory sketch for this work and was executed by Van Rysselberghe.[4] JB

PROVENANCE: Octave Maus, Brussels; Madeleine Octave Maus, Brussels; Hugo Perls, New York; Sotheby's New York, *Impressionist and Modern Drawings and Watercolors,* May 19, 1983 (sale no. 5047), lot no. 208.

EXHIBITIONS: Les XX, Brussels, 1890, no. 8, as "dessin"; Galerie Georges Giroux, Brussels, *Théo van Rysselberghe: Exposition d'ensemble,* 1927, no. 3, as *Sous la lampe;* Palais des Beaux-Arts, Brussels, *Exposition centennale de l'art belge, 1830–1930,* 1930, no. 414 (possibly one of the works published as *Deux dessins*); Museum voor Schone Kunsten, Ghent, *Rétrospective Théo van Rysselberghe,* 1962, no. 185, as *Intérieur le soir;* Hirschl and Adler, New York, *Exhibition of Pointillist Paintings,* 1963, no. 56; Solomon R. Guggenheim Museum, New York, *Neo-Impressionism,* 1968, no. 133; Baltimore Museum of Art, *Cone Drawing Installation,* 1988, no. 6; Baltimore Museum of Art, *The Essence of Line: French Drawings from Ingres to Degas* (University Park: Pennsylvania State University Press, 2005), no. 95, as *Evening: The Three Sèthe Daughters.*

BIBLIOGRAPHY: Madeleine Octave Maus, *Trente années de lutte pour l'art* (Brussels: l'Oiseau bleu, 1926), 66–67; Sotheby's New York, *Impressionist and Modern Drawings and Watercolors,* May 19, 1983 (sale no. 5047), no. 208; Ronald Feltkamp, *Théo van Rysselberghe, 1862–1926* (Brussels: Éditions Racine, 2003), 284.

1. *The Essence of Line: French Drawings from Ingres to Degas* (University Park: Pennsylvania State University Press, 2005), 334, no. 95 (the drawing is printed backward). Although Paul Eeckhout assigns the title of the work correctly as *Intérieur le soir,* he claims that these are portraits of the young Sèthe girls, *Rétrospective Théo van Rysselberghe,* 60 no. 185, and Robert Herbert provided the title *Evening, the Three Sèthe Daughters (Intérieur le soir, les trois filles Sèthe)* in *Neo-Impressionism* (New York: Solomon R. Guggenheim Museum, 1968), 180, no. 133. At the Van Rysselberghe retrospective held at the Galerie Giroux, Brussels, 1927, the drawing was titled *Sous la lampe,* and three years later at the Palais des Beaux-Arts, *Exposition de l'art belge,* it was grouped simply as one of two drawings belonging to Madame Octave Maus.
2. Irma Monnom Maréchal (1854–1907) and Dr. Maréchal were married on August 8, 1878.
3. Sylvie Monnom was born in Gozée, just a few miles to the east of Thuin, and south of the major tourist attraction of the ruins of the Cistercian Abbey of Aulne. In fact, the very house that Sylvie Monnom rented had been used by the monks as their country retreat. See *À Marthe Verhaeren: Deux cent dix-neuf lettres inédites, 1889–1916,* ed. René Vandevoir (Paris: Mercure de France, 1951), 323n1. For nineteenth-century images of Thuin, see Jean-Marie Horemans, *Thuin: Mémoire en images* (Joué-les-Tours, France: Éditions Alan Sutton, 1997).
4. For an illustration, see Sotheby's New York, *Impressionist and Modern Art,* February 15, 2007, no. 43. For a similar use of parallel, albeit vertical instead of horizontal strokes, see Van Rysselberghe's drawing of Maria van Rysselberghe, 1894, in Goddard, *Les XX and the Belgian Avant-Garde,* 366.

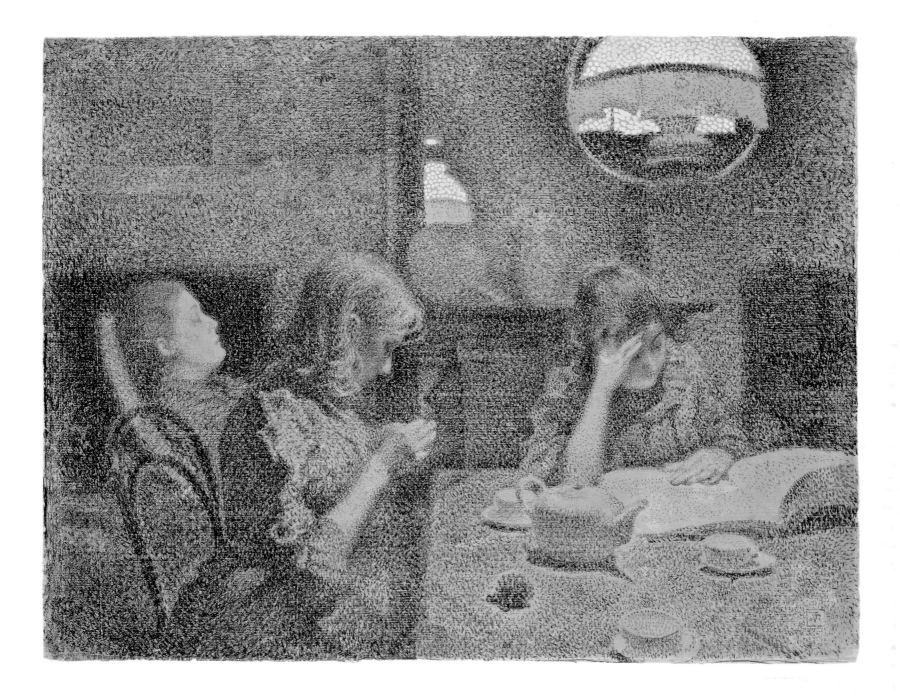

PLATE 48

Théo van Rysselberghe
Belgian, 1862–1926

In July, Before Noon (En juillet, avant-midi), 1890

Oil on canvas, 45½ × 64⅜ in. (115.5 × 163.5 cm)
Monogrammed and dated lower left: 18VR90
Collection Kröller-Müller Museum, Otterlo

On a warm July morning, four women sit in the garden of a country estate, while a fifth seems to float by and children play near the distant house.[1] The setting is quite specific: a rental property at Thuin, located in the Hainaut region about thirty-five miles south of Brussels, leased by Théo van Rysselberghe's mother-in-law, the publisher Sylvie Monnom-Descamps. This house served as the gathering place for members of the Monnom and Sèthe families, as well as Van Rysselberghe's extended circle, including the poet Émile Verhaeren and the painters Georges Lemmen and Henry van de Velde.[2] Here in the private orchard the women relax: at the left in a lilac dress is the painter's wife, Maria, while seated next to her—with her hand draped over the back of the chair holding her straw hat—is Maria Sèthe, future wife of the painter-architect Henry van de Velde.[3]

A recently discovered photograph (see fig. 29), showing Van Rysselberghe painting the group portrait with the sitters posing, records the actual scene at Thuin. However, the painting on the easel differs from the surviving canvas. Among other things, it shows Maria Sèthe leaning against a tree and reveals the face of the figure seated opposite the two Marias.[4] This tantalizing image poses the question whether this is a different version of the painting now lost or a version lying under the surviving canvas.

As Van Rysselberghe's first group portrait, *In July, Before Noon* makes a telling comparison with Seurat's *Sunday on La Grande Jatte,* beginning with their titles referring to specific times of day. In contrast to Seurat's ciphers, Van Rysselberghe's figures are individualized and, indeed, are portraits with personal meaning to the artist. The shadows dappling the grass, the female figure walking in profile, and the screen of trees are clear references to *La Grande Jatte.* Seurat's color scheme of purples and reds is cooler than Van Rysselberghe's palette of lilac and pink. Taking his cues from the abstraction found in

Seurat's Neo-Impressionism, Van Rysselberghe simultaneously presents the naturalistic scene as a decorative pattern of line and color.

The work was singled out by the critics when first shown at Les XX in 1891.[5] In praising Van Rysselberghe, Verhaeren contrasted his art with that of Seurat. "The stiffness in Mr. Seurat is the result of synthetization. Mr. Théo van Rysselberghe is a stranger to this." Rather, Van Rysselberghe "pays more attention to the play of lines than to their moral significance. The caprice and freedom from the conception lead him to a more impulsive art, freer from learned combinations." Verhaeren claimed that his analysis was most applicable to the work *In July, Before Noon* because "what results is an expression of acute individuality. Thus is he drawn to the portrait."[6] As Verhaeren so perceptively observed, Van Rysselberghe treats each of his sitters as a unique personality, despite his seemingly casual approach to the composition. The result of Van Rysselberghe's ease with the style is his ability to forge line and color into a memorable group portrait.

The work remained with the artist's family until 1930, shortly after which it entered the Kröller-Müller collection. JB

PROVENANCE: Family of the artist, until 1930; Galerie Giroux, Brussels; purchased presumably by Snijder van Wissekerke, Wassenaar; D'Audretsch, The Hague, 1930; purchased by Mrs. Kröller-Müller, 1930.

EXHIBITIONS: Les XX, Brussels, Musée moderne, 1891, no. 4; Independents, Paris, 1891, no. 1211; Museum Boymans-van Beuningen, Rotterdam, *De divisioniste school van Georges Seurat tot Jan Toorop,* 1936, no. 38; Stedelijk Museum De Lakenhal, Utrecht, *Van Fantin tot Picasso,* 1950, no. 30; Karl-Ernst Osthaus-Museum, Hagen, *Der junge Van de Velde und sein Kreis,* 1959, no. 36; Museum voor Schone Kunsten, Ghent, *Rétrospective Théo van Rysselberghe,* 1962, no. 55; Musée national d'histoire et d'art, Luxembourg, *Théo van Rysselberghe, 1862–1926,* 1962, no. 21; Palais des Beaux-Arts, Brussels, *Henry Van de Velde, 1863–1957,* 1963, no. 20; Gemeentemuseum, The Hague, *Licht door kleur: Nederlandse luministen,* 1976, no. 3; Royal Academy of Arts, London, *Post-Impressionism: Cross-Currents in European Painting,* 1979, no. 410; Brooklyn Museum, *Belgian Art, 1880–1914,* 1980,

no. 89; Musée national d'art occidental, Tokyo, *Exposition du pointillisme,* 1985, no. 58; Museum voor Schone Kunsten, Ghent, *Théo van Rysselberghe, néo-impressionniste,* 1993, no. 31.

BIBLIOGRAPHY: Gustave van Zype, "Notice sur Théo van Rysselberghe," *Annuaire de l'Académie royale de Belgique* 98 (1932): 130; Marie-Jeanne Chartrain-Hebbelinck, "Les lettres de Théo van Rysselberghe à Octave Maus," *Bulletin des Musées royaux des Beaux-Arts de Belgique* 1–2 (1966): 73; *Paintings of the Rijksmuseum Kröller-Müller* (Otterlo: Rijksmuseum Kröller-Müller, 1969), no. 596; Ronald Feltkamp, *Théo van Rysselberghe, 1862–1926* (Brussels: Éditions Racine, 2003), 289.

1. The painting was first exhibited as *En juillet, avant-midi,* the title that is used here. It was subsequently referred to in several variations on the orchard theme, such as *Famille dans le verger.* The exhibition *Théo van Rysselberghe,* held at the Palais des Beaux-Arts, Brussels, in 2006, correctly used the historic title of the painting.

2. In a conversation with the author in 2007, the poet Roger Foulon (1923–2008), native of Thuin and author of *La Thudinie* (Mons: Fédération du tourisme de la province du Hainaut, 1982), proposed an identification of the property rented by the Monnom–Van Rysselberghe family located in the neighborhood of Le Berceau. Indeed, a large eighteenth-century house on the Chemin de la Celle with its orchard is very likely the setting for Van Rysselberghe's painting. The building is illustrated in *Le patrimoine monumental de la Belgique: Wallonie,* 10: no. 2, *Province de Hainaut, Arrondissement de Thuin* (Liège: Pierre Mardaga, 1983), 777. My thanks to the present owners for a charming visit and to Roger and Brigitte Cardon for making this journey possible.

3. The third sitter is unrecognizable, as her hat covers her face, while the fourth, in a diamond-patterned chair, is cut off by the tree. The same chair appears in Van Rysselberghe's drawing *Intimacy* (*Intimité*) (see plate 49), 1890, also executed at Thuin.

4. My thanks to Raphaël Dupouy, who first used this photograph in his film *Théo van Rysselberghe: Du nord au sud* (Réseau Lalan, 2012), and to Catherine Gide for allowing me to publish the image.

5. Émile Verhaeren, "Les XX," *La Nation,* February 10, 1891, and E. V., "L'Exposition des 'XX,'" *L'Emancipation belge,* March 3, 1891. Some scholars, including Paul Eeckhout (*Rétrospective Théo van Rysselberghe,* 38), Marie-Jeanne Chartrain-Hebbelinck (*Belgian Art, 1880–1914* [Brooklyn Museum, 1980], 147), and Ronald Feltkamp (*Théo van Rysselberghe, 1862–1926,* 289), believe that the painting was shown the previous year at Les XX as well, because of the title *À Thuin* assigned to two works. One of the two can be identified from the contemporary press as *The Tennis Party* (*La Partie de tennis*), which also shows the white house in the background. The press is silent about the other work. Van Rysselberghe routinely showed only his latest works at Les XX, works that he usually sent to the Paris Independents shortly after. In 1891 he did exactly that with our painting, which was reviewed in the press. That the artist virtually never showed works twice at Les XX or the Independents and that it was not specifically mentioned in the press strongly suggests that he did not exhibit it in 1890 at Les XX.

6. "La raideur, qui chez M. Seurat est le résultat d'une synthétisation. M. Théo van Rysselberghe ne la connaît pas. . . . Il fait plus attention au jeu des lignes qu'à leur signification morale; le caprice et la liberté de la conception le conduisent à un art plus primesautier, plus dégagé de combinaisons savantes, et il en résulte une expression de vie individuelle aiguë. Aussi est-il attiré vers le portrait." Verhaeren, *La Nation,* February 10, 1891.

PLATE 49

Théo van Rysselberghe

Belgian, 1862–1926

Intimacy (Intimité), 1890

Conté crayon with gouache on paper, 16⅞ × 19⅝ in. (43 × 50 cm)
Monogrammed and dated lower right: 18VR90
Private collection

This elegant conté crayon drawing was first exhibited at Les XX in 1890, its identity confirmed by a critic's contemporary description of a "superb drawing, in a gently lit room, with young girls reading and doing needlework." As he further elucidated, "The drawing unleashes an impression of calm and peace that justifies its title, Intimité."[1] The drawing shows three female seated figures gathered in the evening hours. In the foreground is Maria Sèthe sewing, rendered in profile as she would also be depicted in her oil portrait by Van Rysselberghe in the following year (see plate 51). The reading figure whose back is to us is undoubtedly the artist's wife Maria, who is seated in a wicker chair that forms an interesting diamond pattern alleviating the rectilinearity of the table and window frame.[2] A related sketch shows these two figures, the two Marias, with the inclusion of the source of illumination—an overhead lamp.[3]

Although the third figure remains unidentified, she was clearly an intimate member of the Van Rysselberghe–Lemmen circle. She is depicted in Van Rysselberghe's drawing from the previous year, Interior, Evening (see plate 47), in which she is also relegated to the background. Both works have as their setting the country house rented by Van Rysselberghe's mother-in-law at Thuin, Belgium, where family members and friends gathered, and both works were owned by Octave Maus, secretary of Les XX and impresario of La Libre Esthétique.

Light falls on Maria Sèthe's face, activating and almost electrifying the hair at the base of her neck and atop her head, which forms an aureole that contrasts with the darker passages of the drawing. Added accents of light are provided by passages of gouache on her lap and around her nose. JB

PROVENANCE: Octave Maus; Mlle Hauman, Brussels.

EXHIBITIONS: Les XX, Brussels, 1891, no. 6, as Intimité; Association pour l'art, Antwerp, 1892, no. 5; Galerie Giroux, Brussels, Théo van Rysselberghe, 1927, no. 4, as À Thuin and erroneously dated 1889; Palais des Beaux-Arts, Brussels, Centennale de l'art belge, 1930, no. 414; Museum voor Schone Kunsten, Ghent, Rétrospective Théo van Rysselberghe, 1962, no. 186, as Jeune femme cousant; Musée d'histoire et d'art, Luxembourg, Théo van Rysselberghe, 1862-1926, 1962, no. 70; Museum voor Schone Kunsten, Ghent, Théo van Rysselberghe, néo-impressionniste, 1993, no. 76; Palais des Beaux-Arts, Brussels, Théo van Rysselberghe, 2005, 214.

BIBLIOGRAPHY: J. Krexpel, "Les XX," La Revue Blanche (March 1891): 380; Marie-Jeanne Chartrain-Hebbelinck, "Les lettres de Théo van Rysselberghe à Octave Maus." Bulletin des Musées royaux des Beaux-Arts de Belgique 1-2 (1966): 73n1; Ronald Feltkamp, Théo van Rysselberghe, 1862-1926 (Brussels: Éditions Racine, 2003), 287.

1. "Mais un superbe dessin: dans une salle, doucement éclairée, des jeunes filles lisant et faisant des ouvrages d'aiguille; ce dessin dégage une impression de calme, de paix, qui justifie le titre: l'Intimité." J. Krexpel, "Les XX," La Revue Blanche (March 1891): 380.
2. The same chair is used in the oil painting In July, Before Noon (1890), whose setting is also Thuin.
3. Reproduced in Feltkamp, Théo van Rysselberghe, 291.

PLATE 49

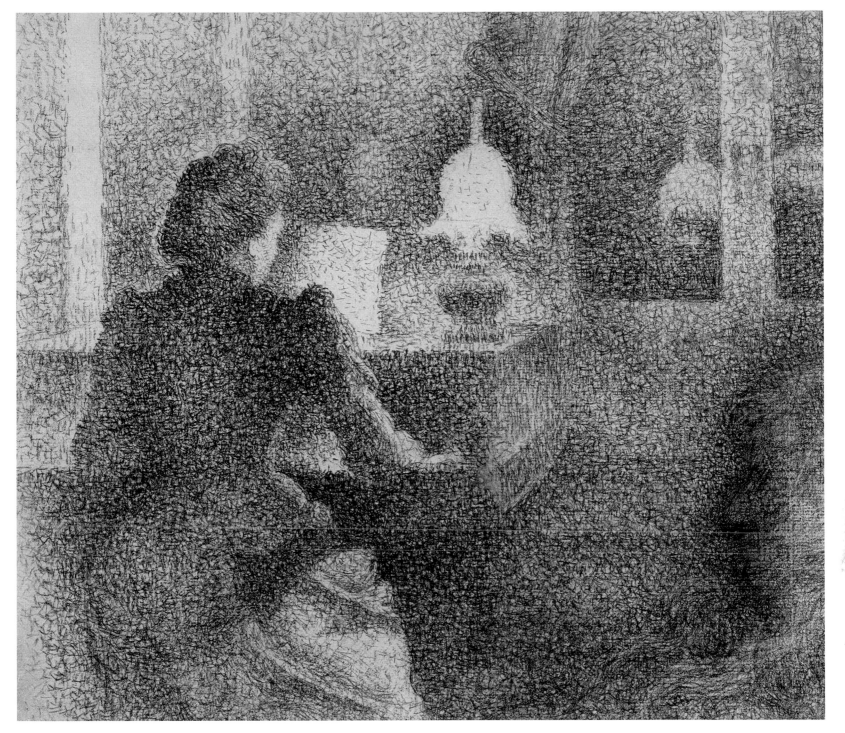

PLATE 50

PLATE 50

Théo van Rysselberghe

Belgian, 1862–1926

Maria Sèthe at the Piano, [1890/91]

Conté crayon on cream laid paper, 12¼ × 14⅛ in. (31.1 × 35.2 cm)
The Art Institute of Chicago, John H. Wrenn Memorial Collection

In this dimly lit interior, a female figure is engaged in an artistic endeavor: playing the piano by lamplight. Théo van Rysselberghe employs the white of the paper to function as a source of light illuminating the sitter's face and dress, the sheet music, and vertical accents of the wall paneling and mirror. The rich, deep black of the conté crayon contrasts with these passages of light, creating a halo around the musician's head and an overall ambiance of intimacy and reverie. The drawing employs the technique derived from Seurat's manner, in which forms are built up of dots or crosshatching to create the black-and-white equivalent of a divisionist painting. Only after we have observed the musician at the piano, the lamp, and the lamp's reflection in the glass of the French doors do we see that there is a person's head in the lower right-hand corner. The inclusion of this second figure suggests a visualization of the ineffable: the act of listening to music.

The pianist has been identified as Marie-Louise Sèthe (called Maria), although several scholars have questioned this identification.[1] Indeed the hair is not characteristic of Maria's, and the figure seems more petite and older. Whoever Van Rysselberghe is capturing, the strong sense of a cultured and musical personality is present. JB

PROVENANCE: Bern, Gutekunst and Klipstein, November 12–13, 1954, *Graphik und Handzeichnungen moderner Meister,* auction no. 77, no. 458; purchased by the Art Institute of Chicago, 1955.

EXHIBITIONS: University of Michigan Museum of Art, Ann Arbor, *A Generation of Draughtsmen,* 1962, no. 132; Wildenstein, New York, *Master Drawings from the Art Institute of Chicago,* 1963, no. 134; Society of the Four Arts, Palm Beach, FL, *Drawings from the Art Institute of Chicago,* 1973, no. 40; Spencer Museum of Art, *Les XX and the Belgian Avant-Garde: Prints, Drawings, and Books ca. 1890,* 1993, no. 146.

BIBLIOGRAPHY: John Rewald, *Post-Impressionism from Van Gogh to Gauguin* (New York: Museum of Modern Art, 1962), 386; Daniel Mendelowitz, *Drawing* (New York: Holt, Rinehart and Winston, 1967), 346–48; Ronald Feltkamp, *Théo van Rysselberghe, 1862–1926* (Brussels: Éditions Racine, 2003), 285.

1. These include Pascal de Sadeleer, email communication with the author, August 22, 2012; and Ronald Feltkamp, in his catalogue raisonné, *Théo van Rysselberghe,* 285. Neither scholar has suggested an alternative identification.

PLATE 51

Théo van Rysselberghe

Belgian, 1862–1926

Maria Sèthe at the Harmonium, 1891

Oil on canvas, 46½ × 33¼ in. (118 × 84.5 cm)
Monogrammed and dated upper center: 18VR91
Koninklijk Museum voor Schone Kunsten, Antwerp

After painting the pointillist portrait of Alice Sèthe in 1888, composed in a modified academic manner, Théo van Rysselberghe executed two Neo-Impressionist portraits in 1890 whose organization reflected the art of James McNeill Whistler: *La Petite Denise* and *Portrait of Madame Charles Maus* (see figs. 24, 25). In 1891 he melded the two traditions in a portrait of Maria, the eldest of the three Sèthe sisters. Maria, in profile, sits at the harmonium, gazing to the left with an air of great authority. The open music suggests that she has briefly interrupted her playing, allowing us to concentrate on her strong, chiseled features and blond coiffure. Her harmonium and chair are recorded in a documentary photograph (fig. 46) taken in her parents' home, where she sits at her instrument, again posed in profile but with her right hand on the keyboard, flanked by her sister Irma, a pupil of Eugène Ysaÿe's, and other members of this great artist's circle.[1]

Van Rysselberghe contrasts the sculptural plasticity of the figure, her arm jutting in the viewer's space, with the rectilinearity of the harmonium and the framed artwork on the wall. The geometric construction is offset by the decorative swirl of Maria's hair and the tassel to the curtain at the right; the abstract, dynamic pattern of the wallpaper or fabric; and the scroll of a cello. This sense of equilibrium caught the critical eye of Van Rysselberghe's friend Émile Verhaeren: "The work is simple without too lively an arrangement. Descending lines and curves of the fabric and curtains on the one hand; stiffness and the horizontals of the furniture on the other. Thereby resulting in an impression of silence and near seriousness."[2] The artist chose to sign the work in an interesting conceit by including the date and his monogram above Maria's head in the mounted artwork. He added a pointillist border composed of an orange ground upon which blue dots activate the frame serving to spotlight Maria, and a halo of complementary colors carves out the space around her figure.

Van Rysselberghe hoped that this portrait would be successful, as he labored to complete it and submit it as his principal entry for the 1891 Independents in Paris.[3] Previously he had used Maria as a subject seated next to his wife in the oil painting *In July, Before Noon* (1890) (see plate 48) and in a drawing, *Intimacy* (see plate 49), where she is featured sewing. Both works were exhibited at Les XX in 1891, just months prior to his offering Maria's portrait to the Paris Independents. When it was exhibited at Les XX in 1892, the painting was very much admired by critic and writer Eugène Demolder: "Isn't she truly delicious, with her fine profile so distinguished, her blue eye of a dreaming musician, her ivory skin, her pronounced chin, that adds to the captivating character of this image?"[4]

Marie-Louise Sèthe (September 1, 1867–December 7, 1942, nicknamed Maria), was born in Paris to Gérard Sèthe, a businessman, and his wife, Louise Frédérique Seyberth. Although Maria is remembered today as the wife of Henry van de Velde, she played an active role in the artistic life of Brussels prior to her marriage on April 30, 1894. Urged by her future husband, Maria returned from England in 1893 with fabrics

Fig. 46. Unknown photographer, Maria Sèthe at the harmonium; next to her stands her sister, Irma, with violin, and pupils of Eugène Ysaÿe, c. 1891. Photograph. Henry van de Velde Archive, Musée de la littérature, Bibliothèque royale de Belgique, Brussels, FSX 191.

and wallpaper that had a decided influence on Van de Velde's development.[5] Maria was a close friend of the Van Rysselberghes' and a pupil of the artist.[6] Announcing the news of the upcoming marriage of Maria and Henry, Van Rysselberghe wrote to their mutual friend, Paul Signac: "They will be an interesting couple . . . because she has much taste, is a musician, and does embroidery, etc. They are, in every sense, very happy."[7]

After Maria and Henry were married, her portrait was given a place of prominence in the central hall of their new home, Bloemenwerf, Van de Velde's first constructed house. Among their subsequent collaborative projects was *Album de Robes de Dames,* a collection of photographs of Van de Velde's modern dresses created by the silk industries of Krefeld, Germany, for which Maria wrote the preface. The primary model was Maria herself, who posed in front of the piano at Bloemenwerf with her portrait clearly visible in the background (fig. 47). JB

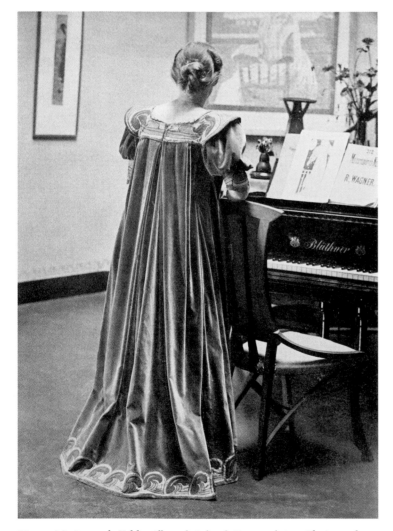

Fig. 47. Maria van de Velde, *Album de Robes de Dames,* plate 5. Photograph. Dusseldorf: Maison d'Édition Wolfrum, 1900.

PROVENANCE: Maria Sèthe van de Velde until 1942; Henry van de Velde; Koninklijk Museum voor Schone Kunsten, Antwerp, 1949.

EXHIBITIONS: Independents, Paris, 1891, no. 1209; Les XX, Brussels, 1892, entries listed as "portraits"; Association pour l'art, Antwerp, 1892, no. 2, as *Mlle. Sèthe; Tentoonstelling van Schilderijen en Teekeningen van eenigen uit de "XX" en uit de "Association pour l'art,"* Haagschen Kunstkring, The Hague, 1892, no. 27, as *Portrait de Mlle. S.;* Exposition des Peintres Néo-Impressionnistes, Paris, 1892–93, no. 69, as *Mlle Maria Sèthe;* Katalog der III Kunst-Ausstellung der Vereinigung Bildender Künstler Österreichs Secession, Vienna, 1899, no. 44, as *Portät der Frau van de Velde;* Galerie Giroux, Brussels, *Théo van Rysselberghe: Exposition d'ensemble,* 1927, no. 20 (erroneously dates the painting 1892); Casino Communal, Knokke, *L'Impressionnisme en Belgique avant 1914,* 1955, no. 50; Karl-Ernst Osthaus Museum, Hagen, *Der junge van de Velde und sein Kreis, 1883–1893,* 1959, no. 38; Singer Museum, Laren, *Vlaamse Schilderkunst, 1850–1950,* 1960, no. 62; Palais des Beaux-Arts, Charleroi, *Trente ans de peinture belge, 1890–1920,* 1960, no. 59; Museum voor Schone Kunsten, Ghent, *Rétrospective Théo van Rysselberghe,* 1962, no. 57; Museum des 20. Jahrhunderts, Vienna, *Belgische Malerei seit 1900,* 1962, no. 94; Sint-Adriaansabdij, Geraardsbergen, *Het portret sinds James Ensor,* 1964, no. 99; Musée de l'Orangerie, Paris, *L'Art flamand d'Ensor à Permeke,* 1970, no. 148; Gemeentemuseum, The Hague, *Licht door kleur: Nederlandse luministen,* 1976, no. 55; La Salle MRO, Kanazawa, *Exposition Le Néo-Impressionisme,* 1984, no. 23; Galerie CGER, *La Musique source d'inspiration dans l'art belge: XIIIᵉ–XXᵉ siècle,* 1985, no. 60; Rijksmuseum Vincent van Gogh, Amsterdam, *Neo-Impressionisten Seurat tot Struycken,* 1988, 114, no. 49; Museum voor Schone Kunsten, Ghent, *Théo van Rysselberghe, néo-impressionniste,* 1993, 14, no. 33; Van Gogh Museum, Amsterdam, *In Perfect Harmony: Picture + Frame, 1850–1920,* 1995, no. 177; Musée d'Orsay, Paris, *Le néo-impressionnisme, de Seurat à Paul Klee,* 2005, 230–31; Musée de Lodève, *Théo van Rysselberghe,* 2012, 25.

BIBLIOGRAPHY: Gustave van Zype, "Notice sur Théo van Rysselberghe," *Annuaire de l'Académie royale de Belgique* 98 (1932): 130 (the date of 1892 is mistakenly used for the painting); Paul Fierens, *Théo van Rysselberghe* (Brussels: Éditions de la Connaissance, 1937), fig. 9; Jane Block, "A Study in Belgian Neo-Impressionist Portraiture," *Art Institute of Chicago Museum Studies* 13 (1987): 49; Griet Claerhout, *The Museumbook: Highlights of the Collection* (Ghent: Snoeck, 2003), 168–69; Ronald Feltkamp, *Théo van Rysselberghe, 1862–1926* (Brussels: Éditions Racine, 2003), 291.

1. Shown left to right are Luigi Sartoni, violin; Irma Sèthe; Maria Sèthe; Jean Kéfer, viola; Henri Gillet, cello; and Mathieu Crickboom, violin.
2. Émile Verhaeren, "Le Salon des Artistes Indépendants," *La Nation,* March 22, 1891. Reprinted in Émile Verhaeren, *Écrits sur l'art,* vol. 1, ed. Paul Aron (Brussels: Éditions Labor, 1997), 416.
3. Théo van Rysselberghe to Octave Maus, 1891, inventory no. 5745. Published by Chartrain-Hebbelinck, "Les lettres de Van Rysselberghe à Octave Maus," 74.
4. "Est-elle délicieuse, vraiment, avec son fin profil, si distingué, son oeil bleu de musicienne rêveuse, ses chairs ivoirines, son menton volontaire, qui ajoute au caractère captivant de son visage." Van Rysselberghe to Signac, November 6 [1893], Signac Archive, Paris.
5. Maria visited London in January and May 1893. William Morris wrote to her on January 15, 1893, inviting her to visit his shop at 449 Oxford Street. Archives et Musée de la littérature, Henry Van de Velde Archive, FSX 597, Bibliothèque royale de Belgique, Brussels.
6. As related by Henry van de Velde in Van Loo and Van de Kerckhove, *Henry van de Velde: Récit de ma vie,* 1: 199–206.
7. "Ce sera, je crois un couple intéressant . . . car elle a beaucoup de goût, est musicienne, fait de broderie, etc. Ils sont en tous les cas très heureux." Eugène Demolder, "L'Exposition des XX," *Société nouvelle* (March 1892): 351.

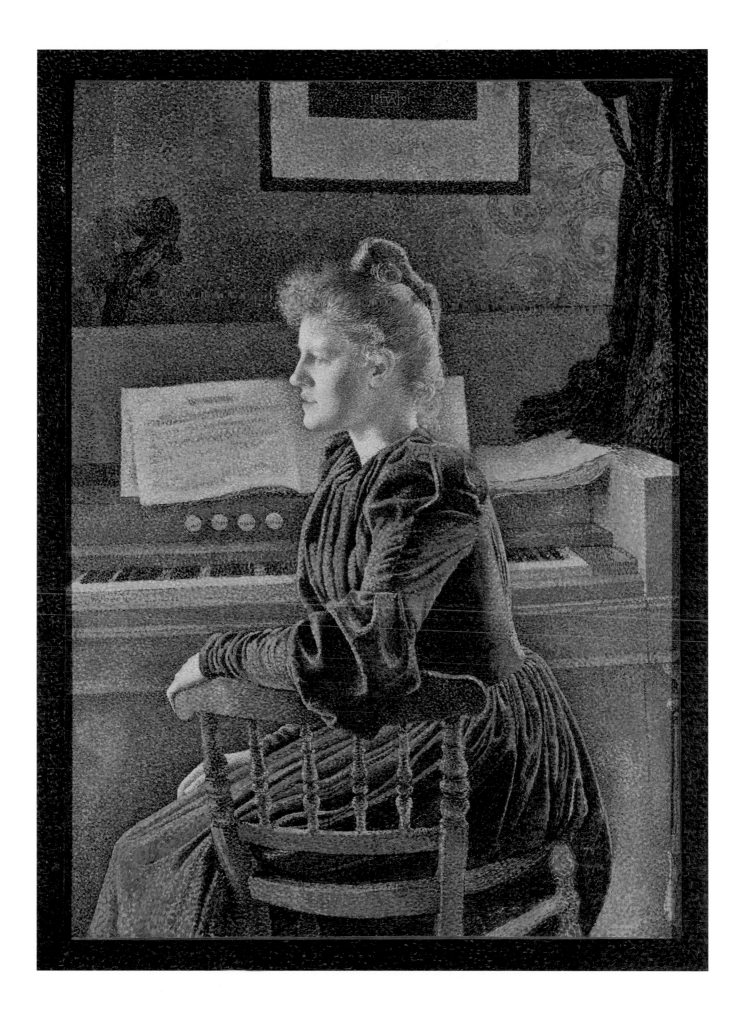

PLATE 52

Théo van Rysselberghe

Belgian, 1862–1926

Émile Verhaeren in His Study, Rue du Moulin (Émile Verhaeren dans son cabinet de travail, rue du Moulin), 1892

Oil on canvas, 33⅞ × 29¾ in. (86 × 75.6 cm)
Monogrammed and dated lower left: 18 VR92
Bibliothèque royale de Belgique, Brussels

This work, one of many where Théo van Rysselberghe captured his friend, the poet and art critic Émile Verhaeren (1855–1916), was shown at the Paris Independents of 1892 at the same time as the artist's portrait of Anna Boch (see plate 53) and at the Antwerp Association pour l'art, where it was shown in close proximity to the artist's portrait of Maria Sèthe at the harmonium (see fig. 23). Van Rysselberghe was repeatedly drawn to capturing the poet's physiognomy, writing in 1884, "You have a good head: Your florid Jordanesque coloring, your large golden mustache and your comical eyes!"[1] In that year, the second of their long and close friendship, the artist first illustrated the poet's published work, a collaboration that led Van Rysselberghe to ornament nearly every important volume by Verhaeren. This association makes it seem natural that Van Rysselberghe's monogram and date are prominently displayed on the orange-covered book in the left foreground of this portrait. In 1891 Van Rysselberghe prepared a conté crayon for this work, indicating the colors for the final oil, as well as a study for the face alone.[2]

Verhaeren is dressed formally, his melon-shaped hat placed jauntily upon the shelf at the rear. His bony and creative right hand emerges from the large white shirt covering his slight build. He has been working on a manuscript, and the clock on the mantel is ticking away the hours. Verhaeren has momentarily put down his pencil as he stares out from his pince-nez, while his familiar long flowing mustache seems to twitch in the light coming from the right. He is surrounded by his writings, inkwell, copper frog paperweight, and tobacco pot, which rest on the flowered table runner, while behind him is a filled bookcase and the bottom of two framed paintings, alluding to Verhaeren's further talents as an art critic and collector.[3] In this private setting, the poet becomes a spectral figure set against a dark background of greens.

This homage to Verhaeren was a well-earned tribute to the poet's defense of Neo-Impressionism. Reviewing Seurat's work shown in Brussels at Les XX in 1887, Verhaeren praised its luminosity and compared *La Grande Jatte* to paintings of the Flemish primitives.[4] By 1887 Verhaeren had acquired two Seurat paintings: *Coin d'un bassin Honfleur* and *L'Hospice et le Phare de Honfleur.*[5] When Seurat returned to Brussels in 1889, Verhaeren defended both Seurat and Van Rysselberghe, who showed his first Neo-Impressionist portraits, including the *Portrait of Alice Sèthe.*[6] He continued to be one of Van Rysselberghe's greatest champions. JB

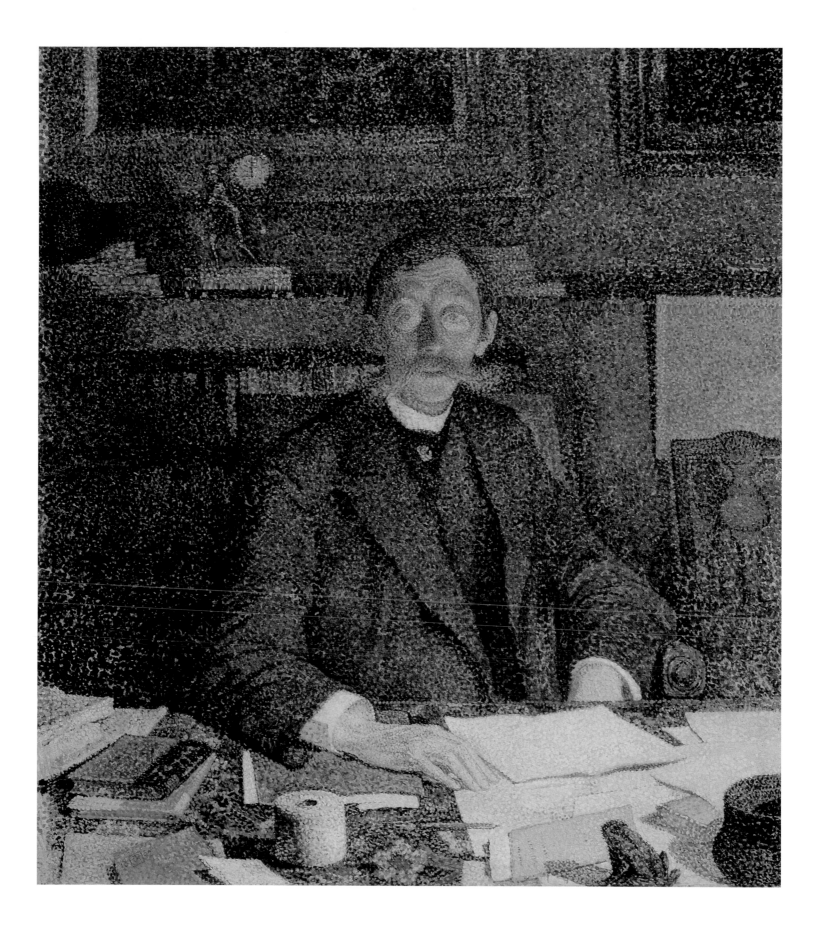

PROVENANCE: Émile Verhaeren until 1916; Martha Verhaeren, 1930; bequest of Martha Verhaeren to the Bibliothèque royale de Belgique, Brussels, 1930.

EXHIBITIONS: Independents, Paris, 1892, no. 1198; Association pour l'art, Antwerp, 1892, no. 3; Haagschen Kunstkring, The Hague, *Tentoonstelling van Schilderijen en Teekeningen van eenigen uit de "XX" en uit de "Association pour l'art,"* 1892, no. 30; Hôtel Brébant, Paris, *Les néo-impressionnistes,* 1892–93, no. 70; Les XX, Brussels, exhibited under rubric "Portraits," 1893, 1–2; Katalog der III Kunst-Ausstellung der Vereinigung Bildender Künstler Österreichs Secession, Vienna, 1899, no. 48; Galerie Giroux, Brussels, *Oeuvres de Théo van Rysselberghe,* 1922, no. 127; Galerie Giroux, Brussels, *Théo van Rysselberghe,* 1927, no. 22; Brussels, *Centenaire de Verhaeren,* 1955, no. 233; Museum voor Schone Kunsten, Ghent, *Rétrospective Théo van Rysselberghe,* 1962, no. 60; Musée d'histoire et d'art, Luxembourg, *Théo van Rysselberghe, 1862–1926,* 1962, no. 23; Deutsche Guggenheim, Berlin, *Divisionism, Neo-Impressionism: Arcadia and Anarchy,* 2007, no. 2; Palazzo Reale, Milan, *Georges Seurat, Paul Signac e i neoimpressionisti,* 2008, no. 57; National Gallery of Victoria, Melbourne, *Radiance: The Neo-Impressionists,* 2012, 99.

BIBLIOGRAPHY: Émile Verhaeren, "Théo van Rysselberghe," *Ver Sacrum* 2 (1899): 13; Gustave van Zype, "Notice sur Théo van Rysselberghe," *Annuaire de l'Académie royale de Belgique* 98 (1932): 130; Ronald Feltkamp, *Théo van Rysselberghe, 1862–1926* (Brussels: Éditions Racine, 2003), 293; Véronique Jago-Antoine, "Théo van Rysselberghe et Émile Verhaeren: Cadrage sur une 'fraternité d'art,'" in *Théo van Rysselberghe,* ed. Olivier Bertrand (Brussels: Fonds Mercator and Belgian Art Research Institute, 2006), 76–97.

1. Van Rysselberghe to Émile Verhaeren, July 6, 1884, Archives et Musée de la littérature, FS XVI 148/1309, Bibliothèque royale de Belgique, Brussels.

2. The drawing, dated 1891, is conserved in the print room of the Bibliothèque royale de Belgique, while the study of the face rests in the Plantin-Moretus Museum, Antwerp. Both are reproduced in Hoozee and Lauwaert, *Théo van Rysselberghe, néo-impressionniste,* 148, 149.

3. The larger of the partial paintings is actually Adolphe Monticelli's *Quatre personnages dans un parc.* Verhaeren's study, which includes this painting, has been reconstructed as the Cabinet Verhaeren in the Bibliothèque royale de Belgique. See Fabrice van der Kerckhove, "Verhaeren collectionneur," in *Émile Verhaeren, un musée imaginaire* (Brussels: Archives et Musée de la Littérature, 1997), 155.

4. Émile Verhaeren, "Le Salon des XX à Bruxelles," *La Vie moderne,* February 26, 1887, 135–39. This review is reproduced in Aron, *Émile Verhaeren, Écrits sur l'art,* 1: 269.

5. For more on Verhaeren as an art collector, see Fabrice van de Kerckhove, "Émile Verhaeren, collectionneur," in *Émile Verhaeren, un musée imaginaire,* ed. Marc Quaghebeur (Paris: Réunion des musées nationaux, 1997), 139–71.

6. Émile Verhaeren, "Aux XX," *L'Art moderne,* February 10, 1889, 41–42.

PLATE 53

Théo van Rysselberghe
Belgian, 1862–1926

Portrait of Anna Boch, [1892 and subsequently reworked]

Oil on canvas, 37½ × 25½ in. (95.2 × 64.8 cm)
Monogrammed lower right: VR
Michele and Donald D'Amour Museum of Fine Arts, Springfield, Massachusetts, The James Philip Gray Collection

Théo van Rysselberghe's portrait of the painter Anna Boch (1848–1936), first painted in early 1892, is his fourth Neo-Impressionist painting of a standing female figure (see appendix) and his eighth female pointillist portrait. The artist depicts Boch with palette and brush in hand, surrounded by the tools of her craft. Dressed in a dark blue smock, she stares critically at a painting just outside the viewer's sight. At a moment arrested in time, Anna is shown as a working artist in her atelier, holding a palette that contains all the colors in Van Rysselberghe's portrait of her. Typical of the artist is the carefully arranged composition of horizontals and verticals. Noticeably absent are the swirling lines so prominent in the portraits of Alice and Maria Sèthe. The verticality of Boch's pose is echoed by the wall behind her and by the frame of the print hanging on it, interrupted by the palette she holds at an angle and the fore-shortened table at lower right. Only the disheveled tabletop suggests the activity of the atelier—pencils in a bowl, sketchbooks, and the holder of brushes that radiate activity with their emphatic blue and orange dots: in fact, the complementary pairs of orange and blue dominate the composition. The framed work behind Boch, taken from her substantial collection of Japanese prints, attests to her artistic taste. Like her brother, the artist Eugène Boch, and Van Rysselberghe, she was a serious collector of Japanese prints.[1] Anna's pose and overall simplification of form echo the figure of the actor in the print. Similarly, the violin scroll refers, however obliquely, to her musical interests and accomplishments.[2]

Boch was the daughter of the wealthy porcelain manufacturer Frédéric Victor Boch and his cousin Anne-Marie Lucie Boch, remembered today in the present firm of Villeroy and Boch. She could afford not only to live in an elegant townhouse on the Toison d'or remodeled in 1895 by Victor Horta, but also to acquire an extensive art collection containing works by Vincent van Gogh, James Ensor, Georges Seurat, Paul Signac,

and Paul Gauguin, many of which she gave to the Musées royaux des Beaux-Arts de Belgique, Brussels.[3] Through her cousin Octave Maus (lawyer, patron of the arts, and secretary of Les XX) Anna formed a strong friendship with Van Rysselberghe, with whom she studied briefly. In addition to her innate talent, her connection with Maus probably helped Boch get elected to membership in Les XX in 1885, making her the only woman member in its ten-year history. Influenced by Georges Seurat's work shown at Les XX in 1887 and 1889 and Van Rysselberghe's conversion to the new style, Boch turned to Neo-Impressionism for a brief period of time. Seurat identified her as one of the members of Les XX "favorably disposed to optical painting."[4] She was among the Belgians receiving works from Seurat's family after his premature death.

Although Van Rysselberghe exhibited the portrait of Anna Boch at the Paris Independents in March 1892, he was not content with it, informing Paul Signac in October that he was repainting it.[5] The next April he reported that it was finished but that he was still not satisfied.[6] Van Rysselberghe's dissatisfaction presumably accounts for the fact that he never exhibited it again. The sitter, however, valued it dearly and kept it her entire life.[7]

JB

PROVENANCE: Anna Boch; Galerie Le Roy, Brussels, December 15, 1936, no. 31; Jean Metthey; Galerie de l'Elysée, Paris; Walter P. Chrysler, Jr.; Coe Kerr Gallery, New York; purchased by the Museum of Fine Arts, Springfield, MA, 1970.

EXHIBITIONS: Independents, Paris, 1892, no. 1199; Galerie Giroux, Brussels, *Théo van Rysselberghe,* 1927, no. 23; Galerie Le Roy, Brussels, *Succession de Mlle Anna Boch, artiste peintre,* December 15, 1936, no. 131; 26th Biennale, Venice, *Il Divisionismo,* 1952, no. 20; Wildenstein Gallery, New York, *Seurat and His Friends,* 1953, no. 98; Dayton Art Institute, *French and Belgian Paintings, 1789-1929, from the Collection of Walter P. Chrysler, Jr.,* 1960, no. 74; Saarland Museum, Moderne Galerie, Saarbrucken, *Anna Boch und Eugène Boch,* 1971, 9; Brooklyn Museum, *Belgian Art, 1880-1914,* 1980, no. 88; Musée d'Ixelles, *L'Impressionnisme et le fauvisme en Belgique,* 1990, no. 57; Museum voor Schone Kunsten, Ghent, *Théo van Rysselberghe, néo-impressionniste,* 1993, no. 32; Royal Academy of Arts, London, *Impressionism to Symbolism: The Belgian Avant Garde 1880-1900,* 1994, no. 71; Musée de Pontoise, *Hommage à Anna et Eugène Boch,* 1994, no. 83.

BIBLIOGRAPHY: Gustave van Zype, "Notice sur Théo van Rysselberghe," *Annuaire de l'Académie royale de Belgique* 98 (1932): 130; Thérèse Faider-Thomas, "Anna Boch et le groupe des XX," in *Miscellanea Professor Jozef Duverger*, vol. 1 (Ghent: Vereniging voor de geschiedenis der textielkunsten, 1968), 406, 407; Jean Sutter, *The Neo-Impressionists* (Greenwich, CT: New York Graphic Society, 1970), 201; F. B. Robinson, "Portrait of Anna Boch," *Springfield Museum of Fine Arts Bulletin* 37 (April–May 1971); *Handbook of the American and European Collections* (Springfield, MA: Museum of Fine Arts, 1979), 92, no. 164; Norbert Hostyn, *Belgische Stilleven- & Bloemenschilderkunst, 1750–1914* (Ostend: Museum voor Schone Kunsten, 1994), 67; Thérèse Thomas and Cécile Dulière, *Anna Boch, 1848–1936* (Tournai: La Renaissance du livre, 2000), 29; Ronald Feltkamp, *Théo van Rysselberghe, 1862–1926* (Brussels: Éditions Racine, 2003), 296; Thérèse Thomas, *Anna Boch: Catalogue raisonné* (Brussels: Éditions Racine, 2005), 150.

1. In October 1887 Van Rysselberghe asked Eugène to mail him from Paris a packet of Japanese woodblock prints. Van Rysselberghe to Eugène Boch, October 11, 1887, Archives de l'art contemporain, no. 3862, Musées royaux des Beaux-Arts de Belgique, Brussels. Five years later, Van Rysselberghe exhibited his Hiroshige woodcuts at the Antwerp Association pour l'art held in 1892.

2. Anna, an accomplished violinist, pianist, and organist, held weekly musical soirées at her home that many of her painter friends attended. She was an ardent follower of Richard Wagner, and her private concerts hosted such musicians as Eugène and Théo Ysaÿe, Gabriel Fauré, and Vincent d'Indy.

3. Five surviving Horta drawings created for the remodeling are illustrated in Franco Borsi and Paolo Portoghesi, *Victor Horta* (New York: Rizzoli, 1991), 394. For a list of works owned by Boch at her death, see Thérèse Thomas and Cécile Dulière, *Anna Boch, 1848–1936* (Tournai: La Renaissance du livre, 2000), 143–57.

4. "Vingtistes favorable à la peinture optique." Letter from Seurat to Félix Fénéon cited in De Hauke, *Seurat et son oeuvre,* 1: xx.

5. Van Rysselberghe to Paul Signac, October 14, 1892, Signac Archive, Paris.

6. Van Rysselberghe to Signac, April 19 [1893], Signac Archive, Paris. Van Rysselberghe announced: "I am finishing this mediocre portrait of Miss Boch." ("Je termine ce médiocre portrait de Mlle Boch.") However, the portrait remained in Van Rysselberghe's possession in 1896, when he wrote to Signac that Boch was, after four years, still waiting for her portrait because he never delivered the one that was exhibited at the Independents, which he found "abominable." Signac Archive, Paris, undated letter, [1896].

7. Following her death, the painting was sold at the Galerie Le Roy, Brussels, in 1936 at the auction *Succession de Mlle Anna Boch, artiste peintre,* December 15, 1936, no. 31.

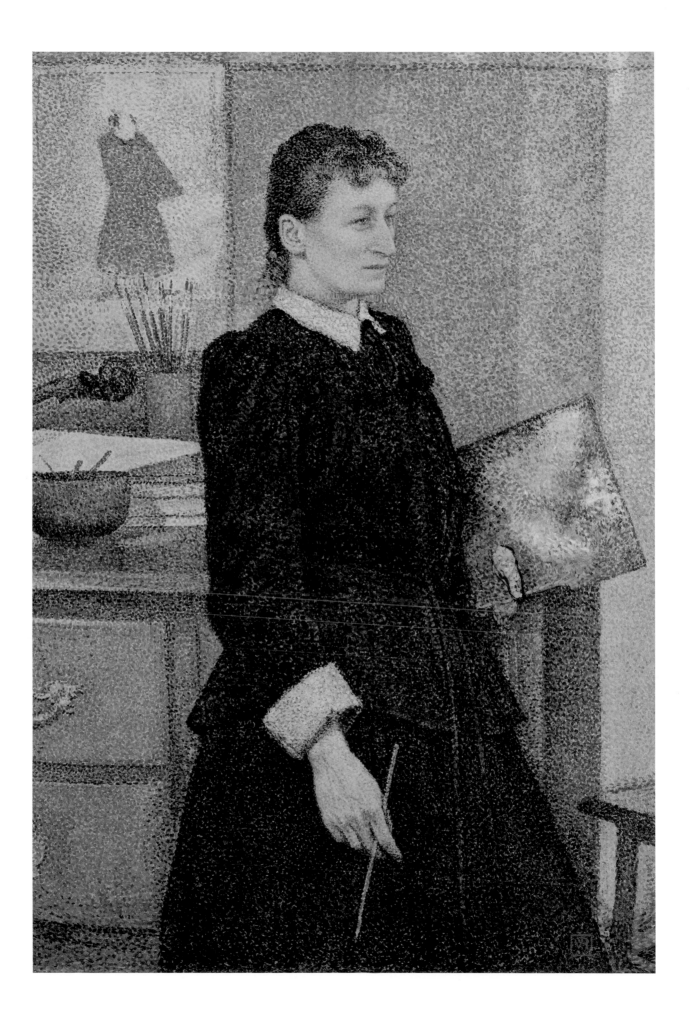

PLATE 54

Théo van Rysselberghe

Belgian, 1862–1926

Portrait of Émile Verhaeren, 1892

Charcoal on paper, 21⅜ × 16⅜ in. (54.4 × 41.7 cm)
Monogrammed and dated upper left: Sept. 18VR92
Inscribed, dated, and signed on reverse: Emile Verhaeren en Septembre 1892 à Hemixem, T.V.R.
Private collection

The Symbolist poet Émile Verhaeren (1855–1916) sits in a state of reverie, gazing perhaps into the fireplace that illuminates his head and hands—that is, his creative thoughts and the instruments that transcribe them into the written word—while casting a long shadow behind him on the wall. His characteristic flowing mustache would have alerted the contemporary Belgian viewer to his identity. The white of the paper and relative thinness of the strokes around Verhaeren's head create a halo that accentuates the flatness of the shadowed area and contrasts with the plasticity of the head. The concentration on the mysterious effect evoked through subtle gradations of light and shadow align this portrait with the Symbolists.

The drawing, one of nearly two dozen works in which Van Rysselberghe captured the poet's visage, records both a personal friendship and a particular moment. During the summer of 1892 Van Rysselberghe stayed on a farm in Cruybeke, near Antwerp, on the edge of the Escaut River.[1] In September, he moved to the other side of the river to stay at the Hotel Mozegat in Hemixem, where he was joined by Verhaeren and where this haunting drawing was created.[2] Toward the end of September 1892 they traveled to England together, visiting London, Oxford, Liverpool, and Manchester.[3] **JB**

PROVENANCE: Elisabeth van Rysselberghe; Catherine Gide; Christie's auction, Paris, December 1, 2006, *Art Impressionniste et Moderne* (sale no. 5435), no. 1.

EXHIBITIONS: *Exposition des Peintres Néo-Impressionnistes,* Paris, 1892–93, no. 70; Galerie Giroux, Brussels, *Théo van Rysselberghe,* 1927, no. 9; La Gazette des Beaux-Arts, Paris, *Seurat et ses amis: La suite de l'impressionnisme,* 1933, no. 109 (erroneously as *Émile Verhaeren in 1890*); Bibliothèque royale de Belgique, Brussels, *Centenaire de Verhaeren,* 1955, no. 217; Museum voor Schone Kunsten, Ghent, *Rétrospective Théo van Rysselberghe,* 1962, no. 194; Musée d'histoire et d'art, Luxembourg, *Théo van Rysselberghe, 1862–1926,* 1962, no. 72; Le Lavandou, *Théo van Rysselberghe intime* (Le Lavandou: Le Réseau Lalan), 2005, no. 48.

BIBLIOGRAPHY: *Émile Verhaeren, 1883–1896: Pour les amis du poète* (Brussels: Edmond Deman, 1896), frontispiece; Émile Verhaeren, "Théo van Rysselberghe," *Ver Sacrum* 2 (1899): 28; Pol de Mont, "Théo van Rysselberghe," *L'Art et la vie* 1 (1902): 14; Paul Fierens, *Théo van Rysselberghe* (Brussels: Éditions de la Connaissance, 1937), fig. 11; Giulia Veronesi, "Neo-impressionisti: Paul Signac e Théo van Rysselberghe," *Emporium* 139 (March 1964): 103; Ronald Feltkamp, *Théo van Rysselberghe, 1862–1926* (Brussels: Éditions Racine, 2003), 295; Véronique Jago-Antoine, "Théo van Rysselberghe et Émile Verhaeren: Cadrage sur une 'fraternité d'art,'" in *Théo van Rysselberghe,* ed. Olivier Bertrand (Brussels: Fonds Mercator and Belgian Art Research Institute, 2006), 80.

1. Théo van Rysselberghe to Lucien Pissarro, July 30, 1892. Van Rysselberghe gives the full address as Nieuw-Veer, à Cruybeke, par Anvers. Pissarro collection, Ashmolean Museum, Oxford.
2. Théo van Rysselberghe to Lucien Pissarro, September 16, 1892. Pissarro collection, Ashmolean Museum, Oxford.
3. Émile Verhaeren to his wife Marthe Verhaeren, dated September 29, 1892 (letter CLV) and September 30, 1892 (letter CLVI). Published in Émile Verhaeren, *À Marthe Verhaeren: Deux cent dix-neuf lettres inédites, 1889–1916,* ed. René Vandevoir (Paris: Mercure de France, 1951), 377–79.

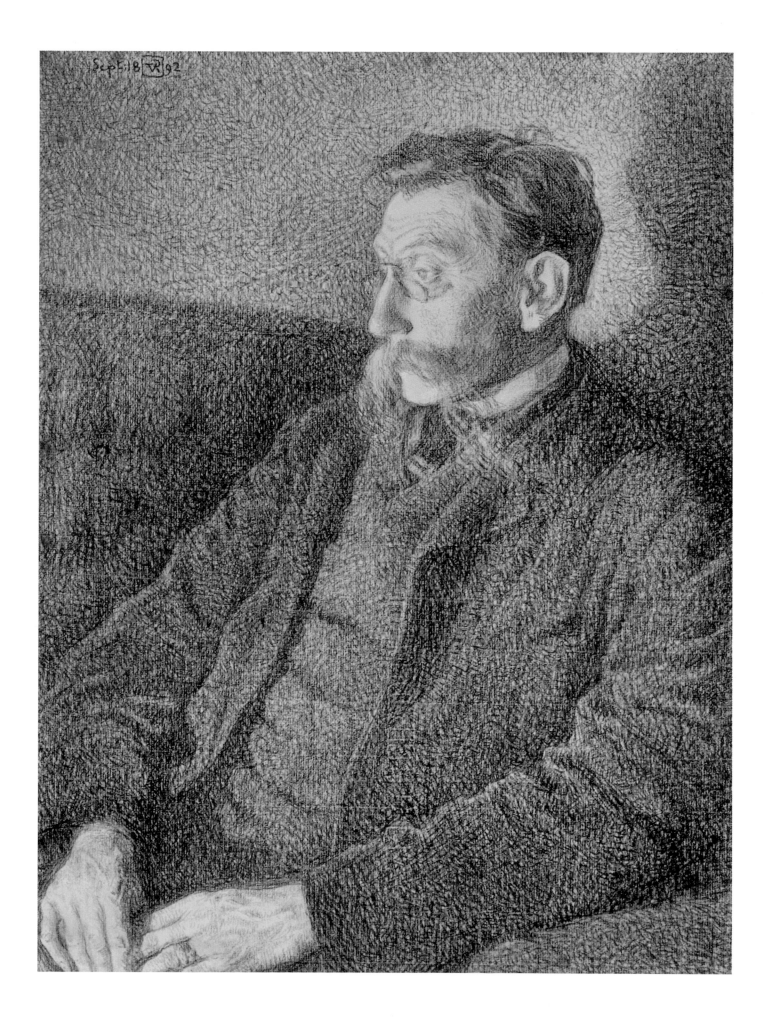

PLATE 55

Théo van Rysselberghe
Belgian, 1862–1926

Doctor Auguste Weber, [1893–94]

Oil on canvas, 53⅛ × 45¼ in. (135 × 115 cm)
Monogrammed upper right: VR
Private collection

In this muted pointillist portrait, Auguste Weber (1852–1936) sits in a relaxed pose, with legs crossed, right arm draped over the chair, recalling the informality of a portrait by Frans Hals, the seventeenth-century artist greatly admired by Théo van Rysselberghe. Nothing in the portrait seemingly reveals Weber's distinguished medical career. While he wears the "radiant vest" by which he was known, he relaxes in the privacy of his home.[1] Van Rysselberghe signed the portrait with his monogram, upper right, on the painting within the painting. With the frame resting on the floor, this clever conceit reveals that Weber was a patron of the arts who owned works by Van Rysselberghe, including *Canal en Flandre,* 1894. Van Rysselberghe was working on the portrait in May and June of 1893 when he was visiting the Webers.[2] Van Rysselberghe created the pointillist frame for the portrait. Weber's ruddy complexion, composed of yellows, greens, blues, mirrored in the reds of his suit, perhaps refers to his widely recognized affability.

Weber studied medicine in Paris, Vienna, and Ghent and established practice in his native Luxembourg in 1883. He worked principally at the newly created factory in Dudelange, the industrial town run by his cousin, the wealthy Luxembourg industrialist Émile Mayrisch.[3] Weber was said to be a great diagnostician whose good sense of humor made him popular with the employees and workers.[4] He was appointed to many commissions and served as president of the Administrative Council to Combat Tuberculosis and Cancer.

Connections between the Van Rysselberghes and the Webers were longstanding and deep. Van Rysselberghe's wife, Maria, had frequented the family of Dr. Weber's wife, Berthe Gansen (1856–1941), in Luxembourg, since she was nine years old. The Webers married in 1884 and had five children. Their home was known for its musical soirées, which included performances by three of their daughters, Marie-Anne, Daisy, and Cécile.[5] Van Rysselberghe also executed portraits of the Weber children, as well as one of Madame Weber.[6] Through the Webers, Van Rysselberghe met their cousin and Auguste's employer, Émile Mayrisch. Van Rysselberghe, in turn, executed several portraits of Mayrisch.[7]

The portrait seems not to have been exhibited in Van Rysselberghe's lifetime and prior to its modern exhibition history was on display only in 1927, when Weber himself lent it to the Van Rysselberghe memorial exhibition held at the Galerie Giroux in Brussels. JB

PROVENANCE: Weber family; Jacques Schroder, Brussels; Hôtel des Ventes, Enghien-les-Bains, France, April 13, 1986, lot 28; Clayre and Jay Haft, New York; Sotheby's, Paris, July 2, 2008, no. 19; Jean-Luc Baroni Ltd, London; private collection.

EXHIBITIONS: Galerie Giroux, Brussels, *Théo van Rysselberghe,* 1927, no. 19; Musée d'histoire et d'art, Luxembourg, *Théo van Rysselberghe, 1862-1926,* 1962, no. 24; Museum voor Schone Kunsten, Ghent, *Théo van Rysselberghe, néo-impressionniste,* 1993, no. 36; Palais des Beaux-Arts, Brussels, *Théo van Rysselberghe,* 2006, 217; Jean-Luc Baroni, *An Exhibition of Master Drawings and Paintings,* 2009, no. 40.

BIBLIOGRAPHY: Gustave van Zype, "Notice sur Théo van Rysselberghe," *Annuaire de l'Académie royale de Belgique* 98 (1932): 130; Jules Mersch, "Auguste Weber," *Biographie nationale du pays de Luxembourg depuis ses origines jusqu'à nos jours,* vol. 6 (Luxembourg: Imprimerie de la Cour Victor Buck, 1963), 343 (reproduction); *Gazette de l'Hôtel Drouot,* March 14, 1986, 119; *Exceptionnels tableaux modernes et sculptures,* Hôtel des Ventes, Enghien-les-Bains, Gérard Champin, Francis Lombrail, and Denise Gautier (April 13, 1986), no. 28; Ronald Feltkamp, *Théo van Rysselberghe, 1862-1926* (Brussels: Éditions Racine, 2003), 297.

1. In his entry on Auguste Weber, Jules Meersch specifically noted Weber's "gilet radieux." *Biographie nationale du pays de Luxembourg* 6 (Luxembourg: Imprimerie Victor Buck, 1963), 342.
2. Van Rysselberghe to George Morren, May 14 [1893]. Van Rysselberghe reveals that the portrait was going very slowly and that he could not return to Brussels before June. A letter from Octave Maus to his cousin, the artist Eugène Boch, dated June 13, 1893, reports that Van Rysselberghe had finally returned from Luxembourg after a month's stay with the Webers. Both letters are housed in the Archives de l'art contemporain, Musées royaux des Beaux-Arts de Belgique, Brussels. The former has the inventory number 47.974 and the latter 3929. My thanks to Véronique Cardon for providing me with access to these letters, and for many other kindnesses.
3. Mayrisch was an enlightened industrialist establishing a medical service for his workers as of 1884, constructing houses for them, creating a fund to assist with their medical expenses, and in 1896 constructing a hospital for them.
4. Meersch, *Biographie nationale,* 341.
5. Marie-Anne sang at concerts at the Libre Esthétique in 1909, 1911, 1912, 1913, and 1914.
6. For reproductions see Feltkamp, *Théo van Rysselberghe.* For a drawing of Cécile, a drawing of Daisy and a pastel of her, 313; for Cécile, 375, 377; and for Marie-Anne (1884-1953), who was a violinist and singer, 343. Van Rysselberghe returned to Auguste Weber in 1907 with two charcoal drawings, 364; and an oil portrait of Berthe Gansen, his wife, in 1908, 375.
7. For oil portraits of Mayrisch, see Feltkamp, *Théo van Rysselberghe,* 400 and 428; and for his bronze bust, 476.

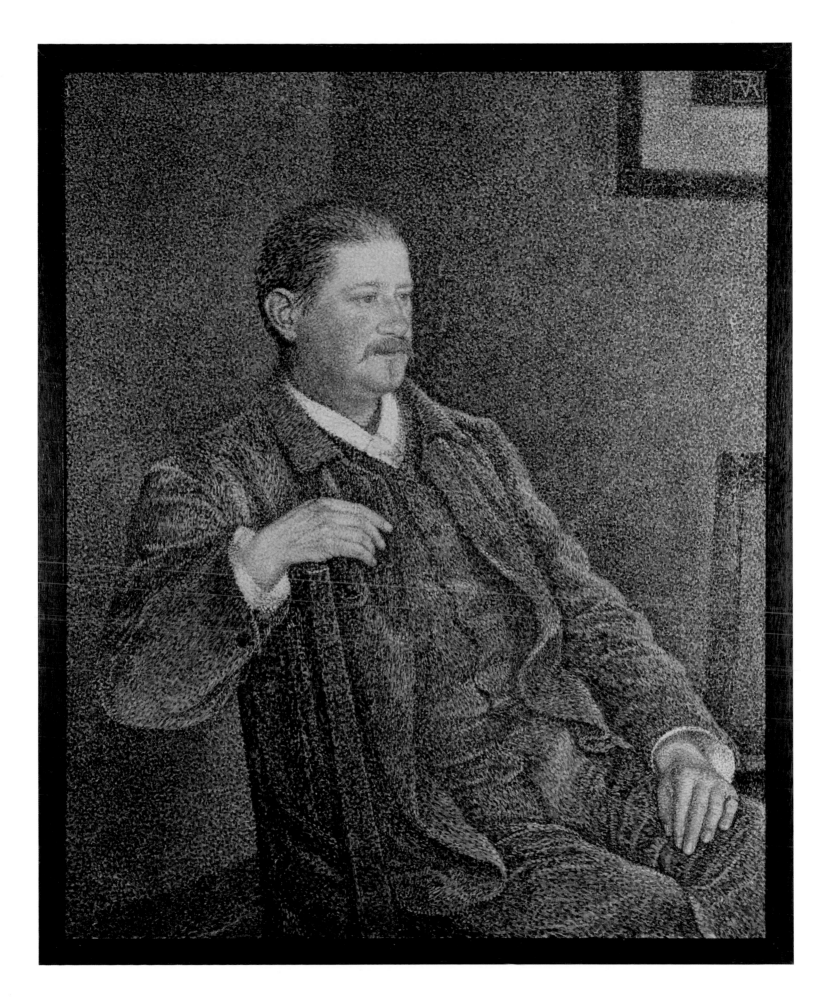

PLATE 56

Théo van Rysselberghe

Belgian, 1862–1926

Portrait of Mademoiselle Irma Sèthe, 1894

Oil on canvas, 77¾ × 45⅛ in. (197.5 × 114.5 cm)
Monogrammed and dated lower right: 18VR94
Petit Palais, Musée d'art moderne, Geneva

Painted in the fall of 1894, this portrait of the youngest Sèthe sister, the violinist Irma (April 27, 1876–May 12, 1958), was Théo van Rysselberghe's fifth full-length female Neo-Impressionist portrait, and his tenth pointillist portrait of a woman. The painting had its debut at the Paris Independents in 1895 and, among many venues, was shown at the Vienna Secession in 1899. The artist had so many requests to lend the work that in 1906 he characterized it in exasperation as the "eternal portrait of Irma!"[1]

The composition is focused on Irma's stunning pink dress, whose multiple folds and ripples emanate from Irma much as the music flows from her instrument. The dress, accented with complementary greens, is reflected in the polished floor, its pinks dissolving into the floor's cooler tones of greens, blues, and violets. Once again, the geometry of the interior provides an important framing device. The figure's verticality is repeated by the wall panel behind her, while the auditor in the next room supplies a horizontal element, as does the étagère. The geo-metrically conceived setting serves as a foil for the plasticity of Irma's form, much as her presentation as an active musician contrasts with the lavender and orange seated listener. The puffed sleeves of Irma's dress, her ribboned sash, and the wisps of her blond hair escaping from her hair clip soften the rectilinear elements of the work.

Irma Sèthe was one of three daughters born to Gérard and Louise Sèthe, whose family tree included Christian Sèthe, to whom the German poet Heinrich Heine dedicated a poem.[2] According to Henry van de Velde, "Madame Sèthe raised her children in the cult of music and the arts. In this environment, music was practiced with respect and the highest sense of per-fection."[3] Irma and her oldest sister, Maria, playing violin and harmonium, could often be heard entertaining the family. Paul Dubois had already sculpted the precocious Irma playing the violin in 1889, when the work was shown at Les XX alongside Van Rysselberghe's portrait of Dubois's wife—Irma's other sister, Alice Sèthe (see plate 46). In fact, Irma began playing the violin at age five, eventually taking lessons from Reinhold Jockisch, and in September 1890 entered the class of Eugène

Ysaÿe (1858–1931) at the Brussels Conservatory, where she won first prize at age fifteen. Van Rysselberghe captured her serious gaze in a pastel at this time (fig. 48).[4]

Irma's first public concert appears to have taken place on April 25, 1892, in Brussels, playing with the prestigious Crickboom quartet (see fig. 46). The reviewer for the *Guide Musical* remarked, "Mlle Sèthe truly possesses what one need call a profound and serious talent, an intelligent and individual understanding, and a respectful interpretation."[5] Mathieu Crickboom (1871–1947), a frequent guest in the Sèthe home, had also been a star pupil of Ysaÿe's. Taken under Ysaÿe's wing, Irma fell in love with him and moved into his house in the fall of 1893 at age seventeen.[6] Irma played a duet with Ysaÿe at the Brussels Conservatory on April 22, 1894, while Van Rysselberghe was still working on her portrait. Three days later her sister Maria and Henry van de Velde were married, with the artist serving as a witness.[7] Upon returning from his honeymoon, Van de Velde received his first commission to design furniture, for Irma's mother. Madame Sèthe asked for an armoire that would contain Irma's violins and for the decoration of a room in which Irma could receive her friends.[8]

Fig. 48. Théo van Rysselberghe, *Irma Sèthe.* Pastel on paper, 17 × 11 in. (43.2 × 27.9 cm). Private collection.

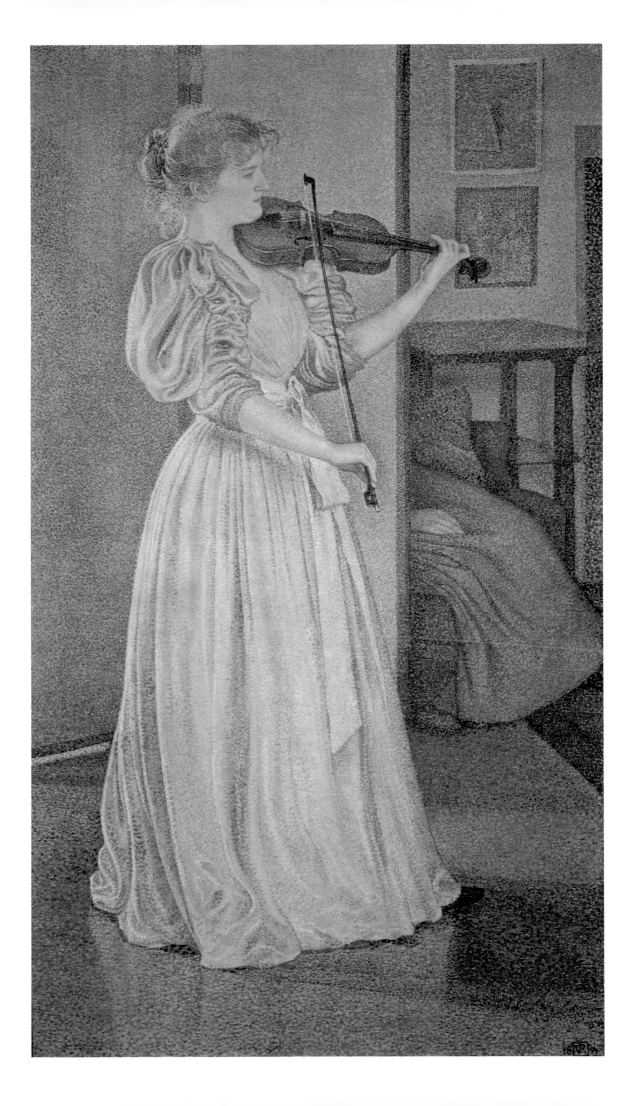

Following a concert tour in 1895, Irma became a favorite in London, playing frequently over the next two years.[9] During her London tours she met Dr. Samuel Saenger (1864–1944), who served as a tutor to many upper-class Brits.[10] They were married on July 31, 1897, shortly after her twenty-first birthday. The couple moved to Berlin, where they eventually had two daughters, Elizabeth (1898–1990) and Magadalene (known as Lella, 1907–1991). Although Irma continued to give concerts after the birth of Elizabeth, she later devoted herself to private teaching in Berlin, for which she could command fairly high fees.[11] Emigrating to the United States after a peripatetic journey fleeing the Nazis, Irma arrived in Los Angeles at age sixty-five with her portrait. Seventeen years later she died in New York at the home of her eldest daughter, Elizabeth Saenger Spiro. **JB**

PROVENANCE: Collection of Irma Sèthe-Saenger; collection of Mrs. Elis Chapiro; collection of Hugo Perls, New York; purchased at public auction, Sotheby's, London, April 3, 1974, no. 76, *Impressionism and Modern Paintings and Sculpture, Watercolours and Drawings;* Oscar Ghez, Geneva.

EXHIBITIONS: Independents, Paris, 1895, no. 1527, as *Portrait de Mlle Irma Sèthe;* Internationalen Kunst-Ausstellung, Dresden, 1897, no. 655; La Libre Esthétique, Brussels, 1898, no. 375, as *Mme Irma Saenger-Sèthe;* Katalog der III Kunst-Ausstellung der Vereinigung Bildender Künstler Österreichs Secession, Vienna, 1899, no. 46, as *Porträt der Frau Saenger-Sèthe;* Hirschl & Adler Galleries, New York, *Exhibition of Pointillist Paintings,* 1963, no. 59; Wildenstein Gallery, New York, *From Realism to Symbolism: Whistler and His World,* 1971, no. 128; Museum voor Schone Kunsten, Ghent, *Théo van Rysselberghe,* 1993, no. 37; Royal Academy of Arts, London, *Impressionism to Symbolism: The Belgian Avant-Garde, 1880–1900,* 1994, no. 72; Galeries nationales du Grand Palais, Paris, *Paris-Bruxelles, Bruxelles-Paris,* 1997, no. 186; Museum of Art, Kochi, *Georges Seurat et le Néo-Impressionnisme, 1885–1905,* 2002, no. 75; Palais des Beaux-Arts, Brussels, 2006, *Théo van Rysselberghe,* 119, 257; Musée National des Beaux-Arts du Québec, *De Caillebotte à Picasso: Chefs-d'oeuvre de la collection Oscar Ghez,* 2006, no. 24; Fondation de l'Hermitage, Lausanne, *Belgique dévoilée de l'impressionnisme à l'expressionnisme,* 2007, no. 83; Musée de Lodève, *Chefs-d'oeuvre de la collection Oscar Ghez,* 2007, no. 20.

BIBLIOGRAPHY: Émile Verhaeren, "Théo van Rysselberghe," *Ver Sacrum* 2 (1899): 12; Camille Mauclair, "Théo van Rysselberghe," *L'Art décoratif* (March 1903): 86; Madeleine Octave Maus, *Trente années de lutte pour l'art* (Brussels: l'Oiseau bleu, 1926), 228n1; Gustave van Zype, "Notice sur Théo van Rysselberghe," *Annuaire de l'Académie royale de Belgique* 98 (1932): 131 (the author erroneously groups the portrait of Irma Sèthe under the date 1897); Paul Fierens, *Théo van Rysselberghe* (Brussels: Éditions de la Connaissance, 1937), 2; John Rewald, "Extraits du journal inédit de Paul Signac: I. 1894–1895," in *Gazette des Beaux-Arts* 36 (July–September 1949): 118; Ronald Feltkamp, *Théo van Rysselberghe, 1862–1926* (Brussels: Éditions Racine, 2003), 304.

1. "L'éternal portrait d'Irma!" Van Rysselberghe to Henry van de Velde, 1906, Archives et Musée de la littérature, FSX800, Bibliothèque royale de Belgique, Brussels.

2. For more on the Sèthe family, see the account of her grandson, Peter Spiro, *Nur uns gibt es nicht wieder* (Cologne: Edition Memoria, 2010), 15.

3. Van Loo and Van de Kerckhove, *Henry van de Velde: Récit de ma vie,* 1: 215.

4. M. K. (Maurice Kufferath), "Notes bruxelloises," *Le Guide Musical,* July 12 and 19, 1891 (one issue), 180.

5. E. C., "Bruxelles," *Le Guide Musical,* May 8, 1892.

6. Ysaÿe gave Irma a pencil drawing of himself inscribed with a musical passage written by him dated January 1893: "Very affectionate keepsake to my best student Irma Sèthe, worthy inheritor of the Vieuxtemps approach." (Bien affectueux souvenir à ma meilleure élève Irma Sèthe—digne petite fille de la pensée de Vieuxtemps.) Private collection. Henri Vieuxtemps (1820–1881) was the leader of the Belgian school of violin playing in the generation before Ysaÿe. Irma cherished this possession and kept it throughout her life. Irma became godmother to Ysaÿe's fourth child, Antoine, born April 11, 1894. For more on Irma and her relationship with Ysaÿe, see Michel Stockhem, *Eugène Ysaÿe et la musique de Chambre* (Brussels: Pierre Mardaga, 1990), 118, 237.

7. Van Loo and Van de Kerckhove, *Henry van de Velde: Récit de ma vie,* 1: 225n1.

8. Ibid., 237. In fact, Van de Velde began remodeling the entire Sèthe villa in Uccle. For images and discussion of this remodeling, see Léon Ploegaerts and Pierre Puttemans, *L'Oeuvre architecturale de Henry Van de Velde* (Brussels: Atelier Vokaer, 1987), 256–57.

9. Arthur M. Abell, "Younger Women Violinists," II, *Musical World* (April 1902): 35–36. The *Athenaeum* documents concerts given by Irma in London in the following issues and columns: "Musical Gossip," October 26, 1895, 577; "Music 'The Week,'" December 14, 1895, 842; "Various Concerts," December 14, 1895, 842. In "Musical Society," January 25, 1896, 127, we learn that Irma "will return to England in March to fulfill her engagements in London, and to make a tour through the provinces." Her concerts were scheduled at St. James Hall on April 30 and May 21, 1896. See also the column "Musical Gossip," *Athenaeum,* for the following dates: November 28, 1896, 765; October 30, 1897, 605; November 27, 1897, 757. *Musical Times* also documents concerts given by Irma between fall 1895 and May 1897 in England. According to the critic of the *Strad,* "Her playing stamped her at once as a violinist of the highest order whether of promise for the future or of actual achievement. She has a singularly attractive method, a truly sympathetic and broad tone, and an intelligence that is all too rare even in these days." Gamba, *Strad* (June 1896): 58. My gratitude to Professor Christina Bashford, University of Illinois, Urbana-Champaign, for this reference.

10 Dr. Saenger was the son of a cantor in Riga, Latvia, and later acquired German citizenship. In 1900 he translated the writings of John Ruskin into German in *John Ruskin: Sein Leben und Lebenswerk* (Strasbourg: Heitz, 1900), which was published with a cover and frontispiece by his brother-in-law Henry van de Velde. After World War I, Saenger served as the first German ambassador from the Weimar Republic to the new Czechoslovak state, remaining in Prague with Irma until 1923, when the family returned to Berlin. He then became an editor for the publishing house Fischer Verlag and wrote under the pseudonym Junius for the journal *Neue Rundschau,* where he was highly critical of the Nazi Party. *Neue Rundschau* was closed and Saenger was dismissed when the Nazis came to power. As a Jew, Saenger was stripped of the pension due him, and he and Irma decided to leave Germany in 1938. After a long and arduous trek through France, Africa, and finally Lisbon, they were admitted to the United States on March 26, 1941. In Los Angeles they joined their daughter Lella, a concert pianist who had emigrated in 1934 and brought with her, according to oral tradition, her mother's Stradivarius.

11. My thanks to Dr. Dietmar Schenk, Universität der Künste Berlin, for sending me this information from *Was muss der Musikstudierende von Berlin wissen?* (What every music student in Berlin must know) by Richard Stern, of 1909 and 1913, and for confirming that Irma was not a teacher at the Königliche akademische Hochschule für Musik or the Stern'sches Konservatorium der Musik. Antoine Ysaÿe, in his *Eugène Ysaÿe* (Brussels: Éditions l'écran du monde, 1947), 499, cites Irma Saenger-Sèthe mistakenly as a "Pr.à la Hochschule de Berlin," presumably linking her with teaching there. In the 1909 edition Irma lists herself as a violin virtuoso living at Uhlandstrasse 48, which was located in Charlottenburg close to the Hochschule. She actually lived at this address from 1905–9, moving to Fürtherstrasse 11a the following year and remaining there through 1914.

PLATE 57

Théo van Rysselberghe
Belgian, 1862–1926

Madame Monnom, 1900

Oil on canvas, 46 × 35½ in. (116.8 × 90.3 cm)
Monogrammed and dated lower left: VR1900
Sterling and Francine Clark Art Institute, Williamstown, Massachusetts

Théo van Rysselberghe portrays his mother-in-law, Sylvie Marie-Thérèse Monnom-Descamps (1836–1921), as a very considerable, palpable presence as she meets our eyes with an air of gravity. The widow of Célestin Monnom, who died in 1871, the Veuve Monnom—as she was invariably called—was the powerful head of the Monnom publishing company located on the rue de l'Industrie in Brussels, which issued the two leading avant-garde Belgian periodicals, *L'Art moderne* and *La Jeune Belgique,* and the catalogues and posters for the exhibition societies Les XX and La Libre Esthétique. She also supported progressive ideas by publishing many monographs, including two editions of Henry van de Velde's *Déblaiement de l'art.* Mme Monnom further enriched the development of modern art in Belgium through her roles as patron and hostess. Through Van Rysselberghe's auspices, she acquired Georges Seurat's *The Channel at Gravelines, Evening* (*Le Chenal de Gravelines, un soir,* 1890), shortly after Seurat's death. She bought two of Signac's works shown at Les XX in 1890 and 1892: *Cassis. Canaille Cape* (*Cassis. Cap Canaille*), and *Concarneau, the Return of the Fishing Boats* (*Concarneau, Rentrée des chaloupes*).[1] Her rented country house in Thuin, Belgium, was a hospitable salon for the friends of her daughter Maria and Maria's husband, Théo, including the writer Émile Verhaeren and artists such as Georges Lemmen and Henry van de Velde.[2]

The tightly knit composition is not composed of the small dots that characterized Van Rysselberghe's earlier portraits, such as that of Irma Sèthe (see plate 56). The burst of deep blue in the upper left is balanced by the strong reds in the lower right. The diagonal produced by these saturated colors is counterbalanced by the diagonal of whites leading from her handkerchief through her blouse and hair to the blossoms in the distant vase. The divided color serves more to break up surfaces, producing a loose airiness, than to heighten the sensation of color through simultaneous contrast, so central to Neo-Impressionist theory. The strokes of color take the form of contour lines providing shape and bulk to the figure.

Mme Monnom's love of beauty is revealed to us by her surroundings as she sits amid the flowers and the paintings in her salon. The "modernity" of her sleek chair, suggesting the work of Victor Horta or Henry van de Velde, further attests to her support of the arts in Brussels. Yet its curving arms coyly reflect the marble bracket on the historicist fireplace behind her.

Van Rysselberghe's mother-in-law provided the artist with a challenging subject as he captured her image throughout the last three decades of her eighty-five years in pencil, pastel, and oil.[3] A charcoal drawing dated May 1899 showing Mme Monnom's bust is nearly identical to the Williamstown oil painting, presumably a study. Nineteen years later, Van Rysselberghe portrayed her as enfeebled and meditative, her head bowed with age.[4] The painter was pleased enough with our portrait to have it reproduced in 1903 in an article by the French critic Camille Mauclair.[5] JB

PROVENANCE: Henri Cuypers; Guy Pogu; Christie's, London, December 2, 1966; purchased by Arthur Tooth & Sons, London, for the Sterling and Francine Clark Art Institute.

EXHIBITIONS: Galerie Giroux, Brussels, *Rétrospective Théo van Rysselberghe,* 1927, no. 31; Clark Art Institute, Williamstown, *Twentieth Anniversary Exhibit: Selected Acquisitions Since the Founding of the Institute (1955),* 1976; Clark Art Institute, Williamstown, *A Tribute to Georges Heard Hamilton,* 1978.

BIBLIOGRAPHY: Camille Mauclair, "Théo van Rysselberghe," *L'Art décoratif* 13 (March 1903): 89; Gustave van Zype, "Notice sur Théo van Rysselberghe," *Annuaire de l'Académie royale de Belgique* 98 (1932), 131; "Chronique des arts," *Gazette des Beaux-Arts* 71 (February 1968): 87, no. 311; W. M. Ittmann, Jr., "Van Rysselberghe's Portrait of the Artist's Mother-in-Law, Mme. Monnom," *Art News* 67 (April 1968): 46–47, 64–66; *List of Paintings in the Sterling and Francine Clark Art Institute* (Williamstown: Sterling and Francine Clark Art Institute, 1972) 96–97; Geraldine Norman, *Nineteenth-Century Painters and Painting* (Berkeley: University of California Press, 1977), 187; Ronald Feltkamp, *Théo van Rysselberghe, 1862–1926* (Brussels: Éditions Racine, 2003), 325; Kelly Pask, *Nineteenth-Century European Paintings at the Sterling and Francine Clark Art Institute,* ed. Sarah Lees (New Haven: Yale University Press, 2013), 727–29, no. 301.[6]

1. The Seurat is presently in the collection of the Museum of Modern Art in New York, and the Signacs are in private hands.
2. Émile Verhaeren wrote to his fiancée, Marthe, from Thuin on September 2, 1890, of his pleasure with the house; see *À Marthe Verhaeren: Deux cent dix-neuf lettres inédites, 1889–1916,* ed. René Vandevoir (Paris: Mercure de France, 1951), 323.
3. For reproductions, see Feltkamp, *Théo van Rysselberghe,* 329 (pastel and pencil works) and 372 (oil).
4. Ibid., 424.
5. Camille Mauclair, "Théo van Rysselberghe," *L'Art décoratif* 13 (March 1903): 89.
6. My thanks to Sarah Lees for making this text available.

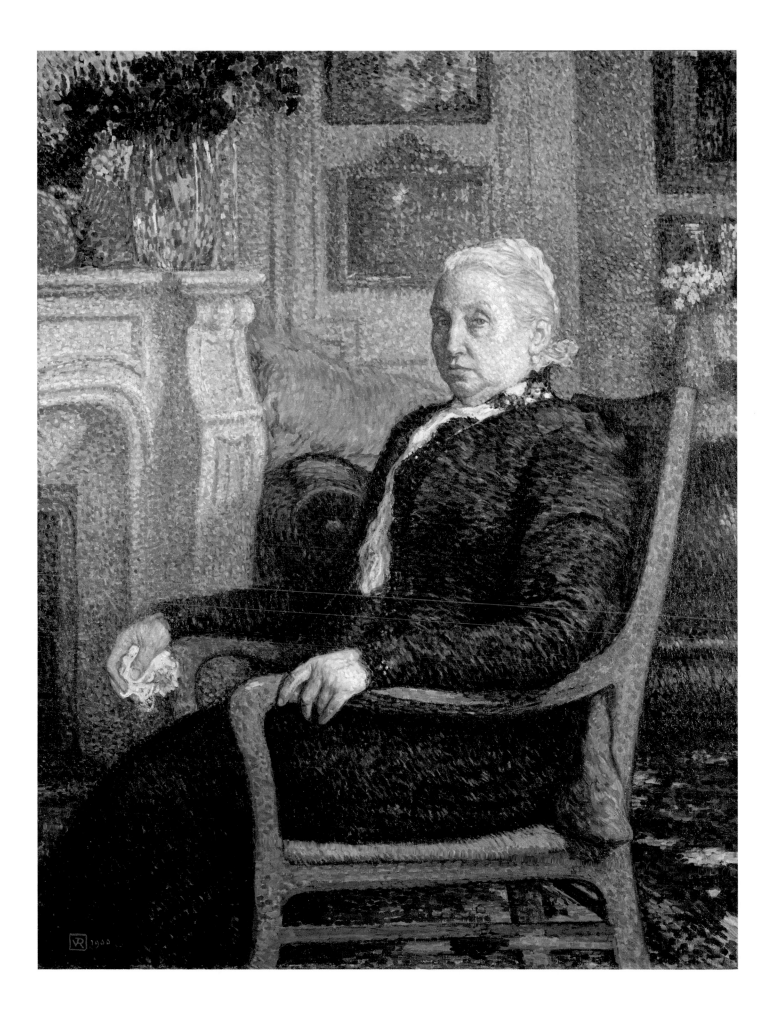

PLATE 58

Théo van Rysselberghe

Belgian, 1862–1926

Three Children in Blue (The Three Guinotte Girls)
(Les Trois enfants en bleu [Les Trois filles Guinotte]), 1901

Oil on canvas, 61 × 72⅞ in. (155 × 185 cm)
Monogrammed and dated lower left: 19VR01
Private collection

The subjects presented here were the daughters of Léon Guinotte (1879–1950), a member of a well-known family of wealthy Belgian industrialists who made their fortune in coal.[1] Guinotte's union with Louise van der Stichelen-Rogier produced nine children, among them the three daughters represented in this charming triple portrait. The artist met Guinotte through a friend, the poet Marie Closset (Jean Dominique, pseud.), who is featured prominently in *The Promenade* (see plate 59).

Prior to portraying these children, Théo van Rysselberghe had painted only a few children's portraits, most of them family members or children of friends. His first large-scale commission for a children's portrait-group, it was followed two years later by the depiction of Maria van de Velde and her three children, and the next year by another portrait of the three daughters of Thomas Braun.[2] Although the Guinotte children are clothed in identical dresses, bracelets, shoes, and sashes, Van Rysselberghe has individualized not only their features but their reactions to the ordeal of posing. Paule, left, separates herself in a willful gesture from her two sisters; Hélène, in the middle, shyly retreats behind her older sister; and Michette, in turn, graciously prepares herself to be portrayed by sitting forward in eager expectation. The girls sit on a long canapé with curved legs, and are supported by a bevy of cushions beside and behind them. Pushed to the corner of the room, the ensemble of figures and furnishings contrasts with the simple, rigid planes of the walls, moldings, windowsill, and framed artwork. The frilly blue dresses contrast with the orange brown of the wooden canapé. The girls' youth is echoed by the fresh cut flowers and the flowered motifs on the pillows. The entire composition exudes charm, balance, and elegance. Van Rysselberghe's Neo-Impressionism was now in the service of a graceful yet relaxed articulation of form and character.

The painting was a challenge for Van Rysselberghe. He first revealed the commission to Henry van de Velde on April 10, 1901: "I've been asked to do a series of portraits, not less than ten! There are some among them that interest me enormously: such as a group of young girls for which I hope to execute an accomplished and important canvas, and on which I have been working for three weeks."[3] Months later, Van Rysselberghe confessed to Marie Closset, "I had to begin over again for the third time the canvas of the little sisters. . . . This time, I have the right version. Listen to this: I cut out of the first canvas the figure of Paule (because it is so truly fine and in the personality of the little one and a good bit of painting) and I sewed it onto the third canvas, which is very close to the sketch." Yet he was pleased with the portrait: "In sum: the canvas, this time, appears beautiful, after all these hesitations and attempts. . . . I work on it with great pleasure. With me, who is always impulsive, this is the best self-control that I have felt for a long time. For quite awhile now painting has not been a picnic and it did not bode anything great, but this time, it's inspirational." He further confessed that although he was behind schedule in his promise to the Guinottes, he did not dare to commit to deliver the painting before January 15 (1902).[4] In December, Van Rysselberghe confirmed his progress on the portrait to Van de Velde: "It's a large canvas and very far along."[5]

Guinotte proved to be a good client and friend to Van Rysselberghe, who executed portraits of other family members even in the last decade of his own life.[6] In 1920–24, the artist prepared a series of decorative paintings for Guinotte's Château de Pachy, which had been designed by the artist's brother, the architect Octave. That project remained unfinished at the time of Théo's death.[7] JB

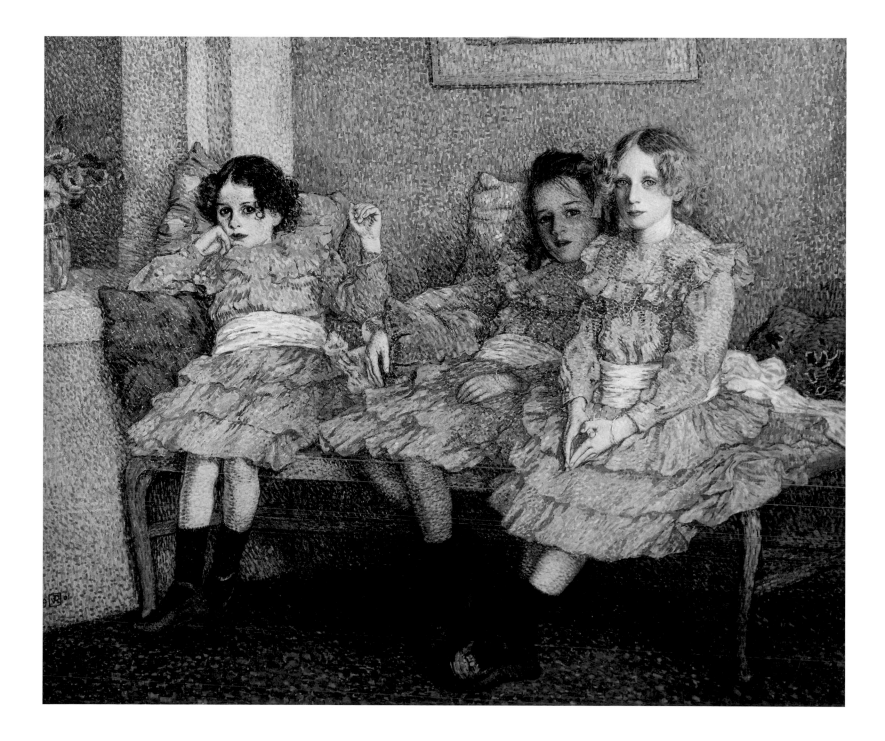

PROVENANCE: Léon Guinotte, Mariemont; private collection, Brussels; private collection, U.S.A.

EXHIBITIONS: La Libre Esthétique, Brussels, 1903, no. 312, as *Portraits de fillettes;* Exposition universelle et internationale, Ghent, 1913, no. 514; Galerie Giroux, Brussels, *Théo van Rysselberghe,* 1922, 7; Galerie Giroux, Brussels, *Théo van Rysselberghe,* 1927, 34, as *Les enfants en bleu;* La Salle MRO, Kanazawa, *Exposition Le Néo-Impressionnisme,* 1984, 47, as *Les trois filles en bleu.*

BIBLIOGRAPHY: Gustave van Zype, "Notice sur Théo van Rysselberghe," *Annuaire de l'Académie royale de Belgique* 98 (1932): 131; Paul Fierens, *Théo van Rysselberghe* (Brussels: Éditions de la Renaissance, 1937), fig. 18; Ronald Feltkamp, *Théo van Rysselberghe, 1862–1926* (Brussels: Éditions Racine, 2003), 84–87, 332–33.

1. Ginette Kurgan-van Hentenrijk, ed., *Dictionnaire des patrons en Belgique: Les hommes, les entreprises, les réseaux* (Brussels: De Boeck Université), 335–36.

2. See Feltkamp, *Théo van Rysselberghe,* 342 and 345.

3. "On m'a, en effet, demandé peindre toute une série de portraits—pas moins de dix! et il y en a parmi eux qui m'intérèssent énormément: tel un groupe de fillettes dont j'espère faire une toile mûrie et importante, et à laquelle je travaille depuis trois semaines." Van Rysselberghe to Van de Velde, Archives et Musée de la littérature, FSX 800/15, Bibliothèque royale de Belgique, Brussels.

4. "J'ai recommencé pour la troisième fois la toile des petites soeurs. . . . cette fois, je tiens la vraie version. Oyez: j'ai découpé, dans la toile no.1 la figure de Paule (parce que c'est vraiment bien dans le caractère de la petite et un bon morceau de peinture) et je l'ai fait coudre dans la toile no. 3, qui est de nouveau très pareille à l'esquisse. . . . En somme, la toile, cette fois, se présente bellement, après toutes ces hésitations et tous ces essais et. . . . j'y travaille avec grand plaisir. Chez moi, qui suis un impulsif, c'est le meilleur contrôle; aussi longtemps que je n'ai pas la sensation d'aller à mon chevalet comme à une partie de plaisir, ça ne promet rien de fameux—mais ce coup-ci, ça ronfle. . . . Le seul ennui, c'et que je suis très en retard. Je n'ose pas promettre qu'avant le 15 janvier je puisse livrer le tableau." Van Rysselberghe to Marie Closset, undated (in pencil marked number 8 [fall 1901]), Museum voor Schone Kunsten, Ghent.

5. "C'est une toile assez grande, et très poussée." Van Rysselberghe to Van de Velde, December 12, 1901, Archives et Musée de la littérature, FSX 800/19, Bibliothèque royale de Belgique, Brussels. The artist also executed an oil sketch for the finished painting and a double portrait of Hélène and Michette. See Feltkamp, *Théo van Rysselberghe,* 333.

6. These include the portraits of Françoise Guinotte, 1905; Louise Guinotte, 1921; and Léon Guinotte, 1923. For reproductions, see, respectively, Feltkamp, *Théo van Rysselberghe,* 351, 431, and 437.

7. For a discussion, see Block, "Théo van Rysselberghe and the Architecture of Decoration," 262.

PLATE 59

Théo van Rysselberghe

Belgian, 1862–1926

Young Women by the Sea, known as The Promenade (Jeunes femmes au bord de la mer, known as La Promenade),[1] 1901

Oil on canvas, 38¼ × 51⅛ in. (97 × 130 cm)
Monogrammed and dated lower right: 19VR01
Musées royaux des Beaux-Arts de Belgique, Brussels

Beginning in 1897 with *Sunset* (*L'Heure embrasée*), a large canvas of nude female bathers set in the south of France, Théo van Rysselberghe turned his attention to decorating large surfaces, often creating figural compositions for particular architectural spaces. This interest affected his portrait paintings. Now portraits of two, three, or even four individuals became more common than his single portraits.

The subjects of this painting, as well as the setting, had personal significance for the painter. Four women, composed of two pairings, walk into the wind on a beach. The woman closest to us clutches her hat from a gust of wind. At the same time she turns to acknowledge our presence by tipping her hat. She is the poet Marie Closset (1873–1952), who published her work under the pseudonym Jean Dominique. The figure next to Closset is most probably Mme Victor Willem, wife of a well-known scientist, who belonged to the inner intellectual and social circle of the group.[2] We can readily identify the two background figures: Laure Flé, an accomplished singer and pianist, closer to the viewer, and farther away, Van Rysselberghe's wife, sporting a jacket and hat without streamer. The site is the wide beach at Ambleteuse, France, where Georges and Laure Flé built Villa Robinson—a summer house designed for them in 1893 by their friend Louis Bonnier (1856–1946), an architect whose portrait the artist also painted.[3] Like the Willems, the Van Rysselberghes were often guests at the villa. In 1898 Van Rysselberghe painted a Neo-Impressionist portrait of Laure Flé and captured her face in a number of sketches.[4]

The painting's imagery holds an additional meaning: dunes, burning sun, and waves lapping at the shore are the very themes that appear in Closset's anthology of poems *Un goût de sel et d'amertume,* published in 1899.[5] Van Rysselberghe con-fided to Closset when working on this painting during a stay in Ambleteuse, "The women in white are progressing and the background becomes adorably opalescent, yes, perfectly. I say that my background is becoming exquisite—I am making the most of these last days of sunshine to push my canvases outside."[6]

The four figures create vertical punctuation marks to the horizontals that define the horizon, shore, and shadows. The two foreground figures are echoed by the striding pair in the background, their dresses and streamers similarly blowing in the breeze. Van Rysselberghe established a slow, liquid movement by this simple device, to which he seems to add the taste of saltwater and the sun's radiance. This movement contrasts with his single earlier portrait-group, *In July, Before Noon* (see plate 48) from 1890, where several female figures from Van Rysselberghe's inner circle sew peacefully in a garden. *The Promenade* is defined by a greater emphasis on drawing than in the decade of the 1890s, and his colors are typical of his later palette of blues, greens, pinks, and purples. His brushstroke has become larger, moving away from the point or dot, and he favors horizontal and parallel strokes, which assist in creating the sensation of movement.

An oil study for the painting shows only two figures: Closset and Maria van Rysselberghe. In the final composition, Closset is brought closer to the picture plane and made more palpable.[7] Marie-Jeanne Chartrain-Hebbelinck determined that despite the painting's inscribed date of 1901, it was not finished until 1903.[8] When it was first exhibited in Brussels at the Libre Esthétique exhibition of 1904, which was devoted to "Impressionism" broadly defined, it was promptly purchased by the Belgian government. JB

PROVENANCE: Purchased from the artist for the Musées royaux des Beaux-Arts de Belgique in March 1904.

EXHIBITIONS: Independents, Paris, 1903, no. 2183, as *Femmes au bord de la mer;* La Libre Esthétique, Brussels, 1904, no. 181, as *La Promenade;* Musées royaux des Beaux-Arts de Belgique, Brussels, *Portraits d'écrivains belges de langue française,* 1952, no. 23; Casino communal, Knokke, *L'Impressionnisme en Belgique avant 1914,* 1955, no. 51; Museum voor Schone Kunsten, Ghent, *Rétrospective Théo van Rysselberghe,* 1962, no. 83; Musée d'histoire et d'art, Luxembourg, *Théo van Rysselberghe, 1862–1926,* 1962, no. 33; Musées royaux des Beaux-Arts de Belgique, Brussels, *Evocation des "XX" et de "La Libre Esthétique,"* 1966, no. 36; Musées royaux des Beaux-Arts de Belgique, Brussels, *Regards et attitudes d'un siècle, Portrait et figures de Navez à Evenpoel,* 1967, no. 43; Musées royaux des Beaux-Arts de Belgique, Brussels, *Peintres belges lumière française,* 1969, no. 62; Musée de l'Orangerie, Paris, *L'Art flamand d'Ensor à Permeke,* 1970, no. 149; Musées royaux des Beaux-Arts de Belgique, Brussels, *La femme dans l'art,* 1975, no. 83; Kunsthalle, Düsseldorf, *Vom Licht zur Farbe Nachimpressionistische malerei zwischen 1886 und 1912,* 1977, no. 99; Brooklyn Museum, *Belgian Art, 1880–1914,* 1980, no. 91; Musées royaux des Beaux-Arts de Belgique, Brussels, *150 ans d'art belge,* 1980, no. 250; Musées royaux des Beaux-Arts de Belgique, Brussels, *Les XX et La Libre Esthétique cent ans après,* 1993, no. 76.

BIBLIOGRAPHY: Ergaste, "L'Impressionnisme à la Libre Esthétique," *Le Petit Bleu* (March 13, 1904); Henri Hymans, *Belgische Kunst des 19. Jahrhunderts* (Leipzig: Verlag von E. A. Seemann, 1906), 202; Albert Dreyfus, "Théo van Rysselberghe," *Die Kunst für Alle* 29 (September 1, 1914): 529; André Mabille de Poncheville, "Théo van Rysselberghe," *Gand Artistique* 1 (January 1926): 15; Gustave van Zype, "Notice sur Théo van Rysselberghe," *Annuaire de l'Académie royale de Belgique* 98 (1932): 132; François Maret, *Théo van Rysselberghe* (Antwerp: De Sikkel, 1948), frontispiece; Marie-Jeanne Chartrain-Hebbelinck, "Théo van Rysselberghe: Le groupe des XX et la Libre Esthétique," *Revue belge d'archéologie et d'histoire de l'art* 34 (1965): 123, 128; Jane Block, "Théo van Rysselberghe peintre aux multiples facettes: Génèse d'un portraitiste néo-impressionniste," *Théo van Rysselberghe, néo-impressionniste* (Antwerp: Pandora, 1993), 20, 119; Ronald Feltkamp, *Théo van Rysselberghe, 1862–1926* (Brussels: Éditions Racine, 2003), 334; Dominique Lobstein, "Théo van Rysselberghe et les salons parisiens," in *Théo van Rysselberghe* (Brussels: Fonds Mercator and Belgian Art Research Institute, 2006), 124.

1. Although it was traditionally titled *The Promenade,* Van Rysselberghe exhibited this work for the first time in 1903 as *Women by the Sea* (*Femmes au bord de la mer*). From Pascal de Sadeleer, who is in possession of Van Rysselberghe's personal list of his works with his final titles, we know that the work should be titled *Young Women by the Sea* (*Jeunes femmes au bord de la mer*), the title used here. The painting was affectionately and humorously referred to by the artist as "La Peacock-March" in a letter dated March 29 [1904]. My thanks to Ronald Feltkamp

for verifying the source of this letter as Archives de l'art contemporain, inv. 12011, Musées royaux des Beaux-Arts de Belgique, Brussels.

2. Yvonne Prévot Pelseneer, friend of the Van Rysselberghe and Flé families, identified the figure as Madame Willem in January 1987. Victor Willem (1866–1952) was a zoologist friend of biologist Jules Bonnier, the brother of architect Louis Bonnier, who directed the laboratory at Wimereux, just four miles south of Ambleteuse. Pelseneer's great uncle Paul was a scientist and colleague of Jules Bonnier's. Feltkamp, *Théo van Rysselberghe,* 88, has a different identification for two of the figures who formed part of the literary group around Jean Dominique, the Peacocks. The person next to Marie Closset he believes is author Blanche Rousseau, and the figure next to Maria van Rysselberghe is Marie Gaspar. Van Rysselberghe was adopted as an honorary member of the Peacocks.

3. In fact, Van Rysselberghe was drawn to the site in 1899 when he painted a sunset, *Soleil couchant à Ambleteuse.* For a color reproduction, see Hoozee and Lauwaert, *Théo van Rysselberghe, néo-impressionniste,* 114. For more on the villa and Van Rysselberghe's relationship to architects in his circle, see Block, "Théo van Rysselberghe and the Architecture of Decoration." Van Rysselberghe presumably met Bonnier when he was designing the Flé villa in 1893. Two years later Bonnier remodeled the Parisian gallery of Siegfried Bing, L'Art nouveau, for which Van Rysselberghe, Henry van de Velde, and Georges Lemmen supplied decoration for several of the rooms. This friendship was to lead to Bonnier's remodeling of Van Rysselberghe's Paris apartment in 1901 and to Van Rysselberghe's executing Bonnier's portrait in 1903. For a color reproduction, see Bernard Marrey, *Louis Bonnier, 1856–1946* (Liège: Pierre Mardaga, 1988), 23.

4. For a color reproduction, see Hoozee and Lauwaert, *Théo van Rysselberghe, néo-impressionniste,* 116.

5. One of the poems is dedicated to Van Rysselberghe's wife, Maria. Van Rysselberghe created the cover design and ornaments for Jean Dominique's book of poems, *L'ombre des roses* (Brussels: Édition du Cyclamen, 1901). For an illustration, see Adrienne and Luc Fontainas, *Théo van Rysselberghe: L'Ornement du livre* (Ghent: Pandora, 1997), 87.

6. "Les femmes en blanc 'marchent' et le fond devient adorablement opalin, oui, parfaitement. Je dis que mon fond deviant exquis—je profite des dernières journées de soleil pour pousser mes toiles de plein air." Théo van Rysselberghe to Marie Closset, whom the artist addresses tenderly as "Mieke peacock," undated, "dimanche Ambleteuse," Museum voor Schone Kunsten, Ghent. Van Rysselberghe was spending July to October 1901 at Ambleteuse while his apartment and studio were being readied in Paris, Villa Aublet, rue Laugier.

7. For a reproduction, see Jane Block, "Théo van Rysselberghe peintre aux multiples facettes: Génèse d'un portraitiste néo-impressionniste," in Hoozee and Lauwaert, *Théo van Rysselberghe, néo-impressionniste,* 19.

8. Van Rysselberghe confessed to Maus in 1903 that he was still working on the "petites femmes marchant sur la plage." Chartrain-Hebbelinck, "Les lettres de Van Rysselberghe à Octave Maus," 92.

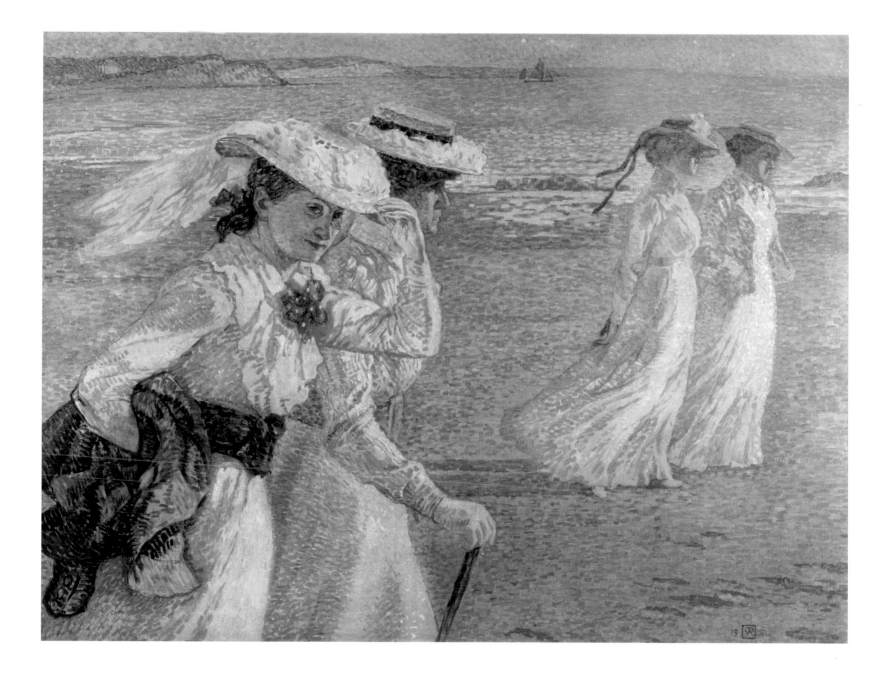

PLATE 60

Théo van Rysselberghe
Belgian, 1862–1926

A Reading (*Une Lecture*), 1903

Oil on canvas, 71¼ × 94½ in. (181 × 240 cm)
Monogrammed and dated lower right: 19VR03
Dated on stretcher: 19 mai 1903
Museum voor Schone Kunsten, Ghent

Painted fifteen years after his first Neo-Impressionist works, *A Reading* stands alone among Théo van Rysselberghe's portraits in terms of its scale, ambition, and complexity.[1] It is also among his very last pointillist portraits, thus serving as a fitting climax to the series. A group portrait depicting seven friends gathered to hear the poet Émile Verhaeren reading from his latest work, it demonstrates the close ties between Paris and Brussels and the integral relationship between literature and the arts.[2] The listeners seated clockwise around the table are Verhaeren (in orange jacket), Félix Le Dantec, Francis Vielé-Griffin, André Gide, Maurice Maeterlinck, and Henri-Edmond Cross; behind them stand Félix Fénéon and Henri Ghéon.[3] The aesthetic setting for the reading in progress is Verhaeren's study at Saint-Cloud, with filled bookstand and bookcase partially revealed behind a curtain, Auguste Rodin's *Femme assise sur un rocher,* George Minne's *Le Petit agenouillé,* and a photograph in a pointillist frame of James A. M. Whistler's *Portrait of Thomas Carlyle* (1872–73).[4]

Although the eight men were well acquainted, so absorbed are they in the overriding magnetism of Verhaeren's dramatic recitation that they barely acknowledge each other's presence. Van Rysselberghe has given a separate space to each participant, who responds to Verhaeren in a slightly different manner. While carefully portraying the physiognomies of each (except for Cross), Van Rysselberghe has arranged them into a single group dynamic, with Verhaeren as the fulcrum around which the close-knit relationships of the group are balanced.

As he reads aloud, Verhaeren is singled out both by the gesture of his outstretched arm and by his dress. His orange-red jacket provides a complementary contrast to the others' blue suits. His dramatic right hand begins a movement of orchestrated hands and heads that circles from Verhaeren to the meditative Cross; to Maeterlinck's anxious tug on his lapel; to Ghéon, dreamily leaning over Gide; to Gide, seemingly lost in thought; to Fénéon, who ponders best, it seems, with cigarette in hand; to front-facing Vielé-Griffin, whose hands are hidden; and finally to Le Dantec, whose gesture serves as a counterpart to Gide's across the table, hand supporting inclined head.

Although the painting is dated 1903, it appears that it had a longer genesis. In early 1900, Van Rysselberghe suggested the idea for such a composition to Vielé-Griffin.[5] In December 1902 Van Rysselberghe wrote to Paul Signac of what was now a concrete project: "Upon my return, I will attack the Verhaeren group."[6] Four months later he reported to publisher Edmond Deman, "I've just begun a canvas that will be important—at least considerable by the amount of work that it will demand: a reading by Verhaeren. Le petit vieux [the little old one, his nickname for Verhaeren] jacketed in red, his eloquent hand toward the middle of the painting, reading a work to a half-dozen friends: Gide, Le Dantec, Fénéon, Ghéon, etc."[7] As was Van Rysselberghe's custom, he began with a number of drawings and oils to prepare for the large painting. These include four portrait drawings in the Ghent Museum voor Schone Kunsten of Fénéon, Ghéon, Maeterlinck, and Vielé-Griffin.[8] None of these studies was executed in a pointillist style.

Verhaeren reported to his wife in May 1903 that he was posing for the work, and that Henri de Régnier, not having the time to sit, would not be included in the portrait.[9] On June 6, Gide announced his imminent arrival at Van Rysselberghe's atelier ready to pose.[10] The work was far enough along for the painter Jacques-Émile Blanche to comment to Gide on June 11, "The canvas of Rysselberghe will be very interesting."[11] Following a pause of six months, Van Rysselberghe informed Gide that he hoped he would be able to finish the painting by the end of January because "Dantec and Vielé-Griffin will be able to pose during this time."[12] Undoubtedly, Van Rysselberghe was in haste to ready the work for the upcoming Libre Esthétique of 1904.[13]

By the time Van Rysselberghe finished the canvas, his art was beginning to respond to recent developments beyond the methods rooted in Neo-Impressionism. The saturated

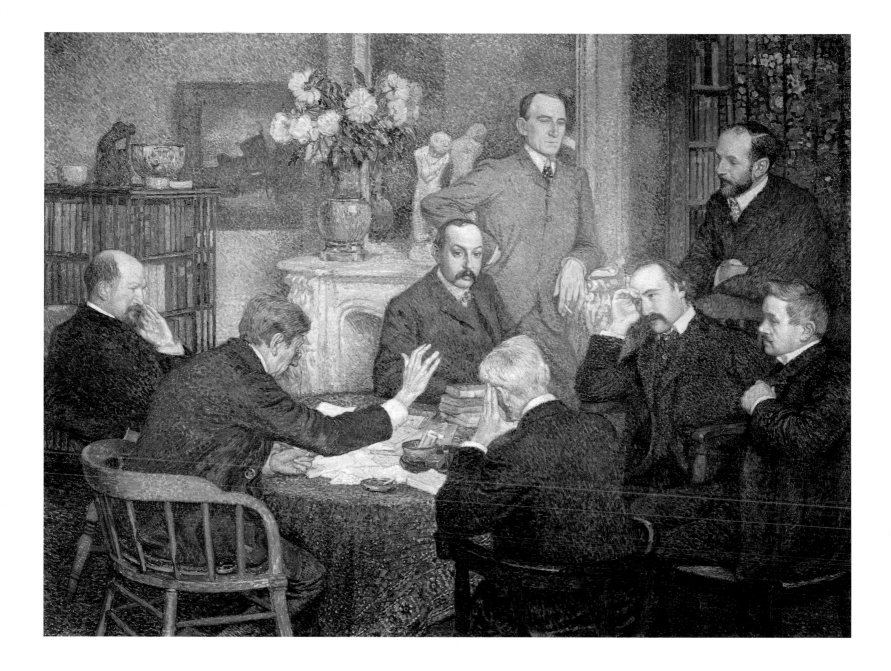

orange-red of Verhaeren's jacket and his more visible brush-strokes seem to have more in common with Henri Matisse than with Seurat. Yet the color system of this large work is harmonized in a manner that is foreign to the Fauves.

Van Rysselberghe characteristically denied that the painting was anything more than "simply the friends of Verhaeren (simplement des amis de Verhaeren)."[14] Yet, without explicit iconographic meaning, *A Reading* provides a deeply moving glimpse of "les amis de Verhaeren" in all their intellectual variety. It serves to document the associates close to Verhaeren and Van Rysselberghe; by implication, it also indicates the strong universal appeal of Verhaeren's work to men of science (represented by Le Dantec); literature (represented by both Verhaeren's generation through Maeterlinck and by the next as well, with the presence of Gide, fourteen years his junior); and to artists (represented by Cross). Finally, Van Rysselberghe has revealed the fraternity of men, united and spellbound by the spark of creativity represented by the reading of Verhaeren's poetry and made palpable through his electrifying gesture.

Immediately hailed as an important work by an acclaimed painter in his prime, *A Reading* was purchased from the artist by the Ghent Museum voor Schone Kunsten, the primary artistic institution in his native city, two years after it was first exhibited. JB

PROVENANCE: Purchased at the Ghent Salon of 1906 by the Museum voor Schone Kunsten, Ghent.

EXHIBITIONS: La Libre Esthétique, Brussels, 1904, no. 180; Salon de Gand, Ghent, 1906, no. 489; *Settima Esposizione internazionale d'Arte della Città di Venezia*, Venice, 1907, no. 56; Galerie Giroux, Brussels, *Théo van Rysselberghe*, 1922, no. 11; Galerie Giroux, Brussels, *Théo van Rysselberghe: Exposition d'ensemble*, 1927, no. 35; Musée d'art moderne, Brussels, *Portraits d'écrivains belges de langue française*, 1952, no. 134; Palais des Beaux-Arts, Brussels, *Le Mouvement symboliste*, 1957, no. 827; Musée national d'art moderne, Paris, *Les sources du XXᵉ siècle*, 1960, no. 591; Museum voor Schone Kunsten, Ghent, *Rétrospective Théo van Rysselberghe*, 1962, no. 87; Arts Council, London, *Autour de 1900: L'Art belge (1884–1918)*, 1965, no. 66; Musée de l'Orangerie, Paris, *L'art flamand d'Ensor à Permeke*, 1970, no. 150; Museum voor Schone Kunsten, Ghent, *1000 jaar Kunst en Cultuur*, 1975, no. 157; Städtische Kunsthalle, Düsseldorf, *Vom Licht zur Farbe, Nachimpressionistische Malerei zwischen 1886 und 1912*, 1977, no. 100; Brooklyn Museum, *Belgian Art, 1880–1914*, 1980, no. 92; Palais des Beaux-Arts, Brussels, *Art nouveau Belgique*, 1980, no. 519; Museum voor Schone Kunsten, Ghent, *Théo van Rysselberghe, néo-impressionniste*, 1993, no. 62; Grand Palais, Paris, *Paris-Bruxelles, Bruxelles-Paris*, 1997, no. 151; Museum voor Schone Kunsten, Ghent, *De Vrienden van Scribe de Europese smaak van een Gents Mecenas*, 1998, 122; Museum voor Schone Kunsten, Ghent, *Art in Exile: Flanders, Wales, and the First World War*, 2002, no. 5; Musée de Lodève, *D'Ensor à Magritte dans les collections du Musée de Gand*, 2004, no. 10; Palais des Beaux-Arts, Brussels, *Ensor à Bosch: Les prémices de la vlaamsekunstcollectie*, 2005, 128, 155; Museum voor Schone Kunsten, Ghent, *L'univers de George Minne and Maurice Maeterlinck*, 2011, 135.

BIBLIOGRAPHY: Gustave van Zype, "Notice sur Théo van Rysselberghe," *Annuaire de l'Académie royale de Belgique* 98 (1932): 126, 131; Paul Fierens, *Théo van Rysselberghe* (Brussels: Éditions de la Connaissance, 1937), 26–27, ill. 19; François Maret, *Théo van Rysselberghe* (Antwerp: De Sikkel, 1948), ill. 15; Marie-Jeanne Chartrain-Hebbelinck, "L'évolution de Théo van Rysselberghe à travers les salons des XX et de la Libre Esthétique," *Les Beaux-Arts* (June 29, 1962), 1–3; Serge Goyens de Heusch, *L'Impressionnisme et le fauvisme en Belgique* (Antwerp: Fonds Mercator and the Belgian Art Research Institute, 1988), 202–3; Jane Block, "Twee sleutelwerken van Théo Van Rysselberghe, De lezing," in *200 Jaar verzamelen:*

Collectieboek Museum voor Schone Kunsten, ed. Arnout Balis et al. (Ghent: Ludion, 2000): 198–201; Ronald Feltkamp, *Théo van Rysselberghe, 1862–1926* (Brussels: Éditions Racine, 2003), 341–2; Véronique Jago-Antoine, "Théo van Rysselberghe et Émile Verhaeren: Cadrage sur une 'fraternité d'Art,'" in *Théo van Rysselberghe,* ed. Olivier Bertrand (Brussels: Fonds Mercator and the Belgian Art Research Institute, 2006), 76–97; Jane Block, "Théo van Rysselberghe," in *Nouvelle biographie nationale,* vol. 11 (Brussels: Académie Royale des sciences, des lettres et des Beaux-Arts de Belgique, 2011), 363–66, ill. 15; Johan De Smet and Cathérine Verleysen, *Dossier Théo van Rysselberghe* (Ghent: Museum voor Schone Kunsten, 2012), 2–3.

1. The painting was first exhibited in 1904, to favorable reviews, at the retrospective exhibition on the Impressionists held at the Libre Esthétique as *Une Lecture (A Reading).* This title is used throughout the catalogue, as it most closely reflects Van Rysselberghe's original intent. Already in *Gand Artistique,* January 1, 1923, 7, it was reproduced as *La Lecture (The Reading)* and subsequently known by this title. The catalogue raisonné by Ronald Feltkamp correctly refers to the painting as *Une Lecture,* as does the catalogue for the Van Rysselberghe exhibition held at the Palais des Beaux-Arts, Brussels in 2006. The title *A Reading* suggests that this was a typical gathering for Verhaeren and friends, whereas *The Reading* denotes that this is an official formal assembly.

2. For a discussion of group portraits, see Alain Bonnet, *Artistes en Groupe: La représentation de la communauté des artistes dans la peinture du XIX^e siècle* (Rennes: Presses Universitaires de Rennes, 2007), and Bridget Alsdorf, *Fellow Men: Fantin-Latour and the Problem of the Group in Nineteenth-Century French Painting* (Princeton: Princeton University Press, 2013). Neither author mentions *A Reading.*

3. Their dates and professions are as follows: Le Dantec (1869–1917), biologist; Vielé-Griffin (1864–1937), writer; Fénéon (1861–1944), art critic; Ghéon (1875–1944), medical doctor turned writer; Gide (1869–1951), writer; Cross (1856–1910), painter; Maeterlinck (1862–1949), lawyer turned writer; and, of course, Verhaeren (1855–1916), lawyer turned writer.

4. Van Rysselberghe wrote to Paul Signac (October 4, 1899) that Whistler had sent him an admirable photograph of the Carlyle portrait; Signac Archive, Paris. See also Fabrice van de Kerckhove, "Émile Verhaeren, collectionneur," 169, in *Émile Verhaeren, un musée imaginaire* (Paris: Réunion des musées nationaux, 1997). A small sculpture sits atop the bookcase above Le Dantec's head. Although it has been published as Constantin Meunier's *Le Petit Blessé* by Claudie de Guillebon ["Une oeuvre dévoilée," 58, in *Musées 2000* (Ghent: Museum voor Schone Kunsten)], it has more convincingly been identified by Anne Pingeot, curator emerita of sculpture, Musée d'Orsay, Paris, as Auguste Rodin's *Femme assise sur un rocher* (Musée de Lyon, terra cotta); letter to the author, June 12, 1997. Antoinette Le Normand-Romain identifies in *A Reading* a "small bronze of Rodin" ("un petit bronze de Rodin") in her essay "Les Amis belges," in *Vers l'âge d'airain: Rodin en Belgique* (Paris: Musée Rodin, 1997), 349n108. It is known that Maria van Rysselberghe owned a bronze by Rodin, *Étude,* shown at Les XX in 1890, but it is not the sculpture seen here.

5. In early 1900 Van Rysselberghe wrote to Vielé-Griffin: "I am already thinking of working on a painting of the good poets." Cited in Eeckhout, *Rétrospective Théo van Rysselberghe,* 44.

6. Van Rysselberghe to Signac, December 29, 1902, Signac Archive, Paris.

7. Van Rysselberghe to Deman, Private collection, Brussels, April 3, 1903.

8. For illustrations, see Hoozee and Lauwaert, *Théo van Rysselberghe, néo impressionniste,* 157–58.

9. The relevant portion of the letter is cited in Eeckhout, *Rétrospective Théo van Rysselberghe,* 45.

10. Cited in *Présence d'André Gide* (Brussels: Bibliothèque royale de Belgique, 1970), 54.

11. Jacques-Émile Blanche, *Nouvelles Lettres à André Gide, 1891–1925,* ed. Georges-Paul Collet (Geneva: Librairie Droz, 1982), 65.

12. Van Rysselberghe to Gide, December 28, 1903, cited in *Présence d'André Gide,* 54.

13. Van Rysselberghe was working on the painting up to the last minute, for he informed Octave Maus he would bring the painting with him to Brussels on "the 21st, in the morning." The Libre Esthétique opened four days later, on February 25. See Chartrain-Hebbelinck, "Lettres de Van Rysselberghe à Octave Maus," 99.

14. Van Rysselberghe to Vielé-Griffin, March 28, 1902, Manuscripts, II.7066C, Bibliothèque royale de Belgique, Brussels.

Artist Biographies

Henri-Edmond Cross
1856–1910

Henri Edmond Joseph Delacroix was born in Douai, in northern France. In 1883, on the advice of his teacher, François Bonvin, he adopted the English translation of his surname to avoid confusion with the celebrated Romantic painter Henri Eugène Delacroix. At the age of ten, Cross took drawing lessons from portraitist Émile Carolus-Duran in Lille, and in 1874 he enrolled in the École des Beaux-Arts there, studying with Alphonse Colas.

The young painter gravitated to Paris by 1879. He gradually abandoned the more conservative exhibition groups, and in 1884 he participated in the creation of the Independents, where he met future Neo-Impressionists Georges Seurat, Paul Signac, Charles Angrand, and Albert Dubois-Pillet. He became increasingly engaged by outdoor painting and created landscapes reflecting his interest in luminous effects.

In spite of his familiarity and friendship with the Neo-Impressionists, Cross did not take up their methods until 1891. His debut was dramatic, announced by the submission of an ambitious portrait of his future wife, Irma Clare France, at the Independents—the same exhibition where Signac first presented his dazzling portrait of Félix Fénéon. In the fall of 1891 Cross moved permanently to the Mediterranean coast, seeking relief for his chronic rheumatism as well as the brilliant color and light he favored as a painter. He rented a house in the tiny town of Cabasson, on the western rim of the Mediterranean, before building a home in nearby Saint-Clair in 1893. From this locale Cross created a series of luminous Neo-Impressionist landscapes, characterized by vibrant color and a highly regular pointillist brushstroke. In 1892, Signac, at the helm of his sailboat, the *Olympia,* arrived in the area and acquired a villa in Saint-Tropez. At this point, the energy of the French Neo-Impressionist movement had effectively shifted to the Mediterranean coast, though all the artists who lived or visited there continued to see Paris as the center of their exhibition activity. Cross was also invited to exhibit with Les XX in Brussels in 1889 and 1893, and with its successor, La Libre Esthétique, in 1895 and 1897.

By 1893, Cross's landscapes were showing his interest in the decorative forms of art nouveau. Painting together, he and Signac increasingly tailored the Neo-Impressionist methods to accommodate their individual aspirations, intensifying color and adopting a larger, more rectangular brushstroke. Both artists expressed their utopian leanings through idyllic images of man and nature in harmony. Highly well read, Cross was at home in literary milieus and conversant with the Symbolist works of authors in France and Belgium. He was the only painter included in Théo van Rysselberghe's group portrait of a literary gathering, *A Reading* (*Une Lecture,* plate 60).

In the early twentieth century Signac and Cross also welcomed to their homes a new generation of painters eager to study their bold experiments with color. Their example inspired artists such as Henri Matisse, Louis Valtat, Henri Manguin, and Charles Camoin to explore the expressive use of color that gave rise to the Fauve movement. During this period Cross also demonstrated his aptitude for watercolor, creating numerous vibrant and limpid works on paper. In 1907, the artist had his last one-man show at Galerie Bernheim in Paris. He died in Saint-Clair in 1910. **EWL**

Henri Delavallée
1862–1943

The career of Henri Delavallée is an intriguing blend of academic training, accomplished printmaking, and firsthand exposure to the tenets of the Pont-Aven School and Neo-Impressionism. Born in Rheims, the artist was a brilliant young student who entered the Sorbonne and the École des Beaux-Arts simultaneously at age seventeen. He studied with Ernest Hébert, Henri Lehmann, and Luc-Olivier Merson, all representatives of traditional academic practice. He also admired Camille Corot and Jean-François Millet and was attracted to their pastoral subjects.

Through a family friend, Delavallée was introduced to Brittany in the early 1880s, reportedly meeting Paul Gauguin there in 1886. In 1887 he came into contact with Georges Seurat, Paul Signac, and Camille Pissarro. That year he painted frequently in the village of Marlotte, near Barbizon, though citations of his working there with Pissarro have not been substantiated. From 1887 through 1890, Delavallée produced several Neo-Impressionist paintings, often featuring Breton subjects. Beyond the occasional use of Synthetist surface pattern and vibrant color, however, his works showed little allegiance to the Pont-Aven School aesthetic. After 1890 Delavallée assumed a more relaxed approach to his brushwork, painting gentle landscapes with the bright colors of Impressionism.

In 1888 Delavallée took up printmaking, creating exquisitely refined etchings that showed his mastery of several techniques. Again, the delicate works reflect little Pont-Aven School influence beyond a tendency to treat trees with the flat, sweeping forms often found in the prints of his colleagues Roderic O'Conor and Armand Séguin. His engravings were the subject of a successful exhibition at the Galerie Durand-Ruel in Paris in 1890.

In the 1890s, Delavallée moved to Constantinople, where he became a favored artist of Turkish officials. A friend of the pioneering French cinematographers the Lumière brothers, Delavallée introduced their work to Turkey. He returned to France in 1901 and spent much of his time at his home in Pont-Aven, where he died in 1943.

The Galerie Saluden in Quimper devoted a retrospective to his work in 1941. Delavallée was married to a painter, Gabrielle Moreau, whom he met during his student days at the École des Beaux-Arts. **EWL**

Albert Dubois-Pillet
1846–1890

Louis-August-Albert Dubois was born in Paris and grew up in Toulouse. A self-taught artist, he attended the French military academy of Saint-Cyr rather than the École des Beaux-Arts. He served in the Franco-Prussian war and was

named a captain in the Garde Républicaine in 1879. By this time the artist had begun exhibiting works at the official Salon in Paris, though his 1880 submission was refused, no doubt encouraging his turn to nonjuried exhibitions.

In 1884 he met Georges Seurat, Paul Signac, and Charles Angrand through the newly founded Independents. In artistic circles, he added Pillet, his mother's maiden name, in order to separate his activities as an artist from those of his military career. Dubois-Pillet was a true leader within the society, writing its statutes and using his Freemason contacts to help the group negotiate exhibition opportunities. In fall 1886 the critic Émile Verhaeren linked him with Seurat, calling both artists "*intéressants oseurs*" (interesting darers). Dubois-Pillet was the first of the Neo-Impressionists to apply the movement's methods to portraiture, exhibiting some examples at the Independents of 1887. He took the study of Neo-Impressionism so seriously that he experimented with a complicated additional theory, called passages, dealing with how retinal nerves respond to various colors. He also painted still lifes and landscapes of Paris.

Displeased with the young captain's close associations with the avant-garde Independents, Dubois-Pillet's military superiors warned him to cease artistic activities. He chose a lower profile within the group but continued painting. In July 1887, the Garde Républicaine's order to reduce their ranks was used as the premise to demobilize the career soldier. In 1888 Dubois-Pillet had his first one-person show at the offices of *La Revue indépendante,* and in 1888 and 1890 he was invited to exhibit with Les XX, the progressive artist's group in Brussels.

In 1888 Dubois-Pillet's past service seems to have earned him a reinstatement in the military. In October 1889 the artist was ordered to Le Puy-en-Velay, in southern France, where he was promoted to major and put in charge of the gendarmerie of the Haute-Loire. Dubois-Pillet quickly endeared himself to the people of the town and began painting landscapes of the region. In the spring of 1890 he was the featured artist on the cover of *Les Hommes d'aujourd'hui,* a periodical that devoted several issues to the leading Neo-Impressionists. Just a few months later, in August 1890, Dubois-Pillet contracted smallpox and died suddenly. At the funeral in Le Puy-en-Velay, his commanding officer spoke of Dubois-Pillet's kindness and sense of duty, and at his burial in Paris a fellow artist praised his ability to combine military service with devotion to the arts. At the next exhibition of the Independents in 1891, Dubois-Pillet was honored with a retrospective of sixty-four works. **EWL**

William Jelley
1856–1932

William Jelley remains a relatively obscure artist both within and outside of his native Belgium. He enrolled at the Royal Academy of Fine Arts in Brussels in 1883, studying under Jean Portaels, where he signed his works with either his Belgian first name, Guillaume, or that of his English grandfather, William. To pay his bills, Jelley worked as a functionary for the ministry of railroads. Recognizing his talent, his colleagues provided Jelley with a basement studio where he could peacefully create oils and watercolors in his spare time. Attracted to Neo-Impressionism around 1890, he later became associated with the Belgian Fauvists, such as Auguste Oleffe, Rodolphe Strebelle, and Fernand Schirren. For a few years around 1900, Jelley dabbled in architecture, perhaps encouraged by his brother-in-law, architect Édouard Elle. In the suburb of Watermael-Boitsfort in 1898–99, Jelley constructed a handful of picturesque country villas with art nouveau decoration.

Jelley is best remembered today as a key player in several exhibition societies independent from the state-sponsored Salon. Among them was L'Effort, founded in 1890, which brought together painters in the late evening hours to share models and work in a bohemian atmosphere. Members included Léon Frédéric, Fernand Khnopff, and Xavier Mellery. Two years later, Jelley established Pour l'art, which attracted such Belgian Symbolists as Albert Ciamberlani, Jean Delville, and Émile Fabry. In 1903, Jelley and his associates from L'Effort founded Les Indépendants, whose goal was to secure space to exhibit their works.[1] Finally, during World War I, he founded Le Labor; was part of the executive committee that sponsored a burlesque art show, the Great Zwans Exhibition of 1914; and continued to paint in a generic Post-Impressionist manner.[2] **JB**

Achille Laugé
1861–1944

Born on April 29, 1861, in Arzens, a small village in the Aude department near Carcassonne, Achille Laugé spent his childhood in a rural setting. After training in Toulouse, where he met Antoine Bourdelle and Henri Martin, he, like them, went to Paris to pursue his studies at the École des Beaux-Arts. He developed a friendship with Aristide Maillol, with whom he shared a studio. Combining their meager resources, they worked side by side for three years, both equally dissatisfied with the education they were

receiving at the École des Beaux-Arts. In their tireless explorations of galleries and exhibition spaces they discovered the Impressionists and, later, at the Independents, they viewed the early works of Georges Seurat and his disciples. The young men engaged in animated discussions on this new approach to painting. In 1888, Laugé returned to the Aude; he never left his native soil again except for brief journeys.

Laugé's independent thinking allowed him to ignore the expectations customarily imposed on painters. He rejected academic dogma and borrowed very selectively from contemporary artistic trends. He remained indifferent to Symbolism. Impressionism intrigued him, but the style did not dominate his work; its ephemeral plays of light seemed to have no real place in this austere landscape, sculpted by brilliant light that abruptly delineated forms, transforming them into geometric shapes.

It was in the 1890s that he adopted Seurat's Divisionism. In the isolation of this remote province he painted canvases that are among the greatest masterpieces of the Neo-Impressionist movement. Laugé re-created and interpreted the style independently and with profound originality. He was not simply a follower of Seurat or Signac; he had the opportunity to play that role but chose another path. Cutting himself off from the capital and its artistic life and remote from avant-garde circles, he shunned the pursuit of fame. He turned his back on public honors and official recognition and soon ceased to participate in the Paris Salon. He developed an artistic approach that was sensitive and personal. Studying Seurat's ideas, he found the answer to his quest for precision, rigor, and clarity, exalting color and simplifying forms. Deaf to critical opinion, he methodically performed his own apprenticeship in a technique that was widely considered to be difficult and unrewarding. He adapted the divisionist technique, rejecting its systematic aspects and softening its brushstrokes while remaining true to the division of color. Few artists have demonstrated such tenacity. While he remained a landscape painter, Laugé was also a successful portraitist and still-life artist, an unusual achievement. His portraits are of friends and family, his fruits and flowers are from his own garden, and his landscapes are the vistas that surrounded his home. He painted the intensity and the softness of light with gravity and simplicity. His works, free of picturesque sentimentality, offer a novel combination of freshness, delicacy, and substance. **NT**

Georges Lemmen
1865–1916

Georges Lemmen, the son of a Brussels archi-
tect, briefly attended the Academy of Fine Arts
at Saint-Josse-ten-Noode. His submissions to
the independent art society L'Essor in Brussels
from 1883–86 show his keen interest in the art of
James Ensor and Fernand Khnopff. In 1888,
Lemmen was elected to membership in Les XX,
and the next year he showed works inspired by
Edgar Degas and Henri de Toulouse-Lautrec. A
faithful member of Les XX, he exhibited annually
from 1889 to 1893 and displayed his work often
with Les XX's successor, La Libre Esthétique,
between 1894 and 1912. Lemmen came under the
influence of Georges Seurat, whose work was
shown four times at Les XX, and became the last
important Belgian convert to Neo-Impression-
ism, producing major work between 1890 and
1895. He also exhibited in Paris with the Inde-
pendents from 1889 to 1892 and between 1901
and 1908.

During his Neo-Impressionist years
Lemmen, like so many of his friends and col-
leagues, turned to the decorative arts, designing
rugs, ornamentation for books and exhibition
catalogues, posters, wallpaper, and endpapers.
Influenced by his colleague Willy Finch, Lemmen
praised the English artist Walter Crane in L'Art
moderne in 1891. He traveled to England in 1892
with Finch, and again in 1894. His cover for the
Les XX catalogue of 1891, the embodiment of the
art nouveau style, features an energetic sun ris-
ing from a sea of undulating lines, symbolizing
Belgium's creative renaissance. Beginning in
1894, Lemmen provided posters and advertise-
ments for Edmond Picard's Société anonyme
l'art, which provided an exhibition gallery and
sales venue for the decorative arts in Brussels.[3]
The following year Lemmen worked with Henry
van de Velde on the smoking room (fumoir) for
Siegfried Bing's Paris gallery, L'Art nouveau,
designing the stained glass, glass mosaic, sten-
ciled frieze, and a rug. Again, Lemmen supplied
the gallery's graphics, including invitations,
numerous advertisements, stationery, and end-
papers. The culmination of his achievement in
the book arts was a new typeface for the deluxe
edition (which Van de Velde designed for Count
Harry Kessler) of Friedrich Nietzsche's Also
sprach Zarathustra (Leipzig: Insel Verlag, 1908).

After his Neo-Impressionist period Lemmen
continued to draw and paint, concentrating on
still lifes, intimiste family scenes, and nudes,
reflecting the influence of Nabi painters Édouard
Vuillard and Pierre Bonnard. Particularly touch-
ing is Lemmen's sensitive rendering of children,
incorporating vibrant colors and textures.
During the years 1907 to 1912 the artist was
often depressed about the poor sale of his works.
Following one-man exhibitions at the Galerie
Druet, Paris (1906 and 1908), his 1913 show at the
Galerie Georges Giroux, Brussels, was his most
successful venture, allowing him to design and
build a house in 1913–14, which he occupied in
1915. Alas, he died the next year at age fifty. JB

Maximilien Luce
1858–1941

Maximilien Luce was born and educated in
Paris. As a youth he witnessed the atrocities of
the Commune after the Franco-Prussian war, an
event that colored his political views for the rest
of his life. In 1872 he began an apprenticeship
with wood engraver Henri-Théophile Hildibrand
and studied drawing in night classes with several
teachers. In 1876 Luce entered the print shop of
Eugène Froment, where he made illustrations for
various journals and met Léo Gausson and Émile
Cavallo-Péduzzi, future associates during the
Neo-Impressionist era. In the course of the next
decade, Luce completed his military service,
worked intermittently as a printmaker, and
studied with Émile Carolus-Duran. He also dis-
covered the early work of Seurat and his followers.
By 1887, Luce had adopted Neo-Impressionist
methods, and at the Independents that year he
met the leaders of the movement. A new colleague,
Paul Signac, purchased one of his divisionist sub-
missions. Luce was an active participant in the
Independents for the rest of his life.

Luce made his first signed political drawing
in 1887, reproduced in La Vie moderne. While
many of the Neo-Impressionists had socialist
and anarchist tendencies, Luce was the one who
created the most overtly political art, contribut-
ing numerous illustrations to the journals he
supported over the years. In 1889, Luce was busy
providing drawings for the anarchist journal Le
Père Peinard, yet during the summer he retreated
to the countryside near Herblay and painted
lyrical Neo-Impressionist landscapes with
Signac. Luce also favored views of Paris, especially
those that highlighted the activities of laborers.
In 1890 he was one of the Neo-Impressionists
profiled by Les Hommes d'aujourd'hui. It was
Signac who drew his likeness for the cover—a
profile view of Luce reading La Révolte, an anar-
chist journal.

In the early 1890s, Paris was wracked by
terrorism, and after the assassination of French
president Sadi-Carnot in 1894, Luce was one of
several anarchist sympathizers who were impris-
oned. After an outcry by his friends, Luce was
released from Mazas prison after six weeks of
incarceration. An invitation to exhibit with La
Libre Esthétique in Brussels the following year
provided an excellent occasion to depart France
for a period. In 1895, Luce made the first of sev-
eral visits to Belgium's mining district, the infa-
mous "Black Country," where the working
conditions whetted his concern for industrial
laborers. He made numerous paintings of this
dramatic land—works that reveal a freer, more
personal approach to Neo-Impressionism.
Luce's canvases showed a looser, larger brush-
stroke and a color scheme not cast by the sys-
tematic division of hues. As Luce wrote to Cross
in 1895, "As for color . . . I follow my instinct."

During the early twentieth century Luce
continued to work productively, painting land-
scapes, urban scenes, and historical images in a
generally Impressionist style. In 1917 he discov-
ered the town of Rolleboise and began spending
time there as well as in Paris. He was featured in
numerous one-man shows. In 1940 Luce mar-
ried Ambroisine Marie Eugénie Bouin, the
mother of his children, whom he had known
since 1893. She died that year, followed by Luce
in 1941. In 1942 the Independents honored him
with a memorial exhibition. EWL

George Morren
1868–1941

George Morren was born into a well-to-do Bel-
gian family in Ekeren, now a suburb of Antwerp,
allowing him to devote himself to his art. He
began his studies in 1888 at the Royal Academy
of Fine Arts in Antwerp, where he was enrolled
for two years. Through his mentor, Émile Claus,
the young artist met Henry van de Velde, who
had joined Les XX in 1888 and who was eager to
introduce Morren to the avant-garde artists in
Brussels. Van de Velde, who became a Neo-
Impressionist follower of Georges Seurat in late
1888, exerted a strong influence on Morren, who
developed his own Neo-Impressionist technique
in the summer of 1890 and remained devoted to
the movement until the spring of 1892.

In addition to exhibiting annually at Les XX,
Morren attended the Independents shows in
Paris. During prolonged stays there in 1892 and
1893 he studied in the ateliers of Alfred Roll,
Pierre Puvis de Chavannes, and Eugène Carrière.
Returning to Antwerp early in 1892 he joined
Van de Velde and Max Elskamp in organizing the
Association pour l'art, a group patterned after
Les XX. Morren showed Neo-Impressionist
works such as À l'harmonie and designed the
cover of the Association's catalogue in 1892.

Morren, like Van de Velde, Georges Lemmen, and Théo van Rysselberghe, was attracted to the Arts-and-Crafts movement and the ideas of William Morris and Walter Crane. In late 1894, Morren exhibited alongside his friends Fernand Dubois and Georges Hobé at the Salle Verlat in Antwerp, showing works in the applied arts as well as more traditional paintings, drawings, and pastels. One year later he was invited to exhibit at Siegfried Bing's gallery in Paris, showing his jewelry, stained glass, inkwell, candlestick, and fabrics. From 1895 on he exhibited frequently with La Libre Esthétique in Brussels. From 1900, Morren painted landscapes, still lifes, and especially women in domestic scenes, works that were filled with light and air and executed in a loose and impressionistic style. In 1904 he was one of the founders of the exhibition society Vie et Lumière, which became a forum for luminist painting in Belgium. In 1910 he acquired a property in Saint-Germain-en-Laye, dividing his time between Belgium and France. He returned to Belgium for good in 1926. That year he was given a retrospective at the Galerie Giroux in Brussels, and five years later another retrospective in Brussels at the Palais des Beaux-Arts. He did not live to see a third retrospective that opened in 1942, five months after his death. JB

Hippolyte Petitjean
1854–1929

The art of Hippolyte Petitjean seemed to move between the delicate touch and methodical use of color devised by Georges Seurat to the lyrical, Symbolist idylls of Puvis de Chavannes. The artist spent his childhood in Mâcon, on the Saône River north of Lyon. His family had little money, and the aspiring artist received his first training at the local school for drawing. With funding assistance from his hometown, Petitjean enrolled in the École des Beaux-Arts in Paris and studied with Alexandre Cabanel and Puvis de Chavannes. In light of his traditional, academic grounding, it is not surprising that Petitjean chose to exhibit at the conservative Salon during the 1880s.

Petitjean is said to have met Seurat in 1884, though he did not begin associating with the Neo-Impressionists in 1886, and no documented divisionist works before 1890 have been identified. In 1891 he began to exhibit with the Independents, a group with which he would maintain a long relationship. His work was included in the 1892 exhibition at Le Barc de Boutteville in Paris, and he was invited to exhibit at Les XX in Brussels in 1893. Around the turn

of the century he exhibited with his Neo-Impressionist colleagues in Berlin and Weimar.

By 1894, Petitjean was feeling constrained by the practice of Neo-Impressionism, and he turned to painting allegorical and bathing scenes that show his Symbolist instincts and the influence of his training with Puvis. Petitjean also revered J.-F. Millet and J.A.D. Ingres, and he installed a plaque with the names of the three artists above the entrance to his home. Always pressed for money, he took a job as a drawing instructor in two Paris schools. Around 1910, Petitjean revisited Neo-Impressionism, creating deft, delicate pointillist watercolors that rank among his best works. EWL

Lucien Pissarro
1863–1944

Eldest son of Camille Pissarro, Lucien forged a career that encompassed the Impressionist and Neo-Impressionist movements and the revival of printmaking. He was introduced to painting by his father. During the late 1870s and early 1880s, Lucien attempted a career in commerce, living in Paris and London. To his mother's dismay, however, he was determined to be an artist. Lucien returned to the family home in Eragny in 1884, painting and studying wood engraving with Auguste Lepère. In 1885 father and son met Georges Seurat and Paul Signac and adopted the tenets of Neo-Impressionism, exhibiting in the same room with Seurat's *Sunday on the Grande Jatte (Un Dimanche à la Grande Jatte)* at the last Impressionist exhibition in 1886. Lucien continued working with Neo-Impressionist methods through 1890 and was an active member of the Independents. He was invited to exhibit with Les XX in Brussels in 1890 and 1892. During the same period he also pursued his interest in printmaking, creating illustrations and exhibiting his engravings and lithographs.

In November 1890, Lucien Pissarro moved to England, which would be his home for the rest of his life. He married Esther Levi Bensusan in 1892. While there were frequent trips to France, Lucien became a naturalized British citizen in 1916. The correspondence between Camille and Lucien during their various separations has left one of the richest records of artistic opinion and current events during the last decades of the nineteenth century.

Lucien founded Eragny Press in 1894, devoting his attention to designing typefaces and illustrated books rather than painting. Inspired by the Pre-Raphaelites and the English Arts-and-Crafts movement, he created thirty-five books before the press closed due to World War I.

During the early 1900s, Lucien gradually resumed painting. He associated with such progressive British artists as Walter Sickert and Spencer Gore, and for a time he was active in several artists' groups. His style evolved to a modified Impressionism, and the artist frequently braved the British weather to paint outdoors. Lucien participated in several exhibitions in London and was often occupied with the exhibition and preservation of his father's work. He died in Somerset in 1944. EWL

Darío de Regoyos
1857–1913

Darío de Regoyos was a Spanish painter and graphic artist with lifelong ties to Belgium. Born in Ribadesella, in the province of Asturias, at age twenty he studied landscape drawing at the Real Academia de Bellas Artes de San Fernando in Madrid under the Belgian-born Carlos de Haes. His musician friends Isaac Albéniz and Enrique Fernández Arbos, already studying in Brussels at the Conservatory of Music, invited him for a visit in 1879. In Brussels, Regoyos studied with painter Joseph Quinaux at the Académie Royale des Beaux-Arts in 1879–80.

In 1881, Regoyos joined the exhibition society L'Essor, whose core group of artists broke away two years later to form the avant-garde society Les XX. Following his first exhibition with L'Essor in 1882 he showed the next year with Frantz Charlet and Théo van Rysselberghe, who had produced works in Spain and Morocco. A founding member of Les XX, Regoyos exhibited at nine of their ten annual shows. He was befriended especially by fellow Vingtistes James Ensor and Van Rysselberghe, who both depicted him serenading the group with his guitar and voice.

Although Regoyos lived in Spain during the time of Les XX, he returned to Belgium often. In June, July, and August 1888 he traveled to Spain with the Symbolist poet Émile Verhaeren. While traveling the back roads of the Basque country—Navarre, Aragon, and Castille—they witnessed the customs and mores of its local peoples, including funerals, pilgrimages, processions, bullfights, and all manner of daily rural life. Verhaeren commemorated the excursion with a four-part article dedicated to Regoyos published in *L'Art moderne,* entitled "Impressions d'artiste." This series served as the basis for the book *España Negra,* published in 1899 with text by Verhaeren in Spanish translation and illustrations from the trip by Regoyos.

In Brussels, Regoyos absorbed the Impressionist style of Claude Monet and Camille Pissarro, but he was drawn to the Neo-Impressionism of

Georges Seurat, who exhibited with Les XX in 1887, 1889, and 1891. He painted in the Neo-Impressionist manner for a brief period of time, producing his masterpiece *Nets Drying: San Sebastian (Las Redes)* in 1893. In turn, during his frequent trips home to Spain he acquainted young Basque and Catalan artists with the latest discoveries of his Franco-Belgian colleagues.

Regoyos exhibited at the Independents in Paris frequently from 1890 onward and with the successor to Les XX, La Libre Esthétique. He also showed at official exhibitions in Madrid, Bilbao, San Sebastian, and Barcelona and was given one-man shows in Paris at Durand-Ruel in 1897 and the Galerie Druet in 1906. Following his death he was given a memorial exhibition at La Libre Esthétique in 1914. In addition, his friends gathered his works for display at the Galerie Choiseul in Paris and issued a catalogue with a preface by Verhaeren. At the show's opening, his old friend and traveling companion read his preface as tribute to this unique Spanish-Belgian modernist. **JB**

Georges Seurat
1859–1891

The influential career of Georges Seurat, founder of the Neo-Impressionist movement, was confined to little more than a decade. He was born in Paris and grew up with his mother and two siblings, while his father opted to live in a nearby suburb, returning occasionally for family meals. His parents did not object to Seurat's artistic aspirations and provided him with an allowance that allowed him to pursue his art with independence.

In 1878 Seurat entered the École des Beaux-Arts in Paris, following the traditional academic training of Henri Lehmann. His drawings from the nude model leave no doubt of his ability as a draftsman. Independently, Seurat studied the writings of theoretician Charles Blanc and the research of Michel-Eugène Chevreul and Ogden Rood on color relationships. After completing a year of obligatory military service in Brittany, he returned to Paris and rented a studio.

Working in the artistic milieu of Paris, Seurat was highly aware of the Impressionists' use of more brilliant color schemes, and his early landscapes combine an awareness of the Barbizon tradition with bright color and strong compositional structure. In 1884 he completed his first major work, *Bathing Place, Asnières (Une baignade, Asnières)*, a luminous landscape populated by an orderly, carefully designed arrangement of figures. During the mid-1880s Seurat formulated the basic methods of his aesthetic,

devising a scientifically inspired approach to his choice and handling of color. In 1885 he reworked another large outdoor scene, adding stippled brushwork of bright, divided color that became the hallmark of the style. That painting, *Sunday on the Grande Jatte (Un Dimanche à la Grande Jatte)*, made its debut at the eighth Impressionist exhibition in 1886 and became the controversial manifesto of the new movement, named Neo-Impressionism by the enthusiastic critic Félix Fénéon. Seurat also analyzed the intrinsic expressive capacities of line and color, drawing on the findings of Humbert de Superville and the scientist and aesthetician Charles Henry. His beliefs about the independent emotive power of line and color appear in Seurat's statement of theory, written in August 1890.

Seurat also made exquisite conté crayon drawings that demonstrate his awareness of the rich contrasts inherent in black and white. These works manifest the artist's remarkable expressive gifts and reveal his profound understanding of people as well as form.

Through the founding and operation of the jury-free, no-awards Independents, Seurat met many of the progressive artists who were to adopt his methods. Though he did associate with them, Seurat was a reclusive, private personality, doggedly committed to an intense work ethic. He established a pattern of working through his ideas and theories in major figural paintings in his studio during the cooler months, and then passing the summers in small French port towns, painting luminous marine pictures composed of deft pointillist strokes. Seurat also participated as an invitee to the exhibition group Les XX in Brussels, where he exhibited in 1887, 1889, and 1891. Several Belgian painters adopted his approach.

While working on the installation of the 1891 exhibition of the Independents in March, Seurat became ill and died three days later of a respiratory infection, probably a form of diphtheria, at the age of thirty-one. His devastated associates were further shocked to learn of the existence of Seurat's mistress, Madeleine Knoblock, and their baby son. The following year the artists of Les XX and the Independents devoted memorial exhibitions to their young colleague. **EWL**

Paul Signac
1863–1935

Paul Signac was born in Paris into a family of successful merchants. At the age of sixteen he decided to become a painter after viewing an exhibition of Claude Monet's work. From the outset he showed a marked taste for color and

expressive freedom. Within just three years the young self-taught artist was in the Normandy village of Port-en-Bessin painting seascapes that could have been attributed to a much more experienced Impressionist. These works were remarkable for their brilliant colors and rigorously geometric compositions.

In 1884, Signac exhibited at the first Independents, where he met Georges Seurat. They were both intrigued by Michel-Eugène Chevreul's theories on the perception of colors. During the winter of 1885–86, Seurat completely reworked *Sunday on the Grande Jatte (Un Dimanche à la Grande Jatte)*, adding tiny spots of color to the canvas. The principle of color division involved dotting the canvas with touches of pure pigment, leaving the viewer's retina to perform the work of blending the hues from a distance. To achieve maximum effect, colors had to be juxtaposed in accordance with the laws of contrast established by Chevreul or Charles Henry. Signac immediately adopted this technique and exhibited works of divided color at the eighth Impressionist exhibition in 1886. The term Neo-Impressionist appeared in print for the first time that same year, in September.

Signac enthusiastically promulgated the movement, particularly in Belgium, where he was fittingly referred to as the "Saint Paul of Neo-Impressionism"; he recruited a considerable number of converts there. He was equally active in France, where he assisted Vincent van Gogh, newly arrived in Paris, in his explorations of color. He also recruited Maximilien Luce and Henri-Edmond Cross to the movement.

Signac was also an enthusiastic sailor. He spent his summers in Brittany or Normandy, painting lyrical, ethereal seascapes that were visual poems of color and light. In 1892, following the death of Seurat, he embarked on his sailboat, the *Olympia,* for Saint-Tropez, where he would pass his future summers. His brushstrokes gradually became looser, imbuing Neo-Impressionism with a greater sense of freedom. He also wrote a theoretical volume entitled *From Eugène Delacroix to Neo-Impressionism (D'Eugène Delacroix au néo-impressionnisme)*. It was published in 1899, translated into German, and regularly reissued. In the early twentieth century Signac organized retrospectives of the work of Seurat and Van Gogh. In 1905 he was at the epicenter of all modern artistic trends; his villa, La Hune, was the gathering place for young painters in Saint-Tropez.

Following the war, Signac traveled throughout France, his watercolor brushes in hand. He served as president of the Independents from 1908 to 1934 and continued to exhibit Neo-

Impressionist canvases there until he died. However, he favored the art of watercolor in his later years. MFB

Jan Toorop
1858–1928

Johannes Theodorus Toorop, known as Jan, was born in Poerworedjo, in central Java. Although the family was predominantly Southeast Asian, the Netherlands was considered to be the clan's homeland, and Dutch was spoken at home. Toorop studied at the Academy of Fine Arts in Amsterdam in 1880 and took classes with Jan Portaels at the Academy of Fine Arts in Brussels in 1882–83. He showed with the exhibition society L'Essor in 1883 and was elected to Les XX in December 1884, exhibiting with the members in 1885. Among his friends were such supporters of Les XX as the poet Émile Verhaeren, lawyer and patron of the arts Edmond Picard, secretary of Les XX and lawyer Octave Maus, and art critic and socialist writer Jules Destrée.

Toorop's early work, such as an 1885 portrait of the Vingtiste painter Guillaume Vogels, shows a variety of influences, including Realism and Impressionism. Toorop also responded to Vingtistes James Ensor and Fernand Khnopff, and James Whistler, an exhibitor to Les XX. Although struck by the works of Seurat when he exhibited at Les XX in 1887, Toorop did not begin showing his own Neo-Impressionist works until 1889. He became an important conduit for channeling avant-garde ideas into the Netherlands, mounting a Les Vingt show with Vogels in Amsterdam in May 1889. After his return to Holland he resided in Katwijk, where, once again, he promoted art by members of Les XX at The Hague, with the help of Théo van Rysselberghe and Henry van de Velde, in July 1892. This exhibition motivated several younger artists, among them Hendrik Pieter Bremmer, Jan Vijlbrief, and Johan Joseph Aarts, to experiment with Neo-Impressionism. However, Toorop's personal and original interpretation of Neo-Impressionism freed him of the rigorous color theory used by Seurat.

Although Toorop had created a dozen Neo-Impressionist works by 1891, he abandoned the style and turned to Symbolism. His new style, as exemplified in *O Grave, Where Is Thy Victory?* (1892), shows the confrontation between good and evil communicated through flat patterned surfaces and undulating art nouveau lines. His new manner lent itself to a number of uses, such as a commercial poster for the salad oil Delft, 1894; a playbill, *Venice Preserved* (*Venise sauvée*), for the avant-garde Parisian theater led by Lugné-Poe; or the poster for the feminist movement Work for Women (1898). In 1892 he exhibited with the Parisian Symbolist group Rose + Croix and had his first one-man show at the Kunstkring, The Hague, of which he was a cofounder. He exhibited with La Libre Esthétique in Brussels from 1894 on and also with the Vienna Secession in 1900 and 1902.

Toorop returned to Neo-Impressionism in 1899, painting in a delicate and decorative manner two of his portrait masterpieces, Jeannette de Lange and Dr. Aegidius Timmerman. Through mounting the Eerste Internationale Tentoonstelling (First International Exhibition) held at The Hague in May and June of 1901, where works of Belgian and French Neo-Impressionists were on display, he inspired a new generation of Dutch artists, including Jan Sluyters, Leo Gestel, and Piet Mondrian, to experiment with the technique.

A second phase of his Neo-Impressionist style emerged around 1905, when he used large mosaic blocks of color in his canvases. At that time he converted to Catholicism and painted primarily religious scenes and portraits of religious figures thereafter. JB

Henry van de Velde
1863–1957

Although Henry van de Velde began his career as a painter, he is best known today as an architect and industrial designer. Following studies in his native Antwerp at the Academie voor Schone Kunsten (Academy of Fine Arts) from 1880 to 1883, he then studied in Paris from fall 1884 until the spring of 1885 at the studio of the academic painter Carolus-Duran. In Paris he was attracted to the work of the Barbizon painter Jean-François Millet. Returning to Belgium, he joined an artists' colony in Wechelderzande, based on its French counterpart. Van de Velde became a member of Les XX, first showing with the group in 1889. Here he encountered two early formative influences on his art: Georges Seurat and Vincent van Gogh. Seeing Seurat's Neo-Impressionist works in 1887 profoundly changed his style, and in 1888 he painted his first Neo-Impressionist pictures. Van de Velde saw Vincent van Gogh's work at Les XX exhibitions of 1890 and 1891, a memorial retrospective to the artist. Van de Velde responded to Van Gogh's work by experimenting with the power of line and color between 1890 and 1892.

Like so many of his colleagues in Les XX, Van de Velde was deeply affected by the Arts-and-Crafts movement. His interest in the unity of the arts led him to architecture, and in 1895 he designed Bloemenwerf, a house located in the Brussels suburb of Uccle, for his new wife Maria Sèthe; he created all the interior furnishings, including Maria's dresses. He established his own manufacturing company, Société Van de Velde in Brussels, to produce his metalwork, furniture, and rugs. His ornamentation decorated such periodicals and books as *Van Nu en Straks* and *Dominical*. Van de Velde vigorously promoted his own work and ideas through lectures and publications. In *Déblaiement d'art* (1894) and *Aperçus en vue d'une synthèse d'art* (1895), Van de Velde presented art as an instrument of social reform.

In 1895, the Parisian art dealer Siegfried Bing visited Bloemenwerf and invited Van de Velde to design three rooms for his new gallery, L'Art nouveau. When these rooms were exhibited two years later in Dresden, Van de Velde's popularity soared, particularly in the Germanic world, and in 1900 he moved to Berlin. For his new patron Karl Ernst Osthaus he remodeled the Folkwang Museum (1902) and Osthaus's own house, Hohenhof (1907–8), both in Hagen. In 1902 he moved to Weimar at the behest of patron and art collector Harry Kessler and Elisabeth Förster-Nietzsche, sister of the philosopher. He was named artistic advisor to Wilhelm Ernst, grand duke of Saxe-Weimar, and appointed to lead the new School of Decorative Arts (Kunstgewerbeschule). During the Weimar period (1902–17) Van de Velde produced some of his finest architectural designs, graphic work, and the monumental edition of the *Also Sprach Zarathustra* (1908), for which Georges Lemmen designed a new typeface.[4]

Van de Velde's theater for the 1914 Deutscher Werkbund exhibition in Cologne became one of his most famous buildings, its sinuous forms contrasting with Walter Gropius's model factory. At the outbreak of World War I, the grand duke was forced to dismiss Van de Velde, a foreigner. However, the authorities heeded his recommendation for a successor, hiring Walter Gropius, who developed the famous Bauhaus directly from Van de Velde's legacy. Following three years in Switzerland, in 1920 he began work for one of his greatest patrons, Helene Kröller-Müller, and relocated to the Netherlands. There he worked on the Kröllers' large estate, the Hoge Veluwe Park in Otterlo, designing the art gallery, the Rijksmuseum Kröller-Müller, built between 1936 and 1944.

In 1925, Van de Velde was invited to return to Belgium as a professor of architecture at the University of Ghent. The following year King Albert appointed him to lead the new Institut supérieur des arts décoratifs in Brussels, where

he taught for the next two decades. He received commissions to design the Belgian pavilions at the Universal Exposition of 1937 in Paris and the World's Fair of 1939 in New York. In 1947 Van de Velde returned to Switzerland to work on his memoirs, and he died there in 1957. JB

Vincent van Gogh
1853–1890

Vincent Willem van Gogh was born in Groot-Zundert to a family highly influenced by the reform movement of Dutch Calvinism. He was not someone convinced at an early age of his desire to be an artist. After working in branches of the gallery Goupil & Cie. in The Hague, Brussels, London, and Paris from 1869 to 1876, Van Gogh grew discouraged with the commercial art trade and sought a vocation more in keeping with his growing religious convictions and desire for social service.

Van Gogh struggled with theological studies and, thanks to his father's intervention, was appointed to minister to the people of the Borinage, Belgium's bleak mining region, in 1878. Less than a year later he was terminated for his unusual, intense behavior. With encouragement from his brother Theo to pursue his interest in drawing, Vincent committed to becoming an artist in 1880. Largely self-taught, he studied in various locations in Belgium and the Netherlands for the next five years, reading color theory and realizing his admiration for the painting of J.-F. Millet. Vincent continued to be a passionate reader of a wide variety of literature.

In early March 1886, Van Gogh left the Low Countries for Paris. There he lived with his brother Theo, a dealer in avant-garde painting for the gallery Boussod, Valadon & Cie. (formerly Goupil & Cie.). Van Gogh plunged into the ferment of the city's progressive ideas and rapidly lightened his somber palette. To perfect his drawing, he attended the Atelier Cormon for a time, meeting Henri de Toulouse-Lautrec and Émile Bernard there. In November 1886 Van Gogh met Paul Gauguin, who had just returned from Pont-Aven. He came to know both Georges Seurat and Paul Signac, and during the spring of 1887 painted the most thoroughly Neo-Impressionist works of his career.

By February 1888, Van Gogh was feeling physical and psychological stress from the pressures of Parisian life. That month he departed for the south of France and lived in Arles through Theo's ongoing support. He was dazzled and energized by the brilliant blossoms and sunlight of Provence in spring. Vincent embarked upon a prolific period of painting landscapes, still lifes,

and portraits of the people he came to know there. He hung prints from his rapidly growing Japanese woodblock collection on the white walls of his new studio. Working alone in Arles also reinforced his dream of a community of artists painting together. After persuasion (and underwriting) from Theo, Gauguin agreed to join Vincent in Arles. He arrived in late October 1888, and both painters experienced a period of great creativity. However, living and working together for more than nine weeks inevitably created tensions between the two very strong temperaments. On December 23 Vincent had a mental breakdown and cut off part of his ear. On December 25, Gauguin was on a train for Paris.

After recurring bouts of illness, Van Gogh voluntarily entered the asylum of Saint-Paul-de-Mausole in nearby Saint-Rémy. Doctors diagnosed his sickness as a kind of epilepsy. Painting views of and from the asylum when he was healthy enough, Van Gogh continued his use of vibrant, contrasting color applied with rich, energetic strokes of the brush. Many of these works express the artist's pantheistic belief in nature and his powerful identification with the cycles of life. He still exhibited actively with Les XX in Brussels and the Independents in Paris. In early 1890 his nephew and namesake was born to Theo and his wife, Jo Bonger van Gogh.

Van Gogh left the asylum in May 1890 and moved north of Paris to Auvers-sur-Oise, where Theo had made arrangements for him to be cared for by a homeopathic doctor and amateur painter named Paul Gachet. He painted actively there for more than two months, creating landscapes and portraits of standard size as well as a group of "double-square" proportioned canvases. On July 27, 1890, Van Gogh suffered a self-inflicted gunshot wound and died two days later. Theo died less than six months after Vincent, and the brothers are buried side by side in the cemetery at Auvers. EWL

Théo van Rysselberghe
1862–1926

Théo van Rysselberghe, painter and graphic artist, was born in Ghent, Belgium, and died in Saint Clair, France. Following studies at the Academy of Fine Arts in Ghent, he moved to Brussels to study with Jean-François Portaels, whose paintings of northern Africa instilled in him an interest in the exotic. In 1882, after winning a travel scholarship, he visited Spain and Morocco, where he was dazzled by the light. One year later, in Brussels, he met Émile Verhaeren, who was to become his lifelong friend and for whom he would supply ornaments and decora-

tions for the poet's published works. Van Rysselberghe was a founding member of the avant-garde exhibition society Les XX. As artistic advisor to Octave Maus, the group's secretary, he was responsible for recruiting many artists to exhibit at Les XX, including Henri de Toulouse-Lautrec and Vincent van Gogh. On September 16, 1889, he married Marie Monnom, daughter of Sylvie Monnom-Descamps, who published the important interdisciplinary review *L'Art moderne.* Through Les XX, Van Rysselberghe was exposed to the ideas of William Morris and the Arts-and-Crafts movement. In the early 1890s the decorative arts flourished in Brussels. In addition to paintings, Van Rysselberghe designed books, posters, prints, and furniture. His most comprehensive experiment with book design came in 1895 for *Almanach,* a calendar book with poems by Verhaeren. Van Rysselberghe supplied initial letters, head and tail pieces for each month, and four full-page illustrations of the seasons.[5]

As a painter Van Rysselberghe was drawn early to the work of the French Impressionists and James McNeill Whistler, who had exhibited at Les XX in 1884, as revealed in his *Portrait of Octave Maus* (1885). A turning point came in 1886 when, in the company of Verhaeren, Van Rysselberghe viewed Georges Seurat's *Sunday on the Grande Jatte (Un Dimanche à la Grande Jatte)* at the Independents exhibition in Paris. Van Rysselberghe became an avid convert to Seurat's new pointillist method, applying the technique to portraiture. Among his first such works was *Alice Sèthe,* shown at Les XX in 1889. He holds the distinction of having produced the greatest quantity of Neo-Impressionist portraits among his French and Belgian colleagues. Van Rysselberghe's Neo-Impressionist portraits, seascapes, and landscapes were admired in Germany and Austria, and exhibitions at the Keller & Reiner gallery in Berlin (1898) and at the Vienna Secession (1899) increased his fame.

After 1903, Van Rysselberghe's pointillist technique became more relaxed and was abandoned altogether around 1907. Following the examples of Paul Signac's large decorative painting *In the Time of Harmony (Au temps d'harmonie)* (1895) and Henri-Edmond Cross's *The Evening Air (L'Air du soir)* (1894), Van Rysselberghe created a similar monumental work, *Sunset (L'Heure embrasée)* (1897), in which female bathers frolic at the water's edge. Working at this grand scale unleashed in the painter a gusto for the physicality of the painted surface that had been long held in check by the rigors of Neo-Impressionist practice. An important commission came when the architect Victor Horta invited him to decorate

a prominent stair landing for the Armand Solvay townhouse at 224 Avenue Louise, Brussels. His large canvas *A Reading in the Garden* (*Une Lecture au jardin*) (1902) led to later commissions, including panels for Paul Nocard and for Léon Guinotte at the château of Pachy, near Mariemont.

Frequently traveling to the south of France to visit colleagues Henri-Edmond Cross and Paul Signac, Van Rysselberghe moved there permanently in 1911, settling in a house designed by his architect brother, Octave. He is buried in the cemetery at nearby Lavandou, close to the grave of his friend Cross, for whose tomb he realized a portrait medallion. JB

1. For more on the Belgian Independents, see Victor Martin-Schmets, *Les Indépendants belges, 1904–1929: Catalogues et dossiers de presse* (Brussels: Tropismes, 1999).

2. See Jacques van Lennep, "Les expositions burlesques à Bruxelles de 1870 a 1914: L'art zwanze—une manifestation pré-dadaïste?" *Bulletin des Musées royaux des Beaux-Arts de Belgique* (1970) 19: 1–2, 127–48.

3. For more on Picard's gallery see Jane Block, "Bruxelles-Paris: La Maison d'Art Edmond Picard et la galerie L'Art nouveau de Siegfried Bing," *Bulletin des Musées royaux des Beaux-Arts de Belgique* (2010): 93–118, and her "La Maison d'Art: Edmond Picard's Asylum of Beauty," in *Irréalisme et art moderne: Les Voies de l'imaginaire dans l'art des XVIIIᵉ, XIXᵉ et XXᵉ siècles. Mélanges Philippe Roberts-Jones,* ed. Michel Draguet (Bruxelles: Université libre de Bruxelles, 1991), 145–62.

4. See Jane Block, "The Insel-Verlag 'Zarathustra': An Untold Tale of Art and Printing," *Pantheon* 45 (1987): 129–37.

5. For Almanach, see Jane Block, "L'Almanach d'Émile Verhaeren et Théo van Rysselberghe," *Le Livre et l'estampe* 55: 172 (2009): 9–40, and 55: 171 (2009), 256 for a color illustration. For Van Rysselberghe's book designs, see Adrienne and Luc Fontainas, *Théo van Rysselberghe: L'Ornement du livre, Catalogue raisonné* (Antwerp: Pandora, 1997).

Appendix
Neo-Impressionist Oil Portraits, 1886–1904

Jane Block

This roster of selected Neo-Impressionist portraits does not include studies for finished works. All the works are oil on canvas unless specified. They are listed in chronological order for each artist.

Henri-Edmond Cross

Madame Hector France, 1891
Irma Clare France, future wife of the artist
81⅞ × 58⅝ in. (208 × 149 cm)
Musée d'Orsay, Paris

Portrait of Madame Cross, [1901]
Irma Clare Cross, wife of the artist
37⅜ × 29½ in. (95 × 75 cm)
Musée d'Orsay, Paris

Henri Delavallée

The Boot Polisher (*Le Cireur de bottes*), 1890
[Unknown]
62⅝ × 31⅞ in. (159 × 81 cm)
Courtesy of Roberto Polo Gallery, Brussels

Albert Dubois-Pillet

Portrait of Mademoiselle B. or *The Lady in the White Dress* (*La Dame à la robe blanche*), [1886–87]
[Unknown]
34⁷⁄₁₆ × 26¾ in. (87.5 × 68 cm)
Musée d'art moderne de Saint-Étienne Métropole

Portrait of Monsieur Pool, 1887
Laurent Bernard Pool, the artist's colleague in the Garde Républicaine
21⅝ × 18⅛ in. (55 × 46 cm)
Indianapolis Museum of Art

Louis Hayet

Cellist at Practice (*Violoncelliste à l'étude*), 1889
Louis Abbiate, friend of the artist
32¼ × 24⅛ in. (82 × 61 cm)
Private collection

William Jelley

Portrait of Alfred Verhaeren, [c. 1890]
Friend of the artist
Oil on cardboard
14 × 10½ in. (35.6 × 26.7 cm)
Indianapolis Museum of Art

Adolphine Jelley, 1890
Daughter of the artist
7⅞ × 9⅞ in. (20 × 25 cm)
Private collection

Achille Laugé

Portrait of Madame Astre, 1892
Marie Salvan, first wife of Achille Astre
78 × 52⅜ in. (198 × 133 cm)
Musée des Beaux-Arts de Carcassonne

Portrait of Jeanne Sarraut, c. 1892
Friend of the artist
72½ × 49¼ in. (184 × 125 cm)
Location unknown

Portrait of Mademoiselle Jeanjean, 1892
Marie-Henriette-Antoinette Jeanjean, whose father was the artist's neighbor
47¼ × 33⅛ in. (120 × 84 cm)
Private collection

Portrait of Madame Martimort, [1895]
Friend of the artist
17⅞ × 16½ in. (45.5 × 42 cm)
Private collection

Dr. Victor Gaujon, 1895
Childhood friend of the artist
19⅝ × 24 in. (50 × 61 cm)
Private collection

Self-Portrait in a White Beret (*Autoportrait au béret blanc*), c. 1895–96
15⅜ × 19¼ in. (39 × 49 cm)
Collection of Robert Bachmann, Lisbon

Against the Light—Portrait of the Artist's Wife (*Contre-jour—Portrait de la femme de l'artiste*), 1899
36⅝ × 44⅛ in. (93 × 112 cm)
Musée d'Orsay, Paris (on deposit at the Musée de Grenoble)

Before the Window (*Devant la fenêtre*), 1899
Wife of the artist and her niece
48⅜ × 59 in. (123 × 150 cm)
Petit Palais, Musée d'art moderne, Geneva

Georges Lemmen

Young Woman Crocheting (*Jeune femme faisant du crochet*), 1890–91
Julie Lemmen, the artist's sister
18½ × 15 in. (47 × 38 cm)
Private collection

Self-Portrait, [1890]
17 × 15 in. (43 × 38 cm)
Private collection

Émile Verhaeren, 1891
Poet and friend of the artist
Oil on panel
14¼ × 12¼ in. (36.2 × 31 cm); with frame painted by the artist, 20⅛ × 18⅛ in. (51 × 45.9 cm)
Museum Plantin-Moretus, Antwerp

Mademoiselle Maréchal, [1891–92]
Aline Maréchal, future wife of the painter
23⅝ × 20⅛ in. (60 × 51 cm)
Musée d'Orsay, Paris

Mademoiselle L. (*Portrait of the Artist's Sister*), [1892]
Julie Lemmen, the artist's sister
24⁷⁄₁₆ × 20¹⁄₁₆ in. (62 × 51 cm)
The Art Institute of Chicago

The Two Sisters or *The Serruys Sisters,* 1894
Berthe and Jenny Serruys, children of the artist's friends
23⅝ × 27½ in. (60 × 70 cm); with painted frame 26¾ × 31⅜ in. (68.1 × 79.8 cm)
Indianapolis Museum of Art

Maximilien Luce

Mother and Child Before the Window (*Mère et enfant devant la fenêtre*), 1887
Joséphine and Marcel Gausson, sister-in-law and nephew of the artist Léo Gausson
32¼ × 25⅝ in. (81 × 65 cm)
Formerly Hammer Galleries, New York

Getting Dressed (*La Toilette*), 1887
[Unknown]
36¼ × 28¾ in. (92 × 73 cm)
Petit Palais, Musée d'art moderne, Geneva

Morning, Interior (*Le Lever, intérieur*), 1890
Gustave Perrot, an artist and friend of Luce
25½ × 31⅞ in. (64.8 × 81 cm)
The Metropolitan Museum of Art

Portrait of Paul Signac, [1890]
Oil on wood
13¾ × 10⅝ in. (35 × 27 cm)
Private collection

Bathing of the Feet (*Le Bain de pieds*), 1891
Père Legaret and Eugénie Givort, friends of the artist
31⅞ × 39⅜ in. (81 × 100 cm)
Location unknown

Portrait of Paterne Berrichon [pseud.], 1891
Pierre Eugène Dufour, friend of the artist
15¾ × 13 in. (40 × 33 cm)
Private collection

Coffee (*Le Café*), 1892
[Unknown]
31⅞ × 25⅝ in. (81 × 65.2 cm)
Private collection

Portrait of a Young Woman, 1893
[Unknown]
21⅝ × 18⅛ in. (55 × 46 cm)
Collection Gustav Rau for UNICEF

Portrait of Henri-Edmond Cross, 1898
Colleague of the artist
39⅜ × 31⅞ in. (100 × 81 cm)
Musée d'Orsay, Paris

George Morren

Sunday Afternoon (*Dimanche, après-midi, portrait*), 1892
[Unknown]
20 × 29⁵⁄₁₆ in. (50.8 × 74.5 cm)
Indianapolis Museum of Art

Hippolyte Petitjean

Young Woman Seated (*Jeune femme assise*), 1892
Louise Claire Chardon, future wife of the artist
28¾ × 23⅞ in. (73 × 60.5 cm)
Musée d'Orsay, Paris (on deposit at the Musée des Beaux-Arts, Nancy)

Young Woman Standing (*Jeune femme debout*), 1894
Louise Claire Chardon, future wife of the artist
38¾ × 23¼ in. (98.3 × 59 cm)
Musée d'Orsay, Paris

Lucien Pissarro

Corner of the Studio (*Coin d'atelier*), 1887
Georges Pissarro, the artist's brother, in the atelier of Camille Pissarro
12⅝ × 15¾ in. (32 × 40 cm)
Private collection

Interior of the Studio (*L'Intérieur d'atelier*), 1887
Georges Pissarro, the artist's brother, in the atelier of Camille Pissarro
25¼ × 31½ in. (64.1 × 80 cm)
Indianapolis Museum of Art

Portrait of Jeanne, 1889
The artist's sister
28¾ × 23¼ in. (73 × 59 cm)
Private collection

Léon Pourtau

Madame Vallad, [1891–92]
The artist's mother-in-law
45⅝ × 31⅞ in. (116 × 81 cm)
Collection Gustav Rau for UNICEF

Darío de Regoyos

Portrait of Dolores Otaño, 1892
Family friend of the artist
21⅝ × 13¾ in. (55 × 35 cm)
Museo Nacional Centro de Arte Reina Sofía, Madrid

Georges Seurat

Young Woman Powdering Herself (*Jeune femme se poudrant*), 1889–90
Madeleine Knoblock, the artist's companion
37⅝ × 31¼ in. (95.5 × 79.5 cm)
The Courtauld Gallery, London

Paul Signac

Opus 217. Against the Enamel of a Background Rhythmic with Beats and Angles, Tones and Tints, Portrait of M. Félix Fénéon in 1890 (*Opus 217. Sur l'émail d'un fond rythmique de mesures et d'angles, de tons et de teintes, Portrait de M. Félix Fénéon en 1890*), 1890–91
Critic and supporter of the artist
29 × 36½ in. (73.5 × 92.5 cm)
Museum of Modern Art, New York, fractional gift of Mr. and Mrs. David Rockefeller

Woman Arranging Her Hair, Opus 227 (*Arabesques for a Dressing Room*) (*Femme se coiffant. Opus 227* [*arabesques pour une salle de toilette*]), 1892
Berthe Roblès, the artist's future wife
Encaustic on canvas mounted on canvas
23¼ × 27½ in. (59 × 70 cm)
Private collection

Portrait of My Mother, Opus 235 (*Portrait de ma mère. Opus 235*), 1892
Héloïse Signac, mother of the artist
25⅝ × 31⅛ in. (65 × 81 cm)
Private collection

Woman with a Parasol, Opus 243 (*Femme à l'ombrelle. Opus 243*), 1893
Berthe Signac, the artist's wife
32¼ × 14⅝ in. (82 × 67 cm)
Musée d'Orsay, Paris

Jan Toorop

Portrait of Marie Jeannette de Lange, 1900
Friend of the artist
27¾ × 30½ in. (70.5 × 77.4 cm)
Rijksmuseum, Amsterdam

The Print Lover (*Dr. Aegidius Timmerman*), 1900
Dr. Aegidius Timmerman, friend of the artist
26⅛ × 31⅛ in. (66.5 × 76 cm)
Collection Kröller-Müller Museum, Otterlo

Henry van de Velde

Portrait of Laurent in Blankenberghe, c. 1888
The artist's brother
17⅜ × 13⅜ in. (44 × 34 cm)
Groeningemuseum, Bruges

Portrait of a Woman, [1888]
Possibly Phil de Keyser, the artist's landlady
40⅝ × 31⅛ in. (103.1 × 79 cm)
Galerie Michael Haas, Berlin

Woman Seated at the Window (*Femme assise à la fenêtre*), 1889
Possibly Phil de Keyser, the artist's landlady
43¾ × 49¼ in. (111 × 125 cm)
Koninklijk Museum voor Schone Kunsten, Antwerp

The Seamstress (*La Ravaudeuse*), 1890
Jeanne Biart, the artist's sister
30¾ × 40 in. (78 × 101.5 cm)
Musées royaux des Beaux-Arts de Belgique, Brussels

Père Biart Reading in the Garden, 1890–91
Émile Biart, the father-in-law of the artist's sister
Oil on brown paper mounted to canvas
24½ × 20⅜ in. (62.1 × 51.9 cm)
Indianapolis Museum of Art

Vincent van Gogh

Self-Portrait, [1887]
Oil on artist's board, mounted on cradled panel
16⅛ × 13¼ in. (41 × 32.5 cm)
The Art Institute of Chicago

Portrait of Alexander Reid, [1887]
Art dealer and friend of the artist
Oil on cardboard
16½ × 13 in. (42 × 33 cm)
Kelvingrove Art Gallery and Museum, Glasgow

Théo van Rysselberghe

Mademoiselle Alice Sèthe, 1888
Future wife of Paul Dubois, sister of Maria (1891) and Irma (1894)
76¾ × 38⅝ in. (195 × 98 cm)
Musée départemental Maurice Denis, Saint-Germain-en-Laye

Little Denise (*La Petite Denise*), 1889
Denise Maréchal, niece of the artist's wife, Maria, and sister of Germaine (see below)
40⅛ × 23⅝ in. (102 × 60 cm)
Private collection

Portrait of Madame Charles Maus, 1890
Octave Maus's mother
22 × 18½ in. (56 × 47 cm)
Musées royaux des Beaux-Arts de Belgique, Brussels

In July, Before Noon (*En juillet, avant-midi*), 1890
Left, Maria, wife of the artist, and right, Maria Sèthe, the future wife of Henry van de Velde
45½ × 64⅜ in. (115.5 × 163.5 cm)
Collection Kröller-Müller Museum, Otterlo

Madame Octave van Rysselberghe, 1891
Mathilde Vereeken, the artist's sister-in-law
25⅝ × 21¼ in. (65 × 54 cm)
Private collection

Maria Sèthe at the Harmonium, 1891
Future wife of Henry van de Velde, sister to Alice (1888) and Irma (1894)
46½ × 33¼ in. (118 × 84.5 cm)
Koninklijk Museum voor Schone Kunsten, Antwerp

Young Woman Sewing [known as *The Straw Hat*] (*Jeune femme cousant* [known as *Le chapeau de paille*]), [1891]
Maria van Rysselberghe, the artist's wife
26⅜ × 21¼ in. (67 × 54 cm)
Private collection

Portrait of Mme V. R. (*Madame Van Rysselberghe*), 1891–92
Maria van Rysselberghe, the artist's wife
72⅞ × 38⅜ in. (185 × 97.5 cm)
Collection Kröller-Müller Museum, Otterlo

Émile Verhaeren in His Study, Rue du Moulin (*Émile Verhaeren dans son cabinet de travail, rue du Moulin*), 1892
Poet and friend of the artist
33⅞ × 29¾ in. (86 × 75.6 cm)
Bibliothèque royale de Belgique, Brussels

Portrait of M. A. D. (*Monsieur Auguste Descamps*), [1892]
Uncle of the artist's wife
25¼ × 20⅞ in. (64 × 53 cm)
Petit Palais, Musée d'art moderne, Geneva

Denise Maréchal, c. 1892
Niece of the artist's wife and sister to Germaine Maréchal
Oil on panel
14⅛ × 10⅜ in. (36 × 26.5 cm)
Private collection

Portrait of Anna Boch, [1892 and subsequently reworked]
Anna Boch, painter and friend of the artist
37½ × 25½ in. (95.2 × 64.8 cm)
Michele and Donald D'Amour Museum of Fine Arts, Springfield, MA

Young Girl in Green (Portrait) (*Jeune fille en vert* [portrait]), 1892
Germaine Maréchal, niece of the artist's wife Maria
31⅞ × 23⅞ in. (81 × 60.5 cm)
Private collection

Portrait of Michel van Mons, 1892
Uncle of Émile Verhaeren
79½ × 39⅜ in. (202 × 100 cm)
Private collection

Doctor Auguste Weber, [1893–94]
Cousin of Émile Mayrisch, friend of the Van Rysselberghes
53⅛ × 45¼ in. (135 × 115 cm)
Private collection

Portrait of Mademoiselle Irma Sèthe, 1894
Sister of Maria van de Velde and Alice Dubois
77¾ × 45⅛ in. (197.5 × 114.5 cm)
Petit Palais, Musée d'art moderne, Geneva

Paul Signac at the Helm of Olympia (*Paul Signac à la barre de l'Olympe*), 1896
Friend of the artist
36¼ × 44⅝ in. (92.2 × 113.5 cm)
Private collection

Portrait of Berthe Signac, c. 1896
Wife of Paul Signac
29½ × 34⅝ in. (75 × 88 cm)
Private collection

Portrait of Madame Georges Flé, 1898
Laure Flé, friend of the Van Rysselberghes
46¼ × 29⅛ in. (117.5 × 74 cm)
Musée national d'Histoire et d'Art du Grand-duché de Luxembourg, Luxembourg

Portrait of Wife and Child, 1899
Maria and Élisabeth van Rysselberghe, the artist's wife and their daughter
37¾ × 50¾ in. (96 × 129 cm)
Musées royaux des Beaux-Arts de Belgique, Brussels

Portrait of Mme Émile Verhaeren, 1899
Marthe Massin Verhaeren, wife of Émile Verhaeren
39⅜ × 31½ in. (100 × 80 cm)
Bibliothèque royale de Belgique, Cabinet Verhaeren, Brussels

Margery, 1899
[Unknown]
39⅜ × 21¼ in. (68 × 54 cm)
Private collection

Woman Reading or *Woman in the Blue Hat* (*Dame lisant* or *La dame au chapeau bleu*), 1900
The artist's wife, Maria
29⅛ × 23⅝ in. (74 × 60 cm)
Collection Kröller-Müller Museum, Otterlo

Madame Monnom, 1900
Sylvie Monnom-Descamps, mother-in-law of the artist
46 × 35½ in. (116.8 × 90.3 cm)
Sterling and Francine Clark Art Institute, Williamstown, MA

Madame Eugène Demolder in a Green Dress (*Mme Eugène Demolder en robe verte*), 1900
Claire Rops Demolder, daughter of the artist Félicien Rops
36⅝ × 41⅜ in. (93 × 105 cm)
Private collection

Three Children in Blue (The Three Guinotte Girls) (*Les Trois enfants en bleu [Les Trois filles Guinotte]*), 1901
Paule, Hélène, and Michette, daughters of the artist's patron Léon Guinotte
61 × 72⅞ in. (155 × 185 cm)
Private collection

Élisabeth van Rysselberghe in a Straw Hat (*Élisabeth van Rysselberghe au chapeau de paille*), 1901
The artist's daughter
31½ × 27½ in. (80 × 70 cm)
Private collection

Young Woman at the Water's Edge (*Jeune femme en bord de la grève*), 1901
[Unknown]
39⅜ × 31⅞ in. (100 × 81 cm)
Private collection

Young Women by the Sea, known as *The Promenade* (*Jeunes femmes au bord de la mer,* known as *La Promenade*), 1901
Foreground pair: the poet Marie Closset and Mme Victor Willem
Background pair: Laure Flé and Maria van Rysselberghe
38¼ × 51⅛ in. (97 × 130 cm)
Musées royaux des Beaux-Arts de Belgique, Brussels

A Summer's Afternoon (*Après-midi d'été*), 1900–1902
Maria van de Velde, Laure Flé, and Maria van Rysselberghe
38⅝ × 51⅛ in. (98 × 130 cm)
Musée d'Ixelles, Brussels

A Reading (*Une Lecture*), 1903
From left: Félix Le Dantec, Francis Vielé-Griffin, Félix Fénéon, Henri Ghéon, André Gide, Maurice Maeterlinck, and Henri-Edmond Cross (back to the viewer); in orange, Émile Verhaeren
71¼ × 94½ in. (181 × 240 cm)
Museum voor Schone Kunsten, Ghent

Madame Van de Velde and Her Children (*Mme Van de Velde et ses enfants*), 1903
Maria, wife of Henry van de Velde, and their three daughters, Cornélie, Helen, and Anna
41⅜ × 49⅜ in. (105 × 125.5 cm)
Petit Palais, Musée d'art moderne, Geneva

Portrait of Louis Bonnier, 1903
Architect and friend of the artist, through Laure and Georges Flé
39⅜ × 31½ in. (100 × 80 cm)
Private collection

Selected Bibliography

Jane Block

General

Angrand, Pierre. *Naissance des Artistes Indépendants, 1884.* Paris: Nouvelles Éditions Debresse, 1965.

Aron, Paul, ed. *Émile Verhaeren: Écrits sur l'art.* Vol. 1, 1881–92, and Vol. 2, 1893–1916. Brussels: Éditions Labor et Archives et Musée de la littérature, 1997.

Bailey, Colin B., ed. *Renoir's Portraits: Impressions of an Age.* New Haven: Yale University Press, 1997.

Bailly-Herzberg, Janine, ed. *Correspondance de Camille Pissarro.* 5 vols. Vol. 1, 1865–85, Paris: Presses Universitaires de France, 1980; Vol. 2, 1886–90, Paris: Éditions du Valhermeil, 1986; Vol. 3, 1891–94, Paris: Éditions du Valhermeil, 1988; Vol. 4, 1895–98, Paris: Éditions du Valhermeil, 1989; Vol. 5, 1899–1903, Paris: Éditions du Valhermeil, 1991.

Berson, Ruth, ed. *The New Painting: Impressionism, Documentation: 1874–1886.* 2 vols. San Francisco: Fine Arts Museums of San Francisco, 1996.

Block, Jane. *Les XX and Belgian Avant-Gardism, 1868–1894.* Ann Arbor, MI: UMI Research Press, 1984.

———. "A Neglected Collaboration: Van de Velde, Lemmen, and the Diffusion of the Belgian Style." In *The Documented Image: Visions in Art History,* ed. Gabriel P. Weisberg and Laurinda S. Dixon, 147–64. Syracuse: Syracuse University Press, 1987.

———, ed. *Belgium, the Golden Decades, 1880–1914.* New York: Peter Lang, 1997.

Bowness, Alan, John House, and Mary Anne Stevens. *Post-Impressionism: Cross-Currents in European Painting.* London: Royal Academy of Arts in association with Weidenfeld and Nicolson, 1979.

Brooklyn Museum. *Belgian Art, 1880–1914.* Brooklyn: Brooklyn Museum, 1980.

Canning, Susan M. *Le Cercle des XX.* Brussels: Galerie Tzwern-Aisinber Fine Arts, 1989.

Delevoy, Robert L., ed. *Les XX, Bruxelles: Catalogue des dix expositions annuelles.* Brussels: Centre international pour l'étude du XIXe siècle, 1981.

Garb, Tamar. *The Painted Face: Portraits of Women in France, 1814–1914.* New Haven: Yale University Press, 2007.

Goddard, Stephen, ed. *Les XX and the Belgian Avant-Garde: Prints, Drawings, and Books, ca. 1890.* Lawrence: Spencer Museum of Art, University of Kansas, 1992.

Goyens de Heusch, Serge. *L'Impressionnisme et le fauvisme en Belgique.* Antwerp: Fonds Mercator, 1988.

Herbert, Eugenia W. *The Artist and Social Reform: France and Belgium, 1885–1898.* New Haven: Yale University Press, 1961.

Legrand, Francine-Claire. *Le Groupe des XX et son temps.* Brussels: Musées royaux des Beaux-Arts de Belgique, 1962.

Lobstein, Dominique. *Dictionnaire des indépendants, 1884–1914.* 3 vols. Dijon: L'Échelle de Jacob, 2003.

Maus, Madeleine. *Trente années de lutte pour l'art, 1884–1914.* Brussels: Librairie l'Oiseau bleu, 1926, reprinted Lebeer Hossmann, 1980.

Mendgen, Eva A. *In Perfect Harmony: Picture + Frame, 1850–1920.* Zwolle: Waanders Uitgevers, 1995.

Moffett, Charles S. *The New Painting: Impressionism, 1874–1886.* Geneva: R. Burton, 1986.

Monneret, Jean. *La conquête de la liberté artistique: l'Histoire du salon des Indépendants.* Paris: Société des Artistes Indépendants, 1989.

Newton, Joy. "Whistler and La Société des Vingt." *Burlington Magazine* 143 (August 2001): 480–88.

Ollinger-Zinque, Gisèle. *Les XX, la Libre Ésthétique: Honderd jaar later=Cent ans après.* Brussels: Musées royaux des Beaux-Arts de Belgique, 1993.

Palais des Beaux-Arts. *Le Portrait Espagnol du XIVe au XIXe Siècle.* Brussels: Palais des Beaux-Arts, 1970.

Pingeot, Anne, and Robert Hoozee. *Paris-Bruxelles, Bruxelles-Paris: Réalisme, impressionnisme, symbolisme, art nouveau. Les relations artistiques entre la France et la Belgique, 1848–1914.* Paris: Réunion des musées nationaux, 1997.

Quaghebeur, Marc, ed. *Émile Verhaeren, un musée imaginaire.* Les Dossiers du musée d'Orsay, no. 63. Paris: Réunion des musées nationaux, 1997.

Rewald, John. *Post-Impressionism from Van Gogh to Gauguin.* 3rd rev. ed. New York: Museum of Modern Art; Boston: New York Graphic Society, 1978.

San Nicolás, Juan. *Los XX: El Nacimiento de la pintura moderna en Bélgica.* Madrid: Fundación Cultural MAPRFRE Vida, 2001.

Sanchez, Pierre. *Le Salon des "XX" et de la Libre Esthétique.* Bruxelles: Répertoire des exposants et liste de leurs œuvres, 1884–1914. Dijon: L'Échelle de Jacob, 2012.

Stevens, Mary Anne, and Robert Hoozee. *Impressionism to Symbolism: The Belgian Avant-Garde, 1880–1900.* London: Royal Academy of Arts, 1994.

Thorold, Anne. *Artists, Writers, Politics: Camille Pissarro and His Friends: An Archival Exhibition Held at the Ashmolean Museum.* Oxford: Ashmolean Museum, 1980.

Neo-Impressionism

L'Aube du XXe Siècle: Néo-impressionistes et autour du néo-impressionnisme. Geneva: Petit Palais, 1962.

Block, Jane. "Tête à tête: Le visage néo-impressionniste." In *Bruxelles convergence des arts (1880–1914),* ed. Malou Haine, Denis Laoureux, and Sandrine Thieffry, 297–310. Paris: Vrin, 2013.

Budde, Rainer. *Pointillisme: Sur les traces de Seurat.* Lausanne: Fondation de l'Hermitage, 1998.

Cariou, André. *Impressionnistes et néo-Impressionnistes en Bretagne.* Rennes: Éditions Ouest-France, 1999.

Catalogus van Schilderijen uit de Divisionistische school van Georges Seurat tot Jan Toorop. Rotterdam: Museum Boymans, 1936.

Coret, Noël. *Autour des néo-impressionnistes: Le groupe de Lagny.* Lagny-sur-Marne: Musée Gatien-Bonnet, 1999.

Cros, Henry, and Charles Henry. *L'Encaustique et les autres procédés de peinture chez les anciens: Histoire et technique.* Paris: J. Rouam, 1884, reprinted Bayeux: La Bayeuserie, 1988.

Draguet, Michel. *Signac, Seurat: Le Néo-impressionnisme.* Paris: Éditions Hazan, 2001.

Duvivier, Christophe. *Georges Seurat et le Néo-impressionnisme, 1885–1905.* Tokyo: APT, 2002.

Exposition Le Néo-Impressionnisme. Kanazawa: MRO, 1984.

Exposition du Pointillisme. Tokyo: Musée national d'art occidental, 1985.

Ferretti Bocquillon, Marina. *Le Néo-impressionnisme: De Seurat à Paul Klee.* Paris: Réunion des musées nationaux, 2005.

———. *Georges Seurat, Paul Signac e i neoimpressionisti.* Milan: Skira, 2008.

———. *Radiance: The Neo-Impressionists.* Victoria: National Gallery of Victoria, 2012.

Greene, Vivien. *Divisionism, Neo-Impressionism: Arcadia and Anarchy.* New York: Guggenheim Museum, 2007.

Halperin, Joan Ungersma, ed. *Félix Fénéon: Oeuvres plus que complètes.* 2 vols. Geneva: Librairie Droz, 1970.

———. *Félix Fénéon: Aesthete and Anarchist in Fin-de-Siècle Paris.* New Haven: Yale University Press, 1988.

Henry, Charles. "Introduction à une esthétique scientifique." *La Revue contemporaine* 2 (August 1885): 441–69.

———. *Cercle chromatique présentant sous les compléments et toutes les harmonies de couleurs avec une introduction sur la théorie générale de la dynamogénie, autrement dit: Du contraste, du rythme et de la mesure.* Paris: Charles Verdin, 1888.

Herbert, Robert L., and Eugenie W. Herbert. "Artists and Anarchism: Unpublished Letters of Pissarro, Signac, and Others." *Burlington Magazine* 102 (November 1960): 473–82; 102 (December 1960): 517–22.

———. *Neo-Impressionists and Nabis in the Collection of Arthur G. Altschul.* New Haven: Yale University Art Gallery, 1965.

———. *Neo-Impressionism.* New York: Solomon R. Guggenheim Museum, 1968.

Hutton, John G. *Neo-Impressionism and the Search for Solid Ground: Art, Science, and Anarchism in Fin-de-Siècle France.* Baton Rouge: Louisiana State University Press, 1994.

Kahn, Gustave. "Au temps du Pointillisme." *Mercure de France* 171 (April 1924): 5–22.

Lee, Ellen Wardwell. *The Aura of Neo-Impressionism: The W. J. Holliday Collection.* Indianapolis: Indianapolis Museum of Art, 1983.

Licht door kleur: Nederlandse luministen. The Hague: Haags Gemeentemuseum, 1976.

Maingon, Claire. "Le portrait divisionniste: Un exercise de style." In *Le Portrait: Formes, catégories et fonction d'un genre* (electronic edition), ed. Sandra Costa. 132ᵉ Congrès national des sociétés historiques et scientifiques, 27–37. Arles: Bouches-du-Rhône, 2007. http://cths.fr/ed/edition.php?id=5395.

Neo-Impressionism: Artists on the Edge. Portland, ME: Portland Museum of Art, 2002.

Les Néo-Impressionnistes. Paris: Galerie André Maurice, 1960.

Peintures néo-impressionnistes. Pontoise: Musée Pissarro, 1985.

Pointillisme. London: Arthur Tooth and Sons, 1966.

Quelques tableaux de maîtres néo-impressionnistes. Paris: Galerie Hervé, 1967.

Rood, Ogden N. *Théorie scientifique des couleurs et leurs applications à l'art et à l'industrie.* Paris: G. Ballière, 1881. (Original edition: *Modern Chromatics: Students' Text-book of Color with Application to Art and Industries.* New York: D. Appleton, 1879.)

Roslak, Robin Sue. *Neo-Impressionism and Anarchism in Fin-de-Siècle France: Painting, Politics, and Landscape.* Aldershot, England: Ashgate, 2007.

Scheps, Ofir. *Le Pointillisme: Catalogue des œuvres néo-impressionnistes de la collection du musée du Petit Palais.* Geneva: Petit Palais, 1996.

Seurat et ses amis, la suite de l'impressionnisme. Paris: Galerie Beaux-Arts, 1933.

Signac, Paul. *D'Eugène Delacroix au néo-impressionnisme, La Revue Blanche.* Paris, 1899. New edition with an introduction and notes by Françoise Cachin. Paris: Hermann, 1964; reissue 1978 and 1987.

Sutter, Jean, ed. *The Neo-Impressionists.* Greenwich, CT: New York Graphic Society, 1970.

Van Rysselberghe, Maria (Marie Saint-Clair). *Il y a quarante ans: Suivi de Galerie privée, Strophes pour un rossignol.* Brussels: Éditions Labor, 2005. (Original edition: 1936, Gallimard.)

———. *Je ne sais si nous avons dit impérissables choses: Une anthologie des Cahiers de la Petite Dame.* Paris: Gallimard, 2006. Extracted from *Les Cahiers de la Petite Dame. Notes pour l'histoire authentique d'André Gide,* ed. Claude Martin. 4 vols. Paris: Gallimard, 1973–77.

Vom Licht sur Farbe: Nachimpressionistische Malerei zwischen 1886 und 1912. Düsseldorf: Städtische Kunsthalle, 1977.

Ward, Martha. *Pissarro, Neo-Impressionism, and the Spaces of the Avant-Garde.* Chicago: University of Chicago Press, 1996.

Wendermann, Gertrud. *Studien zur Rezeption des Neo-Impressionismus in den Niederlanden.* Munster and Hamburg: Lit, 1993.

Woloshyn, Tania, and Anne Dymond, eds. "New Directions in Neo-Impressionism." Special issue, *Journal of the International Association of Research Institutes in the History of Art* 0041 (July 14, 2012), http://www.riha-journal.org/articles/2012/2012-jul-sep/special-issue-neo-impressionism/woloshyn-dymond-introduction.

Artists

CHARLES ANGRAND

Duvivier, Christophe. *Charles Angrand, 1854–1926.* Paris: Somogy Éditions d'art, 2006.

Lespinasse, François. *Charles Angrand, 1854–1926.* Rouen: Le Cerf, 1982.

———, ed. *Charles Angrand Correspondances, 1883–1926.* Rouen: F. Lespinasse, 1988.

Welsh-Ovcharov, Bogomila. *The Early Works of Charles Angrand and His Contact with Vincent van Gogh.* Utrecht: Éditions Victorine, 1971.

HENRI-EDMOND CROSS

Baligand, Françoise, Sylvie Carlier, et al. *Henri-Edmond Cross, 1856–1910.* Douai: Musée de la Chartreuse, 1998.

Baligand, Françoise, Raphaël Dupouy, et al. *Henri-Edmond Cross: Études et œuvres sur papier.* Le Lavandou: Le Réseau Lalan, 2006.

Baligand, Françoise, Françoise Chibret-Plaussu, et al. *Henri-Edmond Cross et le néo-impressionnisme: De Seurat à Matisse.* Paris: Hazan, 2011.

Compin, Isabelle. *Henri Edmond Cross: Catalogue raisonné.* Paris: Quatre-Chemins-Éditart, 1964.

Cousturier, Lucie. *Henri-Edmond Cross.* Paris: G. Crès, 1932.

HENRI DELAVALLÉE

Boyle-Turner, Caroline. *The Prints of the Pont-Aven School: Gauguin and His Circle in Brittany.* Washington, DC: Smithsonian Institution Traveling Exhibition Service, 1986.

Catalogue de l'exposition Henri Delavallée. Quimper: Galerie Saluden, 1941.

Chassée, Charles. *Gauguin et son temps.* Paris: Bibliothèque des Arts, 1955.

Morane, Daniel. *Henri Delavallée, 1862–1943: Catalogue de l'oeuvre gravé.* Pont-Aven: Musée de Pont-Aven, 1996.

Musée de Quimper. *L'École de Pont-Aven dans les collections publiques et privées de Bretagne.* Quimper: Musée de Quimper, 1978.

ALBERT DUBOIS-PILLET

Bazalgette, Lily. *Albert Dubois-Pillet, sa vie et son œuvre (1846–1890).* Paris: Gründ Diffusion, 1976.

Christophe, Jules. "Dubois-Pillet." *Les Hommes d'aujourd'hui* 8, no. 370 (May 1890).

Gounot, Roger. "Le peintre Dubois-Pillet." *Cahiers de la Haute-Loire* (1969): 99–131.

ALFRED WILLIAM FINCH

Derrey, Danielle. *A. W. Finch, 1854–1930.* Brussels: Musées royaux des Beaux-Arts de Belgique and Crédit Communal, 1992.

Finlande, tradition et formes nouvelles: Tapis Rya et rétrospective A. W. Finch. Brussels: Palais des Beaux-Arts, 1967.

CHARLES FRECHON

Charles Frechon, 1856–1929. Milan: Silvana, 2008.

Lespinasse, François. *Charles Frechon, 1856–1929: Musée de Louviers.* Louviers: Musée de Louviers, 1998.

LÉO GAUSSON

Eberhart, Pierre, and Micheline Hanotelle. *Léo Gausson, 1860–1944: Peintures, aquarelles, dessins, eaux-fortes, sculptures.* Lagny-sur-Marne: Musée municipal Gatien-Bonnet, 1988.

Hanotelle, Micheline. *Léo Gausson, 1860–1944: Un peintre méconnu du Post-Impressionnisme.* Villeneuve d'Ascq: Presses universitaires du Septentrion, 2001.

LOUIS HAYET

Dulon, Guy, and Christophe Duvivier. *Louis Hayet, 1864–1940: Peintre et théoricien du néo-impressionnisme.* Pontoise: Musée de Pontoise, 1991.

Louis Hayet, 1864–1890. Pontoise: Musée Pissarro, 1983.

WILLIAM JELLEY

Du Jacquier, Yvonne. "A la Belle Époque . . . Dans le grenier de 'L'Effort.'" *Brabant tourisme,* January 1963, 8–12.

Morjan, Jean. *L'Académie et l'art nouveau: 50 artistes autour de Victor Horta.* Brussels: Académie royale des beaux-arts, 1996. 1: 164–69.

Van Loo, Anne, ed. *Dictionnaire de l'architecture en Belgique de 1830 à nos jours.* Antwerp: Fonds Mercator, 2003, 376.

ACHILLE LAUGÉ

Drouot-Rive Gauche. *Atelier Achille Laugé.* Paris: Drouot-Rive Gauche, Maîtres A. Godeau, L. Solanet, P.-E. Audap, March 5, 1976, and March 11, 1977.

Galerie Marcel Flavian. *Achille Laugé, 1861–1944.* Paris: Galerie Marcel Flavian, 1969.

Kaplan Gallery. *Achille Laugé (1861–1944).* London: Kaplan Gallery, 1966.

Tamburini, Nicole. *Achille Laugé, 1861–1944: Portraits pointillistes.* Saint-Tropez: Musée de l'Annonciade, 1990.

———. *Achille Laugé: Le Point, la ligne, la lumière.* Milan: Silvana, 2009.

GEORGES LEMMEN

Block, Jane. "A Study in Belgian Neo-Impressionist Portraiture." *Art Institute of Chicago Museum Studies* 13, no. 1 (1987): 36–51.

———. "A Neglected Collaboration: Van de Velde, Lemmen, and the Diffusion of the Belgian Style." In *The Documented Image: Visions in Art History,* ed. Gabriel P. Weisberg and Laurinda Dixon, 147–64. Syracuse: Syracuse University Press, 1987.

Cardon, Roger. *Georges Lemmen, 1865–1916.* Antwerp: Pandora, 1990.

———. *Georges Lemmen, 1865–1916.* Ghent: Snoeck-Ducaju and Zoon; Antwerp: Pandora, 1997.

Nyns, Marcel. *Georges Lemmen.* Antwerp: De Sikkel, 1954.

MAXIMILIEN LUCE

Bouin-Luce, Jean, and Denise Bazetoux. *Maximilien Luce: Catalogue raisonné de l'oeuvre peint.* 3 vols. Paris: Éditions JBL, 1986.

Cazeau, Philippe. *Maximilien Luce.* Lausanne: Bibliothèque des Arts, 1982.

Ferretti Bocquillon, Marina. *Maximilien Luce, néo-impressionniste: Rétrospective.* Milan: Silvana, 2010.

Maximilien Luce, 1858–1941: Peintre anarchiste. Charleroi: Musée des Sciences de Parentville et l'Institut de Sociologie de l'Université libre de Bruxelles, 1995.

Maximilien Luce: Peindre la condition humaine. Paris: Somogy Éditions d'art, 2000.

Sutter, Jean. *Maximilien Luce, 1858–1941: Peintre anarchiste.* Paris: Galerie des Vosges, 1986.

GEORGE MORREN

Calabrese, Tony. *George Morren: Monographie générale suive du catalogue raisonné de l'oeuvre.* Antwerp: Pandora, 2000.

HIPPOLYTE PETITJEAN

Catalogue de l'exposition du centenaire d'Hippolyte Petitjean (1854–1954) suivi d'un sommaire de technologie divisionniste. Paris: Galerie de l'Institut, 1955.

LUCIEN PISSARRO

Duvivier, Christophe. *Lucien Pissarro et le post-impressionnisme anglais.* Pontoise: Musée de Pontoise, 1998.

Pickvance, Ronald. *Lucien Pissarro, 1863–1944: A Centenary Exhibition of Paintings, Watercolours, Drawings, and Graphic Work.* London: Arts Council of Great Britain, 1963.

Rewald, John, ed. *Camille Pissarro: Letters to His Son Lucien.* Rev. ed. Mamaroneck, NY: Paul P. Appel, 1972.

Shorvon, S. D., and Jon Whitely. *Lucien Pissarro in England: The Eragny Press, 1895–1914.* Oxford: Ashmolean Museum, 2011.

Thorold, Anne. A *Catalogue of Oil Paintings by Lucien Pissarro.* London: Athelney, 1983.

———, ed. *The Letters of Lucien to Camille Pissarro, 1883–1903.* Cambridge: Cambridge University Press, 1993.

LÉON POURTAU

Mollard-Chaumette, P. "Léon Pourtau." *Le Petit Bonhomme,* no. 2. Pontoise: Musées de Pontoise, 1985.

DARÍO DE REGOYOS

Darío de Regoyos: Un espagnol en Belgique/een spanjaard in Belgie. Brussels: Banque Bruxelles Lambert, 1985.

Darío de Regoyos, 1857–1913. Madrid: Fundación Caja de Pensiones, 1986.

Darío de Regoyos: Impresiones del norte. Madrid: Fundación Santillana, 2000.

San Nicolás, Juan. *Darío de Regoyos.* Barcelona: Diccionari Ràfols, 1990.

———. *Darío de Regoyos, 1857–1913.* Madrid: Fundación Cultural MAPFRE Vida, 2002.

GEORGES SEURAT

Dorra, Henry, and John Rewald. *Seurat, l'oeuvre peint, biographie et catalogue critique.* Paris: Les Beaux-Arts, 1959.

Ferretti Bocquillon, Marina. *Seurat et le dessin néo-impressionniste.* Paris: Musée d'Orsay, 2005.

Franz, Erich, and Bernd Growe. *Georges Seurat, Drawings.* Boston: Little, Brown, 1984.

Hauke, César M. de. *Seurat et son œuvre.* 2 vols. Paris: Gründ, 1961.

Herbert, Robert L. "Seurat and Émile Verhaeren: Unpublished Letters." *Gazette des Beaux-Arts* 54 (December 1959): 318–21.

———. *Seurat's Drawings.* New York: Shorewood, 1962.

———. *Georges Seurat, 1859–1891.* New York: Metropolitan Museum of Art, 1991.

———. *Seurat: Drawings and Paintings.* New Haven: Yale University Press, 2001.

———. *Seurat and the Making of La Grande Jatte.* Chicago: Art Institute of Chicago in association with the University of California Press, 2004.

Homer, William Innes. *Seurat and the Science of Painting*. Cambridge, MA: MIT Press, 1964.

House, John. "Meaning in Seurat's Figure Paintings." *Art History* 3 (September 1980): 345–56.

Lee, Ellen Wardwell. *Seurat at Gravelines: The Last Landscapes*. Indianapolis: Indianapolis Museum of Art in cooperation with Indiana University Press, 1990.

Rewald, John. *Seurat*. New York: John Wittenborn, 1943.

Seurat et ses amis. Paris: Galerie Wildenstein, 1953.

Smith, Paul. *Seurat and the Avant-Garde*. New Haven: Yale University Press, 1997.

———. ed. *Seurat Re-Viewed*. University Park: Pennsylvania State University Press, 2009.

Thomson, Richard. *Seurat*. Oxford: Phaidon, 1985.

Zimmermann, Michael F. *Les Mondes de Seurat: Son oeuvre et le débat artistique de son temps*. Antwerp: Fonds Mercator, and Paris: Éditions Albin Michel, 1991.

PAUL SIGNAC

Cachin, Françoise. *Paul Signac*. Greenwich, CT: New York Graphic Society, 1971.

Cachin, Françoise. *Signac: Catalogue raisonné de l'oeuvre peint*. In collaboration with Marina Ferretti Bocquillon. Paris: Gallimard, 2000.

Chartrain-Hebbelinck, Marie-Jeanne. "Les lettres de Paul Signac à Octave Maus." *Bulletin des Musées royaux des Beaux-Arts de Belgique* 18, nos. 1–2 (1969): 52–102.

Coustuvier, Lucie. *Paul Signac*. Paris: Crès, 1922.

Distel, Anne. *Signac: Au temps d'harmonie*. Paris: Gallimard, 2001.

Ferretti Bocquillon, Marina. *Signac et Saint-Tropez, 1892–1913*. Saint-Tropez: Musée de l'Annonciade, 1992.

———. "Signac and Van Rysselberghe: The Story of a Friendship, 1887–1907." *Apollo* 147 (June 1998): 11–18.

———, ed. *Signac: Les Couleurs de l'eau*. Paris: Gallimard, 2013.

Ferretti Bocquillon, Marina, Anne Distel, et al. *Signac, 1863–1935*. New York: Metropolitan Museum of Art, 2001.

Franz, Erich. *Signac et la libération de la couleur de Matisse a Mondrian*. Paris: Réunion des musées nationaux, 1997.

Lemoyne de Forges, Marie-Thérèse. *Signac*. Paris: Musée du Louvre, 1963.

Rewald, John, ed. "Extraits du journal inédit de Paul Signac, Part I: 1894–1895." *Gazette des Beaux-Arts* 36 (July–September 1949): 97–128, 166–74; Part II: 1897–98, 41 (April 1952): 265–84, 298–304; and Part III:

1898–99, 42 (July–August 1953): 27–57, 72–80.

Signac et la liberation de la couleur: De Matisse à Mondrian. Paris: Réunion des musées nationaux, 1996.

JAN TOOROP

Hefting, Victorine. *Jan Toorop, 1858–1928: Impressionniste, symboliste, pointilliste*. Paris: Institut néerlandais, 1977.

———. *J. Th Toorop: De jaren 1885 tot 1910*. Otterlo: Rijksmuseum Kröller-Müller, 1978.

Mertens, Phil. "De brieven van Jan Toorop aan Octave Maus." *Bulletin des Musées royaux des Beaux-Arts de Belgique* 18, nos. 3–4 (1969): 157–209.

Reynaerts, Jenny. "'From a Hygienic and Aesthetic Point of View': Jan Toorop, *Portrait of Marie Jeannette de Lange, 1900*." *Rijksmuseum Bulletin* 57, no. 2 (2009): 114–35.

Siebelhoff, Robert. "Toorop, Van de Velde, Van Rysselberghe and the Hague Exhibition of 1892." *Oud Holland* 95, no. 2 (1981): 97–107.

Van der Coelen, Peter, and Karin Van Lieverloo. *Jan Toorop, Portrettist*. Zwolle: Waanders Uitgervers, 2003.

HENRY VAN DE VELDE

Canning, Susan M. *Henry van de Velde (1863–1957): Schilderijen en tekeningen, Paintings and Drawings*. Antwerp: Koninklijk Museum voor Schone Kunsten, 1987.

Delevoy, Robert. *Henry van de Velde, 1863–1957*. Brussels: Palais des Beaux-Arts, 1963.

Hammacher, Abraham Marie. *Le Monde de Henry van de Velde*. Antwerp: Fonds Mercator, 1967.

Ollinger-Zinque, Gisèle. "La fille qui remaille ou la ravaudeuse." *Bulletin des Musées royaux des Beaux-Arts de Belgique* 22 (1973): 165–69.

Van Loo, Anne, and Fabrice van de Kerckhove, eds. *Henry van de Velde: Récit de ma vie*. Vol. 1: 1863–1900, 1992; Vol. 2: 1900–1913, 1995. Brussels: Versa/Flammarion.

VINCENT VAN GOGH

Faille, J. B. de la. *L'Oeuvre de Vincent Van Gogh: Catalogue raisonné*. 4 vols. Paris: Van Oest, 1928. Rev. ed., *The Works of Vincent van Gogh: His Paintings and Drawings*. New York: Reynal, 1970.

Homburg, Cornelia, Elizabeth C. Childs, et al. *Vincent van Gogh and the Painters of the Petit Boulevard*. Saint Louis: Saint Louis Museum of Art in association with Rizzoli, 2001.

Hulsker, Jan. *The New Complete Van Gogh: Paintings, Drawings, Sketches*. Amsterdam: Meulenhoff, and Philadelphia: John Benjamins, 1996.

Vincent Van Gogh: The Letters—The Complete Illustrated and Annotated Edition. 6 vols. London: Thames and Hudson in association with the Van Gogh Museum and the Huygens Institute, 2009.

Welsh-Ovcharov, Bogomila, and Monique Nonne. *Van Gogh à Paris*. Paris: Réunion des musées nationaux, 1988.

THÉO VAN RYSSELBERGHE

Bertrand, Olivier. *Théo van Rysselberghe*. Brussels: Fonds Mercator and Belgian Art Research Institute, 2006.

Block, Jane. "Théo van Rysselberghe and the Architecture of Decoration." *Low Countries* 18 (2010): 254–64.

———. "Théo van Rysselberghe." Entry in *Nouvelle Biographie Nationale* 11, 363–66. Brussels: Académie Royale des sciences, des lettres et des beaux-arts de Belgique, 2012.

Chartrain-Hebbelinck, Marie-Jeanne. "Théo van Rysselberghe: Le groupe des XX et la Libre Esthétique." *Revue belge d'archéologie et d'histoire de l'art* 34, no. 1–2 (1965): 99–134.

———. "Les lettres de Van Rysselberghe à Octave Maus." *Bulletin des Musées royaux des Beaux-Arts de Belgique* 15, nos. 1–2 (1966): 55–112.

Eeckhout, Paul. *Rétrospective Théo van Rysselberghe*. Ghent: Musée des Beaux-Arts, 1962.

Feltkamp, Ronald. *Théo van Rysselberghe, 1862–1926: Catalogue raisonné*. Brussels: Éditions Racine, 2003.

Fierens, Paul. *Théo van Rysselberghe*. Brussels: Éditions de la Connaissance, 1937.

Hoozee, Robert, and Helke Lauwaert, eds. *Théo van Rysselberghe, néo-impressionniste*. Ghent: Pandora, 1993.

Maret, François. *Théo van Rysselberghe*. Antwerp: De Sikkel, 1948.

Schaëfer, Carina. "Théo van Rysselberghe, Henry van de Velde et la clientèle allemande des portraits néo-impressionnistes." In *Du romantisme à l'art déco: Lectures croisées: Mélanges offerts à Jean-Paul Bouillon*. ed. Rossella Froissart, Laurent Houssais, and Jean-François Luneau, 167–79. Rennes: Presses universitaires de Rennes, 2011.

Tamburini, Nicole. *Théo van Rysselberghe: L'instant sublime*. Musée de Lodève: Éditions midi-pyrénéennes, 2012.

Théo van Rysselberghe intime. Le Lavandou: Le Réseau Lalan, 2005.

Contributors

Jane Block, the Andrew Turyn Professor of Library Administration at the University of Illinois, has published extensively on Belgian art of the years around 1900. Her books include *Homage to Adrienne Fontainas: Passionate Pilgrim for the Arts*, *Belgium: The Golden Decades, 1880–1914*, *Gisbert Combaz (1869–1914)*, and *Les XX and Belgian Avant-Gardism*.

Ellen Wardwell Lee is the Wood–Pulliam Senior Curator at the Indianapolis Museum of Art. She is the author of *The Aura of Neo-Impressionism: The W. J. Holliday Collection* and *Seurat at Gravelines: The Last Landscapes* and served on the curatorial team for *Snapshot: Painters and Photography, Bonnard to Vuillard* (Van Gogh Museum, Amsterdam; The Phillips Collection, Washington, DC; Indianapolis Museum of Art, 2011–12).

Marina Ferretti Bocquillon is directeur scientifique of the Musée des impressionnismes, Giverny, and in charge of the Signac Archives. She has written numerous essays devoted to Impressionism and Neo-Impressionism and has curated several exhibitions, including *Seurat, Signac, and Neo-Impressionism* (Palazzo Reale, Milan, 2008) and *Signac: The Colors of Water* (Musée des impressionnismes, Giverny, 2013).

Nicole Tamburini, an art historian, is working on the forthcoming catalogue raisonné of Achille Laugé; her other books include *Achille Laugé, 1861–1944: Portraits pointillistes* and *Achille Laugé: Le Point, la ligne, la lumière*. She was associate curator of the exhibition *Théo van Rysselberghe: L'Instant sublimé* (Musée de Lodève, 2012).

Index

Illustration Credits

The photographers and the sources of visual material other than the owners indicated in the captions are as follows. Every effort has been made to supply complete and correct credits; if there are errors or omissions, please contact Yale University Press so that corrections can be made in any subsequent edition.

Figures

Fig. 1. Photo: Gérard Blot © RMN-Grand Palais/Art Resource, NY.

Figs. 2, 16. Photo: H. Lewandowski © RMN-Grand Palais/Art Resource, NY.

Fig. 3. © BnF, Dist. RMN-Grand Palais/Art Resource, NY.

Figs. 4, 6. Photography © The Art Institute of Chicago.

Fig. 5. Photo by Peter Willi/The Bridgeman Art Library.

Fig. 7. © Royal Museums of Fine Arts of Belgium, Brussels/AACB.

Figs. 8, 11. Courtesy of the Indianapolis Museum of Art.

Fig. 9. © Royal Museums of Fine Arts of Belgium, Brussels/AACB/Photo: J. Geleyns/Ro scan.

Figs. 10, 28. Erich Lessing/Art Resource, NY.

Figs. 12, 24, 35. © KIK-IRPA, Brussels.

Fig. 13. Courtesy of The Albuquerque Museum © The Raymond Jonson Collection, University of New Mexico Art Museum, Albuquerque.

Fig. 14. Image copyright © The Metropolitan Museum of Art. Image source: Art Resource, NY.

Fig. 15. © RMN-Grand Palais/Art Resource, NY.

Fig. 17. Photo: Hervé Lewandowski © RMN-Grand Palais/Art Resource, NY © 2014 Artists Rights Society (ARS), New York/ADAGP, Paris.

Fig. 18. © Lukas-Art in Flanders VZW/Photo: Hugo Maertens/The Bridgeman Art Library © 2014 Artists Rights Society (ARS), New York/SABAM, Brussels.

Fig. 19. Photograph by Peter Jacobs Fine Arts Imaging.

Fig. 20. Scala/Art Resource, NY.

Fig. 21. Photo by A. C. L., Brussels. © Bibliothèque royale de Belgique, Brussels. Archives et Musée de la Littérature.

Figs. 22, 23. Photo by Nicole Hellyn. © Bibliothèque royale de Belgique, Brussels. Archives et Musée de la Littérature.

Fig. 25. © Royal Museums of Fine Arts of Belgium, Brussels/Photo: J. Geleyns/Ro scan.

Fig. 26. Scala/Art Resource, NY.

Fig. 27. Courtesy of Patrick Derom Gallery, Brussels.

Fig. 29. Digital image courtesy of Raphaël Dupouy. © Archives André Gide.

Fig. 30. Photo by Thierry LeMage © RMN-Grand Palais/Art Resource, NY.

Figs. 31, 41. Digital image courtesy of the Indianapolis Museum of Art.

Fig. 32. © étude Audap, Godeau, Solanet. © 2014 Artists Rights Society (ARS), New York/ADAGP, Paris.

Fig. 33. Courtesy of the Kröller-Müller Museum, Otterlo, the Netherlands.

Fig. 34. Digital image by Luc Schrobiltgen.

Fig. 36. Private collection.

Figs. 37, 46. © Bibliothèque royale de Belgique, Brussels. Archives et Musée de la Littérature.

Fig. 38. Courtesy of Vassar College Libraries © 2014 Artists Rights Society (ARS), New York/ADAGP, Paris.

Fig. 39. Photograph by Peter Jacobs Fine Arts Imaging. © Estate of Lucien Pissarro.

Fig. 40. Courtesy of the Indianapolis Museum of Art. © Estate of Lucien Pissarro.

Fig. 42. Scala/Art Resource, NY.

Fig. 43. Courtesy of Vassar College Libraries.

Fig. 44. Private collection.

Fig. 45. Courtesy of Danielle Dubois.

Fig. 47. Photograph by Michael Gould. Courtesy of the Trustees of the Boston Public Library, Arts Department.

Fig. 48. Courtesy of the Spiro Family.

Plates

Plate 1. Photo: Hervé Lewandowski © RMN-Grand Palais/Art Resource, NY.

Plate 2. Courtesy of the Roberto Polo Gallery, Brussels.

Plate 3. Photo: Yves Bresson. Musée d'art moderne de Saint-Étienne Métropole.

Plates 4, 5, 24. Courtesy of the Indianapolis Museum of Art.

Plate 6. Digital image © Musée des Beaux-Arts de Carcassonne. © 2014 Artists Rights Society (ARS), New York/ADAGP, Paris.

Plate 7. Courtesy of Galerie Moulins-Toulouse. © 2014 Artists Rights Society (ARS), New York/ADAGP, Paris.

Plate 8. Digital image © André Morin. © 2014 Artists Rights Society (ARS), New York/ADAGP, Paris.

Plate 9. Collection of Robert Bachmann, Lisbon. © 2014 Artists Rights Society (ARS), New York/ADAGP, Paris.

Plate 10. Photo: Bulloz. © RMN-Grand Palais/Art Resource, NY © 2014 Artists Rights Society (ARS), New York/ADAGP, Paris.

Plate 11. Photo: Félicien Faillet. Image courtesy of bpk, Berlin/Art Resource, NY © 2014 Artists Rights Society (ARS), New York/ADAGP, Paris.

Plate 12. Photo: Hannema De Stuers Fundatie.

Plates 13, 21. Digital image courtesy of the Indianapolis Museum of Art.

Plate 14. Image courtesy of ING, Belgium.

Plates 15, 53. © KIK-IRPA, Brussels.

Plates 16, 19, 49, 58. Private collection.

Plate 17. Photo: Gérard Blot © RMN-Grand Palais/Art Resource, NY.

Plates 18, 52. © Bibliothèque royale de Belgique, Brussels.

Plates 20, 22, 23, 44, 50. Photography © The Art Institute of Chicago.

Plate 25. Image courtesy of the Board of Trustees, National Gallery of Art, Washington, photographer Lea Ingold. © 2014 Artists Rights Society (ARS), New York/ADAGP, Paris.

Plate 26. Image courtesy of the Signac Archives. © 2014 Artists Rights Society (ARS), New York/ADAGP, Paris.

Plate 27. Image Copyright © The Metropolitan Museum of Art. Image source: Art Resource, NY © 2014 Artists Rights Society (ARS), New York/ADAGP, Paris.

Plate 28. Courtesy of the Indianapolis Museum of Art. © 2014 Artists Rights Society (ARS), New York/ADAGP, Paris.

Plate 29. Private collection. © 2014 Artists Rights Society (ARS), New York/ADAGP, Paris.

Plate 30. Photo: Hervé Lewandowski © RMN-Grand Palais/Art Resource, NY.

Plate 31. Courtesy of the Indianapolis Museum of Art © Estate of Lucien Pissarro.

Plate 32. Courtesy of the Museo Nacional Centro de Arte Reina Sofía, Madrid.

Plate 33. © The Samuel Courtauld Trust, The Courtauld Gallery, London.

Plates 34, 35. Image courtesy of the Signac Archives.

Plate 36. Digital image © The Museum of Modern Art/Licensed by SCALA/Art Resource, NY.

Plate 37. Photo by Peter Willi/The Bridgeman Art Library.

Plate 38. Photograph by Patrice Schmidt.

Plate 39. Collection Rijksmuseum, Amsterdam.

Plate 40. Courtesy of the Kröller-Müller Museum, Otterlo, the Netherlands.

Plate 41. © Lukas-Art in Flanders VZW/The Bridgeman Art Library © 2014 Artists Rights Society (ARS), New York/SABAM, Brussels.

Plate 42. Courtesy of Galerie Michael Haas, Berlin © 2014 Artists Rights Society (ARS), New York/SABAM, Brussels.

Plate 43. Courtesy of the Indianapolis Museum of Art © 2014 Artists Rights Society (ARS), New York/SABAM, Brussels.

Plate 45. Courtesy of Kelvingrove Art Gallery and Museum, Glasgow, Scotland.

Plate 46. Droits réservés Musée départemental Maurice Denis, Saint-Germain-en-Laye, France.

Plate 47. Image courtesy of the Baltimore Museum of Art.

Plates 48, 56. Erich Lessing/Art Resource, NY.

Plate 51. © Lukas-Art in Flanders VZW/Photo: Hugo Maertens/The Bridgeman Art Library.

Plate 54. Photo © Christie's Images/The Bridgeman Art Library.

Plate 55. Private collection. Courtesy of Jean-Luc Baroni, Ltd.

Plate 57. The Bridgeman Art Library.

Plate 59. Fine Art Photographic Library, London/Art Resource, NY.

Plate 60. Giraudon/The Bridgeman Art Library.